the Adobe® photoshop® CS4 book

for digital photographers

Scott Kelby

The Adobe Photoshop CS4 Book for Digital Photographers Team

CREATIVE DIRECTOR
Felix Nelson

TECHNICAL EDITORS
Kim Doty
Cindy Snyder

TRAFFIC DIRECTOR
Kim Gabriel

PRODUCTION MANAGER
Dave Damstra

DESIGNER
Jessica Maldonado

COVER PHOTOS BY
Scott Kelby

Published by
New Riders

Composed in Cronos and Helvetica by Kelby Media Group, Inc.

Trademarks
All terms mentioned in this book that are known to be trademarks or service marks have been appropriately capitalized. New Riders cannot attest to the accuracy of this information. Use of a term in this book should not be regarded as affecting the validity of any trademark or service mark.

Photoshop is a registered trademark of Adobe Systems, Inc.
Macintosh is a registered trademark of Apple, Inc.
Windows is a registered trademark of Microsoft Corp.

Warning and Disclaimer
This book is designed to provide information about Photoshop for digital photographers. Every effort has been made to make this book as complete and as accurate as possible, but no warranty of fitness is implied.

The information is provided on an as-is basis. The author and New Riders shall have neither the liability nor responsibility to any person or entity with respect to any loss or damages arising from the information contained in this book or from the use of the discs or programs that may accompany it.

THIS PRODUCT IS NOT ENDORSED OR SPONSORED BY ADOBE SYSTEMS INCORPORATED, PUBLISHER OF ADOBE PHOTOSHOP CS4.

ISBN 13: 978-0-321-58009-2
ISBN 10: 0-321-58009-5

9 8 7 6 5 4 3 2 1

www.newriders.com
www.kelbytraining.com

To Kira—
Daddy loves you with all his heart.

ACKNOWLEDGMENTS

After writing books for the past 10 years now, I've found that the thing that's the hardest for me to write in any book is writing the acknowledgments. It also, hands down, takes me longer than any other pages in the book. For me, I think the reason I take these acknowledgments so seriously is because it's when I get to put down on paper how truly grateful I am to be surrounded with such great friends, an incredible book team, and a family that truly makes my life a joy. That's why it's so hard. I also know why it takes so long—you type a lot slower with tears in your eyes.

To my amazing wife, Kalebra: As I write this, you're sitting beside me on a long night's flight. You're reading a book, and thankfully not paying attention to me working beside you on my laptop. A few minutes ago, while you were still reading, you reached over and wrapped your arm around mine. We've been married almost 20 years now, and your touch still makes my heart skip a beat. I've never met anyone more compassionate, more loving, more hilarious, and more genuinely beautiful, and I'm so blessed to be going through life with you, to have you as the mother of my children, my business partner, and best friend. You truly are the type of woman love songs are written for, and as anyone who knows me will tell you, I am, without a doubt, the luckiest man alive to have you for my wife.

To my son, Jordan: It's every dad's dream to have a relationship with his son like I have with you, and I'm so proud of the bright, caring, creative young man you've become. I can't wait to see the amazing things life has in store for you, and I just want you to know that watching you grow into the person you are is one of my life's greatest joys.

To my precious little girl, Kira: You have been blessed in a very special way, because you are a little clone of your mom, which is the most wonderful thing I could have possibly wished for you. I see all her gifts reflected in your eyes, and though you're still too young to have any idea how blessed you are to have Kalebra as your mom, one day—just like Jordan—you will.

To my big brother Jeff, who has always been, and will always be, a hero to me. So much of who I am, and where I am, is because of your influence, guidance, caring, and love as I was growing up. Thank you for teaching me to always take the high road, for always knowing the right thing to say at the right time, and for having so much of our dad in you.

I'm incredibly fortunate to have part of the production of my books handled in-house by my own book team at Kelby Media Group, which is led by my friend and longtime Creative Director, Felix Nelson, who is hands down the most creative person I've ever met. He's surrounded by some of the most talented, amazing, ambitious, gifted, and downright brilliant people I've ever had the honor of working with. People like my Editor Kim Doty, who bless her heart does not have an easy job (wrangling me), but does it with an attitude that would make you believe I'm organized and focused. She just rocks, and our working styles fit together so wonderfully (she's totally organized, on the ball, and calm, and I have the attention span of a hamster—it's a match

made in heaven). Working with Kim is Cindy Snyder, who relentlessly tests all the stuff I write to make sure I didn't leave anything out, so you'll all be able to do the things I'm teaching. She doesn't have it easy either, but you'd never know it by her attitude, temperament, and skill. The look of the book comes from an amazing designer, a creative powerhouse, and someone whom I feel very, very lucky to have designing my books—Jessica Maldonado. The tight, clean layout of the book comes from Dave Damstra, and I can truly say one of the luckiest things that's ever happened to our company was finding Dave, eight or so years ago. Dave kicks #@%!

I owe a huge debt of gratitude to my Executive Assistant and Chief Wonder Woman, Kathy Siler. She runs a whole side of my business life, and a big chunk of our conferences, and she does it so I have time to write books, spend time with my family, and have a life outside of work. She's such an important part of what I do that I don't know how I did anything without her. Thank you, thank you, thank you. It means more than you know.

Thanks to my best buddy, our Chief Operating Officer and father of newborn twins, Dave Moser, first for handling the business end of our book projects, but mostly for always looking out for me.

Thanks to everyone at New Riders and Peachpit Press, and in particular to my very cool Editor, Ted Waitt (who is one heck of a photographer and a vitally important part of everything I do in "Bookland"), my wonderful Publisher Nancy Aldrich-Ruenzel, Marketing Maven Scott Cowlin, and the entire team at Pearson Education who go out of their way to make sure that we're always working in the best interest of my readers, that we're always trying to take things up a notch, and who work hard to make sure my work gets in as many people's hands as possible.

Thanks to my friends at Adobe: Kevin Connor, John Nack, Mala Sharma, John Loiacono, Terry White, Addy Roff, Cari Gushiken, Julieanne Kost, Tom Hogarty, Jennifer Stern, Dave Story, Bryan Hughes, Russell Preston Brown, and the amazing engineering team at Adobe (I don't know how you all do it). Gone but not forgotten: Barbara Rice, Jill Nakashima, Rye Livingston, Bryan Lamkin, Deb Whitman, and Karen Gauthier.

Thanks to my "Photoshop Guys": Dave Cross, Matt Kloskowski, RC Concepcion, and Corey Barker, for being such excellent sounding boards for the development of this book. I want to thank all the talented and gifted photographers who've taught me so much over the years, including: Moose Peterson, Joe McNally, Anne Cahill, Vincent Versace, Bill Fortney, David Ziser, Helene Glassman, Kevin Ames, and Jim DiVitale.

Thanks to my mentors, whose wisdom and whip-cracking have helped me immeasurably, including John Graden, Jack Lee, Dave Gales, Judy Farmer, and Douglas Poole.

Most importantly, I want to thank God, and His son Jesus Christ, for leading me to the woman of my dreams, for blessing us with two amazing children, for allowing me to make a living doing something I truly love, for always being there when I need Him, for blessing me with a wonderful, fulfilling, and happy life, and such a warm, loving family to share it with.

OTHER BOOKS BY SCOTT KELBY

ABOUT THE AUTHOR

Scott Kelby

Scott is Editor, Publisher, and co-founder of *Photoshop User* magazine, Editor and Publisher of *Layers* magazine (the how-to magazine for everything Adobe), and is the host of the top-rated weekly video podcast *Photoshop User TV*.

He is President of the National Association of Photoshop Professionals (NAPP), the trade association for Adobe® Photoshop® users, and he's President of the training, education, and publishing firm Kelby Media Group, Inc.

Scott is a photographer, designer, and an award-winning author of more than 50 books, including *Scott Kelby's 7-Point System for Adobe Photoshop CS3*, *Photoshop Down & Dirty Tricks*, *The Photoshop Channels Book*, *Photoshop Classic Effects*, *The iPhone Book*, *The iPod Book*, and *The Digital Photography Book*, vols. 1 and 2.

For four years straight, Scott has been honored with the distinction of being the world's #1 best-selling author of all computer and technology books, across all categories. His book, *The Digital Photography Book*, vol. 1, is now the best-selling book on digital photography in history.

His books have been translated into dozens of different languages, including Chinese, Russian, Spanish, Korean, Polish, Taiwanese, French, German, Italian, Japanese, Dutch, Swedish, Turkish, and Portuguese, among others, and he is a recipient of the prestigious Benjamin Franklin Award.

Scott is Training Director for the Adobe Photoshop Seminar Tour and Conference Technical Chair for the Photoshop World Conference & Expo. He's featured in a series of Adobe Photoshop training DVDs and online courses at KelbyTraining.com, and has been training Adobe Photoshop users since 1993.

For more information on Scott, visit his daily blog, *Photoshop Insider*, at www.scottkelby.com.

TABLE OF CONTENTS

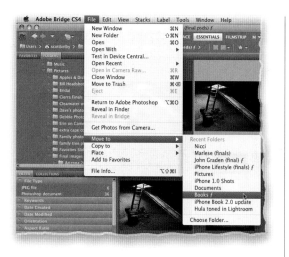

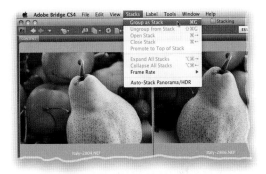

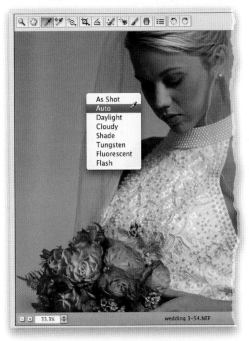

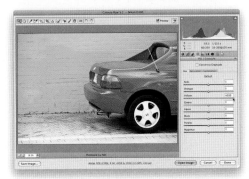

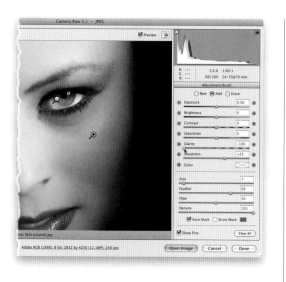

CHAPTER 7 .. 199

Local Color
Color Correction Secrets

CHAPTER 8 .. 227

Black & White World
How to Create Stunning B&W Images

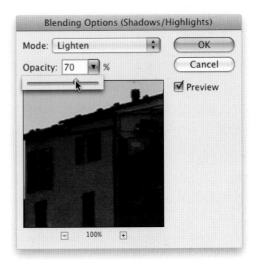

TABLE OF CONTENTS

Five Quick Things You'll Wish You Had Known Before Reading This Book

It's really important to me that you get a lot out of reading this book, and one way I can help is to get you to read these five quick things about the book that you'll wish later you knew now. For example, it's here that I tell you about where to download something important, and if you skip over this, eventually you'll send me an email asking where it is, but by then you'll be really aggravated, and well… it's gonna get ugly. We can skip all that (and more), if you take two minutes now and read these five quick things. I promise to make it worth your while.

(1) You don't have to read this book in order.

I designed this book so you can turn right to the technique you want to learn, and start there. I explain everything as I go, step-by-step, so if you want to learn how to remove dust spots from a RAW image, just turn to page 135, and in a couple of minutes, you'll know. I did write the book in a logical order for learning CS4, but don't let that tie your hands—jump right to whatever technique you want to learn— you can always go back, review, and try other stuff.

(2) Practice along with the same photos I used here in the book.

As you're going through the book, and you come to a technique like "Creating HDR Images," you might not have an HDR-bracketed set of shots hanging around, so in those cases I usually made the images available for you to download, so you can follow along with the book. You can find them at **www.kelbytraining.com/books /cs4** (see, this is one of those things I was talking about that you'd miss if you skipped this and went right to Chapter 1). By the way, the screen captures here are just for looks, but if you like that calendar look, I did a tutorial last year on my blog (scottkelby.com) on how to do it. Just type "calendar" in the search field, and you'll find it fast.

SCOTT KELBY

(3) The intro pages at the beginning of each chapter are not what they seem.
The chapter introductions are designed to give you a quick mental break between chapters, and honestly, they have little to do with what's in the chapter. In fact, they have little to do with anything, but writing these quirky chapter intros has become kind of a tradition of mine (I do this in all my books), so if you're one of those really "serious" types, I'm begging you—skip them and just go right into the chapter because they'll just get on your nerves.

(4) The intros at the beginning of each project are usually pretty important.
If you skip over them, you might wind up missing stuff that isn't mentioned in the project itself. So, if you find yourself working on a project, and you're thinking to yourself, "Why are we doing this?" it's probably because you skipped over that intro. So, just make sure you read it first, and then go to Step One. It'll make a difference—I promise.

(5) I included a chapter on my CS4 workflow, but don't read it yet.
As a bonus, I included a special chapter at the end of the book detailing my own CS4 workflow, but please don't read it until you've read the rest of the book, because it assumes that you've read the book already, and understand the basic concepts, so it doesn't spell everything out (or it would be one really, really long drawn-out chapter). So that's the scoop (and the five quick things). You're good to go now—let's get to work!

SCOTT KELBY

Exposure: 1/5s | Focal Length: 12mm | Aperture Value: ƒ/8.0

London Bridge
bridge essentials

This is the first chapter in the book (which is precisely why, against the wishes of my editor, I call it "Chapter 1"). Anyway, this is as good a time as any to let you know that I have always named the chapters in my books after songs, movies, or TV shows, so it's actually the subtitle that appears under the chapter title that really tells you what the chapter is about. If you looked at the chapter title above, you probably thought, "Oh, how cute. He named this chapter after a nursery rhyme." If you thought that, you are very old. At least 40. However, if you're much, much younger than that (like myself), and incurably cool (ditto), then you probably recognize the title not as a nursery rhyme, but as a tender, emotion-filled love song that includes the touching lyric "I'm Fergie Ferg and me love you long time." Ah ha (you loudly exclaim), that "love you long time"

bit is a reference to the movie *Full Metal Jacket* (which came out in 1987. I was probably a toddler back then and definitely not already 27 years old, if that's what you're thinking). So now you're feeling all "Yeah, I knew that one," but then there's a single bead of sweat trickling down your forehead. It's there because you're afraid someone (me) is going to ask you who this Fergie is and the only Fergie you know (at your advanced age) is the Duchess of York, but you know darn well that she isn't likely to be quoting lines from *Full Metal Jacket* in her R&B songs, but now you're even more worried that the rest of the book you just bought is like this chapter intro. If you're worried about that, it can only mean one thing: you didn't read "Five Quick Things…" that came before this chapter. If I were you, I'd go back and read that now. Don't worry. I'll wait long time.

Getting Your Photos Into Bridge

So, you've finished your shoot and now you're back at your computer and ready to look at your photos, see how you did, separate the keepers from the clunkers, etc. Of course, the first step is to get the photos from your camera onto your computer and into Adobe Bridge CS4. Luckily, Adobe included a built-in photo downloader in Bridge, so the process is pretty simple.

Step One:

To import photos from your digital camera, first launch Adobe Bridge CS4 (from here on out, I'll just call it Bridge for short), and then click the Get Photos from Camera icon on the top-left side of Bridge (it's circled here in red), or if you're charging by the hour, you can go under the File menu and choose Get Photos from Camera. By the way, if Bridge is open and you connect a digital camera or a memory card to your computer, a little dialog will appear asking you if you want to have the Photo Downloader appear automatically each time a camera or card reader is connected to your computer (it's shown here). Since the Photo Downloader is just one click away, personally I'd rather not have it popping up automatically, but this one's totally your call.

Step Two:
Clicking on that Get Photos from Camera icon brings up Bridge's Photo Downloader. Before you do anything else, I recommend clicking on the Advanced Dialog button in the bottom-left corner (as shown here). While this does make some advanced options available, more importantly, it shows you previews of the photos you're about to import.

Step Three:
Here's what the Advanced dialog looks like, with the thumbnail previews on the left, and options on the right. By default, it's set to import every photo it finds on your memory card. If you see a photo you don't want imported, just turn off the check-box under the thumbnail (only checked photos will be imported). If you want just a few photos imported, it's quicker if you start by clicking the UnCheck All button first (below the left side of the thumbnail preview area) to uncheck all the photos. Then select the photos you do want to import by pressing-and-holding the Command (PC: Ctrl) key and clicking on them (as you do, each thumbnail is high-lighted), then turn on the checkbox for any one of these photos, and all your selected photos become checked (and will be imported).

Continued

Step Four:

Once you've chosen which photos you want imported, you'll need to choose where these photos will be saved to on your computer. By default, it saves them in your Pictures folder. If you want them saved to a different location, then click the Choose (PC: Browse) button (as shown here, where I've zoomed in on the Save Options section of the Photo Downloader). This brings up a dialog where you can choose the location where you'd like your imported photos stored. Pretty standard stuff—you've chosen which photos you want to import, and where you want to save them on your computer once they're copied from your memory card.

Step Five:

I recommend letting the Photo Downloader create a separate folder for your imported photos, inside your Pictures folder. If not, it'll just toss them loose into your main folder, which makes staying organized a nightmare. By default, it puts your photos in a folder named with the date you took them. Personally, I think it's more useful to name the folders by topic or subject (that way, you don't have to remember the date). For example, these photos are from a wedding, so from the Create Subfolder(s) pop-up menu, I'd choose Custom Name and then type in the name I'd like for the folder just below it, as shown here, where my custom name is "Johannsen Wedding." When I'm searching on my computer, that name means more to me than just seeing a folder named "20080711."

Step Six:
Also by default, your photos will keep the same non-descriptive, just-about-useless names your camera gave them when they were taken. So, I recommend having the Photo Downloader rename your photos as they're imported with a descriptive name, which will make your life much easier down the road when you need to find these photos again fast. To do this, click on the Rename Files pop-up menu, and a list pops up with a wide range of auto-naming choices (seen here). So, just choose which naming convention you'd like from the options that include a custom name, including the ones followed by the date the photos were taken, from this list.

Step Seven:
If you've chosen any of the naming conventions that have a custom name in it from the Rename Files pop-up menu, the name field is highlighted beneath it. Type in your custom name (in this case, I chose "Johannsen Wedding") and then in the field to the right of it, choose the number where you'd like the sequential auto-numbering to start (it automatically uses a four-digit number). An example of your renaming appears directly under the name field (as seen here). There's also a checkbox that lets you embed the original filename into your renamed file, just in case for some reason you need it one day (by the way, so far I've never needed to know a photo's original camera-given name, but hey—ya never know).

Continued

Step Eight:

In the Advanced Options section, there's a checkbox that automatically opens Bridge (if it's not already open) once your photos are imported. I know what you're thinking: "That's an advanced option?" (Don't get me started.) Anyway, directly under that you have the ability to convert your imported photos into Adobe's DNG format, which is a universal archival format designed primarily for RAW files. For more on the advantages of DNG, jump over to Chapter 4, but in the meantime, here's my rule of thumb for converting to DNG: If it's a RAW file, I turn on the Convert To DNG checkbox. If it's a JPEG or TIFF file, there's not really any advantage for converting to DNG, so I don't. Simple enough. Again, to learn more about DNG and why you might want to convert your RAW photos to DNG, jump over to Chapter 4.

Step Nine:

There are two more options in the Advanced Options section: one I recommend you avoid, and one that is absolutely critical. First, the bad one: there's a checkbox called Delete Original Files. This one erases the photos on your memory card right after they're copied to your computer. So, what if the images you just copied to your computer are corrupt or otherwise messed up? (Hey—it happens.) You can't try to re-import them or rescue them from the memory card because (that's right) you just had Bridge erase them. My golden rule is: Don't erase anything unless you have at least *two* backups first, and you've spot checked at least two or three random photos from those to make sure they're okay. Otherwise, you're really taking your chances. Okay, so that's the bad checkbox (leave Delete Original Files turned off). Now, for the good one.

Advanced Options

☑ Open Adobe Bridge

☐ Convert To DNG [Settings...]

☐ Delete Original Files

☑ Save Copies to:

/.../Desktop/Drobo [Choose...]

Apply Metadata

Template to Use:

[Basic Metadata ⬍]

Creator:

Scott Kelby

Copyright:

Copyright 2009

Step 10:

To make certain you have a second backup copy, turn on the Save Copies To checkbox to automatically back up your imported photos to a different hard drive (click the Choose [PC: Browse] button to choose the external hard drive, network, etc., where you want a copy of the photos you're importing backed up to). This is so incredibly important because at this point, if your computer's hard drive crashes, all your photos are gone. For good. But by turning this feature on, you'll have a second backup set on a totally separate hard drive (and yes, it has to be on a totally separate hard drive—backing up to a different folder on your same computer doesn't help, because if your computer's hard drive crashes, you lose the originals and the backup at the same time).

Step 11:

The next section down is the Apply Metadata section. This is where you're able to embed your name and copyright information into each file automatically, as it's imported. Simply click in the Creator field and type in your name. Then click in the Copyright field, type in your copyright info (as shown here), and you're set. Now, you can have more information embedded upon import than this, but first you'd have to create a metadata template (which would appear in the Template to Use pop-up menu at the top of this section). I show you how to create your own in Chapter 2, so for now, just use the Basic Metadata template and enter your name and copyright info.

Continued

Step 12:

So that's a look at how I set up the Photo Downloader to import photos. Now all you have to do is click the Get Photos button (in the bottom right-hand corner of the Photo Downloader window), and a download status dialog appears (shown here), showing you which files are being imported, how far along you are, etc.

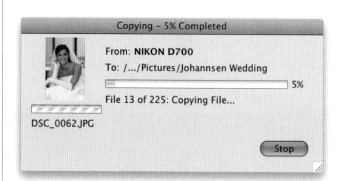

Step 13:

Once your files are imported, they're displayed in Bridge as thumbnails (as shown here), and now you can begin sorting, ranking, and doing all the other cool stuff we're going to learn in the rest of this chapter and in Chapter 2.

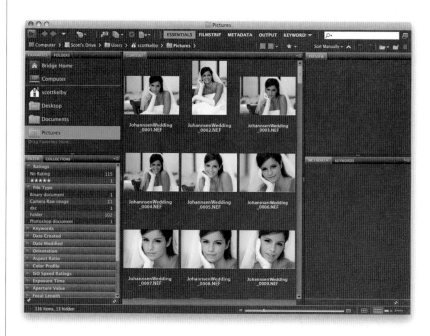

Once you import your photos, they appear in Bridge, but they appear in the default layout. This layout does a good job of giving you access to all of Bridge's different panels and features, but I think it's a pretty lame setup for actually using Bridge. So, here we're going to look at how to set up Bridge for a much a better way to view and work with your photos.

Here's a Better Way to View Your Images

Step One:
Although we call it "importing," your photos aren't actually in Bridge—they're *in* a folder on your computer, and you're looking at what's inside that folder using Bridge. Your photos show up as thumbnails in the Content panel, which by default appears in the center of Bridge (as shown here). You have control over how quickly your thumbnails appear in Bridge based on how high quality you want your thumbnails to be.

Step Two:
You make your "speed" choice from an Options pop-up menu in the Path Bar at the top of the window (shown here). Prefer Embedded (Faster) lets your thumbnails load the fastest by using the same small preview you see on the back of your digital camera. High Quality on Demand (which is the one I use myself), loads low-res thumbnails first, but once you click on a thumbnail, it then renders a higher-quality thumbnail. I don't recommend Always High Quality (which has Bridge individually render a high-res preview of each photo) simply because it's so much slower. Generate 100% Previews is painfully slow because it renders the full-screen preview even if you never use it. Again, my recommendation: High Quality on Demand for initial quick loading, and then higher quality when you click on a thumbnail.

Continued

Step Three:

By the way, if you're going to choose Prefer Embedded (Faster), you don't have to dig through that pop-up menu—just click the little Browse icon to the immediate left of the Options icon. Now, once your thumbnails appear in the Content panel, you can resize them using the thumbnail slider at the bottom right of Bridge (as shown here). Dragging to the right makes the thumbnails larger, and you can pretty much imagine what happens when you drag to the left.

TIP: One-Click Sizing

If you want to jump to the next larger (or smaller) size thumbnail, just click on the little rectangular icon on the far right (or left) of the thumbnail slider.

Step Four:

If you look back at the Bridge capture in Step Three, you'll see a problem—see how the two photos at the very bottom of the center Content panel are cut off? If that drives you as crazy as it does me, you can turn on an option that makes sure that never happens. You see, there's a new little feature that they added in Bridge CS4 that I personally love (it's the little things, right?) called Grid Lock, and you turn this option on by clicking on the little Lock Thumbnail Grid icon in the bottom-right corner of Bridge's window (shown circled here in red). By the way, there are a few other icons there, as well: the next icon over switches you back to regular Thumbnails view; the second icon from the right displays a Details view of your photos, which is a small thumbnail followed by lines of embedded info about your photo; and the icon on the far right gives you a List view, which is a simple list of your images like you might see when viewing a folder of images on your computer.

SCOTT KELBY

Step Five:

Once my photos appear in Bridge, the first thing I generally want to do is get a closer look at them. When you click on a thumbnail, a preview of that photo appears in the Preview panel at the top of the right side Panels area (as seen here). The problem is the preview isn't much bigger than the thumbnail (in fact, if you've dragged the Thumbnail slider to the right, it's not even as big!). So, when I'm starting to look at my images, the first thing I do is make my preview larger—that way I can see my photos at a large enough size that I can actually make a reasonable decision about which ones are "keepers" and which ones don't make the cut. What we need is a much bigger Preview panel, and a much smaller Content panel.

Step Six:

A step in the right direction is to choose one of Adobe's built-in workspaces. These are just different layouts for Bridge's panels that focus on different tasks. Some of these built-in workspaces appear right on the Application Bar at the top of the window, so they're one click away (like Essentials, Filmstrip, etc.). To get to the workspace we need, called Preview, you can either click-and-hold on the little down-facing triangle to the right of the workspaces in the Application Bar and choose Preview from the pop-up menu (as shown here), or just press **Command-6 (PC: Ctrl-6)**. Either way, it changes Bridge's layout to what you see here, with a really big Preview panel on the right, the Content panel (with your thumbnails) really skinny in the center, and the left side Panels area still there on the left. This is better, but I'm not loving it. There's still too much clutter for just viewing your images (we need distractions out of the way, so we can focus on the photos).

Continued

Step Seven:

To put the focus on our photos, we need to hide the left side Panels area. Go back and look at the capture in Step Six, and you'll see a thin divider bar that separates the left side Panels area from the Content panel in the center. Just double-click directly anywhere on that divider bar, and the left side Panels area tucks out of sight, leaving just the Content panel thumbnails on the left, and a really huge Preview panel. Now, I recommend shrinking the size of the Content panel on the left, so you just have one vertical row of thumbnails. You do that by clicking-and-dragging the thin divider bar between the Content and Preview panels to the left to squash the Content panel's size a bit (as shown here).

Step Eight:

This is the exact Bridge layout I use when looking at my imported photos, and if you like this layout, you can save it as your own (so it's only one click away). You do that by going under the Window menu, under Workspace, and choosing New Workspace. A dialog will appear asking you to name your workspace and when you click OK, your workspace will now not only appear in the Workspace submenu, it will also appear as the first workspace in the Application Bar's list of workspaces.

TIP: Panel Tricks

To collapse any panel, just double-click on its tab. To expand it, double-click on its tab again. However, if there's a panel you find you don't use, you can hide it from view—just go under the Window menu and choose the name of the panel you want to hide. To make a hidden panel visible again, do the same thing.

Step Nine:

Now that your Preview panel is nice and large, you can really put it to work. If you press-and-hold the Command (PC: Ctrl) key, and click on more than one thumbnail in the Content panel, it displays them in the Preview panel (as shown here). To remove one of the photos from the Preview panel, Command-click on its thumbnail in the Content panel to deselect it (if you look at the capture in Step 10, you'll see where I've deselected the center photo, leaving just two selected, and they automatically zoom up to fill in the space and give you an even better size for making a comparison).

Step 10:

The Preview panel has another nice feature: a built-in Loupe for zooming in tight (perfect for zooming in on an eye in a portrait to check sharpness). Here's how it works: Move your cursor over a photo, and your cursor changes into a magnifying glass. When you click, a Loupe magnifier (shown here) appears with a 100% view of the area your cursor is over. To reposition the Loupe, click-and-drag it where you want. To zoom in to a tighter 200% view, press the + (plus sign) key on your keyboard (the view magnification amount appears to the right of the photo's name). Click the + key again to zoom to 400%, and once again for the maximum view of 800%. To zoom back out, press the – (minus sign) key. To remove the Loupe, click the little X in its bottom-right corner.

TIP: Flipping the Loupe

If you get so close to an edge that the Loupe would extend outside the image (or the Preview panel itself), it automatically flips to a different orientation.

Continued

Step 11:

One of my favorite new features in Bridge CS4 is the ability to instantly see a full-screen view of any thumbnail—just click on the thumbnail in the Content panel, then press the Spacebar on your keyboard, and it appears full screen (like you see here). As handy as this is, there is another full-screen view mode you may actually like better—Review mode, which is also new in CS4.

Step 12:

To see all the images in your current folder in Review mode, press **Command-B (PC: Ctrl-B).** If you have more than four images in your folder, it puts your images full screen in a cool carousel-like rotation (as seen here). This mode is great for two big reasons: The first being it makes a really nice onscreen slide show presentation. You can use the **Left and Right Arrow keys** on your keyboard to move through the photos or the arrow buttons in the lower-left corner of the screen (as a photo comes to the front, it becomes larger and brighter). If you want to open the image in front in Photoshop, press the letter **O**. To open the front photo in Adobe Camera Raw, press **R**. To open all your images in Camera Raw, press **Option-R (PC: Alt-R)**. To leave Review mode, press the **Esc key**. If you forget any of these shortcuts, just press **H**.

TIP: One-Click Collection from Review Mode

When you're in full-screen Review mode and you've whittled things down to just your keepers, you don't need to leave Review mode and navigate to the Collections panel to create a collection—just click the New Collection button in the bottom-right corner of the screen and whatever's left in Review mode is automatically added to this new collection.

SCOTT KELBY

Step 13:

The second reason to use Review mode is to help you narrow things down to just your best photos from a shoot. Here's how: Let's say you have five or six similar photos, or photos of a similar subject (in this case, food), and you want to find the single best one out of those. Start by Command-clicking (PC: Ctrl-clicking) on just those photos (in the Content panel) to select them, and then press **Command-B (PC: Ctrl-B)** to enter Review mode. As you move through the photos (using the **Left and Right Arrow keys** on your keyboard), and you see one come to front that's not going to make the cut, just press the **Down Arrow key** on your keyboard (or click the Down Arrow button onscreen) and that photo is removed from contention. Keep doing this until you've narrowed things down to just the final image. Once you fall below five images, you no longer get the carousel view. Instead, it looks more like regular Preview mode— it's just full screen (as seen here).

Step 14:

In Review mode, you can still use the Loupe for zooming in—just move your cursor over any photo and click to bring up the Loupe for that photo. You can have multiple Loupes—one for each open image (shown here).

TIP: Moving and Zooming in the Loupe

With some Loupes in place, Command-click (PC: Ctrl-click) and drag within any one of them and they'll all move together, which is handy for inspecting similar photos. Also, if you press **Command–+ (plus sign; PC: Ctrl–+)** to zoom in, all the Loupes zoom in together.

Continued

Step 15:
Okay, this isn't really a step, but I've got a few cool tips about viewing your photos and working with Bridge's panels, and I figured this is a perfect place for them.

TIP: Grouping Panels
You can group panels you want together by clicking on a panel's tab, and dragging-and-dropping it onto another panel. This creates a "nested" panel, where you can now click on a tab to reveal that panel. That way, if you need a lot of panels visible for the way you work, at least you can nest them together. In the example shown here, I clicked-and-dragged the tabs of the panels normally in the right side Panels area and dropped them on the top of the left side Panels area to nest them there (notice the five tabs across the top of the left side Panels area).

TIP: Quick Navigation Using the Path Bar
The Path Bar shows you visually the folder hierarchy (the file path) of what you're seeing in Bridge, but beyond that, each level of that path is clickable. So, if you want to jump back two folders, just click on the folder. This can be a huge time saver when navigating from folder to folder.

TIP: Hide the Path Bar
If you really want the ultimate in clean layouts for viewing your photos, you can hide the Path Bar across the top of Bridge's window—go under the Window menu and choose Path Bar, and it's hidden (in the image here, the Path Bar is hidden, leaving just that one slim bar across the top).

TIP: Hiding Panels Areas
Pressing the **Tab key** hides both side Panels areas, so whatever's in the center panel goes full screen.

Sorting and Arranging Your Photos

Ah, finally we get to the fun part—sorting your photos. We generally have the same goal here: quickly finding out which are the best shots from your shoot (the keepers), marking them as your best shots, and then putting them one click away, so we can view them as slide shows, post them on the Web, send them to a client for proofing, or prepare them for printing. Here we're going to look at how to do just that, in the most efficient way possible, by taking advantage of some of the new features in Bridge CS4.

SCOTT KELBY

Step One:
When you view your images in Bridge, by default, they're sorted manually by filename, so it's pretty likely that the first photo you shot will appear in the upper-left corner of the Content panel. I say it's "pretty likely" because there are exceptions (if you did multiple shoots on different cameras, or shot on different memory cards, etc.), but most likely they'll appear first one shot first. If you want to change how they are sorted, click-and-hold on the words Sort by Filename near the right side of the Path Bar, and a pop-up menu of options will appear (as seen here).

Step Two:
Let's start by quickly rating our photos to separate the keepers from the rest of the bunch. First, I switch to a view mode that's better for decision making, so choose either the workspace we created earlier (seen here) or Full Screen Preview (select any photo and then press the Spacebar. You don't have to select them all first—just click on any one, hit the Spacebar, then use the Left and Right Arrow keys on your keyboard to move through the full-screen images). If you go with the workspace we created earlier, you still use the same Left and Right Arrow keys on your keyboard to move through your images.

Continued

Step Three:

Probably the most popular method for sorting your images is to rate them using Bridge's 1- to 5-star rating system (with 5 being your best images). That being said, I'm going to try to convince you to try a rating system that is faster and more efficient. When you see a photo that is really bad (way out of focus, the flash didn't fire, the subject's eyes are closed, etc.), press **Option-Delete (PC: Alt-Delete)** to mark that photo as a Reject. When you do this, the word Reject appears in red below the large image in the Preview panel, and below the thumbnail, as well (they're both circled here in red). It doesn't delete them; it just marks 'em as Rejects. *Note:* You can choose to have Bridge automatically hide any photos you mark as Rejects by going under the View menu and choosing Show Reject Files (as shown here).

Step Four:

When you see a "keeper" (a shot you may want to print, or show to the client, etc.), then you'll press **Command-5 (PC: Ctrl-5)** to mark that photo as a 5-star image, and this star rating will appear below the selected photo in the Preview panel and the thumbnail, as well (they're shown circled here in red). So that's the drill—move through your photos and when you see a real keeper, press Command-5, and when you see a totally messed up photo, press **Option-Delete (PC: Alt-Delete)** to mark it as a Reject. For all the rest of the photos, you do absolutely nothing. So, why not use the entire star rating system? Because it takes way, way too long (I'll explain why on the next page).

Step Five:

Here's why I don't recommend using the entire star rating system: What are you going to do with your 2-star images? They're not bad enough to delete, so we keep 'em, right? What about your 3-star ones? The client won't see these either, but we keep 'em. What about your 4-star photos (the ones that weren't quite good enough to be five stars)? We keep them, too. See where I'm going? Why waste your valuable time deciding if a photo is a 2- or a 3- or a 4-star, if all we're going to do is keep 'em anyway? The only shots we really care about are the ones we want off our computer (they're messed up and just wasting disk space), and our best shots from that shoot. So, once you've gone through and ranked them, let's get rid of the dogs. Click-and-hold on the Filter Items by Rating icon on the right side of the Path Bar (it's the star) and choose Show Rejected Items Only (as shown here) to see just the Rejects.

Step Six:

Now press **Command-A (PC: Ctrl-A)** to select all of them, and then press **Command-Delete (PC: Ctrl-Delete)** to move these all to your Trash (PC: Recycle Bin). Next, go under the Filter Items by Rating pop-up menu again, but this time choose Show 5 Stars (as shown here) to filter things down so just your keepers—your 5-star images—are visible in Bridge.

Continued

Step Seven:

At this point, we want to set things up so that in the future these 5-star photos are just one click away at any time and we do that using collections. Here's how it works: Our first step is to click on the word Essentials up in the Application Bar, then press **Command-A (PC: Ctrl-A)** to select all your 5-star photos. Now click on the Collections panel's tab (in the middle of the left side Panels area) to make the Collections panel visible. Click on the New Collection icon at the bottom of this panel (it's circled here in red) and a dialog will appear asking if you want to include the selected photos in this new collection (you do, so click the Yes button).

TIP: Removing Ratings

To remove a photo's star rating, just click on the photo, then press **Command-0 (zero; PC: Ctrl-0)**.

Step Eight:

When you click the Yes button, Bridge creates a new collection in the Collections panel. The collection is untitled, but the name field is already highlighted, so all you have to do is type in a name for your collection (as I did here), and press the **Return (PC: Enter) key** on your keyboard to lock in your new name. Now these "best of that shoot" photos will always be just one click away—go to the Collections panel, click on the collection, and just the shoot's 5-star photos appear. Also, if you wanted to view this collection larger, you could either make the thumbnails bigger (using the Thumbnail Size slider at the bottom of the window), or just switch to your viewing workspace (the one we created earlier) and you'll see the images really large in the Preview panel.

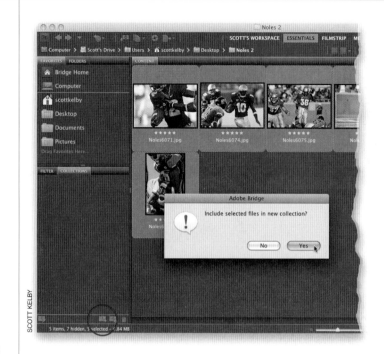

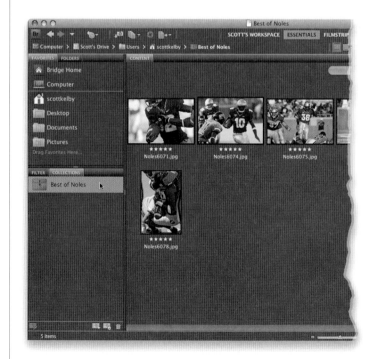

SCOTT KELBY

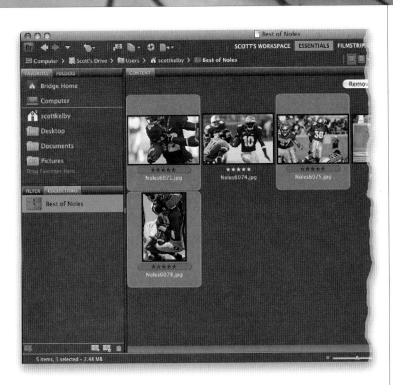

Step Nine:
Now, you can take things a step further if you like. For example, if you show these shots to your client, and they choose three of these 5-star photos to have printed, you can then use color labels to mark those as your "Client Selects." Just Command-click (PC: Ctrl-click) on the photos they chose to select them, then press **Command-6 (PC: Ctrl-6)** which adds a color banner around the star rating (as seen here, where you can see Red labels on three of the images). If I do this, I generally create another collection called "Client Selects" by clicking on the Filter Items by Rating icon (the star on the right side of the Path Bar) and choosing Show Labeled Items Only from the pop-up menu, which displays just those red-labeled photos. Then I select them all **(Command-A [PC: Ctrl-A])**, click the New Collection icon at the bottom right of the Collections panel, and I would name this one "Noles Selects."

Step 10:
If you like this color label thing, there are four other built-in color labels, and you can assign your own names for what each color label represents. Just press **Command-K (PC: Ctrl-K)** to bring up Bridge's Preferences dialog, then click on Labels in the left side column (as seen here). This shows the different colors, their keyboard shortcuts (on the far right), and you can just click in any name field and rename them.

TIP: Assigning Color Labels
There are three ways to add a color label: (1) use the keyboard shortcut, (2) select the photo(s), then Control-click (PC: Right-click) on it, and choose the label you want from the Label submenu, or (3) go under the Label menu and choose the label.

Deleting Photos (and Folders) from Bridge

This probably seems like the most obvious thing in the world, because in just about all Adobe products, if you click on something and hit the Delete key on your keyboard, it goes away. But in Bridge, it doesn't really just go away—a dialog pops up and in a roundabout way, asks you "How much do you really hate this photo?" Here's how to understand what your choices really are:

Step One:
To delete a photo(s), just click on it to select it, then press the Delete key on your keyboard. This brings up the warning dialog shown here, which assumes you don't really want to delete this file, you just want to mark it as a Reject (that's why the Reject button is highlighted as the most likely choice). If you do want to move the selected photo(s) into the Trash (PC: Recycle Bin), then click the Delete button.

Step Two:
Sadly, clicking the Delete button brings up another warning dialog (seen here) asking if you really want to move this photo into the Trash (PC: Recycle Bin). If you want to avoid both of these dialogs when deleting files, here's what to do: Don't just hit the Delete key, instead hit **Command-Delete (PC: Ctrl-Delete)**, which will take you right to the second dialog. When it appears, turn on the Don't Show Again checkbox and from this point on, the Command-Delete shortcut will send your stuff straight to the Trash without any dialogs.

TIP: Deleting Folders
On a Mac, you can't delete folders by just pressing the Delete key. You have to click on the folder(s), and then press **Command-Delete**.

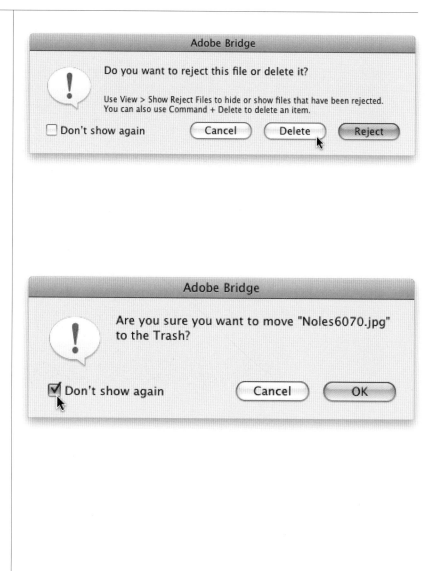

So far we've mostly been working with photos that we just imported from our camera's memory card, but if you want to see photos that are already on your computer, you'll need to work inside the Folders panel. This panel gives you access to any folder of photos on your computer, on an external hard drive, or over a network. Here's how it works:

Viewing Photos Already on Your Computer

Step One:
First, make sure you're in the Essentials workspace (click on Essentials in the Application Bar), then click on the Folders panel's tab to make the Folders panel visible. This Folders panel gives you access to all the files and folders on your computer, so you can simply navigate to a folder of photos and click on it to see them. Of course, if you have an external hard drive connected, or DVD, or CD, etc., you'll see them listed too, and you can look at them the same way. So, it's pretty much like the standard file structure of your computer.

Continued

Step Two:

Right beside the Folders panel's tab is the Favorites panel's tab, and this panel is kind of like your Bookmarks (PC: Favorites) in your Web browser. So, if you find yourself constantly going to a particular folder of photos, you can save a shortcut to that folder in the Favorites panel. That way, you won't have to go digging through your hard drive in the Folders panel to find it—it will be just one click away. To add a folder as a favorite, Control-click (PC: Right-click) on the folder and choose Add to Favorites from the contextual menu that appears. (*Note:* If you use a layout where you can see both the Folders and Favorites panels at the same time, after finding a folder using the Folders panel, you can just drag-and-drop it from the Content panel right into the bottom area of the Favorites panel.)

Step Three:

Once you've saved that folder as one of your favorites, you'll see it added to the bottom of the list in the Favorites panel. Now, to jump directly to the photos in that folder, just click on it (as shown here).

TIP: Renaming Photos

It's hard to imagine why someone wouldn't like such a descriptive name as DSC_00679.jpg, but if you're one of those people who finds it useful to apply names that describe what's actually in the photo (like me), here's how it's done: With a thumbnail selected, click directly on the photo's filename (in the Content panel) and the name will highlight. Type in your new name, press the **Return (PC: Enter) key**, and the thumbnail updates with your new-and-improved name.

Step Four:

If you look in the list of favorites in the Favorites panel, you can see Adobe has kind of already decided what it thinks might be some of your favorite destinations and added them to your list. If you'd like to remove any of them (so there's more room for the items you choose as your favorites), go to Bridge's General Preferences **(Command-K [PC: Ctrl-K])** and in the bottom section of the dialog, within the Favorite Items section, turn off the checkboxes for whichever Adobe-chosen items you don't want to appear in your Favorites panel (as shown here), then click OK. So, that's basically how to look at folders full of photos, and how to save your favorite folders (or discs, or drives, etc.), so they're more convenient. Now on to moving photos from folder to folder.

Step Five:

Another nice feature of Bridge's Folders panel is that you can use it to move photos from one folder to another. You do this by clicking-and-dragging the thumbnail of the photo you want to move, then dropping that photo into any folder that appears in the Folders panel (when you move the dragged photo over a folder, the folder is highlighted letting you know that you've targeted that folder). That photo will now be removed from the currently selected folder and placed into the folder you dragged-and-dropped it into.

Continued

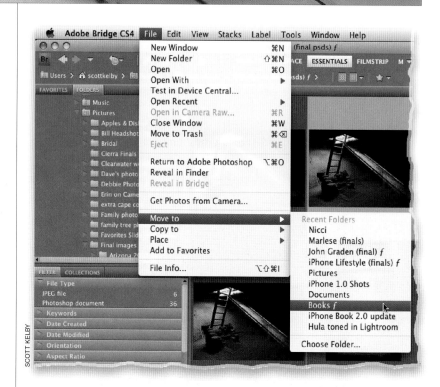

TIP: Dragging-and-Copying

If you press-and-hold the **Option (PC: Alt) key** as you click-and-drag, instead of moving your original photo, Bridge will place a duplicate of your photo into that folder.

Step Six:

If your list of folders is really long, there's a more manual way to move photos from folder to folder. First, click on a photo you want to move to a different folder, then go under the File menu, under Move To, and you'll see a list of your recently viewed folders (as shown here). Now just choose which folder you want that photo to appear in, and you're set. If you didn't recently use the folder you want, just select Choose Folder at the bottom of the submenu. If, instead, you wanted to make a copy of your selected photo and place it into another folder, you'd still go under the File menu, but this time you'd choose Copy To and then choose a recent folder or Choose Folder.

The Scoop on Rotating Photos

Rotating photos within Bridge is as easy as clicking one button. However, when you rotate photos within Bridge itself, you're only really rotating the thumbnail. This is handy, because when you're sorting photos with a portrait orientation (tall rather than wide), you want to be able to see them upright to make a sorting judgment call, but you have a separate decision to make if you want the actual photo rotated—not just the thumbnail. Here's how to do both:

Rotating thumbnails:
Rotating a thumbnail is a total no-brainer—just click on the thumbnail you want to rotate, then click on one of the curved arrow Rotate icons in the top-right corner of Bridge (on the right side of the Path Bar). The left arrow icon rotates counterclockwise; the right arrow icon rotates clockwise. You can also use the shortcut **Command-[(Left Bracket key; PC: Ctrl-[)** to rotate counterclockwise, or **Command-] (Right Bracket key; PC: Ctrl-])** to rotate clockwise.

Rotating the actual photo:

When you rotate a thumbnail, you're doing just that—the photo doesn't get rotated until you actually open it in Photoshop (go look in the image's folder on your hard drive, and you'll see from the file's thumbnail that the actual photo isn't rotated). So if you really want to rotate the original photo, rotate the thumbnail, then double-click on the thumbnail in Bridge, and the image will open in Photoshop with the rotation applied. Now you can choose Save from the File menu to make the rotation permanent.

The Metadata panel is where you can go to see all the background info on your photos, including all the EXIF metadata added by your digital camera at the moment you took the shot, along with any metadata added in Bridge itself (like your copyright info or custom filenames added when you imported the photos from your camera). Here's how to leverage that info into making finding a particular photo that much easier, using the Filter panel:

Finding Photos with the Filter Panel (Using Embedded Metadata)

Step One:

When you take a photo with today's digital cameras, at the moment you take the shot, the camera automatically embeds loads of information about what just took place—things like the make and model of the camera, the time the photo was taken, the exposure setting, the f-stop, shutter speed, etc. (this info is called EXIF camera data). Click on a photo in Bridge, and you'll see the basic camera data is displayed at the top of the Metadata panel (found in the right side Panels area) in a layout similar to an LCD screen on a digital camera (as shown here). Once you bring the digital photo into Bridge, more information is embedded into the photo (stuff like the filename, when it was last edited, the file format it was saved in, its physical dimensions, color mode, etc.). All this embedded info comes under the heading of metadata, and that's why it appears in the Metadata panel. At the top of the panel, under the File Properties section is the info Photoshop embeds into your file. The next section down is IPTC Core metadata, which is where you can embed your own customized info (stuff like copyright, credits, etc.) into the photo (this is covered in detail in the next chapter). The Camera Data (EXIF) section displays data embedded by your camera.

Continued

Step Two:

Metadata is more than just interesting to look at—it can be incredibly useful in helping you find a particular photo (or group of photos), because this metadata is also automatically read by the Filter panel, which appears in the left side Panels area. Here's how it works: click on any folder of photos, and their metadata is automatically added to this Filter panel. For example, click on a folder, and then look in the Filter panel. In the example shown here, it lists the dates the photos in that folder were created, and how many photos in that folder were created on each date. But here's where it gets cool: Go down a little further to the ISO Speed Ratings section. See where it says 200? To the right of that, it shows that 14 photos in this folder were taken at ISO 200. Click on the 200, and now only those 14 photos are displayed in Bridge (and a checkmark now appears before 200 to show you what's currently being displayed). I know, pretty cool (and very powerful)!

Step Three:

Okay, let's say you now want to see all the ISO 200 and ISO 1600 photos together. To do that, just click to the immediate left of 1600 to add a checkmark to that filter, and now both ISO 200 and ISO 1600 photos are displayed together. To remove a line of filtering, click on the checkmark again. To clear all the filters, click on the "No!" symbol in the bottom-right corner of the panel. So, to recap: if you have some idea of what you're looking for (for example, you remembered that these shots were taken indoors during a presentation), metadata filtering can help you quickly narrow the field.

To me, the default colors of Bridge seem…I dunno…kinda uninspiring (that's really being kind). I guess I feel like it looks less like a photographer's program, and more like a business program, which is why the first thing I did when I launched Bridge CS4 was to customize the background colors of it with the same background color scheme as Adobe's Photoshop Lightroom program. I think Lightroom has ideal background colors for working with photography (and for just looking cool in general).

Customizing the Look of Your Bridge

Step One:

Here's the default look for Bridge CS4, which pretty much makes my case (above) for why I needed to change the background colors, and make it feel more like a photographer's application than a business one. To customize the look of your Bridge, press **Command-K (PC: Ctrl-K)** to bring up Bridge's Preferences dialog (shown in the next step).

SCOTT KELBY

Step Two:

When the Preferences dialog appears, by default it brings up the General preferences (shown here), and at the top is the Appearance section. The User Interface Brightness slider controls the color of all the panels except the Content panel and Preview panel (the two panels where you actually see your photos). Now, when I say it controls the "color of all the panels," you really only get three choices: (1) solid white, (2) solid black, and (3) some shade of gray in-between. By default, the main panels are very light gray and the image panels are not quite as light (the default slider settings are shown here).

Continued

Step Three:

To get a better looking background, try clicking-and-dragging the top slider (the User Interface Brightness slider) quite a bit to the left, as shown here. As you can see, this gives the main panels a nice dark gray interface (a similar shade of gray that Lightroom uses), but the Content and Preview panels still have that medium gray background behind them (which we'll change in a minute). By the way, if you want something even darker, of course, you can drag that slider all the way over to Black for a real high-tech look.

Step Four:

Lightroom has a darker gray behind the panels where the photos are viewed, but here's the weird thing: if in Bridge's preferences you click-and-drag the Image Backdrop slider (the bottom slider) to the left so it stops at the same exact spot as the top slider, it makes the background behind the Content and Preview panels darker than the other panels (as shown here). I have no idea why (yet another great mystery of our time). There is one more control here—the Accent Color—which is what you see highlighted when you click on something. By default, it puts a thin yellow line around your photo cell, and it tints the cell a lighter gray. But for this "Lightroom-like" color scheme, I recommend changing the accent color to Crystal (shown here), so when you click on a photo it highlights that photo in a light enough gray that it really stands out, without putting a yellow line around your image.

Step Five:
Besides just choosing background colors, you can also decide how much (or little) information the Content panel displays under each thumbnail. For example, by default the name of each file is displayed below its thumbnail, but you can add up to four additional lines of information (which are pulled from the metadata embedded in the file by your camera, or added in Bridge itself). To turn on these extra lines of info, press **Command-K (PC: Ctrl-K)** to open the Preferences dialog, and in the list on the left side, click on Thumbnails to bring up the Thumbnails preferences. In the Details section, turn on the Show checkbox beside each info line you want to add, and then choose the specific types of info from the pop-up menus to their right (as shown here).

Step Six:
Click OK and you'll see those extra lines of info now appear under your thumbnails (as shown here, in this close-up of one of the thumbnail cells).

TIP: Hiding Info
If you ever want to see just the thumbnails and temporarily hide all those extra lines of metadata, just press **Command-T (PC: Ctrl-T)** and only the thumbnails will be displayed. This is a handy shortcut because all those extra lines of info take up space, and when you're displaying three or four extra lines, plus the file's name, and perhaps even a rating, fewer thumbnails fit in the same amount of space.

Continued

Step Seven:

Now, we'll move on to changing the size of Bridge. Of course, you can just click-and-drag the bottom-right corner of Bridge and resize the window to whatever suits you, but if your goal is a smaller Bridge, then just click on the Switch to Compact Mode icon located in the top-right corner of Bridge (at the end of the Application Bar). Bridge will literally shrink in size, leaving only small thumbnails visible (much like a small version of Bridge's Light Table workspace). The hidden advantage of Compact mode is that it floats in front of whichever applications are open (so if you're working in Photoshop CS4 or another Creative Suite application, Bridge will appear just like a floating panel). By the way, if you like the Compact mode but don't want this floating feature, turn off Compact Window Always On Top from Bridge's flyout menu (click on the down-facing arrow in the top-right corner).

Step Eight:

If you like Compact mode, you're gonna love Ultra-Compact mode (believe it or not, that's its real name—I love it!). First, switch to Compact mode and then click on the Switch to Ultra-Compact Mode icon (it's the third icon from the right in the top-right corner). This hides the thumbnail area, leaving just a few of the Application Bar's options.

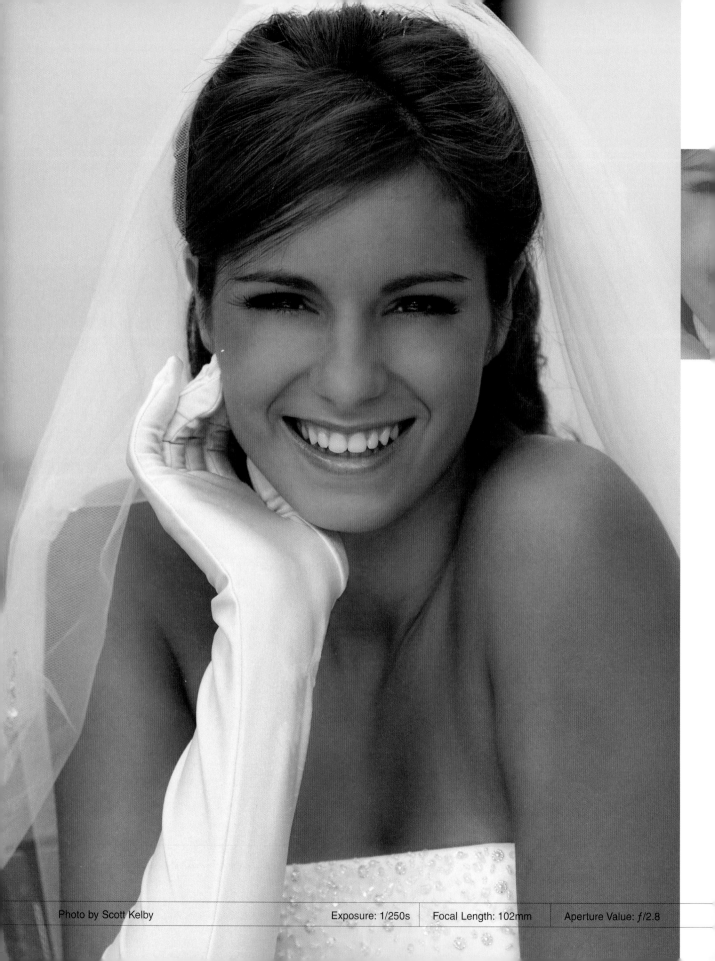

Exposure: 1/250s | Focal Length: 102mm | Aperture Value: ƒ/2.8

The Bridge
advanced bridge techniques

I know, "The Bridge" sounds a little too obvious a name for a chapter on advanced bridge techniques, but it beats the alternative of using the movie title *Bridge to Terabithia* (see, "The Bridge" doesn't sound all that bad now, does it?). It took me all of about four seconds in Apple's iTunes Store to come up with at least 30 song titles that not only included the term "the bridge," but actually were named exactly that. There were versions in the iTunes Store from everyone from Janis Ian to Eddie from Ohio, whose song "The Bridge" appears on his album *I Rode Fido Home*. While listening to the free 30-second preview of Eddie's song, it was at that moment I knew I had to choose this version—the Eddie from Ohio version—as my chapter title. It was because no one (outside of close friends and relatives of Eddie himself) was ever going to do an iTunes search for that song, and if by some cosmic solar accident someone like myself did come across his version of "The Bridge," the chances of a royalty coming Eddie's way were very slim indeed. That's sad in a way, because I think Eddie needs the money. I think Eddie may need the money for music lessons. (I'm kidding of course, Eddie doesn't need music lessons—he's got an album on iTunes, and now that his album *I Rode Fido Home* has gotten a write-up in print, it's only a matter of time before photographers around the world start going to iTunes and plunking down their 99¢ to download their own personal copy of what is soon to be a cult hit—"The Bridge" by Eddie from Ohio. This is precisely why they call me "The Star Maker." It's either that or "The Guy with the Tin Ear." I can't remember which.)

Maximize Your View by Using Two Monitors

If you've got two monitors, have I got a setup for you! You can create a second Bridge window where you can have your thumbnails and other panels appear on one screen, and then on the second screen have a really large version of your selected photo. Here's how to make this setup work for you:

Step One:
Go under Bridge's Window menu and choose New Synchronized Window (as shown here).

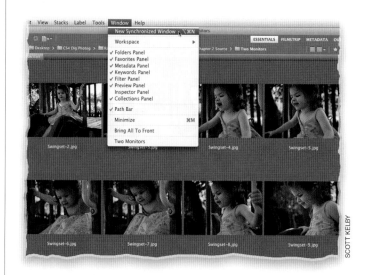

Step Two:
This will create an identical second floating window, but before you just drag it over to that second monitor, there are some things you'll need to do to set this new synchronized window up so it displays just a large-sized preview of the currently selected thumbnail. Start by going under the Window menu and you'll see that just about all the panels have a check-mark by them (indicating that they're visible). Well, you want them all hidden except Preview, so go and choose each one, as shown here (except for Preview, of course), and now all those other panels will be hidden from view.

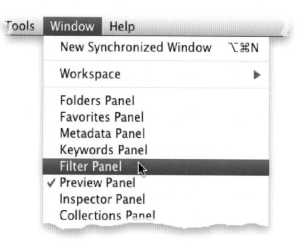

Step Three:

Once you hide these panels, you'll notice that the Content panel is still visible because it's the one panel you can't hide. So, what you need to do is click on the divider bar between the Content panel and the Preview panel, and drag it all the way over to the far-left side. This hides the Content panel from view, leaving just the Preview panel visible (as shown in the image in Step Four).

Step Four:

Now you can click-and-drag this window over to your second monitor, and as you click on a thumbnail in the first window, the large preview will appear in the second monitor (as shown below). One last thing: go ahead and save this setup as a custom workspace by going under the Window menu, under Workspace, and choosing New Workspace. Now you're just one click away from this two-monitor setup. *Note:* You can also save a custom workspace you've created by clicking-and-holding on the down-facing triangle to the left of the search field, and then choosing New Workspace from the pop-up menu.

Stay Organized Using Stacks (Perfect for Panos and HDR Shots)

Let's say you took 10 or 12 shots of a bird, in pretty much the same position. In Bridge, you'll see 10 or 12 thumbnails of these very similar shots, right? This is where stacks come in. You can group these very similar photos together under just one thumbnail (called a stack), so those shots only take up one spot, instead of 12. Any time you want to see your bird photos, you just click on that one and the stack expands to reveal them all. Now, in CS4, Bridge can even create stacks for your panos and HDR shots automatically. Pretty slick, eh?

Step One:
To stack similar photos together, press-and-hold the Command (PC: Ctrl) key, and click on the similar photos you want in your stack to select them.

Step Two:
Now, in the Menu bar, go under the Stacks menu and choose Group as Stack, or just press the keyboard shortcut **Command-G (PC: Ctrl-G)**.

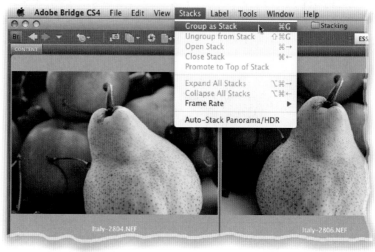

SCOTT KELBY

Step Three:

Once you do either of those, when you look in the Content panel, you'll see two indicators that you have a stack: you'll see a thin stroke around your thumbnail's cell that looks like the outline of a traditional slide mount (as seen here), and a number appears in the top-left corner to let you know how many photos are in that stack (in our case here, it's 4). By stacking these similar photos together, you can now see more photos in your Content panel that otherwise you'd have had to scroll down to see. You can create as many stacks as you'd like—after all they're just there to help you stay organized. How many (or few) stacks you create is totally up to you.

Step Four:

If you want to expand your stack and see what's inside it, just click directly on the number up in the top-left corner, and the stack expands (as shown here). If you actually want to permanently unstack your stack (and have your photos return to just being individual thumbnails), press **Command-Shift-G (PC: Ctrl-Shift-G)**.

TIP: Open Stacked Photos in Photoshop

If you click on a stack and press the **Return (PC: Enter) key**, only the top photo (the visible photo) in that stack will open in Photoshop. However, if you look closely, you'll see that there are two slide mount outlines around each stack. If you click directly on the second slide mount (the one in back), when you press the Return key, it opens all the photos in that stack in Photoshop. By the way, if those photos are in RAW format, they will open in Camera Raw instead.

Continued

Step Five:

To add photos to an existing stack, first click on the stack you want to add them to, then Command-click (PC: Ctrl-click) on the other photo(s) you want to add. Now press **Command-G (PC: Ctrl-G)**, and those photo(s) are added to the stack.

TIP: Scrubbing Through a Stack

If you have 10 or more photos in your stack and you place your cursor over its thumbnail, a little horizontal slider will appear across the top of your stack. If you click-and-drag this slider to the right, it will scroll through and show you the thumbnails of the photos in that stack. That's pretty sweet because you don't have to expand the stack.

Step Six:

After you've created your stack, you can choose any photo as the top photo (and the one visible when the stack is collapsed) by first expanding the stack (click on the number in the thumbnail's top-left corner), and then Control-clicking (PC: Right-clicking) on the photo you'd like as the top photo. When the contextual menu appears, under Stack, choose Promote to Top of Stack (as shown here) and that photo will now represent the stack. Of course, when the stack is expanded, you can drag-and-drop photos into the order you want.

TIP: Instant Stack Slide Show

To the immediate left of that horizontal slider I mentioned in the previous tip is a tiny Play button. Click it to see a quick mini-slide-show of the photos in that stack, right within that thumbnail window.

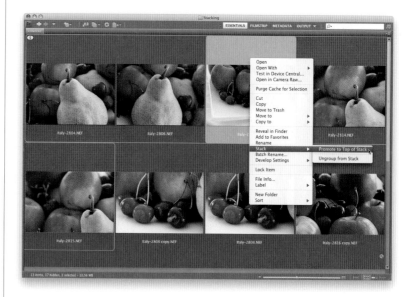

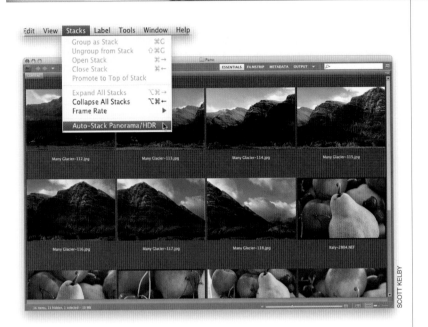

Step Seven:

If you shoot multiple shots to later stitch together as a single panorama, then stacking really makes sense. In CS4, they added an automatic feature that looks at the embedded camera data and tries to determine if the photos are a panorama (it looks at the time between shots). Or, if you took a series of shots at different exposures to compile into a single HDR (High Dynamic Range) photo, it senses that too, and can automatically stack them together. To turn this feature on, go under the Stacks menu and choose Auto-Stack Panorama/HDR (as shown here), and Bridge will search through your current images and see if it can stack any together for you.

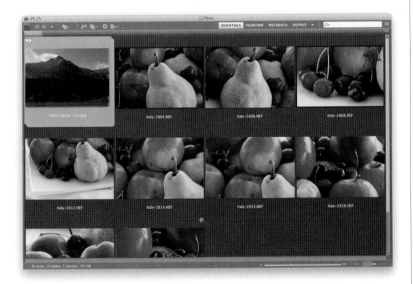

Step Eight:

Here you can see the results of an auto-stack of the panorama shown in the previous step.

TIP: Finding Your Panos Easier

If you don't want to use the auto-stack feature, here's a tip to help you find your panos easier when they're loaded into Bridge: Right before you shoot your pano, hold up your index finger in front of the lens and take a shot. Then shoot your pano, and after the last frame, hold up two fingers and take another shot. That way, later, when you bring your photos into Bridge, you'll not only see a reminder that you shot a pano, you'll see exactly which photos belong in that pano. Try this once, and you'll always do it.

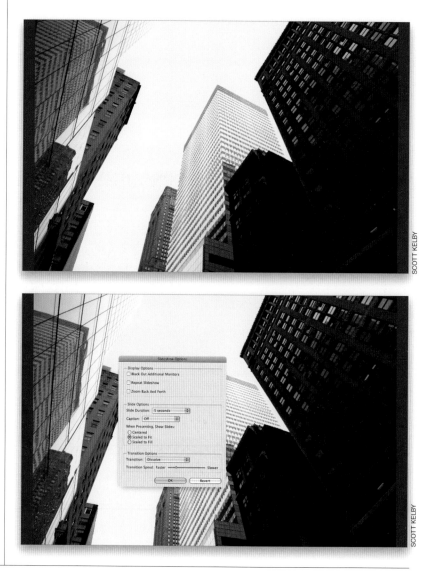

Creating Full-Screen Slide Shows

In the last chapter, you learned how to do a manual full-screen slide show (you press the Spacebar and your photo goes full screen, then you use the Arrow keys on your keyboard), but for a client presentation, you might want a slicker slide show with smooth transitions and effects. Of course, beyond just showing off your work, while the slide show is running, you can still delete any bad shots, apply ratings, rotate shots, etc. Here's how to set one up:

Step One:

To see a full-screen slide show of the photos currently shown in Bridge, press **Command-L (PC: Ctrl-L)** and your slide show starts (as shown here). If you just want certain photos to appear in your slide show, select them by Command-clicking (PC: Ctrl-clicking) on them before you start your slide show. The slides advance automatically, but if you'd prefer to switch slides manually, press the Right Arrow key on your keyboard (to return to the previous slide, press the Left Arrow key. I know, that was pretty obvious. Sorry).

Step Two:

To pause your slide show press the Spacebar. To restart, press it again. To quit your slide show, press the Esc key on your keyboard. Also, there are options for how your slide show displays onscreen, and you bring those up by pressing **Command-Shift-L (PC: Ctrl-Shift-L)** or just choose Slideshow Options from the View menu. The Slideshow Options dialog is shown here.

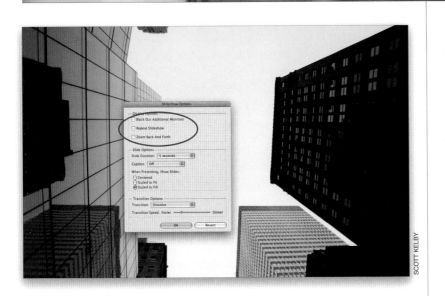

SCOTT KELBY

Step Three:
At the top of the dialog are the display options. The first option only applies to people working with two different monitors (turning this on blacks out the second monitor, so it doesn't distract from your slide show on the first monitor). The Repeat Slideshow checkbox does… come on, do I really have to describe this one? The last checkbox, Zoom Back And Forth, sounds like it would create something really annoying, but actually this is Adobe's name for the popular Ken Burns effect—where your photos slowly and smoothly move toward the screen (or away from it), giving your slide show some subtle motion. You should definitely at least give this a try to see if you like the effect (it's very popular).

Step Four:
The next set of options relates to the slides themselves, including how long each slide appears onscreen and whether any captions you've added to the photo's metadata will appear onscreen, as well. The next option down is important, because it determines how big your photos appear onscreen. I don't like the default Scaled to Fit setting, because (depending on the size of your photos) it can leave gray bars on both sides of your image (look at the image in Step One to see what I mean). That's why I prefer either of the two other choices. The Scaled to Fill option scales your photo to fill the entire screen (which looks really good; see Step Three), and I recommend this option if you choose the Zoom Back and Forth effect. If you're not using Zoom Back and Forth, I like the Centered option, which displays your photos a little smaller, but nicely centered on a gray background (as shown here).

Continued

Step Five:

The last set of options is the transition options, where you can choose from a pop-up menu of transitions. Thankfully, the default transition is a nice, smooth dissolve, but you can choose other transitions, as well as how fast (or slow) the transition effect takes before the next slide appears (you set this using the Transition Speed slider, just below the Transition pop-up menu, as shown here).

Step Six:

This is really more a tip rather than a step, but it's so cool that I had to include it separately. If you're looking at your slide show and you see a RAW photo you'd like to edit, just press the letter **R** (easy to remember—R for RAW). It pauses your slide show and instantly opens that photo in Bridge's own Camera Raw, as shown here (remember—Bridge has Camera Raw built right in), so you can edit the photo. Once you're done editing, click the Done button and you return to the slide show. The changes you made are instantly applied and the slide show continues. This is cooler than it first sounds. Think about it—you're watching your slide show and you see a photo and think "I wonder what that would look like if it was black and white," so you press R to bring up Camera Raw, turn on the Convert to Grayscale checkbox, click Done, and bam, you're back in your slide show, and your photo is black and white. Now come on—that is pretty slick.

SCOTT KELBY

SCOTT KELBY

Step Seven:

There are other keyboard shortcuts for controlling your slide show (like ones for applying star ratings to your slide show photos, or to rotate them, etc.), but you don't have to remember all of them if you can remember just one—the letter **H**. If you press H on your keyboard while the slide show is running, a list of shortcuts appears onscreen (as shown here). To hide the shortcuts, press H again. Okay, now there is one handy shortcut that's not on this list—if you click your mouse button on a photo in the slide show, the slide show pauses and your photo zooms to 100%. To move around the photo while zoomed in, just click-and-drag. Click on the photo again and then press the Space-bar to restart the slide show.

Step Eight:

Sadly, Bridge CS4 still doesn't have a built-in background music feature, but that doesn't mean you can't have background music. Here's what I do: I open Apple's iTunes (for PC or Mac) and start my background music first. Then I jump over to Bridge and start my slide show. The effect is exactly the same—a full-screen slide show with background music. By the way, if you want some ideas for great slide show background music, in Apple's iTunes Store I created a 16-song iMix (basically, a playlist) of great slide show background music, called (surprisingly enough) "Scott's Slideshow Mix." You can listen to a 30-second preview of each track, and you can buy any of them for 99¢ each. To get to my iMix, launch your Web browser and type in this address: http://phobos.apple.com/WebObjects /MZStore.woa/wa/viewPublishedPlaylist ?id=222715 or just go to the iTunes Store and search for my iMix by its name, "Scott's Slideshow Mix."

Finding Your Photos Fast by Using Keywords

It doesn't take long to have thousands of photos on your computer or an external drive, and the secret to keeping all of them just one click away is to use keywords (a fancy name for search terms). That way, for example, if you needed to find all your images of a bride holding a bouquet, you'd just type in bouquet, and instantly every shot you tagged with the keyword "bouquet" would appear. All you have to do is take a few seconds now to create and embed those keywords. Here you'll learn how to embed them, and then how to put them to use.

Step One:
There's a built-in workspace that's designed to make tagging your shots with keywords more convenient, so let's start there by choosing Keyword from the Application Bar's Workspace pop-up menu (click on the down-facing triangle to the left of the search field), or use the keyboard shortcut **Command-F5 (PC: Ctrl-F5)**. This puts the Keywords panel in the bottom left, and your photos take up the rest of the window in Details view (as shown here).

Step Two:
If you look in the Keywords panel, you'll see that Adobe has already included some keyword categories (Adobe calls them parent keywords), including Events, People, and Places, each with some of the most common keywords associated with these categories as subkeywords (for example, under Events, the default keywords are Birthday, Graduation, and Wedding). These default keywords are just there to basically give you an idea of how keywords and subkeywords work, and to give you a starting place, but the real power comes from you creating and applying your own keywords.

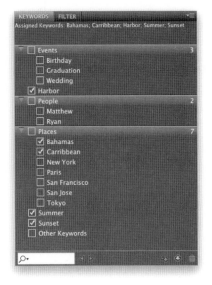

Step Three:

Any keywords that you've assigned to a photo will appear in the Keywords panel. For example, when you look in the Keywords panel, you'll see the generic keywords (Harbor, Summer, Sunset) I added after I imported photos I took down on the island of Nassau in the Bahamas. If I click on one of those photos, two things happen in the Keywords panel: (1) at the top of the panel, it displays all the keywords assigned to that photo, and (2) down in the list of keywords you'll see a checkmark beside each keyword assigned to your selected photo, as shown here (we actually use the term "tagged," as in, "That photo is tagged with Harbor and Sunset." It's important to use slang like this to build "street cred" with the kids— I mean, your colleagues).

Step Four:

The problem is, generic keywords will only get you so far. Here's why: Let's say that you're working on a client project and you need a photo of a lighthouse you remember shooting on one of your summer trips to the Caribbean. Well, you could look in your Caribbean folder, but there could easily be hundreds, or even thousands of photos in that folder. Instead, to narrow your search, you could go to the Filter panel and click on the keyword Summer, and now all the shots you took in summer would appear. That's nice, but what if there are 614 shots you took during the summer (as shown here)? You'll need to narrow your search further, but you really can't, because you only assigned these generic keywords.

Continued

Step Five:

If you want to save yourself from having to spend 30 minutes searching every time you need to find a particular photo, here's what to do: after you import your photos and get rid of the obviously bad, out-of-focus, totally trashed shots, go right then and tag your photos with specific keywords. At this point in the game, it takes just a few minutes, but it will turn your 30-minute searches into 30-second searches, so it's definitely worth doing. You start in the Keywords panel by clicking on the New Keyword icon at the bottom-right corner of the panel (as shown here). This adds a new highlighted parent keyword field, so type in the name you want to add as a keyword (I typed in "Lighthouse"). *Note*: You can also click on a parent keyword, then click on the New Sub Keyword icon to create a subkeyword.

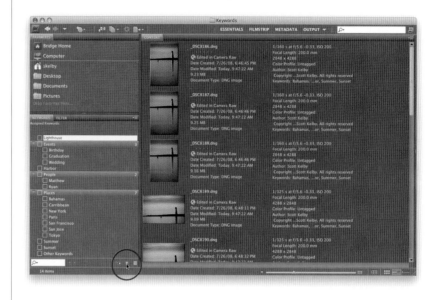

Step Six:

Now scroll through your photos, and when you see one with that lighthouse, Command-click (PC: Ctrl-click) on it to select it. Once they're all selected, go to the Keywords panel and turn on the checkbox for Lighthouse (as shown here), and all the selected photos are now tagged with that keyword. So, that's basically the process—create and assign keywords in the Keywords panel. Then to find photos, use the Quick Search field, or the Find command, which we're going to talk about in just a moment. But first, we need to add more keywords to these photos because a year from now you might not remember that you used the keyword Lighthouse to describe them. So, I would add more keywords, like Nassau, Island, and any other descriptive terms that might help you find these photos in the future.

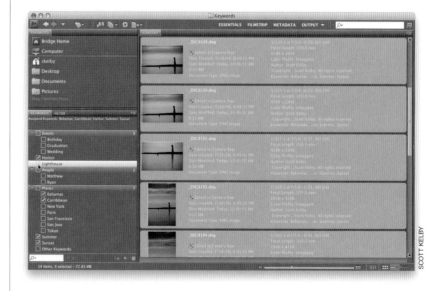

Step Seven:
So, now let's see just how adding these keywords has made your life easier by going back to our client project. Go to the Folders panel, find your Pictures folder, and click on it to show its contents. Find your folder named Caribbean and click on it. Let's say that inside this folder are all the photos you've taken in the Caribbean in the past five or six years (we'll assume you've been there a number of times), so you have several subfolders by date.

TIP: Deleting Parent Keywords
If you want to delete the default parent keywords that Adobe put in the Keywords panel, just go there and click on the parent keyword (like Events or People) and then click on the Trash icon at the bottom of the Keywords panel. You delete subkeywords the same way.

Step Eight:
If you know which subfolder in your Caribbean folder you need to look in, you can use the Filter panel to find it. Just click on the subfolder in the Folders panel, then in the Filter panel, click on the keyword you want (I clicked on Lighthouse here). This will show you only the images in that subfolder with Lighthouse as a keyword. If you took lighthouse photos at different times of day (different ISOs), and you know what ISO you are looking for, you can click on both the keyword and the ISO, and Bridge will filter your photos to ones that contain both.

Continued

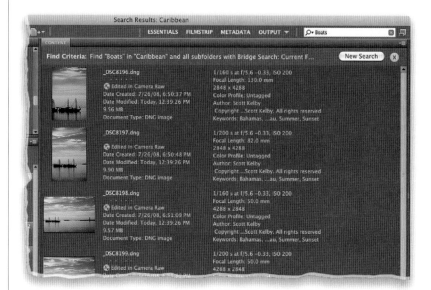

Step Nine:

Now, the other way to quickly find photos is by using the Quick Search field up in the top-right corner of Bridge (this is new in CS4, by the way). Quick Search uses Bridge's search engine by default, and will search in your folder and all subfolders by filename and keyword. Just type in the keyword(s) you want to search for (in this case, "Boats"), and as soon as you start typing, it starts narrowing your search, until just your photos tagged with Boats are showing.

Step 10:

If you want to do an advanced search (a search with more options and power), then skip the Quick Search field up top and, instead, press **Command-F (PC: Ctrl-F)** to bring up the Find dialog (shown here). (*Note:* If you decide to narrow your search after using Quick Search, just press the New Search button at the top right of the Content panel to bring up the Find dialog with your current search criteria in place.) You pick your search criteria from pop-up menus, and you can add as many different lines of criteria as you'd like by clicking on the + (plus sign) button on the far right side of each criteria line. Here I searched for the keyword Boats, but added more criteria, so it only searches for my 5-star images take with my Nikon D300. To search your subfolders, make sure the Include All Subfolders checkbox is turned on near the bottom of the dialog.

TIP: Getting Automatic Find Criteria

If you go to the Keywords panel and Control-click (PC: Right-click) on a keyword you want to search, and choose Find from the contextual menu that appears, it automatically chooses all the right criteria for you and inserts the keyword in the text field. A big time saver!

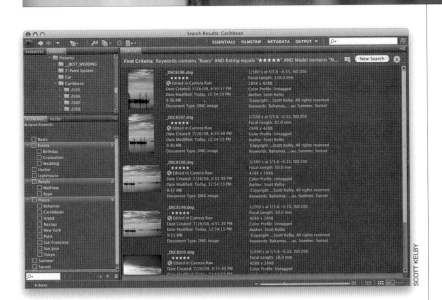

SCOTT KELBY

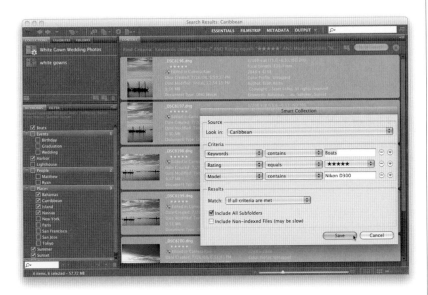

Step 11:

Click the Find button, and within a few seconds just the photos that have been tagged with the keyword Boats, that are 5-star rated, and were taken with that particular make and model of camera will appear in the Content panel (as shown here). To search for something else, click the New Search button in the top right of the Content panel. To clear this advanced search, click the little X button at the top right of the Content panel.

Step 12:

Okay, so all your 5-star boat photos shot with your Nikon D300 appear in the Content panel. Now what? Well, you can sort them, open them in Photoshop, etc., but if you think you'd like to have instant access to this exact same group of photos again (without having to do another Find), you can create a collection of them (remember, we learned that earlier in the sorting our images part of Chapter 1?). To do that, first select the photos you want in that collection (I just do a Select All **[Mac: Command-A; PC: Ctrl-A]** at this point). Then go under the Window menu and choose Collections Panel, and it appears in the top left of the window. Click the New Collection button at the bottom right of the panel, click the Yes button to include the selected files in your new collection, give your new collection a name, and you're set. Now these photos are just one click away in the Collections panel. *Note*: If you make this a smart collection (as shown here), it updates live, meaning whenever you tag a new 5-star photo shot with your Nikon D300 with the Boats keyword, it will automatically be included in this smart collection (and smart collections are really just the results of a search, so it doesn't add any file size. See "Creating Smart Collections" near the end of this chapter). Pretty handy, eh??

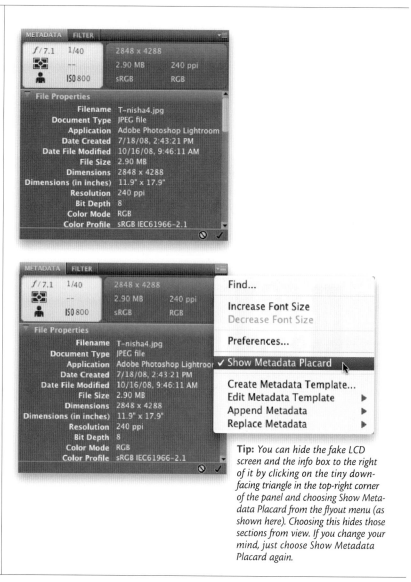

Seeing and Editing a Photo's Metadata

When you take a photo, your digital camera automatically embeds a host of background info right into your photo (called EXIF data), which includes the make and model of your camera, the lens you used, your exposure settings, etc. Bridge not only lets you see this information, but it also lets you embed your own custom info (like your copyright info, contact info, etc.). Bridge also shows the file properties (like the pixel dimensions, resolution, color mode, the file size, etc.). All this embedded info is known as your photo's metadata.

Step One:

Click on a photo in Bridge and then look at the Metadata panel, on the bottom-left side of Bridge if you switch to the Metadata workspace (I zoomed in on it here so you can see it more clearly), to see all the photo's embedded background info. On the top left of the panel, there's a little window that looks like a digital camera's LCD screen. This "fake LCD screen" displays some key EXIF data (shooting info) for that photo, like the f-stop, shutter speed, ISO setting, metering mode, etc. The section to the right of the screen shows some of the file info data, like the physical dimensions, file size (in this case, it's 2.90 MB), resolution, etc. Below these two boxes is the File Properties section, which shows the full file info data, instead of just the "quick glance" version. By the way, Bridge pulls this File Properties info from the photo itself, so this information is not editable by you (or me) in this panel. The only way to change this part of the metadata is to actually change the photo itself by opening it in Photoshop and changing the image size, or color mode, or resolution, etc. Then, when you save the file with the changes, the metadata is updated automatically to reflect them.

Tip: *You can hide the fake LCD screen and the info box to the right of it by clicking on the tiny down-facing triangle in the top-right corner of the panel and choosing Show Metadata Placard from the flyout menu (as shown here). Choosing this hides those sections from view. If you change your mind, just choose Show Metadata Placard again.*

Step Two:

Now scroll down a little further until you come to the Camera Data (EXIF) section, as shown here (you'll scroll right by the IPTC Core info section, but don't worry, we'll look at that next). This section shows the information embedded by your digital camera at the moment you pressed the shutter button. Info in this Camera Data (EXIF) section can't be edited at all—it was put there by your camera and it stays there, so all you can do is look at it (you'll use this info later, and then you'll understand why it's so useful). So, for now, just take a look at it and comment out loud something along the lines of, "That's really cool the way it knows everything about my photo."

Step Three:

Now, there is a long list of Camera Data (EXIF) fields you can't add info into (many more than the average photographer will ever need). That's why most folks set up this list to display only the fields they really want to see. To do this, click on the tiny down-facing triangle in the top-right corner of the Metadata panel and choose Preferences from the flyout menu that appears. This brings up Bridge's Preferences dialog with the Metadata category selected. Scroll down to Camera Data (EXIF) and you'll see the full list of available camera data fields (scary, ain't it?). Only the fields with checkmarks by them will be visible, so to hide a field in the list, just click on the checkmark beside that field. Also, ensure the Hide Empty Fields checkbox is turned on at the bottom, so when you click OK, only the checked fields with information will be visible.

Continued

Step Four:

Okay, so although the camera data isn't editable, there is one section where you can add your own info—it's the IPTC Core section (named for the International Press and Telecommunications Council). This is where you can add info directly into the file, like your copyright info, your contact info, the rights usage for the photo, your website, etc. So, let's add some. In the Metadata panel, scroll down to IPTC Core and click on the right-facing triangle to the left of the words IPTC Core to reveal that section (shown here). If you see a little pencil icon on the far-right side of any field, you can write your own custom info into that field. If you added some metadata during the import process (like your copyright info), you'll see that info has been added to those fields.

Step Five:

To enter your own info, click once in the blank field to the right of the item you want to edit and all the text fields will appear. To see how this works, click to the right of Creator: Address (it's near the top). When the field appears, just type your street address. To move on to the next field down (in this case, it's the Creator: City field), just press the **Tab key** on your keyboard. If you want to jump directly to any field, just click on it. When you're done adding your own custom data, click on the checkmark icon at the very bottom of the Metadata panel. You can also press **Return (PC: Enter)** or, if the field accepts multiple lines of text (such as the Creator: Website field), press **Command-Option-Return (PC: Alt-Enter)**.

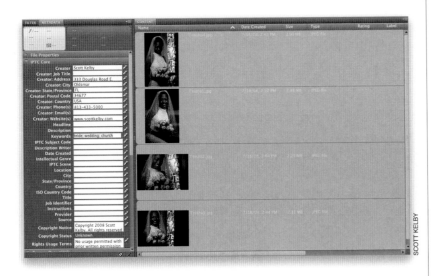

SCOTT KELBY

Step Six:

Applying your own custom info on a photo-by-photo basis can really be slow and tedious, but luckily you can apply your info to as many photos as you'd like, all at once. If you want to apply this info to all the photos in the folder you're currently working with, press **Command-A (PC: Ctrl-A)** to select them all, then click to the right of the info field you want to add to activate it. Now just type in your info, and when you're done, click the checkmark in the bottom-right of the panel, and all those photos will now have that custom metadata applied. But what if you just want to add (or edit) metadata on certain photos? (Maybe you want to add your contact phone number to some photos you're going to post on the Web.) Then do this instead: Click on the first photo you want to edit, then press-and-hold the Command (PC: Ctrl) key and click on all the other photos you want to affect. Once they're selected, click to the right of the phone number field, type your phone number in the active field, click the checkmark, and it's done. Much faster and easier.

TIP: Increasing the Font Size

Because there's so much metadata included in each photo, Adobe had to make the panel's font size really small. Luckily, you can increase it by clicking on the Metadata panel's flyout menu (in the top-right corner of the panel) and choosing Increase Font Size. If it's still not big enough, choose it again. Still not big enough? Choose it again and again, until it's so large your next-door neighbors can read it through your front window. Take a look at the example shown here where I just chose Increase Font Size two times.

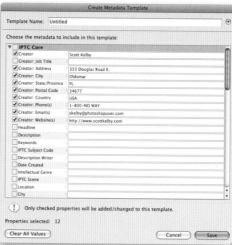

Creating Metadata Templates

I'm pretty sure the last thing you want to do in Bridge is spend a lot of time typing, but you'll probably at least want to embed your copyright info, your contact info, your website, and on and on. That's why you'll want to know how to create a metadata template, which allows you to enter all that info only once, then you can embed it all automatically with just one click of your mouse.

Step One:
You'll need to start with a photo on which to base your template. So navigate to a folder of images within Bridge that you'd like to assign some copyright and contact info to and click on one of the thumbnail images in that folder. Then go under the Tools menu and choose Create Metadata Template (as shown here).

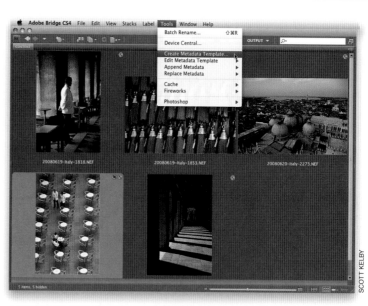

Step Two:
This brings up the Create Metadata Template dialog (shown here). You'll see a checklist of IPTC Core metadata categories on the left-hand side, but only the ones with checkmarks by them will be visible. So turn on the checkboxes for those you want visible, then in the fields to the right, type in the information that you'd like to turn into a template (in the example shown here, I just added my basic contact info). Don't forget, if you scroll down, there are many more fields you can add info to (including the all-important copyright fields).

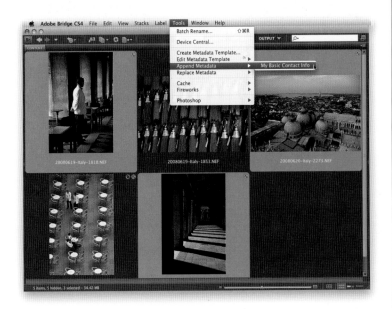

Step Three:

Once you've entered all the information you'd like in your template, type in a name for it in the Template Name field at the top of the dialog (this is the name you'll see listed when you go to apply this template later or during the import process, so be descriptive). Now click the Save button at the bottom of the dialog (as shown here).

Step Four:

Now that your template has been created, applying it is simple. Just select the photos you want to have that info embedded into (as shown here, where I Command-clicked on our photos—on a PC you would Ctrl-click on them). Then go under the Tools menu, under Append Metadata, and choose your saved template (as shown here, where I'm choosing the template I just created named "My Basic Contact Info"). From now on, this template will appear in this list, so you can apply it anytime. Also, you can create and save as many of these templates as you'd like, with each one having a different set of info (so you could have one with detailed copyright info, or one that just has copyright info and nothing else, or one that you'd use when selling a digital image file to a client, etc.).

Stripping Out Metadata from Your Photos

Well, technically I'm not sure if this belongs in a chapter about Bridge, except that so much of what we're talking about is metadata, so I hope you don't mind if I stick it here. Okay, so why would you want to strip out the very metadata that we clearly hold so dear? Well, it contains personal information about you, your whereabouts on a certain day, your equipment, your lenses, your settings, etc. Stuff your clients don't need to know (whether you're giving them the file or selling your work to a stock photo agency). Here's how to quickly strip it out:

Step One:

Go under the Window menu, under Workspace, and choose Metadata. This displays your thumbnails with metadata for each photo displayed to the right of it (the metadata will scroll horizontally, while keeping the thumbnails in place). That's the info we're going to strip out, along with more that's not displayed here. To see the rest, double-click on the Favorites panel tab to collapse it and have the Metadata panel expand into that empty space. If you distribute this photo "as is," all that metadata will be included along with it, and it will be viewable to anyone with a photo editing program. So, double-click on the photo thumbnail to open it in Photoshop CS4.

Step Two:

Go under Photoshop's File menu and choose New. When the dialog appears, click on the Preset pop-up menu at the top and, near the bottom, you'll see the name of your open photo. Select the photo's name, and the exact Width, Height, Resolution, and Color Mode settings from your open photo will be copied into the New dialog's fields. Just click OK and a new document with the same specs as your open photo will appear onscreen.

Step Three:

Once your new blank document is open in Photoshop, click back on the photo you opened. Now press **V** to get the Move tool, press-and-hold the Shift key, and then click-and-drag your photo onto the new blank document. Because you're pressing-and-holding the Shift key while you're dragging, the photo will appear in the exact position it did in the original. However, this dragged copy is on its own separate layer, so press **Command-E (PC: Ctrl-E)** to merge this layer with the Background layer (this flattens the document). Since the document you dragged your photo onto was a new blank document, it has no metadata whatsoever, and your photo, which comes over as a layer, doesn't carry any of its own metadata with it.

Step Four:

Lastly, go under the File menu and choose File Info. When the dialog appears, click on the Camera Data tab and you'll see that all the fields are blank. However, if you click on the IPTC tab, you'll see that all your copyright and contact info has been stripped out, too. Luckily, when you create a metadata template in Bridge, it is also available in Photoshop. So if you'd like to add your IPTC contact and copyright info back in, just click on the downfacing triangle at the bottom right of the dialog and, from the pop-up menu, choose the metadata template with the info you'd like to embed (as shown here). By the way, if you find yourself doing this a lot, this is an ideal thing to record as an action, so the whole process is totally automated (more on actions later).

Batch Renaming Your Files

If you didn't rename your photos when you first imported them from your memory card (or if the photos were already on your computer), then you can use Bridge to automatically rename an entire folder full of images. This is really helpful because you can give your photos descriptive names, rather than the cryptic secret code names assigned by your digital camera (which tends to give your photos fun names like DSC_0486.JPG or DSC_0784.NEF). So, here's how to batch rename a folder full of (or just selected) photos fast!

Step One:

First, you have to tell Bridge which photos you want to rename. If it's just a certain number of images within your main window, you can press-and-hold the Command (PC: Ctrl) key and click on only the photos you want to rename. But a more likely scenario is that you'll want to rename all the photos open in your Content panel, so go under Bridge's Edit menu and choose Select All, or press **Command-A (PC: Ctrl-A)**. All the photos in your Content panel will be highlighted. Now, click on the Refine icon in the Application Bar (it looks like a stack of paper) and, from the pop-up menu, choose Batch Rename.

SCOTT KELBY

Step Two:

When the Batch Rename dialog appears, you need to select a destination for these renamed photos by choosing an option. Will they just be renamed in the folder they're in now? Do you want them renamed and moved to a different folder, or do you want to copy them into a different folder? If you want to either move or copy them, you'll need to click on the Browse button. In the resulting dialog, navigate to the folder you want your photos moved (or copied) into after they're renamed. In our example, we'll just rename them right where they are (which is probably what you'll do most of the time).

Step Three:

Under the New Filenames section of the dialog, the first pop-up menu shows Text by default and a text field appears to the right. Just type in your own custom filename to replace the default text (I entered "Pitcher on Mound"). At the bottom of the dialog, there's a live before-and-after preview of your custom filename so you can see how it will look. Since we're not going to include the date and time in our new filename, or any other additional text, click on the – (minus sign) buttons to the far right of the second and third rows of pop-up menus to remove them (as shown here). Okay, so far, so good, but there's a problem: In your folder, you can only have one photo (or any file for that matter) exactly named Pitcher on Mound, so you'll need to add something to the end of the filename (like a number), so each photo is named something different (like Pitcher on Mound001, Pitcher on Mound002, and so on). This is where the last default row of pop-up menus comes in.

Continued

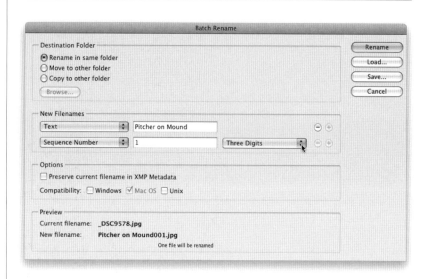

Step Four:

To use the built-in auto-numbering, leave the first pop-up menu in the second row set to Sequence Number (to have Bridge automatically add a sequential number after the name); in the center text field, enter the number you want to start with (I left the number 1); then, from the pop-up menu on the far right, choose how many digits you want for your sequence (I chose Three Digits, as shown here). Look at the preview at the bottom of the dialog to see how the name looks now— Pitcher on Mound001.jpg. (By the way, if you want a space between the last word and the number, just press the Spacebar once after you type in your name in the text field.)

Step Five:

When you click the Rename button, Batch Rename does its thing. If you chose to rename your files in the same folder, you can just take a peek at Bridge, and you'll see that your selected thumbnails are now updated with their new names (as seen here). If you chose to move all your files to a different folder and then clicked the Rename button, the Content panel will be empty (that makes sense because you moved the images to a new folder and the Content panel is displaying the current folder, which is now empty). So, you'll need to go to the Folders panel in Bridge and navigate your way to the folder to which you moved (or copied) all your photos (and best of all, they'll be sporting their new, more descriptive names).

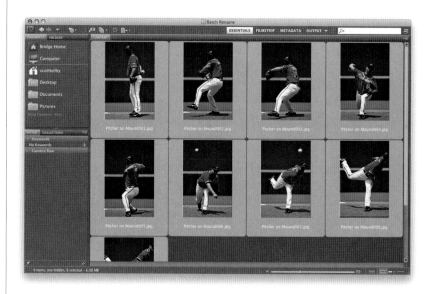

Step Six:

Batch renaming doesn't just change the thumbnails' names, it applies this name change to the actual image file. To check it out, leave Bridge and go to the folder on your hard disk where these photos are stored. Open that folder and you'll see the new filenames have been assigned there, as well.

TIP: Including the Original Filename

If you want to take this renaming thing a step further, you can click on the little + (plus sign) button on the far right of the last row in the New Filenames section to add another set of naming options. From the first pop-up menu in the new row, choose Current Filename, which adds the original filename to the end of your new filename. Hey, some people dig that. Instead of adding the original filename to the end of the new one, what I do is go under the Options section, and turn on the checkbox for Preserve Current Filename in XMP Metadata. That way the original filename is embedded into the file, just in case you have to go searching for the original file one day.

Creating Smart Collections

In CS4, Adobe added smart collections—a very powerful, yet fully automated way to create collections based on a set of criteria you get to select. For example, you could create a smart collection that would include any photo, from all your photos, that has both a 5-star rating and is tagged with Bride as the keyword, but only those that were shot with a wide-angle lens, and only those that were shot this year. You give it the criteria, and it does the rest. Here's how to start making your own smart collections:

Step One:

To create a smart collection, click on the Collections panel's tab (if it's not visible, just choose Collections Panel from the Window menu up top). Next, click on the New Smart Collection icon at the bottom right of the Collections panel (it's shown circled here). This brings up the Smart Collection dialog (seen here). Now, let's use the situation I laid out in the intro above to create your first smart collection. The default criterion is to create a collection based on Filename (as you can see here), but we're going to change that first field to Rating, so click on the word Filename, and choose Rating from the pop-up menu, instead.

Step Two:
When the Rating criterion appears, it changes the criteria to the right of it. Leave the center pop-up menu set to Equals, but choose five stars (as shown here) from the third pop-up menu. If we click Save now, it would just search your computer for five-star photos, but we want to add more criteria to make our search even more powerful. Click the small + (plus sign) button to the right (shown circled in red) to add another search criterion (it appears below the first one, with the default Filename chosen).

Step Three:
Now for our new criterion, from the pop-up menu, choose Keywords, leave the center pop-up menu set to Contains, and then type in Bride in the field on the right (as shown here). If you clicked the Save button now, it would make a smart collection of all your five-star photos that contain the keyword Bride, but we want to add a few more criteria before we create our smart collection. Click the plus sign button again, and this time choose Focal Length from the first pop-up menu, leave the center pop-up menu set to Equals, then type in the length of your wide-angle lens (in this case, 12mm).

Continued

Step Four:

Click the plus sign button again to add another line of criteria. Because we just want to have it collect photos taken this year, we're going to set the first menu to Date Created, the center to Is Greater Than, and set the date to the first of this year (as shown). Lastly, in the Results section, set the Match pop-up menu to If All Criteria Are Met. Now, click the Save button, and this new smart collection will appear in your Collections panel with its name field highlighted ready for you to name. So, just type in a name and then hit the **Return (PC: Enter) key**. Here are two very cool things you'll want to know about smart collections: (1) They're live. If you set the Match pop-up menu to If All Criteria Are Met when you created your smart collection, and you lower the rating of one of your five-star photos, it will be removed from this smart collection automatically, because it no longer matches all the criteria. And, (2) you can edit the criteria for any existing smart collection by clicking on the smart collection first, then clicking the Edit Smart Collection icon at the top right of the Content panel. This brings back up the Smart Collection dialog with your current criteria, so you can add criteria, or delete criteria (by clicking the – [minus sign] button), or change the criteria using the pop-up menus.

Making Prints, Web Photo Galleries, and Contact Sheets

One big area that Adobe updated in CS4 is how you go directly from Bridge to output, and by that I mean going straight from Bridge to either a printed contact sheet (or a regular print), to a full-blown online photo gallery for the Web. You do this in a much different way than in previous versions of Bridge, and now all your printed output is actually saved to a PDF, which to some will be a bonus, and to others...well...let's just say it's not a bonus. Here's how to do both:

Step One:
Adobe has changed this part of the Bridge process enough that it now has its own workspace. When you're ready to make a print (straight from Bridge, without going through Photoshop—keeping in mind that you can use Bridge's version of Camera Raw first, though), go ahead and switch to the Output workspace (click on Output at the right end of the Application Bar; click on the Output icon and choose Output to Web or PDF from the pop-up menu; go under the Window menu, under Workspace, and choose Output; or use the keyboard shortcut **Command-F4 [PC: Ctrl-F4]**). (*Note:* If you still want to create contact sheets and custom prints from Photoshop, see Chapter 14 for how to get these features [and others] back in CS4.)

Continued

Step Two:

When this Output workspace appears, the Output panel appears along the right side of the window, with your Content panel thumbnails as a filmstrip along the bottom in the middle. To start the process, you first choose whether you want a print (from a PDF) or an online Web gallery. We'll start with the prints, so click on the PDF button at the top of the Output panel. Directly under that are the built-in templates you can use, but for our example, choose 4*5 Contact Sheet (as shown here), then down in the Content panel, select the photos you want to appear in your contact sheet.

Step Three:

Even though you can see your selected photos in the Preview panel, they don't appear in the Output Preview panel until you click the Refresh Preview button (circled here in red). Before you click that button, you have a few choices to make first in the Document section of the Output panel, including your paper size, quality (choose High Quality for larger size images), your background color, and whether you want to password protect your PDF (so it can only be opened by someone you give the password to). Also, if you're emailing this to a client for proofing, and you don't want them to be able to print your contact sheet out, then turn on the Permission Password and the Disable Printing checkboxes (as shown here).

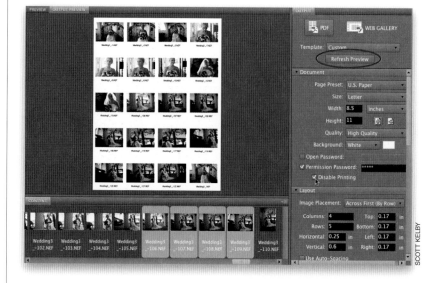

SCOTT KELBY

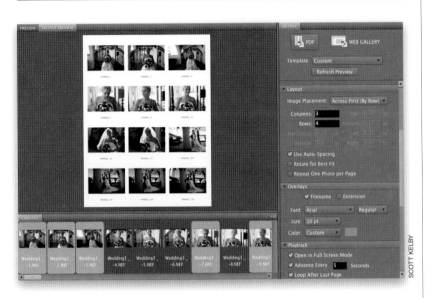

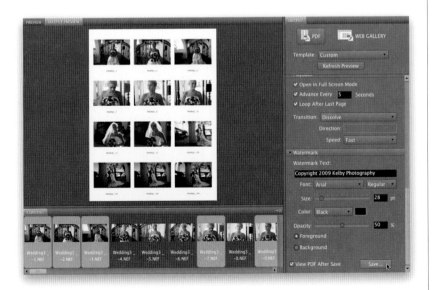

SCOTT KELBY

Step Four:

If you scroll down, you'll see the Layout section, where you can choose how many rows and columns you'd like, and your page margins (here I changed it to 3 columns and 4 rows, which makes the images larger on the contact sheet, but to see that change I had to click the Refresh Preview button). There's also an Overlays section with checkboxes for whether you want the filename to appear below each image, and whether it should show the filename extension. If you choose to print the filename, you get to choose the font, style, size, and color (I chose a medium gray). If you create a multi-page PDF and want it to appear as a slide show when opened, you can use the Playback section.

Step Five:

There's one thing to point out in the Playback section, and that's the Transition pop-up menu. If you choose one (I always choose Dissolve, because I like that it's subtle and doesn't take away from the photos themselves), you'll get either one or two more pop-up menus with options for your selected transition. The final section is the Watermark section, which lets you put a visible watermark (usually a copyright notice or the name of your studio) right over each image. You get to choose the font, style, size, color, and opacity of this watermark. You also get to choose whether it appears over your images or behind them. Lastly, I recommend turning on the View PDF After Save checkbox, so you can see your final contact sheet before you print it or email it. Now all you need to do is click the Save button, and then if you want to print it, you can print from Adobe Acrobat or Photoshop.

Continued

Step Six:

If you choose to create a Web photo gallery instead, you start at the top of the panel by clicking on the Web Gallery button, and when you do an entirely new set of options appears. You can choose a built-in Web gallery template from the Template pop-up menu. My favorites are under Lightroom Flash Gallery (chosen here), and when you choose this, you get to choose which Style you want. Now, sadly there is no preview, so what you have to do is choose a style and (you guessed it) click the Refresh Preview button each time you choose a new style, until you come up with a look you like (the one shown here is Night Life).

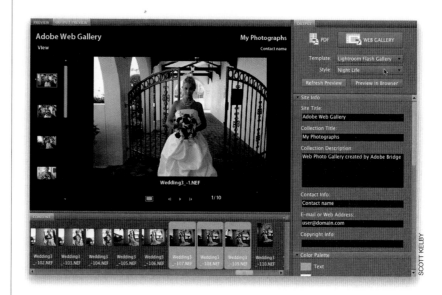

Step Seven:

You customize the text that appears on your Web gallery in the Site Info section of the Output panel. You just click in the text fields and type in the info you'd like to appear on the page. As always, none of this updates live, so after you enter your text, the only way to actually see it on the page is to click that by now really annoying Refresh Preview button (can you tell this is starting to get to me?). Then it redraws the preview with your new text changes.

Step Eight:

If you continue scrolling down the Output panel, you'll find a Color Palette section, where you can choose custom colors for everything from your backgrounds, to your borders, to your text by clicking on the little color swatches. Sounds like fun, until you realize that none of these changes appear until (gotcha!) you click the Refresh Preview button again. (I know, I know. Hey, I didn't design it—I just teach it.) A little farther down is an Appearance section, where you can choose things like which side your filmstrip will appear on, how large your thumbnails will appear, and how big the main preview will appear when you click on a thumbnail.

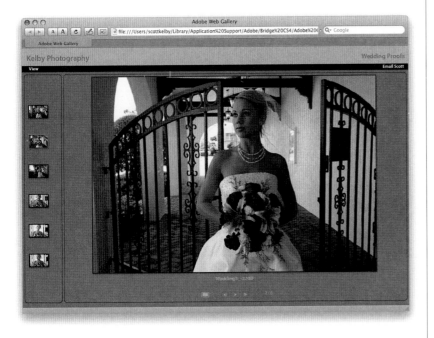

Step Nine:

After you've tweaked your colors, positions, sizes, and basically whatever you felt like tweaking, before you go and save your Web gallery, I absolutely recommend heading back up to the top of the Ouput panel and clicking the Preview in Browser button. This renders a temporary version of the photo gallery—it launches your default Web browser, and opens the page so you can see what your client will see, and how it will really look when it's up on the Web. I've caught little things a dozen or more times that I didn't see (or just didn't notice) until I saw the page previewed in a browser like this, so I definitely recommend giving it a look here before you save the final file.

Continued

Step 10:

When it's time to save your Web photo gallery, scroll down to the very bottom of the Output panel to the Create Gallery section (I know, it should be named "Save Gallery"). Here's where you give your gallery a name and choose whether you want to save it on your computer (for uploading to your Web hosting company) by clicking the Save to Disk radio button, or if you host and maintain your own server, then you can actually upload the files directly to your FTP server by clicking the Upload radio button (by the way, if you were reading that last part about the FTP thing and you thought to yourself, "What's FTP?" then you're a Save to Disk person, so ignore the FTP stuff, which will make sense to people who use FTP [freaks that they are]). For you FTP guys, you enter your server path, login stuff, and root folder (again, if that sounds foreign, you've read too far. Go back and choose Save to Disk).

Exposure: 1/250s | Focal Length: 135mm | Aperture Value: ƒ/16.0

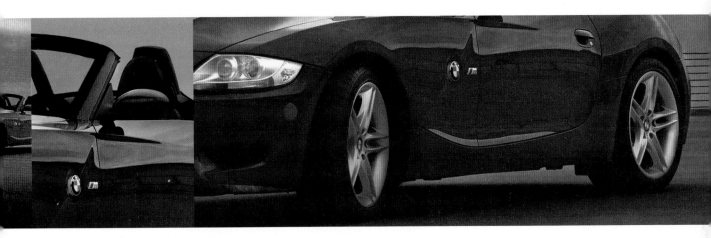

Raw Deal
camera raw essentials

Okay, this title is actually taken from a movie starring California Governor Arnold Schwarzenegger called *Raw Deal*. I found the movie poster for it online, and I must admit it was the movie's tag line that sold me on using it as my chapter title. The tag line was: "The system gave him a Raw Deal. Nobody gives him a Raw Deal." The word "Nobody" was underlined. Like this: Nobody. So here's the weird thing: shouldn't it have been, "Nobody gives him a Raw Deal!" with the "him" either italicized or underlined? But the "Nobody" was underlined instead. Makes you stop and think, doesn't it? Anyway, on the movie poster itself, Arnold is holding a really large automatic weapon (I know—how unusual) while wearing a small white under-shirt, so his arms and chest look really huge. Ya know, if I had arms and a chest the size of Arnold's, I'm not sure I'd even own a shirt.

I'd go shirtless everywhere, and I don't think anyone would give me even an ounce of heat about it. I think restaurants and grocery stores would quickly ease their "no shirt—no service" policy and welcome me right in. Especially if I was carrying that large automatic weapon like he is. Why, I'll bet people get right out of his way. Now, this movie was released in 1986 (I think I was about 6 months old then), and at that time there was no shooting in RAW, so this was years before the RAW wars broke out. (Everybody thought one day we'd have a huge war over oil reserves in the Middle East. But no one had anticipated that long before that, the entire world would be embroiled in a bitter RAW vs. JPEG war that would threaten to take neighboring TIFF and PSD right into the conflict with it. I can't believe you're still reading this. You're my kind of people— ya know, for just one person.)

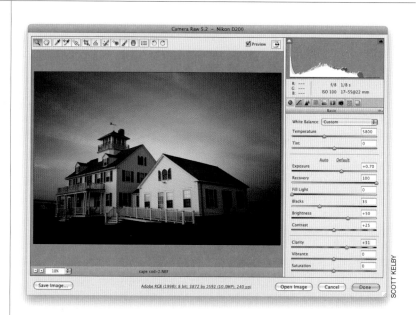

Getting Your RAW, JPEG, and TIFF Images Into Camera Raw

Although Adobe Camera Raw was originally created to process photos taken in your camera's RAW format, you can also use it to process your JPEG and TIFF photos. A big advantage of using Camera Raw that many people don't realize is that it's just plain easier and faster to make your images look good using Camera Raw than with any other method. Camera Raw's controls are simple, they're instantaneous, and they're totally undoable, which makes it hard to beat. But first, you've got to get your images into Camera Raw for processing.

Opening RAW Images:

Since Camera Raw was designed to open RAW images, if you double-click on a RAW image (whether in Bridge or just in a folder on your computer), it will launch Photoshop and open that RAW image in Camera Raw (its full official name is Adobe Camera Raw, and it's often referred to as ACR, but here in the book, I'll just be calling it "Camera Raw" for short, because...well...that's what I call it). *Note:* If you double-click on what you know is a RAW image and it doesn't open in Camera Raw, make sure you have the latest version of Camera Raw—images from newly released cameras need the latest versions of Camera Raw to recognize their RAW files.

Opening JPEG & TIFF Images from Bridge:

If you want to open a JPEG or TIFF image from Bridge, it's easy—click on it and then press the Open in Camera Raw icon at the top-left side of the Bridge window (that icon is shown circled here in red), or use the keyboard shortcut **Command-R (PC: Ctrl-R)**.

Opening JPEG & TIFF Images from Your Computer:

If you want to open a JPEG or TIFF image from your computer, then here's what you do: On a Mac, go under Photoshop's File menu and choose Open. When the Open dialog appears, click on your JPEG (or TIFF, but we'll use a JPEG as our example) image, and in the Format pop-up menu, it will say JPEG. You need to click-and-hold on that Format pop-up menu, and from that menu choose Camera Raw, as shown here. Then click the Open button, and your JPEG image will open in Camera Raw. In Windows, just go under Photoshop's File menu and choose Open As, then navigate your way to that JPEG or TIFF image, change the Open As pop-up menu to Camera Raw, and click Open.

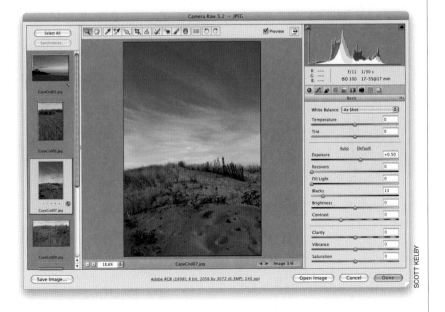

Opening Multiple Images:

You can open multiple RAW photos in Camera Raw by selecting them first (either in Bridge or in a folder on your computer), then just double-clicking on any one of them, and they'll all open in Camera Raw and appear in a filmstrip along the left side of the Camera Raw window (as seen here). If the photos are JPEGs or TIFFs, in Bridge, select 'em first, then press **Command-R (PC: Ctrl-R)**. If they're in a folder on your computer, then you'll need to use Bridge to open them, as well (just use the Folders panel in Bridge to navigate to where those images are located, then select them, and press Command-R).

Continued

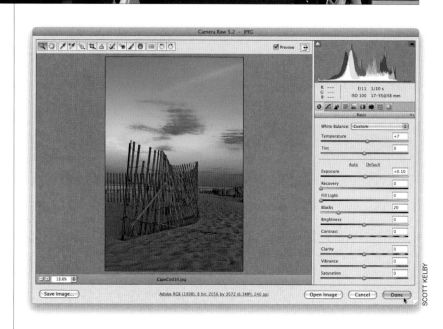

Step One:

One thing about editing JPEGs and TIFFs in Camera Raw: When you make adjustments to a JPEG or TIFF photo and you click the Open Image button, it opens your image in Photoshop (as you'd expect). However, if you just want to save the changes you made in Camera Raw without opening the photo in Photoshop, then click the Done button instead (as shown here), and your changes will be saved to your JPEG or TIFF image. But there is a big distinction between editing JPEG or TIFF images and editing a RAW image. If you click the Done button, you're actually affecting the real pixels of the original JPEG or TIFF photo, whereas, if this were a RAW image, you wouldn't be (which is another big advantage of shooting in RAW). If you click the Open Image button, and open your JPEG or TIFF photo in Photoshop, you're opening and editing the real image, as well. Just so you know.

Step Two:

Here's another thing you'll need to know: there are actually two Camera Raws—one in Photoshop, and a separate one in Bridge. The advantage of having two Camera Raws comes into play when you're processing (or saving) a lot of RAW photos—you can have them processing in Bridge's version of Camera Raw, while you're working on something else in Photoshop. If you find yourself using Bridge's Camera Raw most often, then you'll probably want to press **Command-K (PC: Ctrl-K)** to bring up Bridge's Preferences, and then turn on the checkbox for Double-Click Edits Camera Raw Settings in Bridge (as shown here). Now, double-clicking on a photo opens RAW photos in Bridge's Camera Raw, rather than Photoshop's.

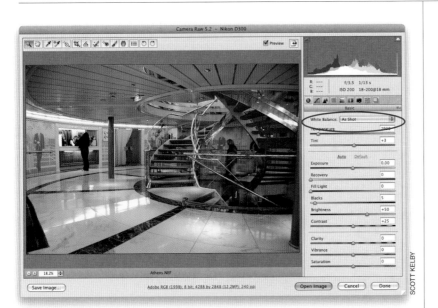

If you've ever taken a photo indoors, chances are the photo came out with kind of a yellowish tint. Unless you took the shot in an office, and then it probably had a green tint. If you just took a shot of somebody in a shadow, the photo probably had a blue tint. Those are white balance problems, and if you've properly set your white balance in the camera, you won't see these distracting tints (the photos will just look normal), but most people shoot with their cameras set to Auto White Balance, which we can fix really easily in Camera Raw.

The Essential Adjustments: White Balance

Step One:

I put adjusting the white balance first for two reasons: (1) it's the very first thing I adjust in my own Camera Raw work-flow, and (2) it fixes one of the biggest problems you're likely to encounter with digital images—the color is off. Getting the white balance right will eliminate 95% of your color problems, so we might as well fix that first thing. At the top of the Basic panel (on the right side of the Camera Raw window), are the White Balance controls. If you look to the right of the words "White Balance," you'll see a pop-up menu (shown circled here in red), and if this is the first time you're opening this particular image, it will be set to As Shot (that is telling you that the white balance you're seeing in Camera Raw is the white balance you had set in your camera when you took the shot). If you look at the photo shown here, you can see that this shot came out with a yellowish tint, but we can fix that with a quick white balance adjustment.

Continued

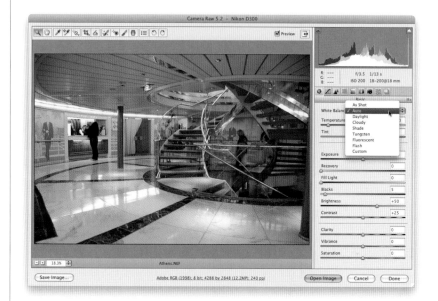

Step Two:

There are three ways to change the white balance in your photo, and the first is to simply choose one of the built-in White Balance presets. Fairly often, that's all you need to do to color correct your image. Just click-and-hold on the White Balance pop-up menu, and you'll see a list of white balance settings you could have chosen in the camera. Just choose the preset that most closely matches what the lighting situation was when you originally took the photo (for example, if you took the shot in the shade of a tree, you'd choose the Shade preset). Here I tried each preset and Auto seemed to look best. It removed some of the yellowish tint, and seemed to add a little red. I also tried Tungsten, which seemed to add a bit of green. That's why it doesn't hurt to try each preset and simply choose the one that looks best to you. *Note:* This is the one main area where the processing of RAW and JPEG or TIFF images differs. You'll only get this full list of white balance presets with RAW images. With JPEGs or TIFFs, your only choice is As Shot or Auto white balance.

Step Three:

The second method is to use the Temperature and Tint sliders (found right below the White Balance preset menu). The bars behind the sliders are color coded so you can see which way to drag to get which kind of color tint. What I like to do is use the built-in presets to get close (as a starting point), and then if my color is just a little too blue or too yellow, I just drag in the opposite direction. So, in this example, the Auto preset was close, but still a little too greenish, so I dragged the Temperature slider a little bit toward blue and the Tint slider toward magenta (as shown here)

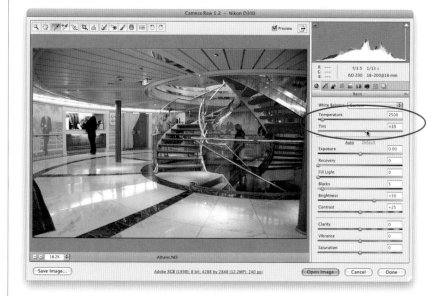

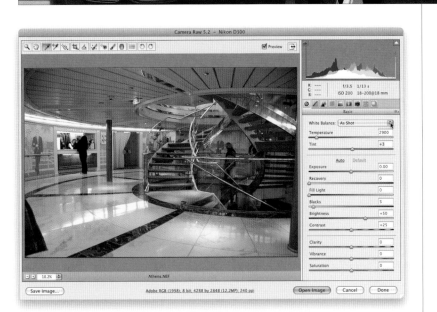

Step Four:
Just a couple of other quick things about manually setting your white balance using the Temperature and Tint sliders: First, when you move either the Temperature or Tint sliders, the white balance chosen in the preset pop-up menu changes to Custom, because now you're creating your own custom white balance from scratch. Also, if you move a slider and decide you didn't want to move it after all, just double-click directly on the little slider "nub" itself, and it will reset to its previous location. By the way, I generally just adjust the Temperature slider, and rarely have to touch the Tint slider. Lastly, to reset the white balance to where it was when you opened the image, just choose As Shot from the White Balance pop-up menu.

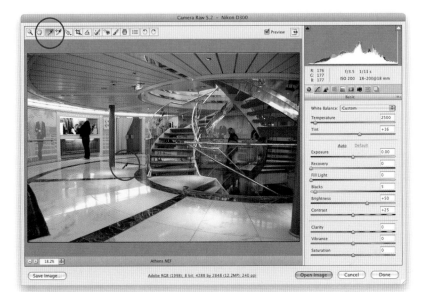

Step Five:
The third method is my personal favorite, and the method I use the most often, and that is setting the white balance using the White Balance tool (I). This is perhaps the most accurate because it takes a white balance reading from the photo itself. You just click on the White Balance tool in the toolbar at the top left (it's circled in red here), and then click it on something in your photo that's supposed to be a light gray (that's right—you properly set the white balance by clicking on something that's light gray). So, take the tool and click it once on a light shadow area to the left of the staircase (as shown here) and it sets the white balance for you. If you don't like how it looks, then just click on a different light gray area.

TIP: Quick White Balance Reset
To quickly reset your white balance to the As Shot setting, just double-click on the White Balance tool up in the toolbar.

Continued

Step Six:

Now, here's the thing: although this can give you a perfectly accurate white balance, it doesn't mean that it will look good. White balance is a creative decision, and the most important thing is that your photo looks good to you. So don't get caught up in that "I don't like the way the white balance looks, but I know it's accurate" thing that sucks some people in—set your white balance so it looks right to you. You are the bottom line. You're the photographer. It's your photo, so make it look its best. Accurate is not another word for good.

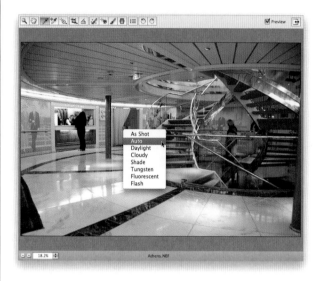

Step Seven:

Here's a before/after so you can see what a difference setting a proper white balance makes (by the way, you can see a quick before/after of your white balance edit by pressing the letter **P** on your keyboard to toggle the Preview on/off).

TIP: Using the Swatch Card

To help you find that neutral light gray color in your images, I've included a swatch card in the back of this book (it's perforated, so you can tear it out), and it has a special Camera Raw white balance light gray swatch area. Once your lighting is set, just have your subject hold it while you take one shot. Then, open that image in Camera Raw, and click the White Balance tool on the swatch card to instantly set your white balance. Now apply that same white balance to all the other shots taken under that same light (more on how to do that coming up in the next chapter).

Before: The As Shot white balance has a yellowish tint

After: With one click of the White Balance tool, everything comes together

The next thing I fix (after adjusting the white balance) is the photo's exposure. Now, some might argue that this is the most essential adjustment of them all, but if your photo looks way too blue, nobody will notice if the photo's under-exposed by a third of a stop, so I fix the white balance first, then I worry about exposure. In general, I think of exposure as three things: highlights, shadows, and midtones. So in this tutorial, I'll address those three, which in Camera Raw are the exposure (highlights), blacks (shadows), and brightness (midtones).

The Essential Adjustments #2: Exposure

Step One:
The Exposure slider affects the overall exposure of the photo (dragging to the right makes your overall exposure lighter; dragging to the left makes it darker). But don't just start dragging the Exposure slider yet, because there's something we need to really watch out for, and that's clipping the highlights (where areas of the photo get so bright that they lose all detail). Luckily, Camera Raw has built-in clipping warnings, so you don't lose highlight detail. First, look at this photo's histogram at the top right of the window. See the solid white triangle in the top-right corner? That's warning you that some parts of this photo are already clipping.

Step Two:
If you want to see exactly which areas are clipping (so you can see if they are even areas we need to worry about), just move your cursor over that highlight warning triangle, click on it, and any areas that are clipping will show up in red (as shown here). That see-your-clipping-areas-in-red warning will now stay on while you're making your adjustments. Click on the little highlight triangle again (or press the letter O on your keyboard) to toggle this feature off/on.

Continued

Step Three:

If you don't like the red clipping warning, or if you have a photo with a lot of red in it, and the red warnings aren't easily seen, there is another warning you can use. Just press-and-hold the Option (PC: Alt) key and then click-and-hold the Exposure slider. This turns your preview area black, and any clipped areas will appear in their color, as seen here (so if the Blue channel is clipping, you'll see blue; if parts of the Green channel are clipping, you'll see areas of green; but of course, the worst is to see areas in solid white, which means all the colors are clipping). By the way, this warning will stay on as you drag the Exposure slider, as long as you have the Option key held down. Also, some things will always clip, like a photo with the sun visible in it, or a specular highlight on the chrome bumper of a car, but that's okay—they don't have any detail. We're only concerned about recovering areas that actually have important detail.

Step Four:

So, now that we know how to find out when we have a clipping problem, how do we make the problem go away? Well, since this problem happens when things get too bright, you could always drag the Exposure slider to the left until the clipping warnings go away. For example, here I lowered the exposure (by dragging the Exposure slider to the left) until the clipping warning finally went away, but that's a really bad tradeoff. We fixed one problem (clipped highlights), but now we have another problem that may be worse (a really underexposed photo). Luckily, there's something simple we can do that lets us keep the overall exposure where we need it, and avoid clipping the highlights at the same time.

Step Five:

Start by dragging the Exposure slider until the exposure looks right to you (here the exposure looked good to me, but some of the important highlight areas were clipping, as shown in Step Three). Now, drag the Recovery slider (located right below the Exposure slider) to the right, and as you do, just the very brightest highlights are pulled back (recovered) from clipping. Keep dragging until the white highlight clipping warning turns solid black (like the one shown here), and you're done! By the way, you can use that same press-and-hold-the-Option (PC: Alt)-key trick while you're dragging the Recovery slider, and the screen will turn black, revealing just the clipped areas. As you drag to the right, you'll actually see the clipped areas go away. Now you've got your overall exposure where you want it, and you have detail in all your highlights at the same time. How sweet is that?

Step Six:

Next, I adjust the shadow areas using the Blacks slider. Dragging to the right increases the amount of black in the darkest shadow areas of your photo. Dragging to the left opens up (lightens) the shadow areas. I switched photos here to show you a better example of how the Blacks slider works.

SCOTT KELBY

Continued

Step Seven:

Increasing the blacks will usually saturate the colors in your photo, as well, so if you have a really washed out photo (as shown in the previous step), just drag the Blacks slider to the right until the color and depth come back (as they have here). Compare this with the original shown in the previous step, and you can see what a dramatic difference increasing the blacks can make for a washed out photo. Okay, let's switch back to the breakfast photo, and pick up there.

Step Eight:

While my biggest concern is clipping the highlights, there's also a shadow clipping warning to let you know when areas have gotten so dark that they lose all shadow detail. That warning is the triangle on the top left of the histogram. If you move your cursor over it and click, any areas that are solid black will appear in bright blue (as seen here). If there's shadow clipping, the only fix is to drag the Blacks slider to the left to reduce the amount of blacks in the shadows, but I generally don't do that, because to me that usually makes a photo look flat and too low contrast. So, I avoid lowering the Blacks amount below the default setting of 5 unless absolutely necessary (here the clipped areas are just shadows, not important detail, so I ignore them). But hey, that's just me. You can also use the press-and-hold-the-Option (PC: Alt)-key trick with the Blacks slider. As you might expect, this works in the opposite way the highlight warning works; instead, the preview area turns solid white, and any areas that are solid black have lost detail and actually have turned to solid black.

Step Nine:

The next slider down is Brightness. Since you've already adjusted the highlights (Exposure slider) and the shadows (Blacks slider), the Brightness slider adjusts everything else (I relate this slider to the midtones slider in Photoshop's Levels adjustment, so that might help in understanding how this slider differs from the Exposure or Blacks sliders). Of the three main adjustments (Exposure, Blacks, and Brightness), this one I personally use the least—if I do use it, I usually just drag it a very short amount to the right to open up some of the midtone detail. But in this case, I dragged it a little to the left to keep the photo from looking too bright. There are no warnings for midtones, but if you push it far enough to the right, you could see some highlight clipping.

Step 10:

If you don't feel comfortable making these adjustments yourself, you can always give Camera Raw a crack at it, by clicking the Auto button (it's the underlined word Auto, shown circled here in red). Back in the CS3 version of Camera Raw, I called this the Overexpose My Photo button, but in CS4, they've greatly improved how Auto works, and now it often does a pretty decent job. When you click on Auto, your photo will either look better, or not. If it's not, just press **Command-Z (PC: Ctrl-Z)** to undo the Auto adjustment, and then try the correction yourself using the Exposure, Blacks, and Brightness sliders. Here, I clicked the Default button (to the right of the Auto button) to reset Camera Raw to its defaults, and then I clicked the Auto button. In this case, it looks kinda flat to me, and that's why it's important to learn to be able to make these corrections yourself.

Letting Camera Raw Auto-Correct Your Photos

If you're not quite comfortable with manually adjusting each image, like I mentioned at the end of the last tutorial, Camera Raw does come with a one-click Auto function, which takes a stab at correcting the overall exposure of your image (including shadows, fill light, contrast, and recovery). If you like the results, you can set up Camera Raw's preferences so every photo, upon opening in Camera Raw, will be auto-adjusted using that same feature. Ahhh, if only that Auto function worked better.

Step One:
Once you have an image open in Camera Raw, you can have Camera Raw take a stab at setting the overall exposure (using the controls in the Basic panel) for you by clicking on the Auto button (shown circled in red here). Although I used the four individual Auto checkboxes in earlier versions of Camera Raw, I dunno…maybe it's my camera, maybe it's me, but so far this Auto button (added in CS3) hasn't met a photo it didn't want to overexpose at least a little. But if you've tried it and you like the results (hey, it could happen), then you might want to make Camera Raw auto-process every image you open in it.

Step Two:
To do that, click on the Preferences icon up in Camera Raw's toolbar (it's the third from the right), and when the Camera Raw Preferences dialog appears, turn on the checkbox for Apply Auto Tone Adjustments (shown circled in red here), then click OK. Now, Camera Raw will evaluate each image and try to correct it. If you don't like its tonal corrections, then you can just click on the Default button, which appears to the right of the Auto button (the Auto button will be grayed out because it's already been applied).

This is one of my favorite features in Camera Raw, and whenever I show it in a class, it never fails to get "Oooohs" and "Ahhhhs." I think it's because it's just one simple slider, yet it does so much to add "snap" to your image. The Clarity slider (which is well-named) basically increases the midtone contrast in a way that gives your photo more punch and impact, without actually sharpening the image (much like certain Curves adjustments in Photoshop can add snap and punch to your photos).

Adding "Snap" (or Softening) to Your Images Using the Clarity Slider

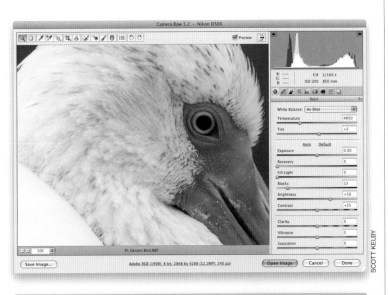

SCOTT KELBY

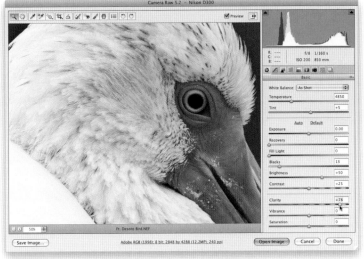

Step One:
The Clarity slider is found in the bottom section of the Basic panel in Camera Raw, right above the Vibrance and Saturation sliders. (Although its official name is Clarity, I heard that at one point Adobe engineers considered naming it "Punch" instead, as they felt using it added punch to the image.) To clearly see the effects of Clarity, first zoom in to a 100% view by double-clicking on the Zoom tool up in the toolbar (it looks like a magnifying glass). In the example shown here, I only zoomed to 50% so you could see more of the image (plus, when that eye got to 100%, it really looked creepy).

Step Two:
Using the Clarity control couldn't be easier—drag the slider to the right to increase the amount of snap (midtone contrast) in your image (compare the top and bottom images shown here). Almost every image I process gets between +25 and +50 Clarity. If the image has lots of detail, like a cityscape, or a sweeping landscape shot, or something with lots of little details like a motorcycle (or the feathers of a bird), then I'll go as high as +75 to +80, as seen here. If the subject is of a softer nature, like a portrait of a child, then in that case, I don't generally apply any Clarity at all.

Continued

Step Three:

The CS4 version of Camera Raw was the first version to offer negative Clarity, meaning you can apply less than 0 (zero) to reduce the midtone contrast for softening effects. For example, here's an original image without any negative Clarity applied.

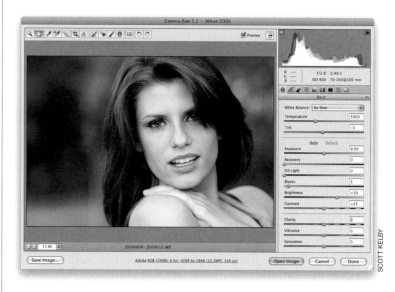

Step Four:

Now drag the Clarity slider to the left (which gives you a negative amount of Clarity), and take a look at how much softer our subject's skin looks. Everything else in the image looks softer too, so it's an overall softening, but in the chapter on the Adjustment Brush (Chapter 4), you'll learn how to apply softening just to your subject's skin (or anything else you need softened), while leaving the rest of the image sharp.

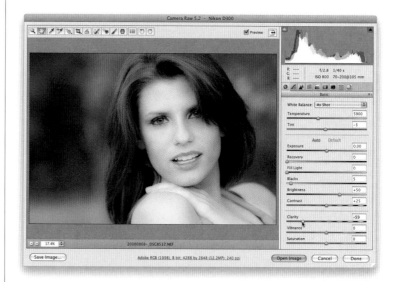

If you have to deal with a backlit subject (and we all do at one time or another, either intentionally or by accident), then you're going to love the Fill Light slider. Unlike the Shadow/Highlight adjustment in Photoshop (which requires you to jump through a few hoops and tweak a number of sliders, so it doesn't look fake and "milky"), the Fill Light slider not only looks more natural, but because of that, it lets you apply more Fill Light and still have your image look good. However, there is one little tweak you'll need to know, but it couldn't be easier.

Fixing Backlit Photos by Adding Fill Light

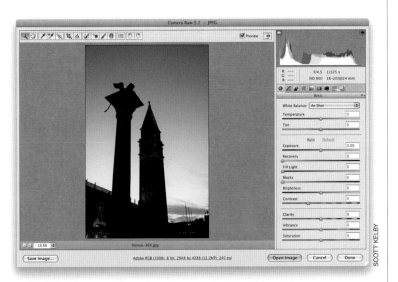

Step One:
Here's a pretty typical image where the subject, shot near sunset, is backlit with the setting sun, and while you can see some detail, the detail areas of the subject are mostly in the shadows.

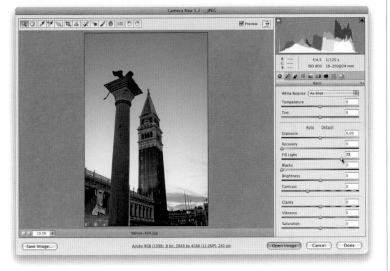

Step Two:
Dragging the Fill Light slider to the right opens up those lower mid-shadow areas, and lets detail that was once hidden in the shadows be revealed (as seen here).

Continued

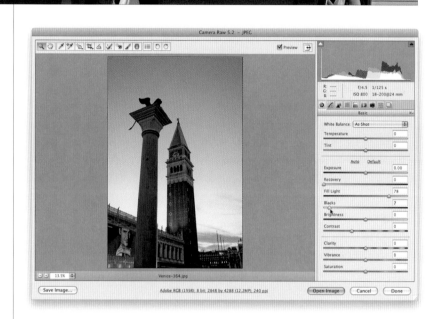

Step Three:

If you have to drag the Fill Light slider quite a bit to the right (as I did here), you're going to run into a little problem in that your deeper shadows might start to look a bit washed out. So when I have to push things as far as I did here, I generally drag the Blacks slider over to the right just a little (as shown here) to bring back some of the richness and color saturation in the deep shadow areas. Now, there is a difference if you're working with RAW or JPEG/TIFF images. With RAW images, the default setting for the Blacks will be 5, and generally all you'll need to do is move them over to 7 or 8. However, on JPEG or TIFF images, your default is 0, and I tend to drag them a little farther (in the example shown here, I started at 0 and dragged up to 7 to get to where it looked right to me). Of course, every image is different, but either way, you shouldn't have to move the Blacks slider too far (just remember—the farther you move your Fill Light slider to the right, the more you'll have to compensate by adding more Blacks).

Step Four:

Here's a before/after with only two edits applied to this photo: (1) I dragged the Fill Light slider over to 78, and (2) I dragged the Blacks slider to 7.

Before: The subject is in the shadows *After: Using Fill Light and adding Blacks*

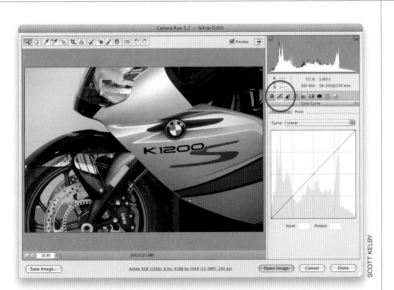

When it comes to adding contrast to a photo, I pretty much avoid the Contrast slider in Camera Raw's Basic panel as much as possible, because it's too broad and too lame (much like the Contrast slider in Photoshop's Brightness/Contrast dialog was before it was improved back in CS3, which was too broad and too lame. I just had a dejá vu). Anyway, when it comes to creating contrast, try the Tone Curve instead, and you'll never go back to that one broad and lame slider that is too broad and too lame. (I know. I did it again. I'm mean, "Oops, I did it again.")

Adjusting Contrast Using Curves

Step One:
After you've done all your exposure and tone adjustments in the Basic panel, and you want to add contrast, skip the Contrast slider and click on the Tone Curve icon (it's the second icon from the left at the top of the Panel area). There are two different types of curves available in Camera Raw: the Point curve, and the Parametric curve. We'll start with the Point curve, so click on the Point tab at the top of the Tone Curve panel. Here's what the photo shown here looks like with no added contrast in the Point curve (notice that the pop-up menu above the curve is set to Linear, which is a flat, unadjusted curve).

Step Two:
The normal default setting for this curve is Medium Contrast. If you want to create much more dramatic contrast, choose Strong Contrast from the Curve pop-up menu (as shown here), and you can see how much more contrast this photo now has, compared with how it looked in Step One. The difference is the Strong Contrast settings create a much steeper curve, and the steeper the curve, the more contrast it creates.

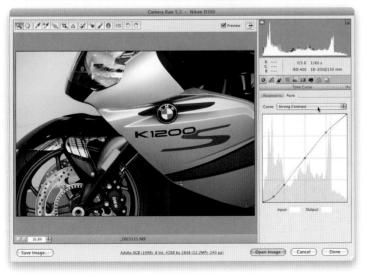

SCOTT KELBY

Continued

Step Three:

If you're familiar with Photoshop's Curves and want to create your own custom curve, start by choosing any one of the preset curves, then either click-and-drag the adjustment points on the curve or use the **Arrow keys** to move them (I think it's easier to click on a point, then use the Up and Down Arrow keys on your keyboard to move that part of the curve up or down). If you'd prefer to start from scratch, choose Linear from the Curve pop-up menu, which gives you a flat curve. To add adjustment points, just click along the curve. To remove a point, just click-and-drag it right off the curve (drag it off quickly, like you're pulling off a Band-Aid).

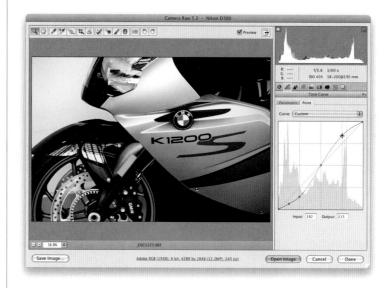

Step Four:

If you create a curve that you'd like to be able to apply again to other photos, you can save this curve as a preset. To do that, click on the last icon in the row of icons at the top of the Panel area to bring up the Presets panel. Next, click on the New Preset icon (which looks just like Photoshop's Create a New Layer icon) at the bottom of the Presets panel. This brings up the New Preset dialog (shown here). If you just want to save this curve setting, from the Subset pop-up menu near the top, choose Point Curve, and it turns off the checkboxes for all the other settings available as presets, and leaves only the Point Curve checkbox turned on (as shown here). Give your preset a name (I named mine "Super Contrast Curve") and click OK.

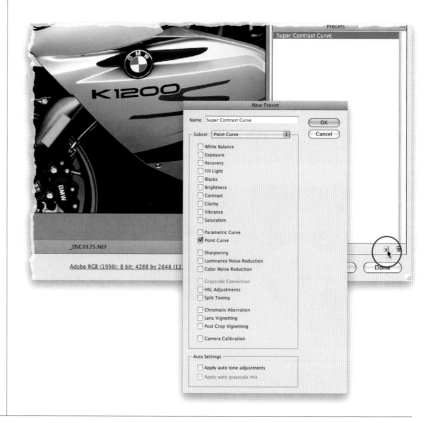

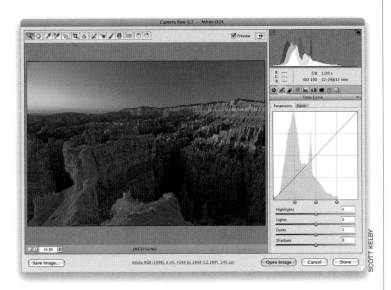

SCOTT KELBY

Step Five:

If you're not comfortable with adjusting the Point curve, try the Parametric curve, which lets you craft your curve using sliders rather than adjusting points. This is popular with photographers because it's so easy to use and, unlike Photoshop's curves, it keeps you from creating a curve that would pretty much trash the photo. When you click on the Tone Curve icon, it's the Parametric tab that appears first. There are four sliders, which control the four different areas of the curve, but before you start "sliding," know that the adjustments you make here are added on top of the default Point curve setting of Medium Contrast. If you'd like to start from scratch, then click on the Point curve tab, choose Linear from the Curve pop-up menu, and then click back on the Parametric curve tab.

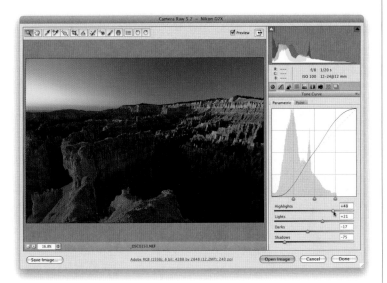

Step Six:

The Highlights slider controls the highlights area of the curve (the top of the curve), and dragging it to the right arcs the curve upward, making the highlights brighter. Right below that is the Lights slider, which covers the next lower range of tones (the area between the midtones and the highlights). Dragging this slider to the right makes this part of the curve steeper, and increases the upper midtones. The Darks and Shadows sliders do pretty much the same thing for the lower midtones and deep shadow areas. But remember, dragging to the right opens up those areas, so to create contrast, you'd drag both of those to the left instead. Here, to create some real punchy contrast, I dragged both the Highlights and Lights sliders to the right, and the Darks and Shadows sliders to the left.

Continued

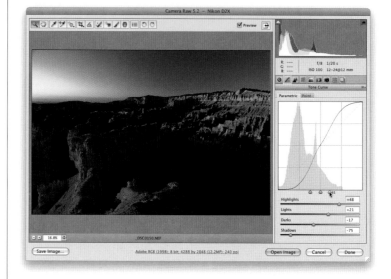

Step Seven:

One advantage of the Parametric curve is that you can use the region divider controls (under the curve) to choose how wide a range each of the four sliders covers. So, if you move the far-right region divider to the right (shown here), it expands the area controlled by the Lights slider. Now the Highlights slider has less impact, flattening the upper part of the curve, so the contrast is decreased. If I drag that same region divider control back to the left instead, it expands the Highlights slider's area, which steepens the curve and increases contrast. *Note:* Shortly after CS4 shipped, Adobe released a Camera Raw update that added the Targeted Adjustment Tool (TAT) to the toolbar for use on the Parametric Curve, the HSL panel, and in Grayscale Mix (see page 214 for how the TAT works). You may find it easier than dragging the sliders. They also snuck in another enhancement: the ability to take a snapshot of your current image (like snapshots in Photoshop's History panel). So, if you make some adjustments you really like, you can save a snapshot of what your image looked like at that point, and return to it anytime if you mess up.

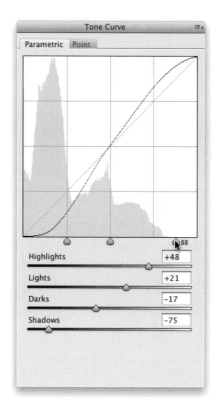

Step Eight:

If your goal is extraordinary contrast (like a black-and-white photo with that super-contrasty look), then you want the steepest curve you can get away with (without damaging the photo). Besides dragging the Highlights and Lights sliders to the right, and the Darks and Shadows sliders to the left, you can compress the tones so the Shadows and Highlights sliders affect larger areas. You do this by dragging the two outside region divider controls toward the center (as shown here), which adds even more steepness to the curve.

Cropping and Straightening

There's a distinct advantage to cropping your photo here in Camera Raw, rather than in Photoshop CS4 itself, and that is you can return to Camera Raw later and bring back the uncropped version of the image. This even holds true for JPEG and TIFF photos, as long as you haven't overwritten the original JPEG or TIFF file. To avoid overwriting, when you save the JPEG or TIFF in Photoshop, just change the filename (that way the original stays intact). With RAW images, you don't have to worry about that, because it doesn't let you overwrite the original.

Step One:
The Crop tool **(C)** is the sixth tool from the left in Camera Raw's toolbar. By default, it pretty much works like the Crop tool in Photoshop (you click-and-drag it out around the area you want to keep), but it does offer some features that Photoshop doesn't—like access to a list of preset cropping ratios. To get them, click-and-hold on the Crop tool and a pop-up menu will appear (as shown here). The Normal setting gives you the standard drag-it-where-you-want-it cropping. However, if you choose one of the cropping presets, then your cropping is constrained to a specific ratio. For example, choose the 2 to 3 ratio, click-and-drag it out, and you'll see that it keeps the same aspect ratio as your original uncropped photo.

Step Two:
Here's the 2-to-3-ratio cropping border dragged out over my image. The area that will be cropped away appears dimmed, and the clear area inside the cropping border is how your final cropped photo will appear. If you want to see the cropped version before you leave Camera Raw (a first in CS4), just switch to another tool in the toolbar.

Continued

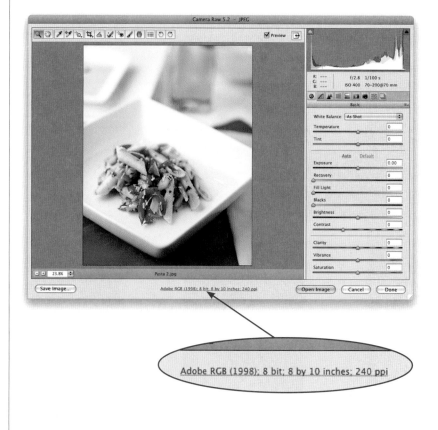

Step Three:

If you reopen your cropped photo again in Camera Raw, you'll see the cropped version. To bring back the cropping border, just click on the Crop tool. To remove the cropping altogether, press the **Esc or Delete (PC: Backspace) key** on your keyboard (or choose Clear Crop from the Crop tool's pop-up menu). If you want your photo cropped to an exact size (like 8x10", 13x19", etc.), choose Custom from the Crop tool's pop-up menu to bring up the dialog you see here. You can choose to crop by inches, pixels, or centimeters.

Step Four:

Here, we're going to create a custom crop so our photo winds up being exactly 8x10", so choose Inches from the Crop pop-up menu, then type in your custom size. Click OK, click-and-drag out the cropping border, and the area inside it will be exactly 8x10". Click on any other tool in the toolbar, and you'll see the final cropped 8x10" image (as seen here). If you click the Open Image button, the image is cropped to your specs and opened in Photoshop. If, instead, you click the Done button, Camera Raw closes and your photo is untouched, but it keeps your cropping border in place for the future.

TIP: Seeing Image Size

The size of your photo (and other information) is displayed under the preview area of Camera Raw (in blue underlined text that looks like a Web link). When you drag out a cropping border, the size info for the photo automatically updates to display the dimensions of the currently selected crop area.

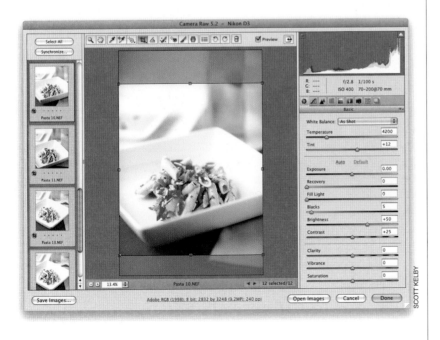

Step Five:

If you save a cropped JPEG or TIFF photo out of Camera Raw (by clicking the Done button), the only way to bring back those cropped areas is to reopen the photo in Camera Raw. However, if you click the Save Options button and you choose Photoshop from the File Extension pop-up menu (as shown), a new option will appear called Preserve Cropped Pixels. If you turn on that checkbox before you click Save, when you open this cropped photo in Photoshop, it will appear to be cropped, but the photo will be on a separate layer (not flattened on the Background layer). So the cropped area is still there—it just extends off the visible image area. You can bring that cropped area back by clicking-and-dragging your photo within the image area (try it— use the Move tool [V] to click-and-drag your photo to the right or left and you'll see what I mean).

Step Six:

If you have a number of similar photos you need to crop the same way, you're going to love this: First, select all the photos you want to crop in Camera Raw (either in Bridge or on your computer), then open them all in Camera Raw. When you open multiple photos, they appear in a vertical filmstrip along the left side of Camera Raw (as shown here). Click on the Select All button (it's above the filmstrip) and then crop the currently selected photo as you'd like. As you apply your cropping, look at the filmstrip and you'll see all the thumbnails update with their new cropping instructions. A tiny Crop icon will also appear in the bottom-left corner of each thumbnail, letting you know that these photos have been cropped in Camera Raw.

Continued

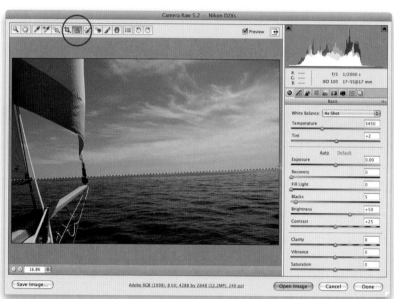

Step Seven:

Another form of cropping is actually straightening your photos using the Straighten tool. It's a close cousin of the Crop tool because what it does is essentially rotates your cropping border, so when you open the photo it's straight. In the Camera Raw toolbar, choose the Straighten tool (it's immediately to the right of the Crop tool, and shown circled here in red). Now, click-and-drag it along the horizon line in your photo (as shown here). When you release the mouse button, a cropping border appears and that border is automatically rotated to the exact amount needed to straighten the photo (as shown in Step Eight).

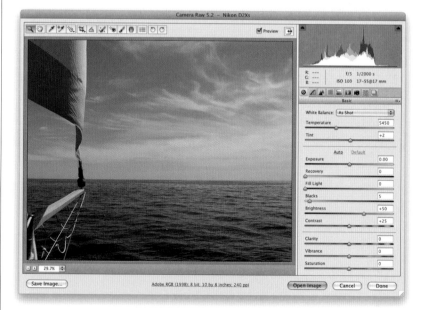

Step Eight:

You won't actually see the straightened photo until you switch tools or open the photo in Photoshop (which means, if you click Save Image or Done, Camera Raw closes, and the straightening information is saved along with the file. So if you open this file again in Camera Raw, you'll see the straightened version, and you won't really know it was ever crooked). If you click Open Image instead, the straightened photo opens in Photoshop. Again, if this is a RAW photo (or if it's a JPEG or TIFF and you clicked the Done button), you can always return to Camera Raw and remove this cropping border to get the original uncropped photo back.

TIP: Canceling Your Straightening

If you want to cancel your straightening, just press the **Esc key** on your keyboard, and the straightening border will go away.

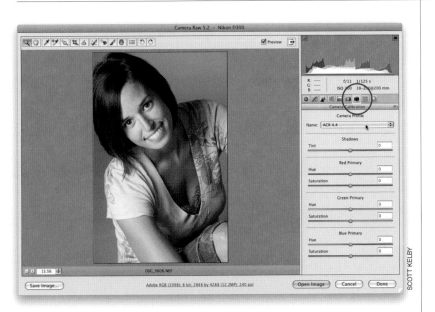

If you've ever looked at a JPEG photo on the LCD screen on the back of your digital camera, and then wondered why your RAW image doesn't look as good, it's because your camera adds color correction, sharpening, contrast, etc., to your JPEG images while they're still in the camera. But when you choose to shoot in RAW, you're telling the camera, "Don't do all that processing—just leave it raw and untouched, and I'll process it myself." But, if you'd like that JPEG-processed look as a starting place for your RAW photo editing, you can use CS4's new Camera Profiles to get you close.

Miss the Look of JPEGs? Try Camera Profiles for That JPEG-Processed Look

Step One:
As I mentioned above, when you shoot in RAW, you're telling the camera to pretty much leave the photo alone, and you'll do all the processing yourself using Camera Raw. Each camera has its own brand of RAW and so Adobe Camera Raw applies a Camera Profile based on the camera that took the shot (it reads the embedded EXIF data, so it knows which camera you used). Anyway, if you click on the Camera Calibration icon (the third icon from the right above the Panel area), you'll see the built-in default Camera Profile used to interpret your RAW photo. In all previous versions of Camera Raw, there were no other choices—there was a pop-up menu, but with only this one ACR profile as a choice.

Continued

Step Two:

If you click-and-hold on the Name pop-up menu at the top (click on ACR 4.4), a menu pops up with a list of profiles for the camera you took the shot with (as seen here, for images taken with a Nikon digital camera). Adobe recommends that you start by choosing the Camera Standard Beta 1 (as shown here), to see how that looks to you.

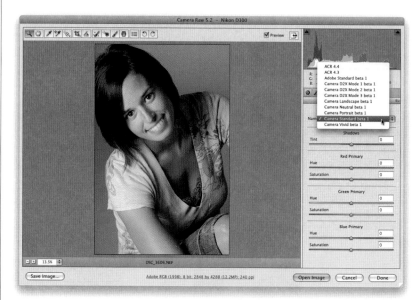

Step Three:

If you have a Nikon or Canon dSLR camera, Adobe also included camera-matching profiles, which are designed to replicate the different color shooting modes that are available in your camera (Camera Raw knows which camera you took the shot with by reading the EXIF metadata). There are five camera-matching profiles for Canon dSLRs, and eight for Nikon dSLRs. (*Note:* If you don't shoot Canon or Nikon, then you'll only have Adobe Standard Beta 1 to choose from, but you can create your own custom profiles using Adobe's free DNG Profile Editor utility, available from Adobe at http://labs.adobe.com.)

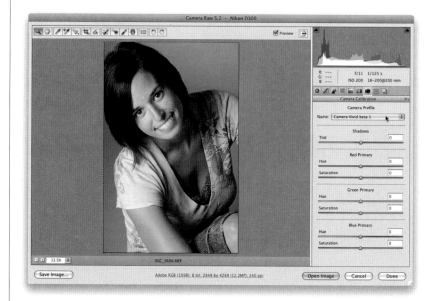

Before: Using the default ACR 4.4 profile *After: Using the Camera Vivid Beta 1 profile*

Step Four:
Here's a before/after with only one thing done to this photo: I chose Camera Vivid Beta 1 (as shown in the pop-up menu in Step Three). Again, this is designed to replicate color looks you could have chosen in the camera, so if you want to have Camera Raw give you a similar look as a starting point, this is how it's done. Personally, I use this when I want my starting point to be closer to the JPEG image I saw on the back of my camera.

Exposure: 1/1200s Focal Length: 300mm Aperture Value: ƒ/4.0

The Next Step
camera raw—beyond the basics

"The Next Step" is really a pretty decent name for this chapter, because (a) it's about what you'd do next in Camera Raw, after you've got the essentials down, and (b) it's also the name of a song by jazz guitarist Kurt Rosenwinkel (from his album of the same name). Now, as far as jazz guitarists go, Kurt certainly is good (hey, I did listen to a 30-second clip of his song in the iTunes Music Store), but my favorite jazz guitarist in iTunes is Barry Greene. Now, I actually know Barry Greene (have known him for years—he's a great guy and an unbelievable guitar player), and while I'm proud to know him, I'm embarrassed to tell you how I know him—he was once the guitar player in my band. That, in and of itself, isn't all that embarrassing, but it's when we played together, and what we played. It wasn't jazz. That's right, it was in the early '80s and we played in a disco band. That's right—I'm not ashamed of it—I was the keyboard player in a disco band. For years. With Barry. An equally embarrassing admission is…I liked it. Sadly, I dressed the part of the '80s disco keyboard player, with long coats, thin ties, I had blonde highlights in my hair, I wore bolos, gloves with the fingers cut out, white boots, you name it. We all did (we thought it was cool. We were wrong). Worse yet, I still have our band photo, and because I want to give you the ultimate mental break before we head into more advanced Camera Raw stuff, I posted it, just for you, on my blog at www.scottkelby .com (when you go there, in the search field on the right, type in "Rumor Hazit," the name of our disco band back then, and you'll find a link to the photo). Now, you may notice that besides wearing devastatingly cool stage clothes, I had a slightly different (thinner) appearance, as well. So when you go there, I have but one request: be kind.

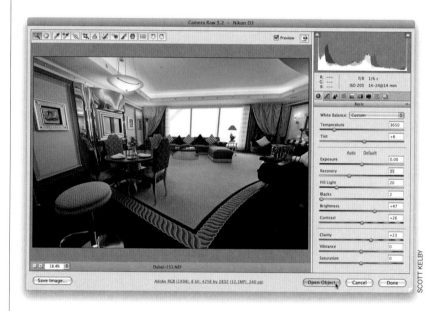

Double-Processing to Create the Uncapturable

As good as digital cameras have become these days, when it comes to exposure, the human eye totally kicks their butt. That's why we shoot so many photos where our subject is backlit, because with our naked eye we can see the subject just fine (our eye adjusts). But when we open the photo, the subject is basically in silhouette. Or how about sunsets where we have to choose which part of the scene to expose for—the ground or the sky—because our camera can't expose for both? Well, here's how to use Camera Raw to overcome this exposure limitation:

Step One:
Open the photo you want to double-process. In this example, the camera properly exposed for the room, so the bright light outside the windows is totally blown out. Of course, or goal is to create something our camera can't—a photo where both the inside and outside are exposed properly. To make things easy, we're going to open this image as a Smart Object in Photoshop, so press-and-hold the Shift key, and the Open Image button at the bottom changes into the Open Object button. Click that button to open this version of the photo in Photoshop as a Smart Object (you'll see the advantage of this in just a minute).

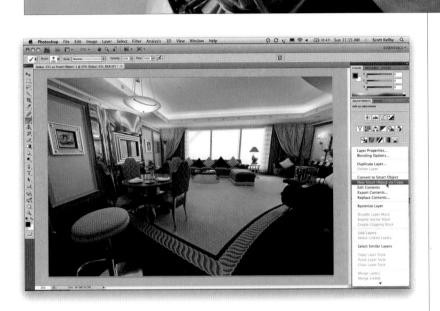

Step Two:
Your image will open in Photoshop as a Smart Object (you'll see the layer thumbnail has a little page icon in the bottom-right corner). So, now we need a second version of this image—one we can expose for the foreground. If you just duplicate the layer, it won't work because this duplicate layer will be tied to the original layer, and any changes you make to this duplicate will also be applied to the original layer. So, to get around that, go to the Layers panel, Control-click (PC: Right click) on the layer, and from the contextual menu that appears, choose New Smart Object via Copy. This gives you a duplicate layer, but breaks the link.

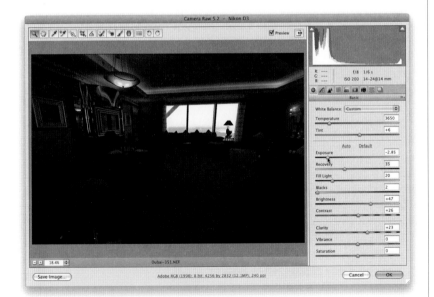

Step Three:
Now double-click directly on this duplicate layer's thumbnail and it opens this duplicate in Camera Raw, but this time, you're going to expose for the view outside the windows, without any regard for how the room in the foreground looks (it will turn really dark, but who cares—you've already got a version with the room properly exposed on its own separate layer). So, drag the Exposure slider way over to the left, until you can see some detail through the windows. Here you can see the ocean outside the windows.

Continued

Step Four:

You now have two versions of your photo (as seen here), each on different layers—the brighter one exposed for the interior on the bottom layer, and the darker version on the layer directly on top of it, and they are perfectly aligned one on top of one another.

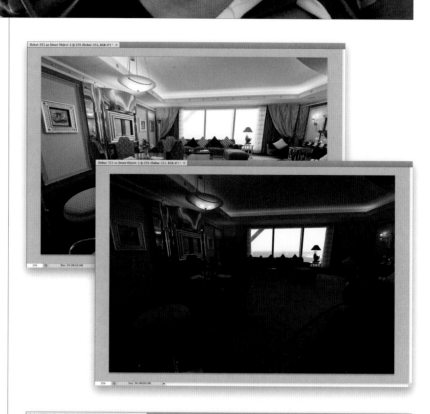

Step Five:

Now, at this point I usually try a little trick first that automatically combines the two images into one, and while it doesn't work with every photo, when it does, it's a thing of beauty. Go to the Layers panel and double-click right below the top layer's name (not on the thumbnail—right below the layer's name) to bring up the Layer Style dialog's Blending Options (seen here). At the bottom are two Blend If sliders, and if you drag the top one to the right, it will blend the darker areas from the layer below it. The problem is it's a very harsh blending (you can actually see harsh jaggy edges), that is unless you press-and-hold the Option (PC: Alt) key before you start dragging. This splits the slider in two, and gives you a smooth blend (look at the half of the slider circled in red here—it splits the slider nub in half).

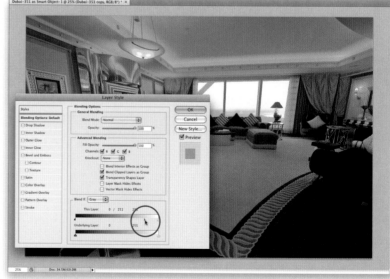

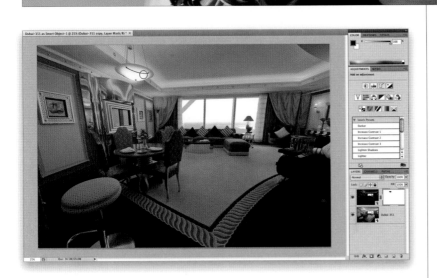

DSC00652.JPG

Adobe RGB (1998): 8 bit: 1080 by 808 (0.9MP): 240 ppi

Workflow Options

Space: Adobe RGB (1998) | OK |

Depth: 8 Bits/Channel | Cancel |

Crop Size: 1080 by 808 (0.9 MP)

Resolution: 240 | pixels/inch |

☑ Open in Photoshop as Smart Objects

Step Six:

In our example, I dragged the top split slider all the way to the right, and it created a blend of the outside exposure and inside exposure (as seen here), but it also did one thing I didn't like: Take a look at the light bulbs in the hanging light fixture over the dining table. They look, well…kinda lame. So, luckily, you can bring back any areas from the original background layer by doing this: click on the Add Layer Mask icon (at the bottom of the Layers panel—it's the third icon from the left), then get the Brush tool **(B)**, choose a soft-edged brush, press **D**, then **X** to set your Foreground color to black, and paint right over the area that doesn't look good (in this case, the hanging lamp), and it returns it to its original condition. Basically, you're covering up the blending with a black mask. More on masks later in the book.

TIP: Always Opening Your Images as Smart Objects

If you always want your RAW-processed images to open as Smart Objects, click on the workflow options link at the bottom of the Camera Raw dialog (the blue text below the Preview area), and when the dialog appears, turn on the Open in Photoshop as Smart Objects checkbox.

Continued

Step Seven:

Unfortunately, most of the time we have to blend these two images manually using layer masks, which just takes longer. Let's start by deleting our duplicate layer, then go back to Step Two and make a copy of your Smart Object layer, and lower the exposure and all that stuff, but stop before you use the Blend If sliders. Instead, go to the Layers panel, press-and-hold the Option (PC: Alt) key, and click on the Add Layer Mask icon at the bottom of the Layers panel. This puts a black mask over the layer with the photo exposed for the outside, covering it so you only see the lighter image on the background layer (as seen here). *Remember:* The darker outside version is still there—it's just hidden behind that black mask. Now, press the letter **B** to get the Brush tool, then click on the down-facing arrow next to the word Brush in the Options Bar and choose a medium-sized, hard-edged brush from the Brush Picker (this helps to keep you from painting outside the lines). Now, press the letter **D** to set your Foreground color to white, and start painting over the areas of the photo that you want to be darker (in this case, the windows). As you paint with white directly on that black mask, the white reveals the darker version beneath the mask. Just be careful not to paint on the walls, curtains, etc.

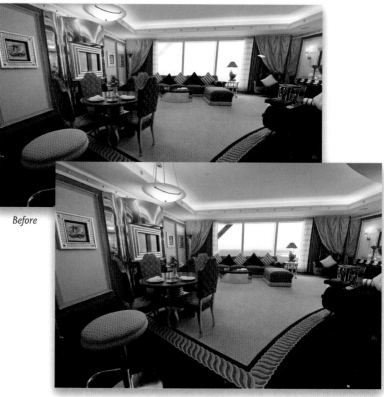

Before

After

One of the biggest advantages of using Camera Raw is that it enables you to apply changes to one photo, and then easily apply those exact same changes to a bunch of other similar photos taken in the same approximate setting. It's a form of built-in automation, and it can save you an incredible amount of time when editing your shoots (plus, if you use Bridge's Camera Raw, rather than Photoshop's, you can have your photos processing in the background, while you're working on something else in Photoshop. That is some serious productivity!).

Editing Multiple Photos at Once

Step One:
The key to making this work is that the photos you edit all are shot in similar lighting conditions, or all have some similar problem. In this case, our photos are from a college football game. Earlier in the day, the field was in the sun, and the white balance and exposure were fine, but later in the day, part of the field wound up in the shadows, so the white balance was off, making the uniforms have a bluish cast, and putting the players in the shadows.

Step Two:
So, go to Bridge, click on a photo to edit, and press **Command-R (PC: Ctrl-R)** to open the photo in Bridge's Camera Raw (as shown here). Adjust the photo the way you'd like. In our example, I started by taking the White Balance tool **(I)** and clicking on the back of this player's leg to remove the blue color cast. Next, I increased the exposure a bit, and raised the Recovery amount to tame the bright light behind him. The player's in the shadows a bit, so I increased the Fill Light amount to make him more visible. Lastly, I moved the Clarity slider to the right to give the photo more punch. When you're done, don't open the image, just click the Done button.

Continued

Step Three:

When you click that Done button, you're returned to Bridge, and the thumbnail for the photo you just edited now reflects the changes you made (you can see here, it's warmer and brighter). Press-and-hold the Command (PC: Ctrl) key and select all the other photos in Bridge that you want to have those exact same edits (white balance, exposure, recovery, fill light, etc.). Now, Control-click (PC: Right-click) on any one of those selected photos, and a contextual menu will appear. Go under Develop Settings and choose Previous Conversion (as shown here).

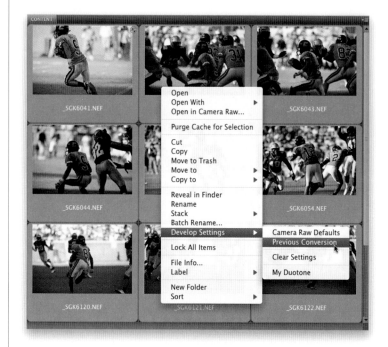

Step Four:

All the changes you made to the previous photo are now applied to all your selected photos in Bridge (as shown here, where you can see the white balance is now better [it's much less blue], the fill light has been tweaked, etc.). Now, what if you only wanted to apply certain edits you made—like just the white balance setting, and not all the other stuff? Then you'd use another method (on the next page).

TIP: Clearing the Develop Settings

If after applying those edits to your photos, you decide one or more of them doesn't look good with those edits, then Control-click (PC: Right-click) to bring up that contextual menu again, but this time go under Develop Settings and choose Clear Settings. This removes any changes made in Camera Raw.

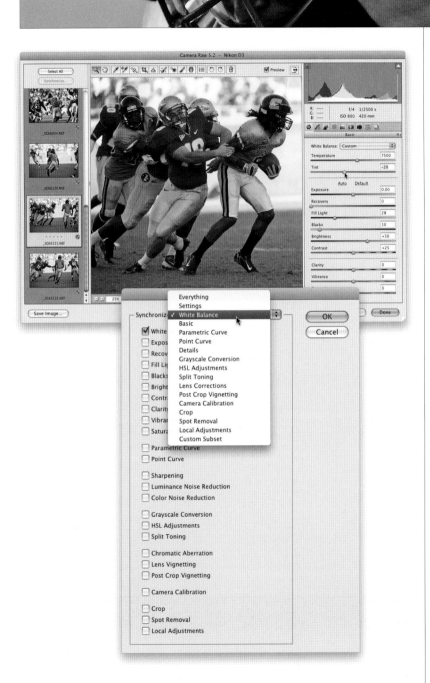

Step Five:

If you're not in Bridge, you can go to the folder on your computer where your RAW photos are, select them, and double-click on one of them to open them all in Camera Raw (you'll see them appear in a vertical filmstrip along the left side. To open JPEGs or TIFFs in Camera Raw, you'll need to select them in Bridge and then press **Command-R [PC: Ctrl-R]**). Click on one of the photos and make your edits. In this case, we just want to fix the white balance and fill light. I used the Shade White Balance preset, but then their pants looked a little magenta, so I dragged the Tint slider a little bit away from magenta (as shown here). I also increased the fill light, then the blacks, so the Fill Light adjustment didn't make the photo look washed out. Now click the Select All button at the top left, and then click the Synchronize button (beneath it). This brings up the Synchronize dialog (shown here), where you choose which of the edits you made to the first photo will be applied to the rest of your selected photos. Here, we only want the White Balance, Fill Light, and Blacks settings applied, so choose White Balance from the Synchronize pop-up menu at the top, and it automatically deselects all the other checkboxes, then turn on the checkboxes for Fill Light and Blacks.

Continued

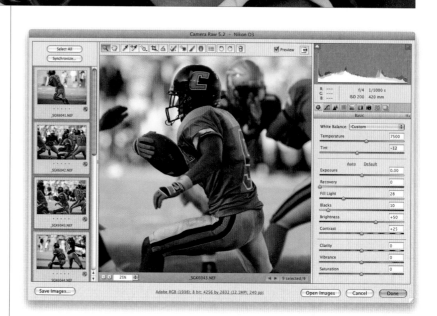

Step Six:

When you click OK, only those checked edits will be applied to all your selected photos in Camera Raw, as seen here, where you can see in the filmstrip how the other thumbnails are now updated with the non-bluish look.

TIP: Editing Only Select Photos

If you only want certain photos to be affected, and not all the ones open in Camera Raw, then in the filmstrip, Command-click (PC: Ctrl-click) on only the photos you want affected and click the Synchronize button.

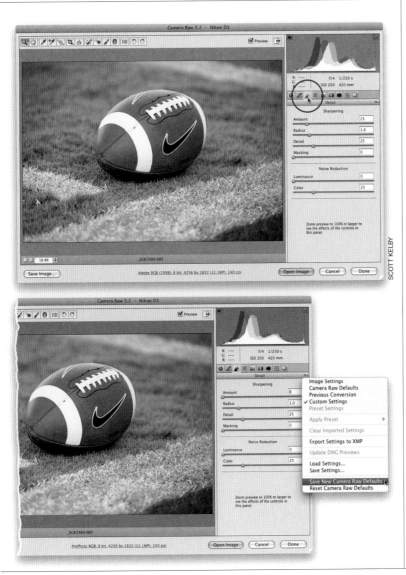

Sharpening in Camera Raw

If you shoot in JPEG, your digital camera applies sharpening to your photo right in the camera itself, so no sharpening is automatically applied by Camera Raw. But if you shoot in RAW, you're telling your camera to ignore that sharpening, and that's why, when you bring a RAW image into Camera Raw, by default, it applies some sharpening, called "capture sharpening." In my workflow, I sharpen twice: once here in Camera Raw, and once more right before I output my final image from Photoshop (called "output sharpening"). Here's how to apply capture sharpening in Camera Raw:

Step One:
When you open a RAW image in Camera Raw, by default, it applies a small amount of sharpening to your photo (not the JPEGs or TIFFs, only RAW images). You can adjust this amount (or turn if off altogether, if you like) by clicking on the Detail icon, as shown here, or using the keyboard shortcut **Command-Option-3 (PC: Ctrl-Alt-3)**. At the top of this panel is the Sharpening section, where by a quick glance you can see that sharpening has already been applied to your photo. If you don't want any sharpening applied at this stage (it's a personal preference), then simply click-and-drag the Amount slider all the way to the left to lower the amount of sharpening to 0 (zero), and the sharpening is removed.

Step Two:
If you want to turn off this automatic, by default sharpening (so image sharpening is only applied if you go and manually add it yourself), first set the Sharpening Amount slider to 0 (zero), then go to the Camera Raw flyout menu and choose Save New Camera Raw Defaults (as shown here). Now, RAW images taken with that camera will not be automatically sharpened.

Continued

Step Three:

Before we charge into sharpening, there's one more thing you'll want to know: if you don't actually want sharpening applied, but you'd still like to see what the sharpened image would look like, you can sharpen just the preview, and not the actual file. Just press **Command-K (PC: Ctrl-K)** while Camera Raw is open, and in the Camera Raw Preferences dialog, choose Preview Images Only in the Apply Sharpening To pop-up menu (as shown here), and then click OK to save this as your default. Now the sharpening only affects the preview you see here in Camera Raw, but when you choose to open the file in Photoshop, the sharpening is not applied.

Step Four:

When this Sharpening section was first introduced in CS3, I'd watch friends and students use it, and you'd see them drag the Amount slider all the way over to the right (to 150) and then back to 0 (zero) again and then back to 150 again, and they'd say, "It's not doing anything!" That's because, even though it says right within the Detail panel itself, "Zoom preview to 100% or larger to see the effects of the controls in this panel," virtually no one sees that. So, forgive me if you did read that message in the panel and this seems totally obvious to you, but (here goes) before you do any actual sharpening, set your view to 100% (as shown here), or you really won't be able to see the sharpening as you apply it (sorry...it had to be said). The quickest way to get to that 100% view is to double-click directly on the Zoom tool (shown circled here). (*Note:* The message will disappear after you zoom in to 100%.)

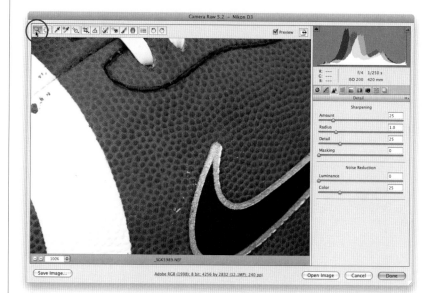

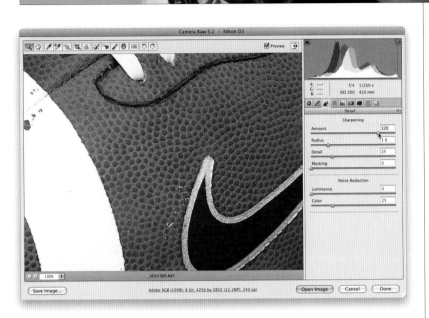

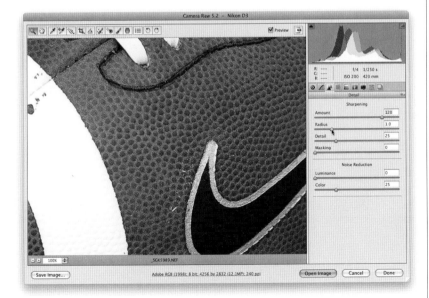

Step Five:

Now that you're at a 100% view, drag the Amount slider all the way to the right so you can see, in fact, that when you're at 100%, the sharpening does indeed work. Again, dipping into the realm of the painfully obvious, dragging the Amount slider to the right increases the amount of sharpening. Compare the image shown here, with the one in Step Four (where the Sharpening Amount was set to the default of 25), and you can see how much sharper the image now appears, even though I only dragged it to 120.

TIP: Making Camera Raw Full Screen

To have Camera Raw expand to fill your entire screen, click the Full Screen icon to the right of the Preview checkbox, at the top of the window.

Step Six:

The next slider down is the Radius slider, which determines how far out the sharpening is applied from the edges being sharpened in your photo. This pretty much works like the Radius slider in Photoshop's Unsharp Mask filter, which is probably why the default is 1 (because that's probably where we'll leave it most of the time). I use less than a Radius of 1 if the photo I'm processing is only going to be used on a website, in video editing, or somewhere where it's going to be at a very small size or resolution. I only use a Radius of more than 1 when the image is visibly blurry and needs some "emergency" sharpening. If you decide to increase the Radius amount above 1 (unlike the Unsharp Mask filter, you can only go as high as 3 here), just be careful, because if you go too much above 1, your photo can start to look fake and oversharpened. You want your photo to look sharp, not sharpened, so be careful out there.

Continued

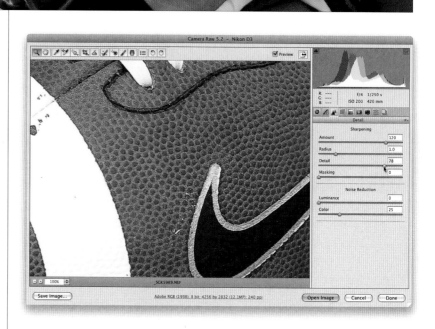

Step Seven:

The next slider down is the Detail slider, which determines how much of the edge areas are affected by sharpening. You'll apply lower amounts of Detail if your photo is slightly blurred, and higher amounts if you really want to bring out texture and detail (which is why this slider is aptly named). So, how much Detail you apply depends on the subject you're sharpening. With an image like this one, with lots of texture in the leather, it's an ideal candidate for a high amount of Detail (so are most landscapes, cityscapes, motorcycle shots—stuff with lots of edges), so I dragged the slider to the right (all the way to 78), until the detail really came out in the leather.

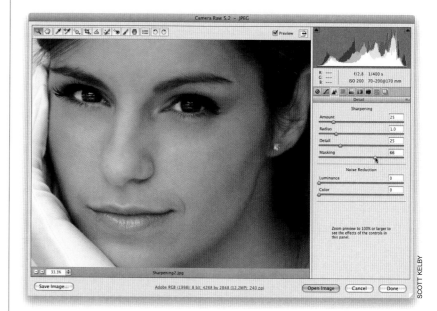

Step Eight:

I'm going to change photos to show you the Masking slider. This one's easier to understand, and for many people, I think it will become invaluable. Here's why: When you apply sharpening, it gets applied to the entire image evenly. But what if you have an image where there are areas you'd like sharpened, but other softer areas that you'd like left alone (like the photo here, where you want to keep her skin soft, but have her eyes, lips, etc., sharpened)? If we weren't in Camera Raw, you could apply the Unsharp Mask filter to a duplicate layer, sharpen this layer, add a layer mask, and paint away (cover) those softer areas, right? Well, that's kind of what the Masking slider here in Camera Raw does—as you drag it to the right, it reduces the amount of sharpening on non-edge areas. The default Masking setting of 0 (zero) applies sharpening to the entire image. As you drag to the right, the non-edge areas are masked (protected) from being sharpened.

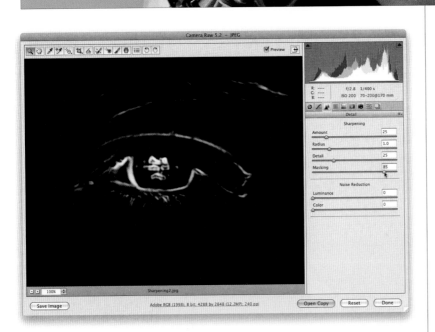

Step Nine:

All four sliders in the Sharpening section of the Detail panel let you have a live preview of what the sharpening is affecting—just press-and-hold the Option (PC: Alt) key as you drag; your screen will turn grayscale, and the areas that the slider you're dragging will affect appear as edge areas in the preview window. This is particularly helpful in understanding the Masking slider, so press-and-hold the Option key and drag the Masking slider to the left. When Masking is set to 0, the screen turns solid white (because sharpening is being evenly applied to everything). As you drag to the right, the preview (shown here) now shows only the parts of the photo receiving sharpening. If you drag all the way to 100, you'll see that only the most obvious edges are now receiving full sharpening.

Step 10:

Here's a before/after of our football shot, first with no sharpening applied (Before), and then a nice crisp amount applied (After) using these settings—Amount: 110, Radius: 1, Detail: 78, Masking: 0. To see your own before/after, press the letter **P** to toggle the Preview on/off.

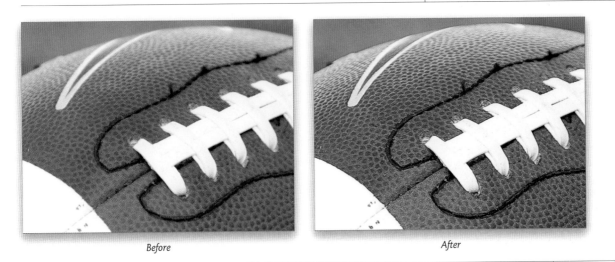

Before *After*

Fixing Chromatic Aberrations (That Colored-Edge Fringe)

Chromatic aberration is a fancy name for that thin line of colored fringe that sometimes appears around the edges of objects in photos. Sometimes the fringe is red, sometimes green, sometimes purple, blue, etc., but all the time it's bad, so we might as well get rid of it. Luckily, Camera Raw has a built-in fix that does a pretty good job.

Step One:

Open the photo that has signs of chromatic aberrations (colored-edge fringe). If chromatic aberrations are going to appear, they're usually right along an edge in the image that has lots of contrast (like between the black edges of this tire, and the pavement behind it). If the aberrations are bad enough, you'll be able to see them right off the bat, but if you just suspect they might be there, you'll have to zoom in for a closer look (by the way, if you're using a quality camera with quality lenses, you might have to look far and wide before coming across a photo suffering from this problem).

Step Two:

Press **Z** to get the Zoom tool in the Camera Raw window and zoom in on an area where you think (or see) the fringe might be fairly obvious. In the example shown here, I zoomed directly in on the back tire and sure enough, it has a purplish fringe running along the edge. To remove this fringe, click on the Lens Corrections icon (it's the sixth icon from the left at the top of the Panel area) to bring up the Chromatic Aberration sliders.

Step Three:
There are only two sliders and you just drag toward the color you want to fix (they're labeled—the top one fixes red or cyan fringe; the bottom fixes blue or yellow fringe). But before you begin dragging sliders, you may want to click on the Detail icon (the third icon from the left at the top of the Panel area) and lower the Sharpening Amount to 0%, because sharpening can also cause color fringes to appear (and you want to make sure you're curing the right problem).

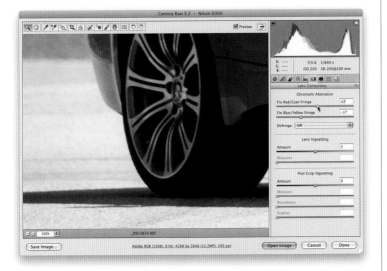

Step Four:
Since the fringe in this particular case is purple, we may have to move more than one slider. Start by moving the bottom Chromatic Aberration slider to the left (toward blue), which reduces the blue part of the purple fringe (just make sure you don't drag so far toward blue that you create a yellow fringe. Hey, I'm just sayin'). There's still a little color fringe, so try the Red/Cyan slider—moving it a little toward cyan seems to do the trick.

TIP: Editing TIFFs and JPEGs
Although you can edit TIFFs and JPEGs in Camera Raw, there is one "gotcha!" Once you edit one of those in Camera Raw, if you click the Done button (rather than opening the image in Photoshop), you'll need to always open that photo from within Camera Raw to see the edits you made. That's because those edits live only inside of Camera Raw; if you bypass Camera Raw and open an edited TIFF or JPEG directly into Photoshop, the Camera Raw edits you made earlier won't be visible.

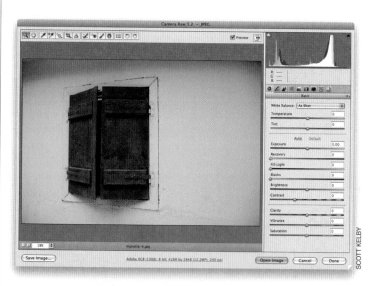

Edge Vignetting: How to Fix It and How to Add It for Effect

If you're looking at a photo and the corners of the photo appear darker, that's lens vignetting. Generally, I look at it this way: If it's just the corners, and they're just a little bit dark, that's a problem and I fix it. However, sometimes I want to focus the viewer's attention on a particular area, so I create a vignette, but I expand it significantly beyond the corners, so it looks like an intentional soft spotlight effect. Here's how to fix (or create) vignettes:

Step One:
In the photo shown here, you can see the dark areas in the corners (that's the bad vignetting I was talking about). This vignetting is normally caused by the camera's lens, so don't blame yourself (unless you bought a really cheap lens—then feel free to give yourself as much grief as you can bear).

Step Two:
To remove this vignetting from the corners, click on the Lens Corrections icon (it's the sixth icon from the left) to bring up the Lens Vignetting controls. Click on the Amount slider and drag it to the right until the vignetting in the corners disappears (dragging to the right essentially brightens the corners, which hides the vignetting). Once you begin moving the Amount slider, the Midpoint slider beneath it becomes available. That slider determines how wide the vignetting repair extends into your photo (in other words, how far out from the corners your repair extends), so drag it to the right to expand the lightening farther toward the center of your photo.

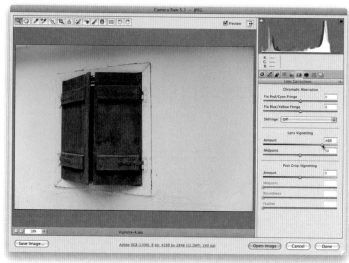

SCOTT KELBY

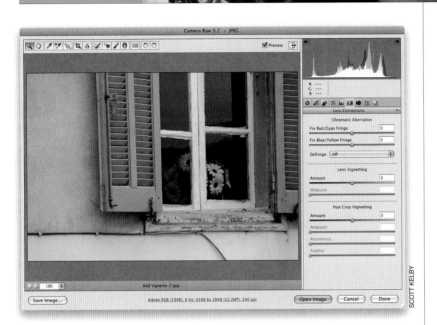

SCOTT KELBY

Step Three:

Now for the opposite: adding vignetting to focus attention (by the way, in the "Special Effects for Photographers" chapter, I also show you how to get the same effect outside of Camera Raw). This time, in the Lens Vignetting section you're going to drag the Amount slider to the left, and as you drag left, you'll start to see vignetting appear in the corners of your photo (as seen in Step Four). But since it's just in the corners, it looks like the bad kind of vignetting, not the good kind, so you'll need to go on to the next step.

Step Four:

To make the vignetting look more like a soft spotlight falling on your subject, drag the Midpoint slider quite a bit to the left, which increases the size of the vignetting and creates a soft, pleasing effect that is very popular in portraiture, or anywhere you want to draw attention to your subject. That's it—how to get rid of 'em and how to add 'em. Two for the price of one!

TIP: Seeing a Before/After

If you want to see a before/after of just the changes you've made in a current panel, press the letter **P** to toggle that panel's Preview checkbox on/off. However, if you want to see a before/after of all the edits you've made in Camera Raw, then you'll need to choose Image Settings from the Camera Raw flyout menu to see the before version, and then from that same menu, choose Custom Settings to see the after version. I agree—it's clunky.

Continued

Step Five:

So far, adding the vignette has been pretty easy—you just drag a couple of sliders, right? But where you'll run into a problem is when you crop a photo, because you're also cropping the vignetting effect away, as well (after all, it's an edge effect, and now the edges are in a different place, and Camera Raw doesn't automatically redraw your vignette at the newly cropped size). That's why one of the most requested Camera Raw features is the ability to add a vignette after the fact, and in CS4, not only did they add it, they added more controls to vignetting. It's called Post Crop Vignetting and it's found at the bottom of the Lens Corrections panel (seen here).

Step Six:

When you crop a photo (like we did here), you can see the problem—the vignette effect (added in Step Five) is pretty much gone. So, to add it back in, go to the Post Crop Vignetting section and drag the Amount slider to the left to darken the edges, then use the Midpoint slider to choose how far into your image this vignetting will extend.

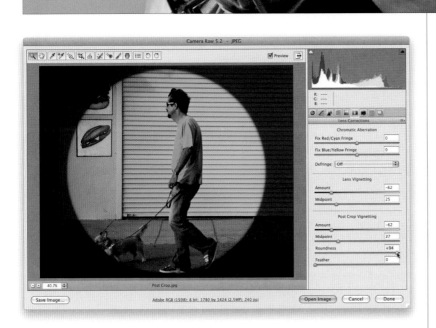

Step Seven:
One of the two new sliders they added in CS4 is a control over the roundness of the vignetting. I lowered the Feather amount here to 0 just so you can get a better idea of what the Roundness slider does. The farther to the right you drag, the rounder the shape gets, and when you drag to the left, it actually becomes more like a large, rounded-corner rectangle.

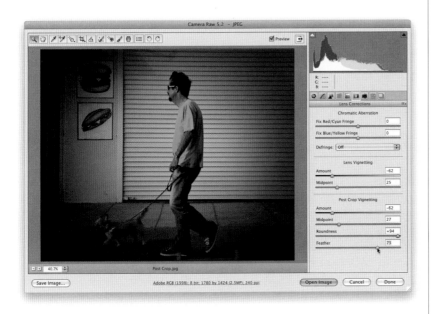

Step Eight:
The Feather slider determines how soft that oval you created with the Roundness slider becomes. I like it really soft, so it looks more like a spotlight, so I usually drag this slider quite a bit over to the right (here I dragged it over to 73, but I wouldn't hesitate to go higher, depending on how it looks on the photo).

The Advantages of Adobe's DNG Format for RAW Photos

Adobe created DNG (an open archival format for RAW photos) because, at this point in time, each camera manufacturer has its own proprietary RAW file format. If, one day, one or more manufacturers abandon their proprietary format for something new (like Kodak did with their Photo CD format), will we still be able to open our RAW photos? With DNG, it's not proprietary—Adobe made it an open archival format, ensuring that your negatives can be opened in the future, but besides that, DNG brings another couple of advantages, as well.

Step One:

There are three advantages to converting your RAW files to Adobe DNG: (1) DNG files are generally about 20% smaller. (2) DNG files don't need an XMP sidecar file to store Camera Raw edits, metadata, and keywords—the info's embedded into the DNG file, so you only have one file to keep track of. And, (3) DNG is an open format, so you'll be able to open them in the future (as I mentioned in the intro above). Here's how to convert to DNG: If you're using Bridge's built-in Photo Downloader, then you can have your images converted to DNG automatically as they're imported from your camera's memory card. In the Advanced Options section of the Photo Downloader, turn on the checkbox for Convert to DNG. If you want to change the settings (I don't— I use the defaults), click the Settings button (as shown here) to bring up the DNG Conversion Settings dialog. I leave the compression turned on (the term "lossless" lets you know there's no loss of quality). Next, I only recommend choosing Convert to Linear Image if you plan to open this DNG in a RAW processing application other than Camera Raw or Photoshop Lightroom, because it makes the file size larger. That's also why I don't embed the original RAW file, because it totally cancels out Advantage #1.

Step Two:
If you have a RAW image open in Camera Raw, you can save it as an Adobe DNG by clicking the Save Image button (as shown here) to bring up the Save Options dialog (seen in the next step). *Note:* There's really no advantage to saving TIFF or JPEG files as DNGs, so I only convert RAW photos.

Step Three:
When the Save Options dialog appears, at the bottom of the dialog, from the Format pop-up menu, choose Digital Negative (shown below). Below that are the same three options we talked about in Step One, when converting to DNG while importing your RAW photos from your memory card. Make your choices, click Save, and you've got a DNG.

TIP: Setting Your DNG Preferences
Once you've converted to DNG, Camera Raw does give you a few preferences for working with these DNG files. Press **Command-K (PC: Ctrl-K)** to bring up Photoshop's Preferences dialog, then click on File Handling in the column on the left side, and click on the Camera Raw Preferences button (or press **Command-K** when you have Camera Raw open). When the dialog appears, go to the DNG File Handling section (shown below). You'd choose Ignore Sidecar ".xmp" Files only if you use a different RAW processing application (other than Camera Raw or Lightroom), and you want Camera Raw to ignore any XMP files created by that application. If you choose Update Embedded JPEG Previews (and choose your preferred preview size from the pop-up menu), then any changes you make to the DNG will be applied to the preview, as well.

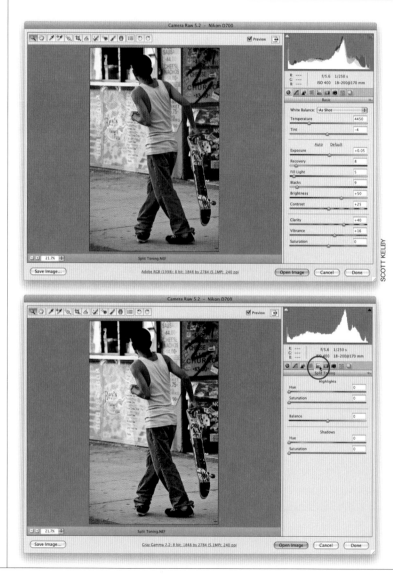

Split Toning and Duotone Effects in Camera Raw

Split toning is a feature borrowed from Photoshop's younger cousin Photoshop Lightroom (the photography workflow application), where it's gained lots of fans. What it does is lets you apply one tint to your photo's highlights, and one tint to your photo's shadow areas, and you even can control the saturation of each tint and the balance between the two for some interesting effects. If you're not a fan of the split-toned look, you can still use split toning to easily create a duotone effect from right within Camera Raw.

Step One:
Creating split-toning effects (which used to be a traditional darkroom technique) is now incredibly easy and, although split-toning effects can be applied to both color and B&W photos, you probably see it most often applied to a B&W image. Here's the original full-color image (if you look at the sliders, you can see where I tweaked the photo to look good in color, but we're going to convert it to black and white, so those settings probably won't do much good). Start by converting it to grayscale in the HSL/Grayscale panel (the fourth icon from the left at the top of the Panel area). Just turn on the Convert to Grayscale checkbox at the top of the panel.

Step Two:
Once the photo was converted to black and white (as shown here), it looked pretty flat to me, so I increased the Fill Light, Contrast, and Blacks amounts quite a bit, so it looked like the image you see here. Now, click on the Split Toning icon at the top of the Panel area (it's circled in red here). At this point, dragging either the Highlights or Shadows Hue slider does absolutely nothing because, by default, the Saturation sliders are set to 0. Luckily, there is a hidden tip that will let you temporarily see the hues at their full saturation as you drag: just press-and-hold the Option (PC: Alt) key, then click-and-drag.

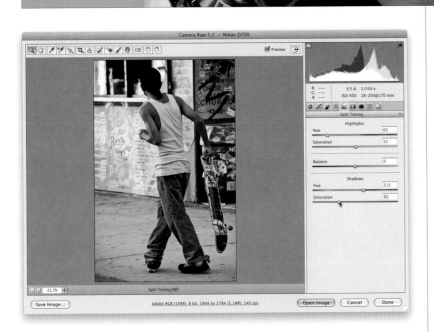

Step Three:
Once you find a highlight hue you like, release the Option (PC: Alt) key and drag the Highlights Saturation slider to the right. The further you drag, the more saturated your highlight tint becomes. Once that's in place, do the same thing with the Shadows Hue slider (press-and-hold the Option key, drag the Hue slider to pick your hue, then release the Option key, and slowly drag the Shadows Saturation slider to the right). In the example shown here, we have a yellow tint in the highlights and a blue tint in the shadows. I know what you're thinking, "Scott, I'm not sure I like split toning." I hear ya—it's not for everybody, and it's definitely an acquired taste (and I'm not quite sure I've acquired it yet), but some people love 'em. There's a name for these people. Freaks! (Kidding.)

Step Four:
There is one more control—a Balance slider which lets you control whether your split tone favors your highlight or shadow color. Just drag left, then back right, and you'll instantly see what this slider does. Although I'm not personally a fan of split-toning effects, I do use the Split Toning panel for something else—creating duotones. All you have to do is use the exact same Hue setting for the Highlights as you do the Shadows, then lower the Saturation of both the Highlights and Shadows until it looks like a duotone. In the example shown here, I set both the Highlights and Shadows Hue sliders to 50, then I lowered the Saturation of both to around 20 or 21, and that gives you the nice duotone effect you see here.

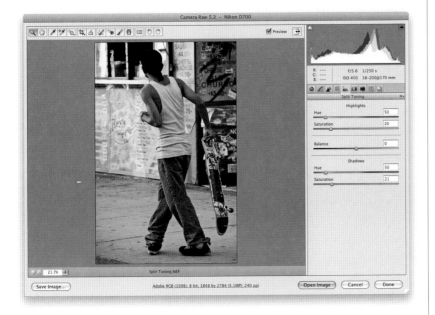

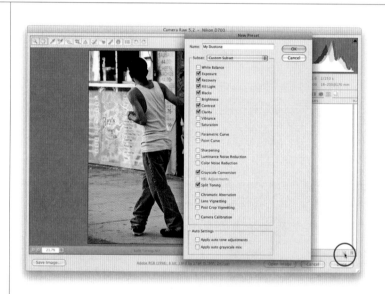

Creating Your Own One-Click Presets

Now that we created a split-tone/duotone effect, this is the perfect time to start making your own one-click presets. That way, the next time you open a photo that you want to have that same effect, you don't have to go through all those steps (converting it to black and white, tweaking it, then applying the Split Toning settings), you can just click one button and all those settings are applied at once, giving you an instant one-click effect anytime. Of course, these presets aren't just for duotones—make one anytime you want to reuse any settings.

Step One:
Since we just created that duotone effect (on the previous page), we'll go ahead and use that to create a one-click preset. Just remember—anytime you come up with a look you like, you can save it as a preset. To create a preset, you click on the Presets icon (it's the second icon from the right at the top of the Panel area), and then click on the New Preset icon (shown circled here in red) to bring up the New Preset dialog (seen here). Now, just turn on the checkboxes for the adjustments you want copied to your preset (as shown here), give your preset a name, and then click the OK button.

Step Two:
Once you've saved the preset, it appears in the Presets list (since there's only one preset here, I'm not sure it qualifies as a list at this point, but you get the idea, right?). To apply it is really a one-click process—just open a different photo, go to the Presets panel, and click on the preset (as shown here), and all those settings are applied. Keep in mind, though, because the exposure is different for every photo, if you save a preset where you had to tweak the exposure a lot, that same exposure will be applied anytime you apply this preset. That's why you might want to save just the split-tone/duotone settings and not all the exposure stuff, too.

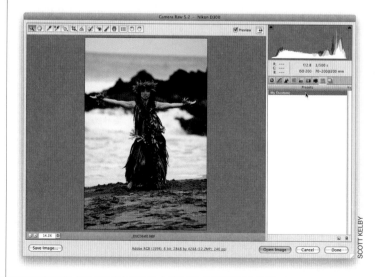

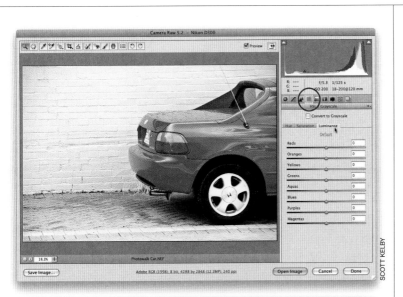

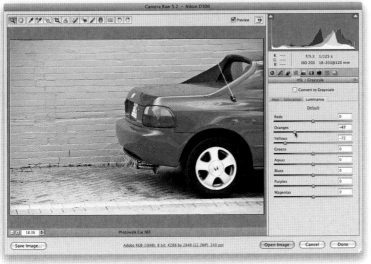

In the next chapter, you're going to learn how to paint an adjustment over any part of your image, but sometimes you need to affect an entire area (like you need the entire sky bluer, or the sand warmer, or a piece of clothing to be an entirely different color). In those cases, where you're adjusting large areas, it's usually quicker to use the HSL adjustments, which not only let you change color, but also let you change the saturation and the lightness of the color. It's more powerful, and handy, than you might think.

Adjusting or Changing Ranges of Color

Step One:

Here's the original image of a red car on a washed-out yellow wall, and what I'd like to do is tweak the color of that wall so it's a richer yellow, which would add a nice contrast to the red car. You tweak individual colors, or ranges of color, in the HSL/Grayscale panel, so click on its icon at the top of the Panel area (it's the fourth one from the left—circled here in red). Now, click on the Luminance tab (as shown here) to bring up the Luminance controls (which control how bright the colors appear).

Step Two:

The yellow in the wall is washed out, so we need to bring some richness and depth back into the color, so drag the Yellows slider way over to the left toward the darker yellows (those color bars behind each slider give you an idea of what will happen when you drag a slider in a particular direction). Now drag the Oranges sliders to the left quite a bit, too (as shown here). Moving the Oranges slider affected the bright yellow reflection in the red car, as well as the wall. How did I know this was going to do that? I had no idea. I just dragged each slider back and forth real quick to see what it would do. I know—it sounds awfully simple, but it works.

Continued

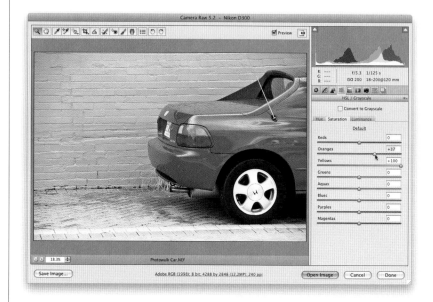

Step Three:

So now the Yellows are bright, but they're not rich and bold yet, so click on the Saturation tab near the top of the panel, and then drag the Yellows slider all the way over to the right, and the wall just comes alive with color. I also dragged the Oranges slider to the right, too (as shown here), because it had such a great effect on the wall earlier, and as a bonus, it also made the orange in the turn signals really stand out. Now that the photo is really vivid, you can see some unintentional edge vignetting in the corners, so just go to the Lens Corrections panel and, under Lens Vignetting, drag the Amount slider to the right until it goes away (for me, it was about +26, and I didn't need to touch the Midpoint slider at all. See page 124 for more on fixing vignetting).

Step Four:

To actually change colors (not just adjust an existing color's saturation or vibrance), you click on the Hue tab near the top of the panel. The controls are the same, but take a look at the color inside the sliders themselves now—you can see exactly which way to drag to get which color. In this case, to make the yellow wall change to a green wall, you'd drag the Yellows slider to the right toward green. Easy enough. Now, quite honestly, I wouldn't actually have changed the wall color to green like that, but I wanted to show you how the Hues section works, and this does the trick. While we're try- ing some wild stuff, try this: to make everything orange, drag the Reds slider to +79, drag the Oranges slider to −32, and the Yellows slider over to −100. How did I figure this one out? You guessed it— I started dragging sliders around (don't tell anybody I actually do this).

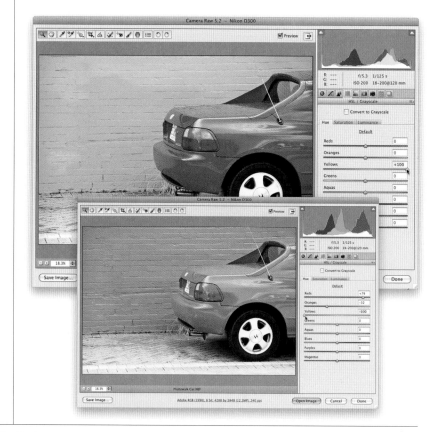

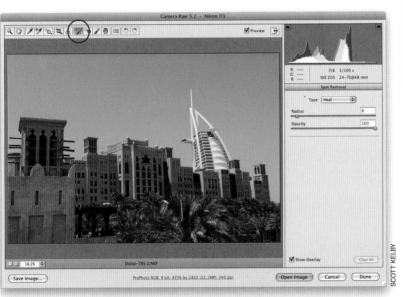

If you need to remove something pretty minor from your photo, like a spot from some dust on your camera's sensor, or a blemish on your subject's face, or something relatively simple like that, you can use the Spot Removal tool right within Camera Raw. If it's more complicated than just a simple spot or two, you'll have to head over to Photoshop and use its much more powerful and precise retouching tools (like the Healing Brush tool, Patch tool, and Clone Stamp tool).

Removing Spots, Specks, Blemishes, Etc.

Step One:
This photo has some simple problems that can be fixed using Camera Raw's Spot Removal tool. You start by clicking on the Spot Removal tool (the seventh tool from the right in the toolbar) by pressing **B** to get it, and a set of options appears in the Spot Removal panel on the right (seen here). Using the tool is pretty simple—just move your cursor over the center of a spot that needs to be removed (in this case, it's those spots in the sky where my camera's sensor got dirty), then click, hold, and drag outward, and a red-and-white circle will appear, growing larger as you drag outward. Keep dragging until that circle is a little larger than the spot you're trying to remove (as shown here below). Don't forget, you can use the Zoom tool **(Z)** to zoom in and get a better look at your spots before you drag out your circle.

Continued

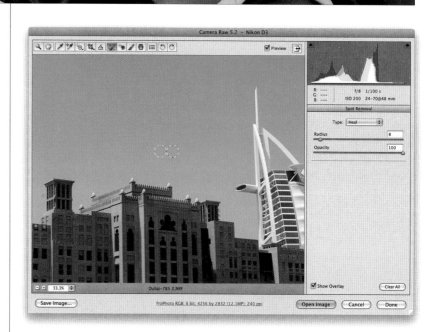

Step Two:

When you release the mouse button, a second circle (this one is green and white) appears to show you the area where Camera Raw chose to sample your repair texture from (it's usually very close by), and your spot or blemish is gone (as seen here).

TIP: When to Fix Blemishes in Camera Raw

So, what determines if you can fix a blemish here in Camera Raw? Basically, it's how close the blemish, spot, or other object you need to remove is to the edge of anything. This tool doesn't like edges (the edge of a door, a wall, a person's face, etc.), so as long as the blemish (spot, etc.) is all by itself, you're usually okay.

Step Three:

To remove a different spot (like the one to the right of the top wood post here), you use the same method: move over that spot, click, hold, and drag out a circle that's slightly larger than the spot, then release the mouse button. In this case, Camera Raw did sample a nearby area, but unfortunately it also sampled the bottom corner of the post and it copied it to the sky area where we were retouching, making the retouch look very obvious with that piece of post hanging out there.

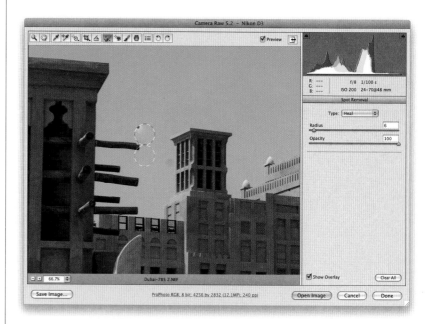

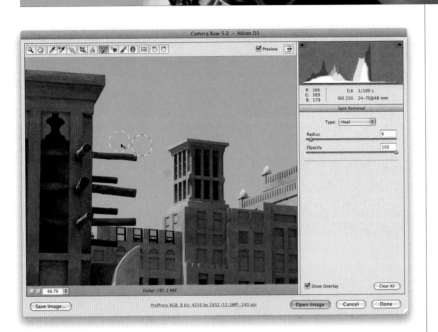

Step Four:

If this happens, here's what to do: move your cursor inside the green-and-white circle, and drag that circle to a different nearby area (here, I dragged upward and to the left to a clean nearby area), and when you release the mouse button, it resamples texture from that area. Another thing you can try, if the area is at all near an edge, is to go to the top of the Spot Removal panel and choose Clone rather than Heal from the Type pop-up menu (although I use Heal about 99% of the time, because it generally works much better).

Step Five:

When you're done retouching, just change tools and your retouches are applied (and the circles go away). Here's the final retouch after removing all the spots in the sky from my dirty sensor. Use this tool the next time you have a spot on your lens or on your sensor (where the same spot is in the same place in all the photos from your shoot). Then fix the spot on one photo, open multiple photos, and paste the repair onto the other selected RAW photos using Synchronize (see "Editing Multiple Photos at Once," earlier in this chapter, and just turn on the Spot Removal checkbox in the Synchronize dialog).

Removing Red Eye in Camera Raw

Camera Raw has its own built-in Red Eye Removal tool, and there's a 50/50 chance it might actually work. Of course, my own experience has been a little less than that (more like 40/60), but hey—that's just me. Anyway, if it were I, I'd probably be more inclined to use the regular Red Eye tool in Photoshop CS4 itself, which actually works fairly well, but if you're charging by the hour, this might be a fun place to start. Here's how to use this tool, which periodically works for some people, somewhere. On occasion. Perhaps.

Step One:
Open a photo in Camera Raw that has the dreaded red eye (like the one shown here). To get the Red Eye Removal tool, you can press the letter **E** or just click on the tool up in Camera Raw's toolbar (as shown here).

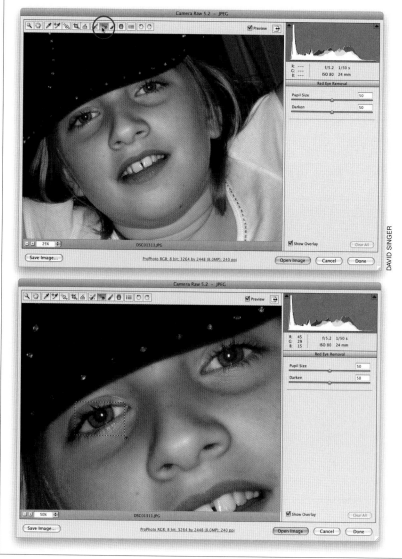

Step Two:
You'll want to zoom in close enough so you can see the red-eye area pretty easily (as I have here, where I just simply zoomed to 50%, using the zoom level pop-up menu in the bottom-left corner of the Camera Raw window). The way this tool works is pretty simple—you click-and-drag the tool around one eye (as shown here; make sure you include some of the surrounding face), and as you drag, it makes a black-and-white box around the eye. That tells Camera Raw where the red eye is located.

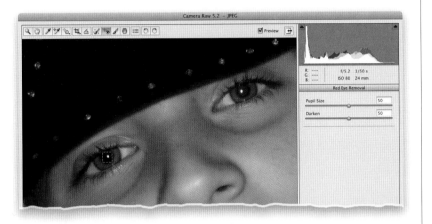

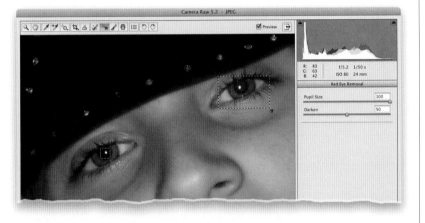

Step Three:

When you release the mouse button, theoretically the box should snap down on the pupil, making a perfect selection around the area affected by red eye. You'll notice that the key word here is "theoretically." In our example, it did. If it doesn't, then press **Command-Z (PC: Ctrl-Z)** to Undo that attempt, and try again, but before you do that, let's try to help the tool along by increasing the Pupil Size setting (in the Red Eye Removal panel on the right) to around 100 (as seen in the next image).

Step Four:

Now, with the Pupil Size setting at 100, the tool should do what we hoped it would—snap right down around the pupil, and remove the red from that area. Once that eye looks good, go over to the other eye, drag out a selection again (as shown here), and it does the same thing (the before and after are shown below). One last thing: if the pupil looks too gray after being fixed, then drag the Darken slider to the right. Give it a try on a photo of your own. It's possible it might work.

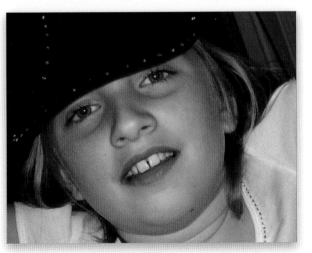

Before

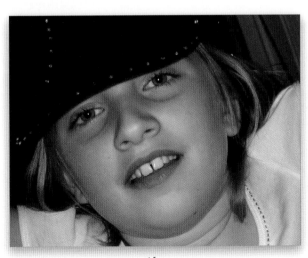

After

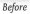

Calibrating for Your Particular Camera

Some cameras seem to have their own "color signature," and by that I mean that every photo seems to be a little too red, or every photo is a little too green, etc. You just know, when you open a photo from that camera, that you're going to have to deal with the slight color cast it adds. Well, if that's the case, you can compensate for that in Camera Raw, and then set that color adjustment as the default for that particular camera. That way, any time you open a photo from that camera, it will automatically compensate for that color.

Step One:

To calibrate Camera Raw so it fixes a persistent color cast added by your camera, open a typical photo taken with that camera in Camera Raw, and then click on the Camera Calibration icon (it looks like a camera and is the third icon from the right at the top of the Panel area). So, let's say that the shadow areas in every photo from your camera appear slightly too red. In the Camera Calibration panel, drag the Red Primary Saturation slider to the left, lowering the amount of red in the entire photo. If the red simply isn't the right shade of red (maybe it's too hot and you just want to tone it down a bit), drag the Red Primary Hue slider until the red color looks better to you (dragging to the right makes the reds more orange).

Step Two:

To have Camera Raw automatically apply this calibration each time a photo from that particular camera is opened in Camera Raw, go to Camera Raw's flyout menu (in the top right of the panel), and choose Save New Camera Raw Defaults (as shown here). Now, when you open a photo from that camera (Camera Raw reads the EXIF data so it knows which camera each shot comes from), it will apply that calibration. *Note:* You can adjust your blues and greens in the same way.

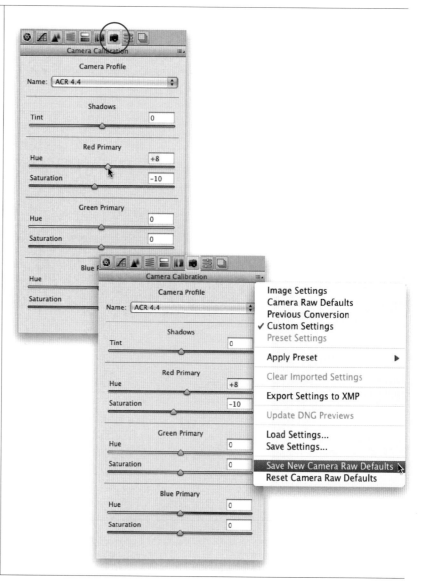

Camera Raw's Noise Reduction

If you wind up shooting in low light (at night, indoors, at a concert, etc.), then you're probably used to cranking up your ISO to 800 or more, so you can hand-hold the shots, right? The downside of a high ISO is the same with digital as it was with film—the higher the ISO, the more visible the noise (those annoying red and green spots or splotchy patches of color), especially in shadows, and it gets even worse when you try to lighten them. Here's what you can do in Camera Raw to lessen the noise. (By the way, the answer is: not much.)

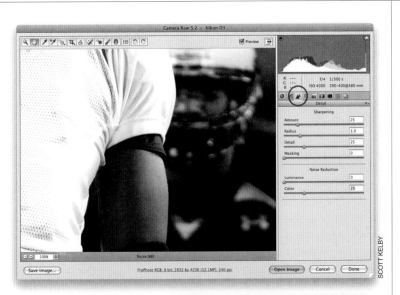

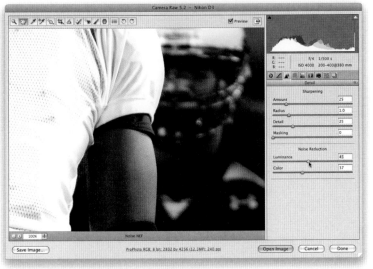

Step One:
Open an image in Camera Raw that has a digital noise issue, press **Z** to get the Zoom tool, and zoom in to at least 100%–200%, so the noise is easily visible. There are two types of noise you can deal with in Camera Raw: (1) high ISO noise, which often happens when you're shooting in low-light situations using a high ISO setting (like the photo shown here); and (2) color noise, which can happen even in normal situations (this noise is more prevalent in some cameras than others). When you see this junk, click on the Detail icon in Camera Raw (its icon is two triangles and is third from the left at the top of the Panel area).

Step Two:
To decrease color noise, drag the Noise Reduction Color slider to the right. It does a fair job of removing at least some of the color noise, though it does tend to desaturate your overall color just a bit. If the problem is mostly in shadow areas, then drag the Luminance slider to the right instead. Be careful, as it tends to make your photo look a bit soft. Now, to be honest with you, Camera Raw's Noise Reduction feature is…well, it ain't great (that's being kind). I use an inexpensive Photoshop plug-in called Noiseware Professional (from Imagenomic) that works absolute miracles. It's really all I use for noise.

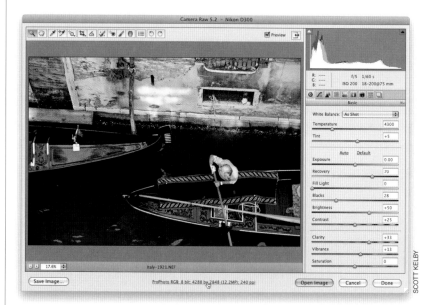

Setting Your Resolution, Image Size, Color Space, and Bit Depth

Since you're processing your own images, it only makes sense that you get to choose what resolution, what size, which color space, and how many bits per channel your photo will be, right? These are workflow decisions, which is why you make them in the Workflow Options dialog. Here are my recommendations on what to choose, and why:

Step One:
Once you've made all your edits, and the photo is generally looking the way you want it to, it's time to choose your resolution, size, etc. Directly below the Camera Raw Preview area (where you see your photo), you'll see your current workflow settings—they are underlined in blue like a website link. Click on that link to bring up the Workflow Options dialog (which is seen in the next step).

Step Two:
We'll start at the top by choosing your photo's color space. By default, it shows the color space specified in your digital camera, but if you're editing a RAW photo, you can ignore that and choose the color space you want the photo processed with. I recommend choosing the same color space that you have chosen as Photoshop's color space. For photographers, at this point in time, I still recommend that you choose Adobe RGB (1998) for Photoshop's color space, and if you've done that, then you would choose Adobe RGB (1998) here, from the Space pop-up menu. See my color management and printing chapter (Chapter 13) for more on why you should use Adobe RGB (1998).

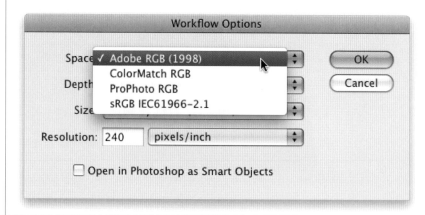

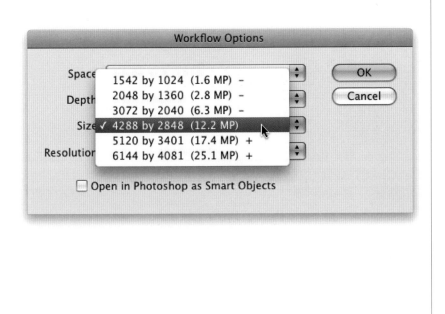

Step Three:

When it comes to choosing your photo's bit depth, I have a simple rule I go by: I always work in 8 Bits/Channel (Photoshop's default), unless I have a photo that is so messed up that after Camera Raw, I know I'm still going to have to do some major Curves adjustments in Photoshop just to make it look right. The advantage of 16-bit is those major Curves adjustments wouldn't damage the photo as much (you'd get less banding or posterization) because of the greater depth of 16-bit. The reasons I don't use 16-bit more often are: (1) many of Photoshop's tools and features aren't available in 16-bit, (2) your file size is approximately double, which makes Photoshop run a lot slower, and (3) 16-bit photos take up twice as much room on your computer. Still, some photographers insist on only working in 16-bit and that doesn't bother me one bit. (Get it? One bit? Aw, come on, that wasn't that bad.)

Step Four:

The next option down is Size. By default, the size displayed in the Size pop-up menu is the original size dictated by your digital camera's megapixel capacity (in this case, it's 4288 by 2848 pixels—the size generated by a 12.2-megapixel camera). If you click-and-hold on the Size pop-up menu, you'll see a list of image sizes Camera Raw can generate from your RAW original (the number in parentheses shows the equivalent megapixels that size represents). The sizes with a + (plus sign) by them indicate that you're scaling the image up in size from the original. The − (minus sign) means you're shrinking the size from the original, which quality-wise isn't a problem. Usually, it's fairly safe to increase the size to the next largest choice, but anything above that and you risk having the photo look soft and/or pixelated.

Continued

Step Five:

The last Workflow Options choice is what you want the resolution of your processed file to be. The topic of resolution is something entire training DVDs are dedicated to, so we won't go in-depth about it here, but I'll give you some quick guidelines. If your photo will wind up on a printing press, use 300 ppi (you don't really need that much, but many print shops still think you do, so just play it safe at 300 ppi). When printing to an inkjet printer at larger than 8x10" size, I use 240 ppi (although some argue that the sweet spot for Epson printers is 360 ppi, so you might try printing the same image at both resolutions and compare). For prints smaller than 8x10" (which are viewed at a very close distance), try 300 ppi. If your photos are only going to be viewed on the Web, you can use 72 ppi. (By the way, the proper resolution is debated daily in Photoshop discussion forums around the world, and everybody has their own reason why their number is right. So, if ever you're bored one night….)

Step Six:

When you click OK and then click Open Image in the Camera Raw dialog, your photo is processed using those settings and opened in Photoshop (here's the processed photo in Photoshop with the Image Size dialog open, so you can see the settings). These workflow settings now become your defaults, so you don't have to mess with them again, unless: (a) you want to choose a different size, (b) you need to work in 16-bit, or (c) you need to change the resolution. Personally, I work at the original size taken by my camera, in 8-bit mode, and at a resolution of 240 ppi, so I don't have to change these workflow options very often.

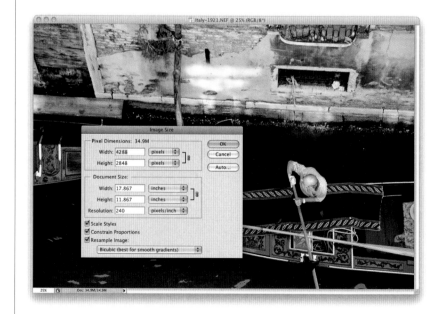

Exposure: 1.0s | Focal Length: 70mm | Aperture Value: ƒ/5.6

Show Stopper
adjusting selected areas

When I pull a title for a chapter, I usually have at least one word in the title that matches what the chapter is about. For example, in my chapter on processing High Dynamic Range images, I named the chapter "High Times," but here I'm breaking my tenth-of-a-century-old tradition and going with a title of a song (by Danity Kane) that describes how I feel about a feature, rather than what the feature is. This actually kinda makes sense in that the ability to make local corrections, and paint on a RAW image, actually is (for photographers anyway) the biggest show-stopping feature in all of Photoshop CS4 (I know—it's a stretch, but work with me here, will ya?). Anyway, it probably doesn't sound like being able to paint on RAW photos is that big an improvement, but if you're a counterfeiter, this is huge! When you're making those $100 counterfeit bills, you really have to pull the maximum detail out of your scanned image, and once you get down to editing with a brush on an 8-bit image, well, the Feds will be just two steps behind you. I remember this one time, I was working on a $20 bill, and I was zoomed in to around 1600%, and I just couldn't make this one part of Andrew Jackson's hair match the original the way I needed to—there just wasn't enough detail in the RAW image, and I thought if I could maybe dodge and burn a bit on the 16-bit RAW original, I'd be outta there early, and maybe I'd get home in time to finish retouching some passports I'd been working on. Unfortunately, at that point, Adobe hadn't invented local adjustments in Camera Raw, and I have to tell you, I went through a number of very expensive printing plates before I finally got it down to where they looked good enough to deliver them to Stanislov. He was so pleased.

Dodging, Burning, and Adjusting Individual Areas of Your Photo

My single favorite feature in all of CS4's Camera Raw is the ability to make non-destructive adjustments to individual areas of your photos (Adobe calls this "localized corrections"). The way they've added this feature is pretty darn clever, and while it's different than using a brush in Photoshop, there are some aspects of it that I'll bet you'll like better. We'll start with dodging and burning, but we'll add more options in as we go.

Step One:

First, do all your regular edits to your photo (exposure, recovery, blacks, etc.). Next, click on the Adjustment Brush tool in the toolbar at the top of the Camera Raw window (as shown here) or just press the letter **K** on your keyboard. When you do this, an Adjustment Brush panel appears on the right side of the window with all the controls for using the Adjustment Brush (seen here).

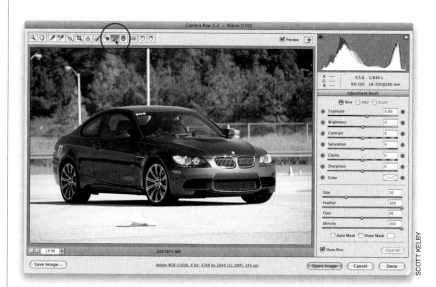

SCOTT KELBY

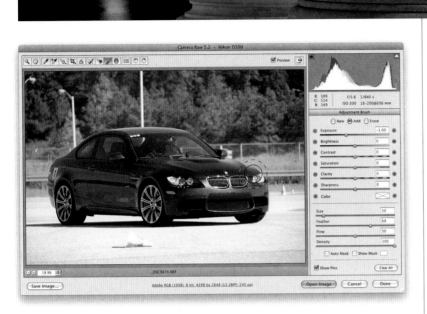

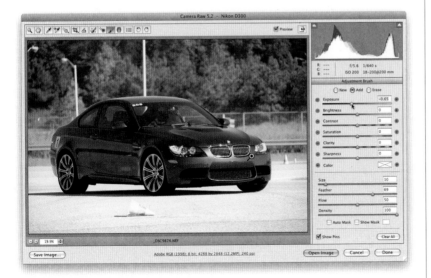

Step Two:

In the example shown here, we want to balance the overall light on the car by darkening (burning) the front of it (which is getting direct sun), and then brightening (dodging) the side of it that's in the shadows. With the Adjustment Brush, you can choose what kind of adjustment you want first, and then you start painting. We'll start with darkening the front of the car, so drag the Exposure slider to the left to –1.00 (also, adjust the size and feather of the brush by using the Size and Feather sliders) and then, with the brush, start painting over the front of the car (as shown here). As you paint, it darkens the areas where you're painting. Luckily, you don't have to know exactly how much darker you want your exposure, because you can change it after the fact (one of my favorite features of this brush).

Step Three:

Paint over the entire front of the car to tone things down a bit there, and then see how it looks to you. If you think it's a bit too dark (I do), then drag the Exposure slider back to the right and it adjusts the part of the car you just painted over (as seen here). So, basically, you choose a starting point for your exposure, and then after you've painted, you can dial in the exposure you want. If you look at the front of the car, you'll see a little green "pin." The pin appears at the place where you started painting, and is your marker for this particular adjustment (darkening the front of the car). You'll see the advantage of these pins in just a moment.

Continued

Step Four:

Now let's lighten the shadow side of the car, but you can't just grab the Exposure slider and drag it over to the right, because it will change the exposure of the front of the car. When you want to adjust a different area of your photo, you first click on the New radio button (shown circled here in red), and then you can paint independently from the first area you painted over. So, go ahead and click on the New radio button, then click the + (plus sign) button to the right of the Exposure slider (I clicked it twice). This bumps the exposure up a bit, and now you're ready to start painting over the side of the car (as shown here). Again, it doesn't matter if the amount of brightening is correct at this point, because you can always change it after the fact. So for now, just paint over the shadow side of the car.

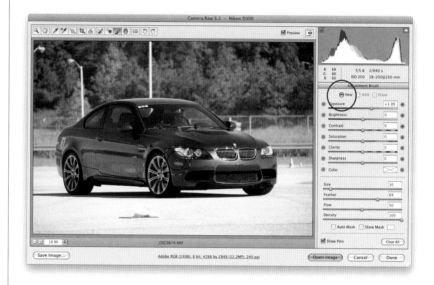

Step Five:

Once you stop painting, you'll notice there's a new green pin on the side of the car at the point you started painting. The side of the car looks a little too bright now, so drag the Exposure slider back to the left a little bit, so it's still brighter, but not quite so bright. Besides the green pin on the side of the car, there's also a light gray pin on the front of the car where you painted earlier. When you see a pin appear in green, it means it's the active pin, and any changes you make in the panel will affect the area represented by that pin. To change to a different pin, just click directly on it, it becomes highlighted in green, and now you're adjusting that area.

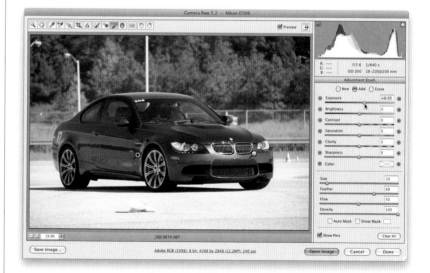

TIP: Changing Brush Sizes

You can change your Adjustment Brush size by using the Left and Right Bracket keys on your keyboard (they're to the right of the letter P). Pressing the **Left Bracket key ([)** makes your brush smaller; pressing the **Right Bracket key (])** makes it bigger.

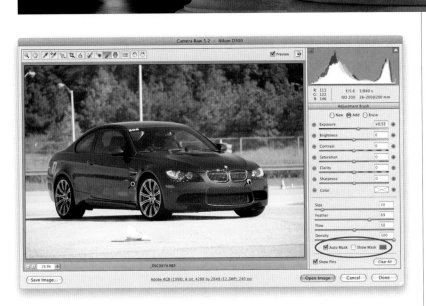

Step Six:

So, how do you know if you've really painted over the entire area you wanted to adjust? How do you know whether you've missed a spot? Well, if you turn on the Auto Mask checkbox near the bottom of the panel and move your cursor directly over a pin, it can show you in a white mask overlay exactly where you painted, so you can see if you missed any areas (here I used a red mask overlay by clicking on the white Mask Overlay color swatch, to the right of the Show Mask checkbox, and then clicking on a shade of red in the Color Picker). This is only visible while your cursor is over the pin. If you want this overlay to stay visible while you're painting, then turn on the Show Mask checkbox at the bottom of the panel. Now that you know where you painted, you can go back and paint over any areas you missed.

Step Seven:

Now let's darken the ground in front of the car. First click on the New radio button at the top of the panel again, lower the Exposure slider, and then start painting over the ground (as shown here). By default, the brush is designed to "build up" as you paint, so if you paint over an area and it's not dark enough, paint another stroke over it again—this build-up amount is controlled by the Flow and Density sliders at the bottom of the panel. The Density slider kind of simulates the way Photoshop's airbrush capabilities work with its Brush tools, but the effect is so subtle here that I don't ever change it from its default setting of 100.

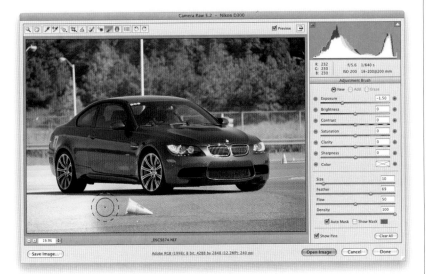

Continued

Step Eight:

You won't have to worry too much about accidentally painting over the car, thanks to Auto Mask (which we turned on in Step Six). It senses where the edges of what you're painting over are (based on color), and it helps to keep you from spilling paint outside the area you're trying to affect. Depending on the image, and what type of object you're trying to paint within, it either does an amazing job, or just a so-so one. Luckily, it works surprisingly well more often than not, so I leave this on all the time, and only turn it off if it's just not working (paint is spilling everywhere). That being said, when you come to the smaller areas right under the car, you should shrink the size of the brush, so it's not tempted to accidentally paint on something it shouldn't. So, go ahead and shrink the size of your brush—using the **Left Bracket key ([)**—and paint the ground directly under the car (as shown here).

TIP: Deleting Adjustments

If you want to delete any adjustment you've made, click on the adjustment's pin to select that adjustment (the center of the pin turns black), then press the Delete (PC: Backspace) key on your keyboard.

Step Nine:

When you're done painting over the ground, you'll see a green pin appear (you can see where I started painting by looking at the green pin shown circled here in red). If you want the ground darker (I do), drag the Exposure slider to the left (as shown here). You can continue in Add mode by painting over the background behind the car (the trees, fence, etc.) to darken that area the same amount as you did the ground.

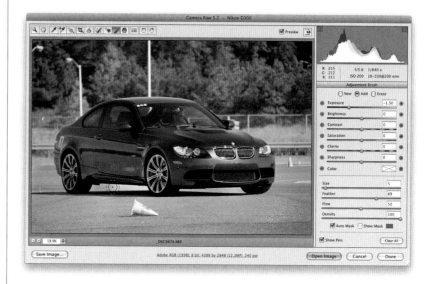

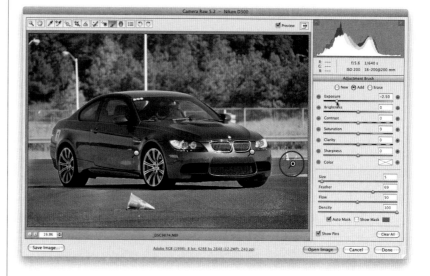

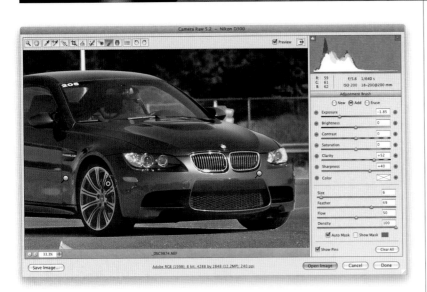

Step 10:

Besides just brightening and darkening areas (dodging and burning), I think one of the slickest things about the Adjustment Brush is that you can add additional adjustments, like Clarity or Sharpening, over just the areas you want them. For example, I'd like to make sure all the chrome and grill parts of the car really stand out, so here's what to do: First, select the Zoom tool **(Z)** from the toolbar and click on the image to zoom in, then click on the New radio button at the top of the panel. Now, drag the Exposure, Clarity, and Sharpness sliders to the right (as I did here), and then paint over the wheels, lights, front top grill, and bottom grill. As you do, those areas become sharper and more contrasty. I noticed that when I did that, though, the hood of the car, right above the grill, was affected as well, and so was the area above the headlight on the left in the image. So, here I moved my cursor over the wheel (where the green pin is), to make the mask visible, so you can see where I accidentally painted onto those areas.

Step 11:

To erase any areas that we didn't want to have effects, you can either click on the Erase radio button at the top of the panel (as shown here) or just press-and-hold the **Option (PC: Alt) key**, which temporarily switches you to Erase mode. Now paint over the hood, right above the grill, and above the headlight on the left in the image to remove the clarity and sharpening from those areas.

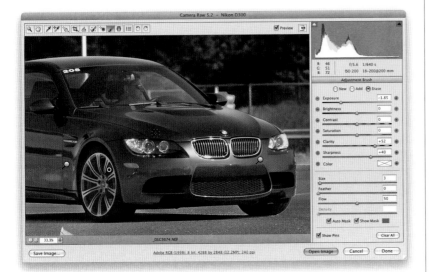

Continued

TIP: Choosing What to Edit

If you have multiple pins, and you drag a slider, Camera Raw will adjust whichever pin is currently active (the pin filled with green and black). So to choose which adjustment you want to edit, click directly on the pin first to select it, then make your changes.

Step 12:

Here's a before/after, and there's also a third version—one where the light poles, the cone, and other distractions have been removed in Photoshop. I did a little quick video for you on how I did that, and you can find it at **www.kelbytraining .com/books/cs4book**. The password is **brush**. Here are a couple of other things about the Adjustment Brush you'll want to know: The Feather slider controls how soft the brush edges are—the higher the number, the softer the brush (I paint with a soft brush about 90% of the time). For a hard-edged brush, set the Feather slider to 0. The Flow slider controls the amount of paint that comes out of the brush (I leave the Flow set at 50 most of the time).

TIP: Resetting a Slider

There's an important thing to note about how the sliders and + and − (plus and minus sign) buttons work. If you click on a + or − button beside a slider, it resets all the other sliders to their default setting, and increases or decreases that slider, so you're just painting with that one adjustment. However, if you want multiple adjustments applied as you paint, don't click on the + or − buttons (or it will reset everything else), just drag the sliders you want instead.

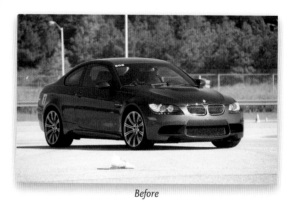

Before

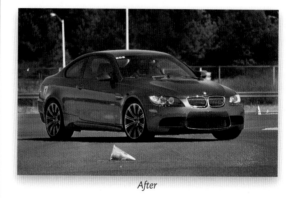

After

Edited in Photoshop

Camera Raw has had the Spot Removal tool since Photoshop CS3, and you could pretty much use it for removing blemishes, and anything else that used to require you to open the image in Photoshop. Well, in CS4, with the Adjustment Brush and its ability to smooth skin, you can now do more than ever right in Camera Raw (just remember to make these adjustments after you've already toned the image in the Basic panel, and then removed any blemishes—always do those first, before you use the Adjustment Brush for retouching).

Retouching Portraits in Camera Raw

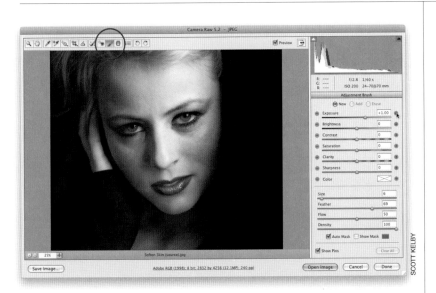

Step One:
In the portrait shown here, we want to make three retouches: (1) we want to lighten and brighten the eyes, (2) we want to soften her skin, and (3) we want to sharpen her eyes and eyelashes. Before CS4, these were all things we'd have to go into Photoshop for, but now we can do all three right here in Camera Raw. Start by selecting the Adjustment Brush **(K)** from the toolbar up top, then in the Adjustment Brush panel on the right, click twice on the + (plus sign) button to the right of the Exposure slider (as shown here), to increase the exposure.

Continued

Step Two:

We'll start with brightening the whites of her eyes. First, select the Zoom tool **(Z)** from the toolbar, and click on the image to zoom in a bit closer, so you can see the eyes clearly. Go back to the Adjustment Brush **(K)**, choose a small brush size using the Size slider, then paint directly over the whites of her eyes (as shown here) and her irises to brighten them. If they look too bright, we can always decrease the Exposure amount after the fact.

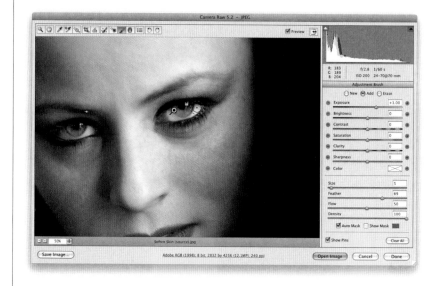

Step Three:

Click on the New radio button at the top of the panel, then click the – (minus sign) button beside Clarity four times to set the Clarity amount at –100, and drag the Sharpness slider to the right to +25. Increase the size of your brush (by using either the Size slider or the **Left or Right Bracket keys** on your keyboard), and then paint over her skin to soften it, avoiding any detail areas like the eyebrows, eyelids, lips, nostrils, hair, etc. (as shown here). Lastly, click on the New radio button again, set the Sharpness to +100, and Clarity to +25, then paint over the irises of her eyes and eyelashes to help make them look sharper and more crisp, which completes the retouch (a before/ after is shown on the next page).

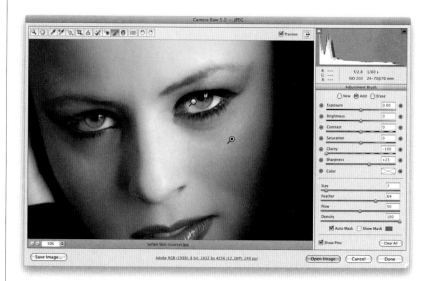

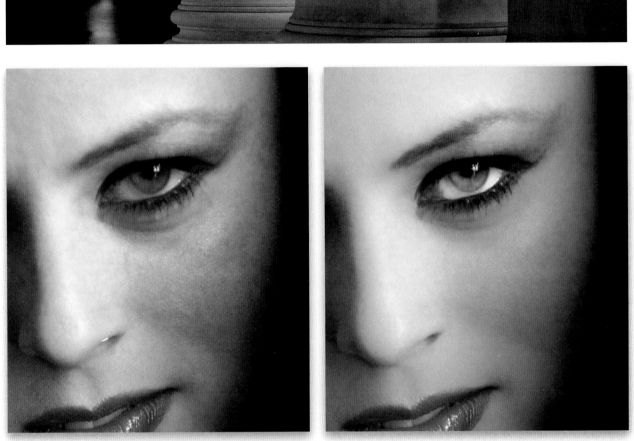

In the After photo on the right, the whites and irises of her eyes are now brighter, and her skin has been softened

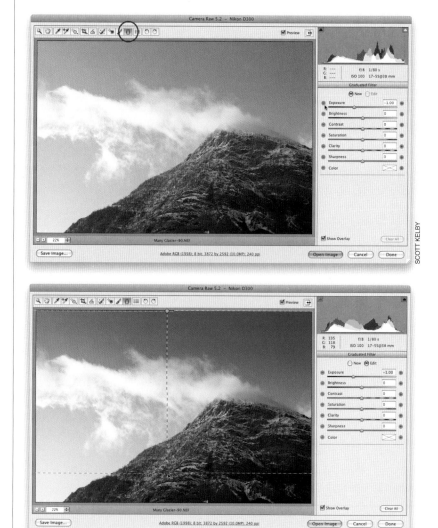

Fixing Skies (and Other Stuff) with the Graduated Filter

The new Graduated Filter (which acts more like a tool) lets you recreate the look of a traditional neutral density gradient filter (these are glass or plastic filters that are dark on the top and then graduate down to fully transparent). They're popular with landscape photographers because you're either going to get a photo with a perfectly exposed foreground, or a perfectly exposed sky, but not both. However, with the way Adobe implemented this feature, you can use it for much more than just neutral density gradient effects (although that probably will still be its number one use).

Step One:
Start by selecting the Graduated Filter tool **(G)** up in the toolbar (it's shown circled in red here). When you click on it, its options panel appears (shown here) with a set of effects you can apply that are similar to the ones you can apply using the Adjustment Brush. Here we're going to replicate the look of a traditional neutral density gradient filter and darken the sky. Start by dragging the Exposure slider to the left, or just click on the – (minus sign) button two times to get to –1.00 (as seen here).

Step Two:
Press-and-hold the Shift key (to keep your gradient straight), click at the top center of your image, and drag straight down until you reach nearly the bottom of the photo (as shown here). Generally, you'll want to stop dragging the gradient before it reaches the horizon line, or it will start to darken your properly exposed foreground, but in this case, where there's sky almost all the way to the bottom of the photo, I dragged down about 80% of the way to the bottom. You can see the darkening effect it has on the sky and the photo already looks more balanced. *Note:* Just let go of the Shift key to drag the gradient in any direction.

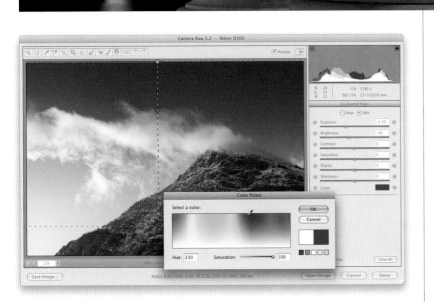

Step Three:

The green pin shows the top of your gradient; the red pin shows the bottom. In this case, we'd like the sky a little darker still, so drag the Brightness (midtones) slider to the left a bit to darken the midtones in the sky (don't click the + or − [plus or minus sign] buttons, or it will reset the Exposure slider to 0). What's nice about this tool is, like the Adjustment Brush, once we've dragged out the Graduated Filter, we can add other effects to that same area. In this case, we'd like the sky bluer, so click on the Color swatch, and when the Color Picker appears, click on a blue color (as shown here) to add more blue to the sky, and complete our effect.

TIP: Gradient Tips

You can reposition your gradient after the fact—just click-and-drag downward on the line connecting the green and red pins to move the whole gradient down. Click-and-hold on the red pins to rotate your gradient after it's in place. You can also have more than one gradient (click on the New radio button at the top of the panel) and to delete a gradient, just click on it and press the Delete (PC: Backspace) key.

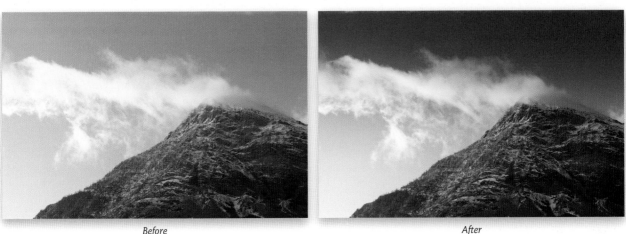

Before

After

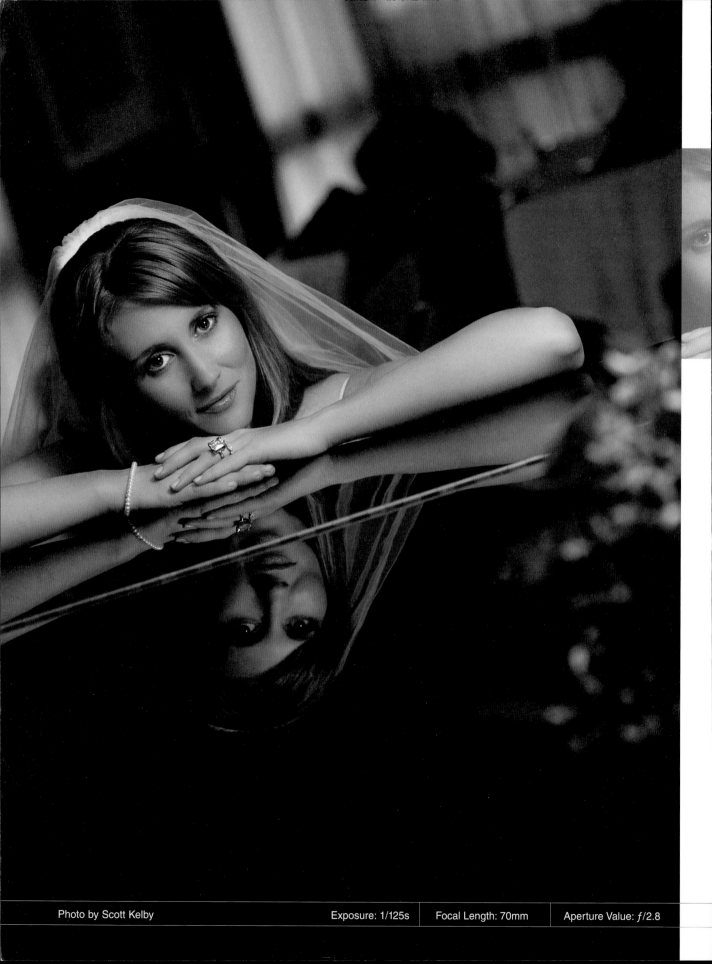

Exposure: 1/125s | Focal Length: 70mm | Aperture Value: ƒ/2.8

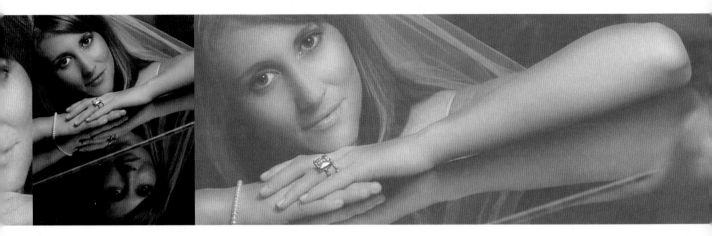

Resized
resizing and cropping your images

I could only find one song with the title "Resized," and I think it's a perfect fit for a chapter on resizing and cropping your photos. The song is by a band called Bungle and this particular song features Laura Pacheco. It's from their album *Down to Earth*. I'm telling you this like you're going to go and buy the CD, but trust me—you're not. That's because I'm going to try and talk you out of doing just that. Here's why: the full-length song is five minutes and 55 seconds. After hearing just the free 30-second preview of it on Apple's iTunes Store, I imagine there are some people (not you, mind you, but some people) who might become somehow adversely affected by its super-fast-paced hypnotic beat and might do things that they might not normally do while listening to selections from the Eagles or James Taylor.

In fact, I would advise against even listening to the 30-second free preview if any of these conditions are present: (1) it's late at night and you have all the lights out, (2) the lights are out and you have a strobe light flashing, (3) the lights are out, a strobe is flashing, and you're holding a large butcher knife, or (4) the lights are out, a strobe is flashing, you're holding a large butcher knife, and you've just been fired from your job. "Resized" would make a great background track for *House of the Dead VII*, because it's not one of those gloomy Metallica songs—it actually has a fast pop-like beat, but at the same time, it makes you want to grab a butcher knife (not me, of course, and certainly not you, but you know…people like that one really quiet guy who works in accounting. I'd keep him away from that song. Especially if he ever gets fired).

Three Key Things About Working in CS4's New Interface

In each new version of Photoshop, Adobe tweaks the interface a bit to find ways to manage loads of panels and filters and tools in a way that makes working in Photoshop easier and more efficient. In CS4, Adobe made some pretty major changes, and luckily it seems like almost all of them are improvements. There are dozens of little changes, and I've interspersed some of them throughout the book where appropriate, but there are a few major things I think we need to tackle up front, especially if coming to CS4 from CS3 or an earlier version.

Tabbed Documents:

To help you manage your open images, CS4 has tabbed documents, so if you have one image open, and open a second or third image, it appears tabbed within the current window (kind of like tabs in a Web browser). You can see here that I've got four images open—all four appear as tabs (displaying the image names) across the top of this window. You can toggle through these tabs to see each image by pressing **Control-Tab**. To close an image, click on the little X at the right end of its tab. To put the images in their own separate windows, choose Float All in Windows, under Arrange in the Window menu.

Dragging Between Documents:

A lot of people like this tabbed environment, but sadly, I'm not one of them, because we can't drag-and-drop layers between documents as easily. Now we have to drag the layer up to the tab of the window we want to move it to. Then, we pause a moment while that image becomes visible, and then we have to move our cursor out over the image area and release the mouse. To me, that's just plain clunky, and it's why I turned tabbing off by going under the Photoshop menu (PC: File menu), under Preferences, and choosing Interface, then turning off the checkbox for Open Documents as Tabs.

Rotate Your View:

Another new CS4 interface feature is the ability to rotate your viewing area. If you're working with a Wacom tablet, and you like to keep it in your lap while retouching or painting, you're probably going to love this feature, because it lets you position the canvas in a very natural position for working with a wireless pen. To rotate your view, just click the Rotate View tool (found up in the Application Bar up top—it's shown circled here in red—or just press **R**), and then click-and-hold in your image. A compass overlay will appear in the center of your image, and now you can just drag to rotate your view (by the way, this rotating doesn't actually rotate the pixels, just your view, so don't worry—you're not messing up your image). If you want every new image opened at this same rotated view, turn on the Rotate All Windows checkbox up in the Options Bar. To return to a normal view, click on the tool again and press the Reset View button also in the Options Bar, or simply double-click on the tool itself in the Toolbox, or press the **Esc key**.

For Mac Users (Application Frame):

This is only for Mac users, because the Windows version of Photoshop has always had this feature. By turning this feature on (you go under the Window menu and choose Application Frame), it puts Photoshop in a floating window just like a Web browser (as seen here), and like a Web browser window, Photoshop is now resizable (just grab the bottom-right corner and drag inward). This also puts a gray background behind your working area, so you won't accidentally click on the desktop background and leave Photoshop, which is a feature Windows users coming over to the Mac really like.

Cropping Photos

After you've sorted your images in Adobe Bridge, one of the first editing tasks you'll probably undertake is cropping a photo. There are a number of different ways to crop a photo in Photoshop. We'll start with the basic garden-variety options, and then we'll look at some ways to make the task faster and easier. At the end of this project, I've added a new way to see your cropping that won fame when it was added to Adobe Photoshop Lightroom, but I figured out an easy way to get the exact same cropping trick here in Photoshop CS4.

Step One:
Press the letter **C** to get the Crop tool (you could always select it directly from the Toolbox, but I only recommend doing so if you're charging by the hour).

Step Two:
Click within your photo and drag out a cropping border. The area to be cropped away will appear dimmed (shaded). You don't have to worry about getting your crop border right when you first drag it out, because you can edit the border by clicking-and-dragging the points that appear in each corner and at the center of each side.

SCOTT KELBY

Step Three:

If you don't like seeing your photo with the cropped-away area appearing shaded (as in the previous step), you can toggle this shading feature off/on by pressing the **Forward Slash (/) key** on your keyboard. When you press the Forward Slash key, the border remains in place, but the shading is turned off (as seen here).

Step Four:

While you have the cropping border in place, if you need to rotate your photo, you can do that as well (so basically, you're doing two things at the same time: cropping and rotating). You rotate the cropping border by just moving your cursor anywhere outside the border. When you do this, the cursor will change into a double-headed arrow. Just click, hold, and drag up (or down) and the cropping border will rotate in the direction you choose (as shown here).

TIP: For Mac Users Only

Not just Mac users, but specifically Mac users using new MacBooks, because Apple added a new feature called Multi-Touch gestures, which lets you make certain finger movements on your MacBook's trackpad to control things within your Mac. Adobe leveraged these new gestures in CS4 by assigning some Photoshop features to them. For example, to rotate the canvas, just put your fingers together like you're trying to pick up a quarter by the edges, then rotate around (like you're rotating the coin), and Photoshop's canvas will rotate along with you. You can zoom in by pinching your fingers together; zoom out by spreading your fingers (iPhone users will feel right at home).

Continued

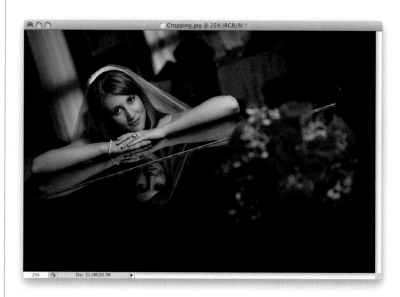

Step Five:
Once you have the cropping border right where you want it, press the **Return (PC: Enter) key** to crop your image. The final cropped image is shown here, where we cropped off some of the windows above and to the left (the daylight coming through them was drawing your attention over there, which we don't want), and we also cropped away a distracting chair on the right and a table on the left. You can see the uncropped image on the previous page.

TIP: Deciding Not to Crop
If you drag out a cropping border and then decide you don't want to crop the image, you can either press the **Esc key** on your keyboard, click on the "No!" symbol in the Options Bar, or just click on a different tool in the Toolbox, which will bring up a dialog asking if you want to crop the image. Click on the Don't Crop button to cancel your crop.

Step Six:
Another popular way to crop is to skip the Crop tool altogether and just use the Rectangular Marquee tool **(M)** to put a selection around the area of your photo you want to keep. You can reposition the selection by clicking inside the selected area and dragging. When your selection is positioned where you want it, go under the Image menu and choose Crop. The area outside your selection will be cropped away instantly. Press **Command-D (PC: Ctrl-D)** to Deselect.

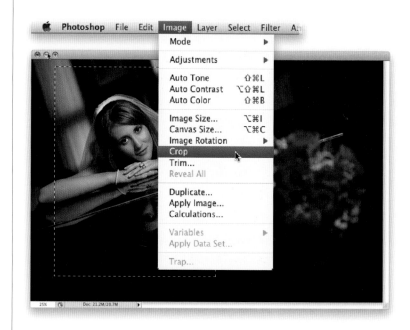

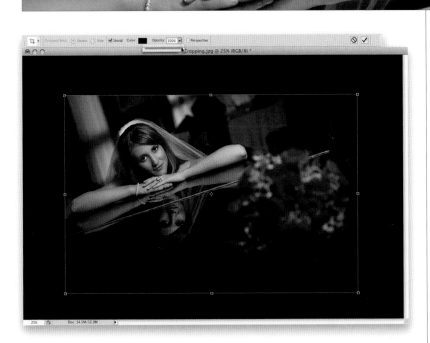

Step Seven:

Okay, are you ready for the ultimate cropping experience? (There's a sentence that's probably never been written before.) It's inspired by Lightroom's popular Lights Out full-screen cropping method. In Lights Out mode, as you crop, it surrounds your photo with solid black, so you see a live preview of what the final cropped photo will look like as you crop. It's pretty sweet, and once you try it, you won't want to crop any other way. Luckily, you can do the same thing here in Photoshop CS4. Start by taking the Crop tool and dragging it over part of your photo (it doesn't matter where or what size). In the Options Bar, there's an Opacity field, which lets you choose how light the area you're cropping away is going to display onscreen. Click on the downward-facing triangle and increase the Opacity to 100%, so it's solid black (as shown here).

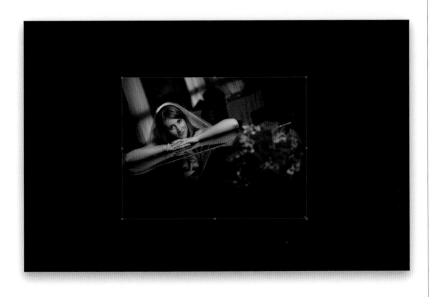

Step Eight:

Now press the **Esc key** to remove your cropping border. Press **Tab**, then the **F key** twice to hide all of Photoshop's panels and menus, plus this centers your photo onscreen surrounded by solid black (as seen here). That's it—you're in "Lights Out cropping mode" because you made any cropped-away area solid black, which matches the black full-screen area surrounding your photo. So, try it yourself—get the Crop tool again, drag out a cropping border, then drag any one of the cropping handles inward and you'll see what I mean. Pretty sweet, eh? When you're done cropping, press **Return (PC: Enter)**, then press the letter **F** once more to leave full-screen mode, then press the **Tab key** to bring your panels, menus, and Toolbox back.

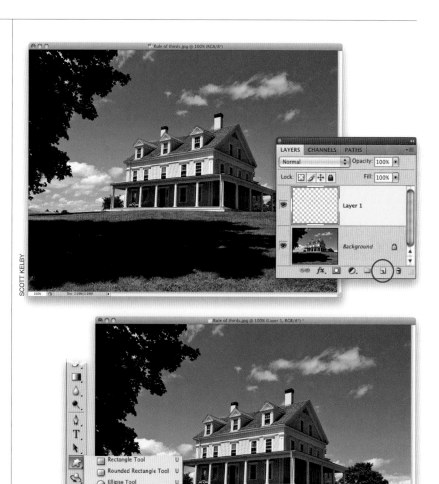

Cropping Using the "Rule of Thirds"

The "rule of thirds" is a trick that photographers sometimes use to create more interesting compositions. Basically, you visually divide the image you see in your camera's viewfinder into thirds, and then you position your horizon so it goes along either the top imaginary horizontal line or the bottom one. Then, you position the subject (or focal point) at the center intersections of those lines. But if you didn't use the rule in the viewfinder, no sweat! You can use Photoshop to crop your image using the rule of thirds to create more appealing compositions.

Step One:
Open the photo you want to apply the rule-of-thirds cropping technique to (the shot here is poorly composed, with the subject right in the center—it just screams "snapshot!"). So, start by creating a new blank layer by clicking on the Create a New Layer icon at the bottom of the Layers panel (it's circled in red here).

Step Two:
Now, go to the Toolbox and get the Custom Shape tool (as shown here), or press **Shift-U** until you have it.

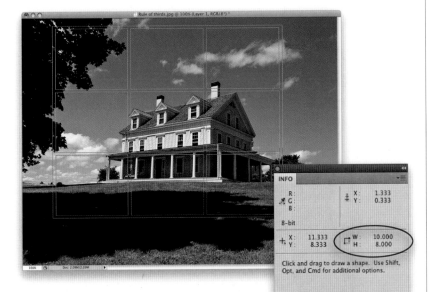

Step Three:
The Custom Shape tool's options will appear up in the Options Bar. First, click on the third icon from the left (so your shape will draw pixels, instead of a Shape layer or a path). Next, click on the downward-facing triangle to the immediate right of the current shape, and the Shape Picker will pop down (as shown here). In the default set of shapes there is a Grid shape, and that shape is already divided into equal thirds, so click on that shape to choose it.

Step Four:
You're going to need to see the exact size you want to crop down to, so go under the Window menu and choose Info. This brings up the Info panel (shown here), which displays the Width and Height for any shape you draw. So now take the Custom Shape tool and drag out a grid, and as you drag, keep an eye on the Info panel's Width and Height fields (our goal is to print an 8x10" print, so we're going to want our final grid size to be 8" tall by 10" wide). Now, start dragging (don't worry about positioning the grid right yet—just keep your eye on that Info panel, and your wrist steady, so you can drag out exactly an 8x10" grid. Also, don't worry about damaging your photo— that's why we created that new blank layer in Step One, so your grid will appear on this new layer).

Continued

Step Five:

Press the letter **V** to switch to the Move tool, and click-and-drag your rule-of-thirds grid into the position you'd like it (ideally, your subject, or point of interest, would appear at one of the four places within the grid where the lines intersect. I've marked all four here as a visual reminder).

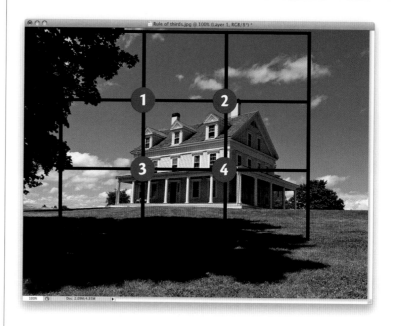

Step Six:

Once the grid is positioned right where you want it, get the Rectangular Marquee tool **(M)** and click-and-drag out a selection that is the exact same size as the grid (as shown here).

TIP: Jump to Any Tool and Back Automatically

File this under "Did it always work like this?" In CS4, while you're working with one tool, you can temporarily access another tool, and when you're done, automatically switch back. Just use the one-key shortcut for the tool you want (like **V** for the Move tool, or **B** for the Brush tool), but don't just press it once, or it makes the switch permanent. Instead, just press the letter and hold it, use the tool, then release the letter, and you're right back to the tool you started with.

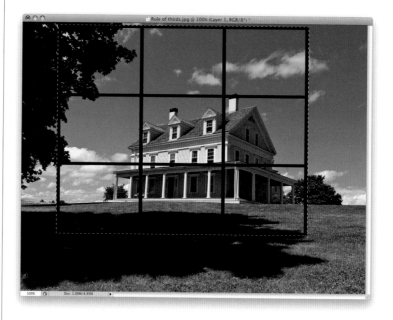

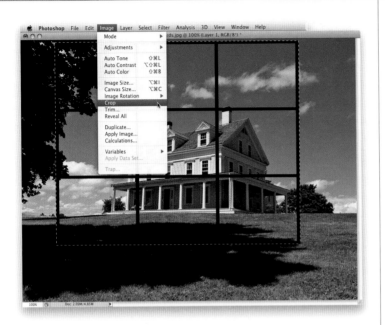

Step Seven:
Now go under the Image menu and choose Crop (as shown here).

TIP: Cropping to Add Canvas
You can also use the Crop tool to make your canvas area bigger. First, open a photo, then press the letter **F** (to make the gray area outside your photo visible). Take the Crop tool **(C)**, and drag out over a small area inside your photo. Now, you can drag any corner or side point of your cropping border right outside your image area, off into that gray area surrounding your photo (so you can visually position where you want more canvas area). Then, when it's right where you want it, press the **Return (PC: Enter) key** and the area outside your image area now becomes white canvas area. Not bad, eh?

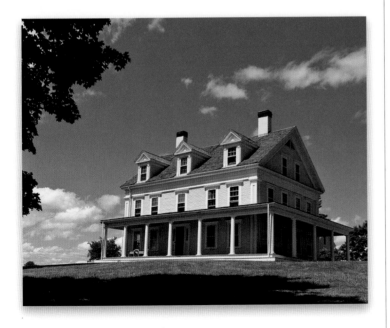

Step Eight:
When you choose Crop from that menu, it crops the photo based on your current selection, so basically it crops the photo down to the edges of your grid. Now, press **Command-D (PC: Ctrl-D)** to Deselect, and then go to the Layers panel and drag Layer 1 (your grid layer) into the Trash (at the bottom of the Layers panel) to delete it. You can now see your final cropped photo—cropping using the rule of thirds.

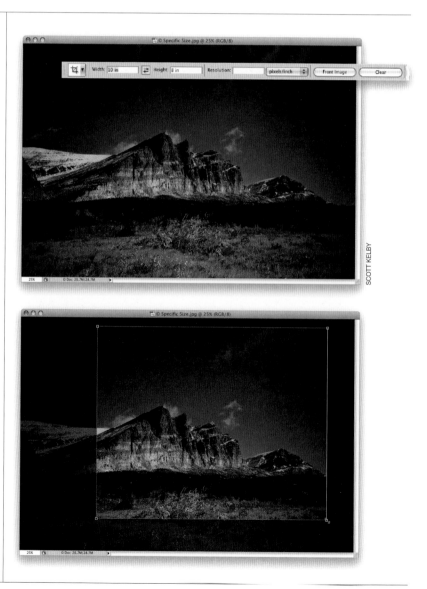

Cropping to a Specific Size

If you're outputting photos for clients, chances are they're going to want them in standard sizes so they can easily find frames to fit their photos. If that's the case, you'll find this technique handy, because it lets you crop any image to a predetermined size (like 5x7", 8x10", and so on).

Step One:
Let's say our image measures roughly 16x10", and we want to crop it to be a perfect horizontal 10x8". First, press the **C key** to get the Crop tool, and up in the Options Bar on the left, you'll see Width and Height fields. Enter the size you want for the width, followed by the unit of measurement you want to use (e.g., "in" for inches, "px" for pixels, "cm" for centimeters, "mm" for millimeters, etc.). Next, press the **Tab key** to jump over to the Height field and enter your desired height, again followed by the unit of measurement.

Step Two:
Click within your photo with the Crop tool and drag out a cropping border. You'll notice that as you drag, the border is constrained to a horizontal shape, and once you release the mouse button, no side points are visible—only corner points. Whatever size you make your border, the area within that border will become a 10x8" photo.

Step Three:
After your cropping border is onscreen, you can reposition it by moving your cursor inside the border (your cursor will change to an arrow). You can now drag the border into place, or use the **Arrow keys** on your keyboard for more precise control. When it looks right to you, press **Return (PC: Enter)** to finalize your crop, and the area inside your cropping border will be 10x8". (I made the rulers visible by pressing **Command-R [PC: Ctrl-R]**, so you could see that the image measures exactly 10x8".)

TIP: Clearing the Width and Height
Once you've entered a Width and Height in the Options Bar, those dimensions will remain in place until you clear them. To clear the fields (so you can use the Crop tool for freeform cropping to any size), just go up in the Options Bar and click on the Clear button (while you have the Crop tool active, of course).

COOLER TIP: Cropping to Another Photo's Size
If you already have a photo that is the exact size and resolution that you'd like to apply to other images, you can use its settings as the crop dimensions. First, open the photo you'd like to resize, and then open your ideal-size-and-resolution photo. Get the Crop tool, and then in the Options Bar, click on the Front Image button. Photoshop will automatically input that photo's dimensions into the Crop tool's Width, Height, and Resolution fields. All you have to do is crop the other image, and it will share the exact same specs as your ideal-size photo.

The Trick for Keeping the Same Aspect Ratio When You Crop

Okay, let's say you want to crop a photo down in size, but you want to keep the aspect ratio the same as the original photo from your camera (so when you crop, the photo will be smaller in size, but it will have the exact same width-to-height ratio as the original photo). You could pull out a calculator and do the math to figure out what the new smaller size should be, but there's a faster, easier, and more visual way. (By the way, although the Crop tool within Camera Raw gives you a menu of preset ratios, you can only use those presets on a RAW image, but this technique works on any photo.)

Step One:
Open the photo you want to crop. Press **Command-A (PC: Ctrl-A)** to put a selection around the entire photo.

Step Two:
Go under the Select menu and choose Transform Selection. This lets you resize the selection itself, without resizing the photo within the selection (which is what usually happens).

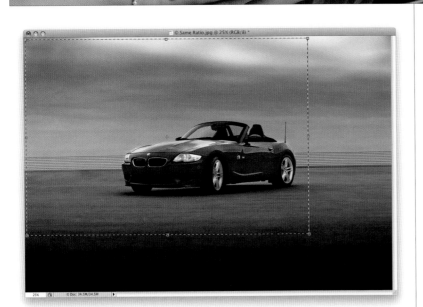

Step Three:
Press-and-hold the Shift key, grab a corner point, and drag inward to resize the selection area. Because you're holding the Shift key as you scale, the aspect ratio (the same ratio as your original photo) remains exactly the same. Once you get the selection near the size you're looking for, move your cursor inside the bounding box, and then click-and-drag to position your selection where you want to crop. Then, press **Return (PC: Enter)** to complete your transformation.

Step Four:
Now that you've used your selection to determine the crop area, it's time to actually crop, so go under the Image menu and choose (no big surprise here) Crop.

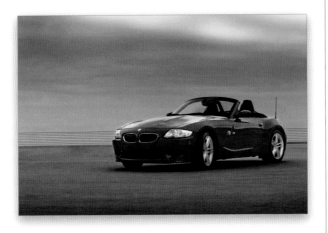

Step Five:
Once you choose Crop, the image is then cropped to fit within your selection, so just press **Command-D (PC: Ctrl-D)** to Deselect. Because you followed the steps shown here, your cropped image maintains the same aspect ratio as your original photo.

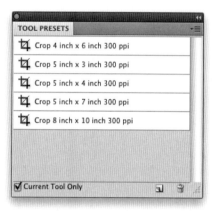

Creating Your Own Custom Crop Tools

Although it's more of an advanced technique, creating your own custom tools isn't complicated. In fact, once you set them up, they will save you time and money. We're going to create what are called "tool presets." These tool presets are a series of tools (in this case, Crop tools) with all our option settings already in place. So we'll create a 5x7", 6x4", or whatever size Crop tool we want. Then, when we want to crop to 5x7", all we have to do is grab the 5x7" Crop tool preset. Here's how:

Step One:
Press the letter **C** to switch to the Crop tool, and then go under the Window menu and choose Tool Presets to bring up the Tool Presets panel (or click on it in the panel dock on the right side of your screen, where it's nested by default). You'll find that five Crop tool presets are already there, all set to 300 ppi. That's great if you need these sizes at 300 ppi; but if you don't, you might as well drag these tool presets onto the Trash icon at the bottom of the panel. (Also, make sure that the Current Tool Only option is turned on at the bottom of the panel so you'll see only the Crop tool's presets, and not the presets for every tool.)

Step Two:
Go up to the Options Bar and enter the dimensions for the first tool you want to create (in this example, we'll create a Crop tool that crops to a wallet-size image). In the Width field, enter 2. Then press the **Tab key** to jump to the Height field and enter 2.5. *Note:* If you have the Rulers set to Inches under the Units section in Photoshop's Units & Rulers Preferences **(Command-K [PC: Ctrl-K])**, when you press the Tab key, Photoshop will automatically insert "in" after your numbers, indicating inches.

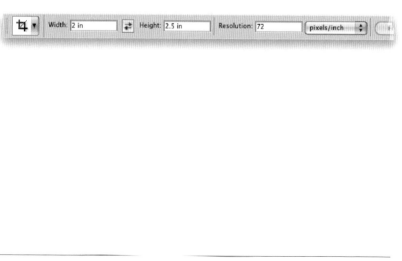

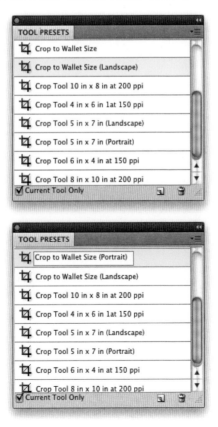

Step Three:
In the Tool Presets panel, click on the Create New Tool Preset icon at the bottom of the panel (to the left of the Trash icon). This brings up the New Tool Preset dialog, in which you can name your new preset. Name it "Crop to Wallet Size," click OK, and the new tool is added to the Tool Presets panel.

Step Four:
Continue this process of typing in new dimensions in the Crop tool's Options Bar and clicking on the Create New Tool Preset icon until you've created custom Crop tools for the sizes you use most. Make sure the name is descriptive (for example, add "Portrait" or "Landscape").

TIP: Changing the Names of Presets
If you need to change the name of a preset, just double-click directly on its name in the panel, and then type in a new name.

Continued

Step Five:

Chances are your custom Crop tool presets won't be in the order you want them, so go under the Edit menu and choose Preset Manager. In the resulting dialog, choose Tools from the Preset Type pop-up menu, and scroll down until you see the Crop tools you created. Now just click-and-drag them to wherever you want them to appear in the list, and then click Done.

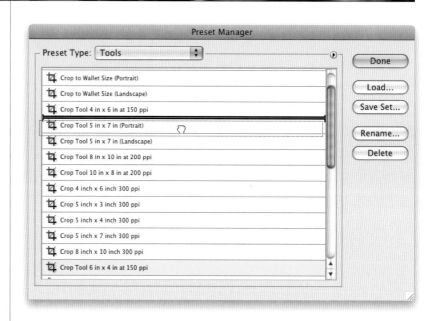

Step Six:

Now you can close the Tool Presets panel because there's an easier way to access your presets: With the Crop tool selected, just click on the Crop icon on the left in the Options Bar. A pop-up menu of tools will appear. Click on a preset, drag out a cropping border, and it will be fixed to the exact dimensions you chose for that tool. Imagine how much time and effort this is going to save (really, close your eyes and imagine... mmmm...tool presets...yummy...).

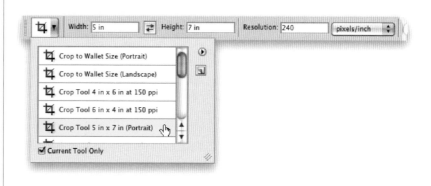

Photoshop's dialog for creating new documents has a pop-up menu with a list of preset sizes. You're probably thinking, "Hey, there's a 4x6", 5x7", and 8x10"— I'm set." The problem is there's no way to switch the resolution of these presets (so the Portrait, 4x6 will always be a 300 ppi document). That's why creating your own custom new document sizes is so important. Here's how:

Custom Sizes for Photographers

Step One:
Go under the File menu and choose New. When the New dialog appears, click on the Preset pop-up menu to reveal the list of preset types, and choose Photo. Then click on the Size pop-up menu to see the preset sizes, which include 2x3", 4x6", 5x7", and 8x10" in both portrait and landscape orientation. The only problem with these is that their resolution is set to 300 ppi by default. So, if you want a different size preset at less than 300 ppi, you'll need to create and save your own.

Step Two:
For example, let's say that you want a 5x7" set to landscape (that's 7" wide by 5" tall). First choose Photo from the Preset pop-up menu, then choose Landscape, 5x7 from the Size pop-up menu. Choose your desired Color Mode, and then enter a Resolution (I entered 212 ppi, which is enough for me to have my image printed on a high-end printing press). Once your settings are in place, click on the Save Preset button.

Continued

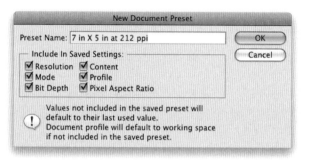

Step Three:
This brings up the New Document Preset dialog. In the Preset Name field, enter your new resolution at the end of the size. You can turn on/off the checkboxes for which parameters you want saved, but I use the default setting to include everything (better safe than sorry, I guess).

Step Four:
Click OK and your new custom preset will appear in the New dialog's Preset pop-up menu. You only have to go through this once. Photoshop CS4 will remember your custom settings, and they will appear in this Preset pop-up menu from now on.

Step Five:
If you decide you want to delete a preset, it's simple—just open the New dialog, choose the preset you want to delete from the Preset pop-up menu, and then click the Delete Preset button. A warning dialog will appear asking you to confirm the delete. Click Yes, and it's gone!

If you're used to resizing scans, you'll find that resizing images from digital cameras is a bit different, primarily because scanners create high-res scans (usually 300 ppi or more), but the default settings for many digital cameras produce an image that is large in physical dimensions, but lower in pixels-per-inch (usually 72 ppi). The trick is to decrease the physical size of your digital camera image (and increase its resolution) without losing any of its quality. Here's the trick:

Resizing Digital Camera Photos

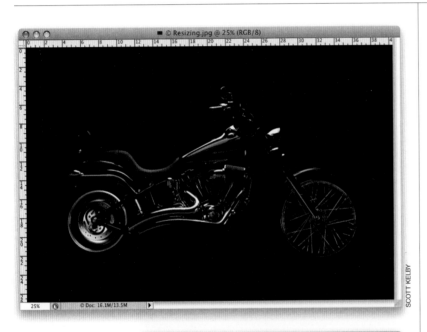

SCOTT KELBY

Step One:
Open the digital camera image that you want to resize. Press **Command-R (PC: Ctrl-R)** to make Photoshop's rulers visible. As you can see from the rulers, the photo is about 40" wide by 27" high.

Step Two:
Go under the Image menu and choose Image Size (or press **Command-Option-I [PC: Ctrl-Alt-I]**) to bring up the Image Size dialog. Under the Document Size section, the Resolution setting is 72 ppi. A resolution of 72 ppi is considered "low resolution" and is ideal for photos that will only be viewed onscreen (such as Web graphics, slide shows, and so on), but it's too low to get high-quality results from a color inkjet printer, color laser printer, or for use on a printing press.

Continued

Step Three:

If we plan to output this photo to any printing device, it's pretty clear that we'll need to increase the resolution to get good results. I wish we could just type in the resolution we'd like it to be in the Resolution field (such as 200 or 300 ppi), but unfortunately this "resampling" makes our low-res photo appear soft (blurry) and pixelated. That's why we need to turn off the Resample Image checkbox (it's on by default). That way, when we type in a Resolution setting that we need, Photoshop automatically adjusts the Width and Height of the image down in the exact same proportion. As your Width and Height come down (with Resample Image turned off), your Resolution goes up. Best of all, there's absolutely no loss of quality. Pretty cool!

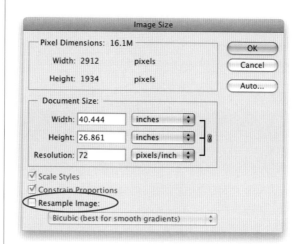

Step Four:

Here I've turned off Resample Image and I entered 150 in the Resolution field for output to a color inkjet printer. (I know, you probably think you need a lot more resolution, but you usually don't.) This resized my image to almost 13x19", so with a little bit of cropping I can easily output a 13x19" print (which happens to be the maximum output size for my Epson Stylus Photo R2880—perfect!).

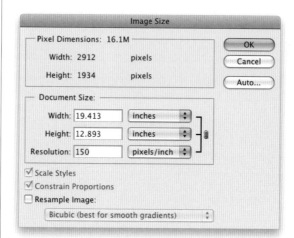

Step Five:

Here's the Image Size dialog for our source photo, and this time I've increased the Resolution setting to 212 ppi for output to a printing press. (Again, you don't need nearly as much resolution as you'd think.) As you can see, the Height of my image is no longer 27"—it's now just over 9". The Width is no longer 40"—now it's just over 13".

Step Six:

When you click OK, you won't see the image window change at all—it will appear at the exact same size onscreen—but look at the rulers. You can see that it's now about 9" high by about 13.75" wide. Resizing using this technique does three big things: (1) it gets your physical dimensions down to size (the photo now fits easily on an 11x17" sheet); (2) it increases the resolution enough so you can output this image on a printing press; and (3) you haven't softened, blurred, or pixelated the image in any way—the quality remains the same—all because you turned off Resample Image. *Note:* Do not turn off Resample Image for images that you scan on a scanner—they start as high-res images in the first place. Turning Resample Image off is only for low-res photos taken with a digital camera.

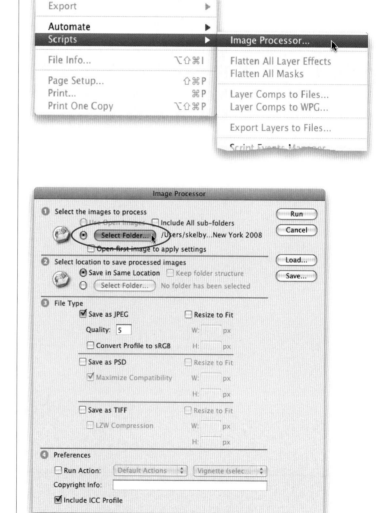

Automated Saving and Resizing

Back when Photoshop CS was fairly new, Russell Preston Brown (Adobe's in-house evangelist and Photoshop madman) introduced a pretty slick little utility called Dr. Brown's Image Processor, which would let you take a folder full of images and save them in various formats (for example, it could open a PSD file and automatically make a JPEG and a TIFF from it, and resize each along the way). It became a cult hit, and so in CS2, an updated version of it was included (but sadly, they dropped the "Dr. Brown's" part, which I always thought gave it its charm).

Step One:
Go under the File menu, under Scripts, and choose Image Processor. By the way, if you're working in Adobe Bridge (rather than Photoshop), you can Command-click (PC: Ctrl-click) on all the photos you want to apply the Image Processor to, then go under the Tools menu, under Photoshop, and choose Image Processor. That way, when the Image Processor opens, it already has those photos pegged for processing. Sweet!

Step Two:
When the Image Processor dialog opens, the first thing you have to do is choose the folder of photos you want it to "do its thing" to by clicking on the Select Folder button, then navigating to the folder you want and clicking Choose (PC: OK). If you already have some photos open in Photoshop, you can click on the Use Open Images radio button (or if you choose Image Processor from Bridge, the Select Folder button won't be there at all—instead it will list how many photos you have selected in Bridge). Then, in the second section, decide whether you want the new copies to be saved in the same folder or copied into a different folder. No big whoop (that's a technical term).

Step Three:

The third section is where the fun begins. This is where you decide how many copies of your original you're going to wind up with, and in what format. If you turn on the checkboxes for Save as JPEG, Save as PSD, and Save as TIFF, you're going to create three new copies of each photo. If you turn on the Resize to Fit checkboxes (and enter a size in the Width and Height fields), your copies will be resized too (in the example shown here, I chose a small JPEG of each file, then a larger TIFF, so in my folder I'd find one small JPEG and one larger TIFF for every file in my original folder).

Step Four:

In the fourth section, if you've created an action that you want applied to your copies, you can also have that happen automatically. Just turn on the Run Action checkbox, then from the pop-up menus, choose which action you want to run. If you want to automatically embed your copyright info into these copies, type your info in the Copyright Info field. Lastly, there's a checkbox that lets you decide whether to include an ICC profile in each image or not (of course, I'm going to try to convince you to include the profile, because I included how to set up color management in Photoshop in Chapter 13). Click the Run button, sit back, and let it "do its thing," and before you know it, you'll have nice, clean copies aplenty.

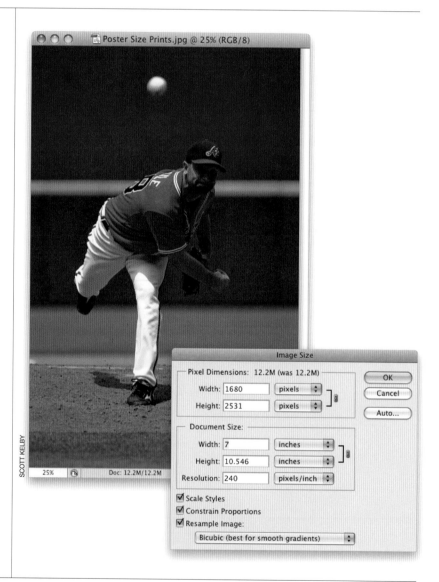

Rule-Breaking Resizing for Poster-Sized Prints

This is a resizing technique I learned from my friend (and world-famous nature photographer) Vincent Versace. His poster-sized prints (24x36") always looked so sharp and crisp—but we were both shooting with the same 6-megapixel camera—so I asked him his secret. I figured he was using some scaling plug-in, but he said he did the whole thing in Photoshop. My thanks to Vinny for sharing his simple, yet brilliant technique with me, so I could share it with you.

Step One:

Open the photo you want to resize, then go under the Image menu and choose Image Size. By the way, in Photoshop CS2, Adobe finally added a keyboard shortcut to get to the Image Size dialog: **Command-Option-I (PC: Ctrl-Alt-I)**.

Step Two:

Type in the dimensions you want as your final print size. The original width for my image is 7", so when I type 24" for the Width, the Height field will automatically adjust to just over 36" (the Width and Height are linked proportionally by default—adjust one and the other adjusts in kind; here I'll have to crop my height down to 36"). Of course, not all images scale perfectly, so depending on how many megapixels your camera is, you may not be able to get exactly 36" (and in fact, you may not want to go that big. But if you do, you might need to enter more than 24" to make your height reach 36", and then you can go back and crop your width down to 24" [see the "Cropping to a Specific Size" technique earlier in this chapter]).

Step Three:

Once your size is in place, you'll need to adjust your resolution upward, so go to the Resolution field and enter 360. Now, you know and I know that this goes against every tried-and-true rule of resolution, and breaks the never-just-type-in-a-higher-number-with-the-Resample-Image-checkbox-turned-on rule that we all live and die by, but stick with me on this one—you've got to try it to believe it. So, type it in, grit your teeth, but don't click OK yet.

Continued

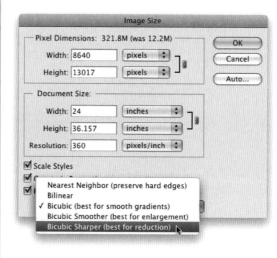

Step Four:

Back in Photoshop CS, Adobe introduced some new sampling algorithms for resizing images. According to Vincent's research, the key to this resizing technique is to not use the sampling method Adobe recommends (which is Bicubic Smoother), and instead to choose Bicubic Sharper in the Resample Image pop-up menu, which actually provides better results—so much so that Vincent claims that the printed results are not only just as good, but perhaps better than those produced by the expensive, fancy-schmancy upsizing plug-ins.

Step Five:

I've tried this technique numerous times, and I have to say—the results are pretty stunning. But don't take my word for it—click OK, print it out, and see for yourself. Here's the final image resized to 24x36" (you can see the size in the rulers by pressing **Command-R [PC: Ctrl-R]**).

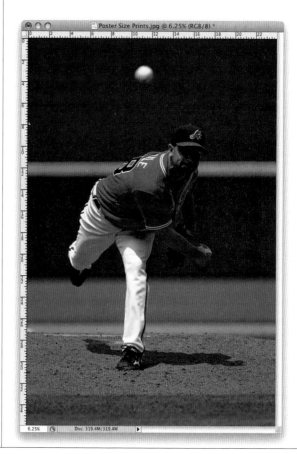

There's a different set of rules we use for maintaining as much quality as possible when making an image smaller, and there are a couple of different ways to do just that (we'll cover the two main ones here). Luckily, maintaining image quality is much easier when sizing down than when scaling up (in fact, photos often look dramatically better—and sharper—when scaled down, especially if you follow these guidelines).

Making Your Photos Smaller (Downsizing)

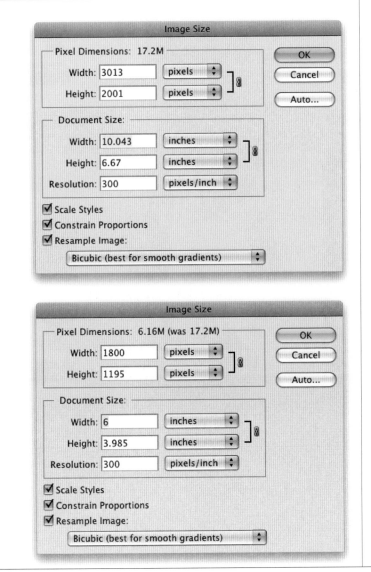

Downsizing photos where the resolution is already 300 ppi: Although earlier we discussed how to change image size if your digital camera gives you 72-ppi images with large physical dimensions (like 24x42" deep), what do you do if your camera gives you 300-ppi images at smaller physical dimensions (like a 10x6" at 300 ppi)? Basically, you turn on Resample Image (in the Image Size dialog under the Image menu), then simply type in the desired size (in this example, we want a 6x4" final image size), and click OK (don't change the Resolution setting, just click OK). The image will be scaled down to size, and the resolution will remain at 300 ppi. IMPORTANT: When you scale down using this method, it's likely that the image will soften a little bit, so after scaling, you'll want to apply the Unsharp Mask filter to bring back any sharpness lost in the resizing (go to Chapter 12 to see what settings to use).

Making one photo smaller without shrinking the whole document:

If you're working with more than one image in the same document, you'll resize a bit differently. To scale down a photo on a layer, first click on that photo's layer in the Layers panel, then press **Command-T (PC: Ctrl-T)** to bring up Free Transform. Press-and-hold the Shift key (to keep the photo proportional), grab a corner point, and drag inward. When it looks good, press **Return (PC: Enter)**. If the image looks softer after resizing it, apply the Unsharp Mask filter.

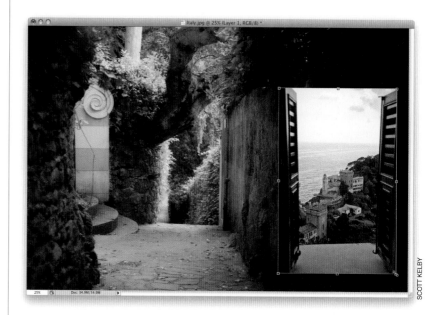

TIP: Reaching the Free Transform Handles

If you're resizing a photo on a layer using Free Transform and you can't reach the handles (because the edges of your photo extend outside the image area), just press **Command-0 (PC: Ctrl-0)**, and your window will automatically resize so you can reach all the handles—no matter how far outside your image area they once were. Two things: (1) This only works once you have Free Transform active, and (2) it's Command-0—that's the number zero, not the letter O.

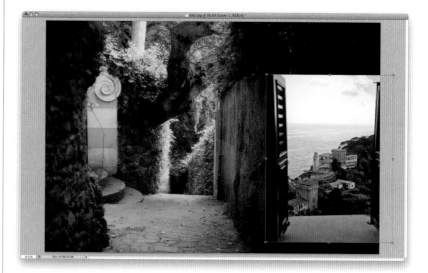

SCOTT KELBY

Resizing problems when dragging between documents:

This one gets a lot of people, because at first glance it just doesn't make sense. You have two documents, approximately the same size, side-by-side onscreen. But when you drag a 72-ppi photo (a clock on a wall) onto a 300-ppi document (Untitled-1), the photo appears really small. Why? Simply put—resolution. Although the documents appear to be the same size, they're not. The tip-off that you're not really seeing them at the same size is found in each photo's title bar. Here, the clock image is displayed at 100%, but the Untitled-1 document below is displayed at only 25%. So, to get more predictable results, make sure both documents are at the same viewing size and resolution (check in the Image Size dialog under the Image menu).

TIP: Automated Cropping & Straightening

Want to save time the next time you're scanning prints? Try gang scanning (fitting as many photos on your flatbed scanner as will fit and then scan them as one big single image), and then you can have Photoshop automatically straighten each individual image and place it into its own separate document. You do this by going under the File menu, under Automate, and choosing Crop and Straighten Photos. No dialog will appear. Instead, Photoshop will look for straight edges in your photos, straighten the photos, and copy each into its own separate window (by the way, it seems to work best when the photos you scan as a group have similar tonal qualities. The more varied the colors of the photos are, the harder time it seems to have straightening the images). This automation also works on single, crooked images.

Resizing Just Parts of Your Image Using "Content-Aware" Scaling

One of the most jaw-dropping new features in Photoshop CS4 is "content-aware scaling," and why it rocks is you can resize one part of your image, while the important parts stay intact. For example, let's say you took a portrait of an executive, and you need to be able to add some text beside her for a magazine cover. If you didn't compose the shot to accommodate the text when you took the shot, you'd have a lot of cloning and background work to do. But with content-aware scaling, you can stretch the background without stretching your exec. Here's how it works:

Step One:
One of the things I use content-aware scaling for most is making digital camera images fit in traditional photography sizes (like 8x10", 5x7", etc.). You always have to crop the image, or leave white space at the top and bottom, when resizing an image to fit in one of these standard sizes, as shown here, where I dragged a digital camera image into an 8x10" document. When you position it so you see the full image, it leaves a huge gap at the top.

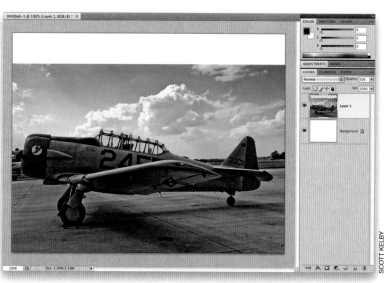

Step Two:
So, rather than leaving the gap, most folks try to just resize the photo so it fills the full 8x10" area, but you can see what happens when you do that—you no longer see the full image as you composed it. In our case—worse yet—it clips off the nose and tail of the plane (as seen here).

Step Three:
Since the zoom-to-fill-cropping from Step Two doesn't work, we'll go back to what we did in Step One, which at least gives you the full image as you shot it. You could try just stretching the image by going to Free Transform (press **Command-T [PC: Ctrl-T]**), and when the resizing handles appear, grab the center handle and drag upward, but that distorts everything and now you have a really squatty-looking bloated plane, and so this really isn't an option for most images.

Step Four:
This is where content-aware scaling comes in handy. Resize the image so it fits fully in the image area (like back in Step One), then go under the Edit menu and choose Content-Aware Scale (or use the keyboard shortcut **Command-Option-Shift-C [PC: Ctrl-Alt-Shift-C]**). Then, grab the top handle and drag straight upward, and you'll notice that it stretches the sky upward, but pretty much leaves the airplane intact, without stretching or bloating it. Now, if you keep dragging upward (beyond what we've dragged here), it will start dragging the plane, so you can't just drag forever, but luckily you see a live onscreen preview as you're dragging, so you'll know right away how far you can drag. When you've dragged far enough, press **Return (PC: Enter)** to lock in your change. Next, let's look at another way to use content-aware scaling.

Continued

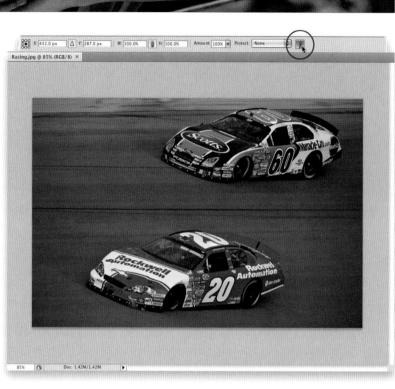

Step Five:

Since Content-Aware Scale is aware of your subject, you can use it in other ways. For example, if you wanted these two NASCAR race cars closer to each other (obviously, what I'm about to show you is not for news reporters—you'd be doing this strictly for personal artistic reasons. Moving cars together after the fact is, well...cheating). But before we start moving cars, I want to point out another option, and that is a button up in the Options Bar that looks like a person (shown circled here in red). You turn this option on when you have people in the photo you're about to resize. That tells the Content-Aware Scale command to protect anything that has a skin tone, and then it tries to avoid those areas. It doesn't always work, but it usually helps.

Step Six:

Now, back to our cars. If you were to try this with regular old Free Transform (just opening Free Transform and dragging the top handle downward), it doesn't move the cars closer together—it just squashes everything, and makes the photo pretty unusable. So, once you try this, before you hit the **Return (PC: Enter) key** to lock in your transformation, hit the **Esc key** on your keyboard to cancel your transformation. Instead, let's try the same thing using the Content-Aware Scale command.

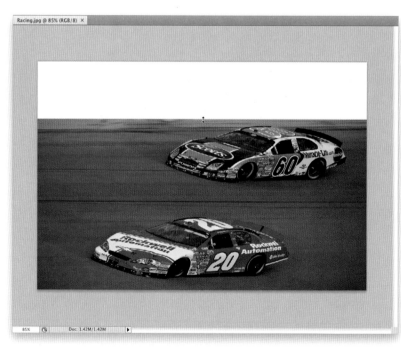

SCOTT KELBY

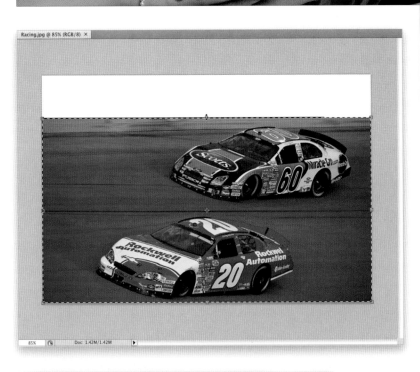

Step Seven:

Press **Command-A (PC: Ctrl-A)** to Select All, then go under the Edit menu and choose Content-Aware Scale. Grab the top-center resize point and drag straight downward, and check out how the cars actually do move closer together (if I dragged any closer, their bumpers would be touching), but the cars themselves aren't distorted or squashed. I know—amazing! At this point I would crop the photo, cropping off some of the open area in front of the cars, so it goes back to a normal aspect ratio.

Step Eight:

Here are two more controls you need to know about: First, if you try Content-Aware Scale and it stretches your subject more than you want, go get the Lasso tool **(L)** and drag a selection around your subject (as shown here, top left), then go under the Select menu and choose Save Selection. When the Save Selection dialog appears, just click OK. Then bring up Content-Aware Scale again, but this time, go up in the Options Bar and choose Alpha 1 from the Protect pop-up menu (as shown here) to tell Photoshop where your subject is. Now you can drag to the right to fill the empty space with the least stretching (as seen here in the photo of my buddy Jeff Revell). There's also an Amount control up in the Options Bar, which determines how much stretching protection is provided. At its default of 100%, it's protecting as much as possible. At 50%, it's a mix of protected resizing and regular Free Transform, and for some photos that works best. The nice thing is the Amount control is live, so as long as your handles are still in place, you can lower the Amount and see live onscreen how it affects your resizing.

SCOTT KELBY

Straightening Crooked Photos

If you hand-held your camera for most of your shots rather than using a tripod, you can be sure that some of your photos are going to come out a bit crooked. Here's a quick way to straighten them accurately in just a few short steps:

Step One:

Open the photo that needs straightening. Choose the Ruler tool from Photoshop's Toolbox (it looks like a little ruler, and it's hidden behind the Eyedropper tool, so just click-and-hold for a moment on the Eyedropper tool until the Ruler tool appears in the flyout menu).

Step Two:

Try to find something in your photo that you think is supposed to be straight or relatively straight (the horizon, in this example). Click-and-drag the Ruler tool horizontally along this straight edge in your photo, starting from the left and extending to the right. As soon as you drag the tool, you can see the angle of the line displayed in the Info palette (found under the Window menu) and up in the Options Bar, but you can ignore them both because Photoshop is already taking note of the angle and placing that info where you'll need it in the next step.

SCOTT KELBY

Step Three:
Go under the Image menu, under Image Rotation, choose Arbitrary, and the Rotate Canvas dialog will appear. Photoshop has already entered the proper angle of rotation you'll need to straighten the image (based on your measurement), and it even sets whether the image should be rotated clockwise or counterclockwise.

Step Four:
All you have to do now is click OK, and your photo will be perfectly straightened (check out the horizon in the photo shown here—it's now nice and straight).

Step Five:
After the image is straightened, you might have to crop it to remove the extra white canvas space showing around the corners of your photo, so press **C** to switch to the Crop tool, drag out a cropping border, and press the **Return (PC: Enter) key**.

TIP: Clearing the Ruler Line
When you use the Ruler tool, the line it draws stays on your photo until you rotate the image. If you want to clear the measurement and remove the line it drew on your image, click on the Clear button in the Options Bar.

Local Color
color correction secrets

In previous editions of the book, I pretty much used up all the good titles for this chapter. I already used "True Colors" (my personal favorite title, inspired by the Cindy Lauper song), and up to this point, I have skillfully avoided using Chicago's "Color My World" as a title. By the time I got to the CS2 version of the book, I was already running out of decent names, so I had to go with "The Color of Money" (from the movie of the same name), which admittedly was kind of lame. So this time I dug a little deeper and found a movie called *Local Color*, made back in 1977, that starred Jane Campbell, Bob Herron, and Temmie Brodkey, among others. If none of those people sound familiar, it's probably because you didn't see *Local Color*, which was the story of a young boy in a small village who only had Photoshop 5.5 and used only Brightness/Contrast for his tonal corrections. This made the other children laugh at him, and recalibrate his monitor to crazy colors when he was off selling his handmade trinkets to the American tourists who would visit his tiny village. Then one day, he met a kind American tourist (we'll call him Señor Willmore), who was getting on his air-conditioned tour bus when he stopped and looked back at the uncalibrated little boy, and tossed him an X-Rite Eye-One Display 2 hardware calibrator. The little boy's eyes filled with joy as he ran back to his 25 Mhz Macintosh Quadra, opened the box, took out the USB cable, and started to connect the calibrator, but then he realized his old Mac Quadra didn't have a USB port, and he cried and cried, then the movie ended. It was a really sad movie. No wonder you didn't see it.

Two Things to Do Before You Color Correct Anything

Before we correct even a single photo, there are two quick little changes we need to make in Photoshop to get better, more accurate results. The first is to change how the Eyedropper tool measures color, and the second is to get a neutral gray background behind your photos, so your background doesn't affect how you color correct your photos. Although it's just two simple changes, don't underestimate their impact—this is important stuff.

Step One:

Go to the Toolbox and click on the Eyedropper tool (or just press the letter I). If you look up in the Options Bar, you'll see that the default Sample Size setting for this tool is Point Sample. The problem with this setting is it gives you a reading from just one individual pixel, rather than giving you an average of the area where you're clicking (which is much more accurate for color correction purposes). To fix this, go up to the Options Bar, and change the Sample Size pop-up menu to 3 by 3 Average (as shown here). By the way, if you're working on super-high-resolution images, in CS3, Adobe added larger sampling areas, like 5x5, 11x11, 31x31, and on up to 101x101.

Step Two:

Although having a colorful desktop background is fine when we're working in Photoshop, you'll rarely find a professional doing color correction with a colorful desktop background, because it changes how you perceive color (and that will influence how you color correct your photos). Ideally, you'd use a neutral gray background, and to get one, just press the letter **F** once. This centers your photo onscreen with a neutral gray background behind it. To return to regular mode, press the letter **F** two more times. Okay, now you're ready.

Today's digital cameras do an incredible job of giving you great color and contrast, as long as the lighting is perfect and your white balance is set properly for that lighting. However, if anything changes, like you move from sunlight into shade, or from outdoors to indoors, or the lighting changes during the day (the sun is always on the move), then you wind up having to color correct your images. Here's a step-by-step method that makes getting perfect color and contrast pretty darn easy.

Color Correcting Digital Camera Images

SCOTT KELBY

Step One:
Open the photo you want to color correct. The photo shown here doesn't look all that bad, but as we go through the correction process, you'll see that it really needed a correction. The thing I see right off the bat is that the photo looks kinda flat, so it's low on contrast and there's a blue color cast to the photo, which is typical on a cloudy day or when your subject winds up in the shade and your camera is set to Auto white balance.

Step Two:
Go under the Image menu, under Adjustments, and choose Curves (or press **Command-M [PC: Ctrl-M]**). Curves is the hands-down choice of professionals for correcting color because it gives you a greater level of control than other tools, like Levels, where you pretty much are limited to just three adjustment sliders. The Curves dialog may look intimidating at first, but the technique you're going to learn here requires no previous knowledge of Curves, and it's so easy, you'll be correcting photos using Curves immediately.

Continued

Step Three:

First, we need to set some preferences in the Curves dialog, so we'll get the results we want when color correcting. We'll start by setting a target color for our shadow areas. To set this preference, in the Curves dialog, double-click on the black Eyedropper tool (the Eyedroppers are found below the center of the curve grid, and the shadow Eyedropper is the first Eyedropper from the left [the one half-filled with black], as shown here).

Step Four:

When you double-click on that shadow Eyedropper, it brings up the Color Picker asking you to select your target shadow color. This is where you'll enter some new RGB numbers that will help remove any color casts your camera introduced in the shadow areas of your photo. We're going to enter values in the R, G, and B (Red, Green, and Blue) fields of this dialog (the Blue field is highlighted here).

For R, enter 7
For G, enter 7
For B, enter 7

Now click OK to save these numbers as your target shadow settings. Because these figures are evenly balanced (they're all the same number), it helps ensure that your shadow areas won't have too much of one color (which is exactly what causes a color cast—too much of one color), and by using 7 we get dark shadows while still maintaining shadow detail in our inkjet prints.

Step Five:

Now we'll set a preference to make our highlight areas neutral. Double-click on the white Eyedropper (the third of the three Eyedroppers at the bottom of the Curves dialog). The Color Picker will appear asking you to Select Target Highlight Color. Click in the R field, and then enter these values (*Note:* To move from field to field, just press the **Tab key**):

For R, enter 245
For G, enter 245
For B, enter 245

Click OK to set those values as your highlight target.

Step Six:

Now, set your midtone preference. You know the drill: Double-click on the midtone Eyedropper (the middle of the three Eyedroppers), so you can Select Target Midtone Color. Enter these values in the RGB fields:

For R, enter 133
For G, enter 133
For B, enter 133

Then click OK to set those values as your midtone target. That's it—you've done all the hard work. The rest from here on out is pretty easy.

Continued

Step Seven:

If you still have the Curves dialog open, click OK to exit it for now, and you'll get a warning dialog asking you if you want to Save the New Target Colors as Defaults. Click Yes (as shown here), and from this point on, you won't have to enter these values each time you correct a photo, because they'll already be entered for you—they're now the default settings. So, the next time you color correct a photo, you can skip these seven steps and go straight to the correcting.

Step Eight:

Okay, now that you've entered your preferences (target colors) in the Curves dialog, you're going to use these same Curves Eyedropper tools (shown here) to do most of your color correction work. In a nutshell, here's what you'll do with those three Eyedroppers:

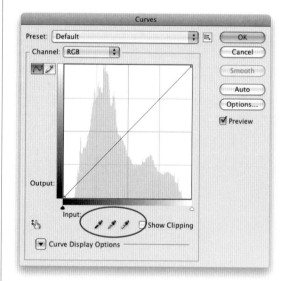

(1) Find something in your photo that you know is supposed to be the color black. If you can't find something black, find the darkest area in your photo and convert that area to your target shadow color by clicking on that area once with the shadow Eyedropper.

(2) Find something in your photo that you know is supposed to be the color white. If you can't find something white, find the brightest area in your photo and convert that area to your target highlight color by clicking on that area once with the highlight Eyedropper.

(3) Find a neutral gray area in your photo and convert that to your target midtone color by clicking on that area once with the midtone Eyedropper.

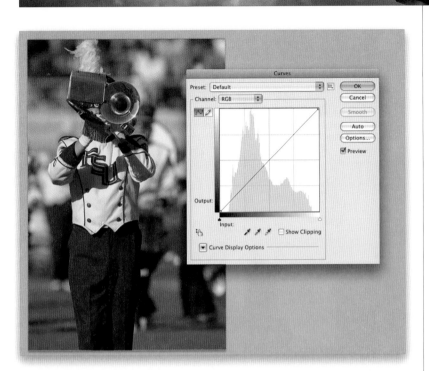

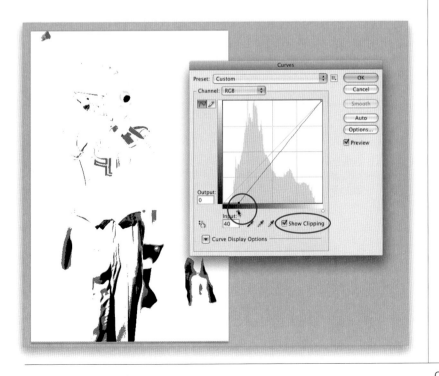

Step Nine:

Let's start by setting the shadows first, so press **Command-M (PC: Ctrl-M)** to bring back up the Curves dialog (shown here). Now, your job is to look at the photo and find something that's supposed to be the color black. In most photos, this won't be a problem—you'll see a dark area of shadows (like the center of the trombone's bell in this photo, or a black car tire, or a black shirt, etc.), and in those cases, it's no sweat. But, if you can't find something that's supposed to be the color black, then you can have Photoshop show you exactly where the darkest part of the photo is.

TIP: Using Curves from the Adjustments Panel

If you're familiar with adjustment layers, you can apply your Curves as an adjustment layer, instead, using CS4's new Adjustments panel. Just click on the icon that looks like the Curves grid, and instead of getting a floating dialog, you can adjust your curve from right within the panel. More on adjustment layers later on.

Step 10:

There are two sliders directly under the curve grid that can help you find where the darkest and brightest parts of your image are. Start by turning on the Show Clipping checkbox (shown here), and your image area turns solid white, then click-and-hold on the left (shadow) slider. As you drag slider to the right, the first areas that appear onscreen are the darkest parts of your photo. That's Photoshop telling you exactly where to click, so remember where those areas are (in this case, I'd probably choose that circle in the center of the bell of the trombone, because it's showing up as solid black, which means all three color channels are solid black).

Continued

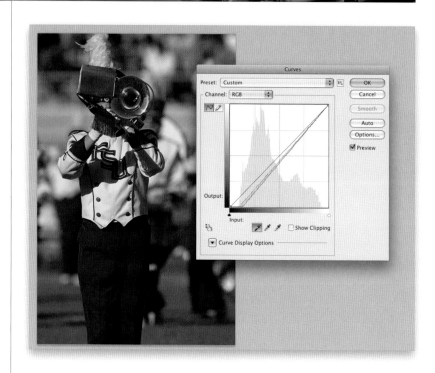

Step 11:

Now that you know where your shadow area is, drag that shadow slider back to the left, and turn off the Show Clipping checkbox. Click on the shadow Eye-dropper, move out over your photo (while the Curves dialog is still open), and click once on that shadow area. In this case, click in the shadow area in the center of the trombone's bell (shown circled here in red), and it converts your shadow areas to a neutral shadow color, and the color cast is removed from the shadow areas (compare this photo with the one in Step Nine and you'll see the difference this one click makes, in both color and contrast).

TIP: Turning Off the Channel Overlays

When you click in that shadow area, three new lines appear in your curve, showing how the Red, Green, and Blue channels were affected by your move. Although some users love seeing these lines, some folks (like me) find it really distracting. If you'd like those channel lines turned off, just click on the triangle next to Curve Display Options at the bottom left of the Curves dialog, then turn off the checkbox for Channel Overlays (as shown here).

Step 12:

Now, on to setting the highlight point. Your job: find something that's supposed to be the color white. Again, this is usually pretty easy, but if you can't find something white, you can use the same trick you just learned to have Photoshop show you where the lightest part of your photo is. Turn on the Show Clipping checkbox again, but this time drag the far-right slider to the left. The screen turns black (as shown here), and as you drag to the left the first white areas that appear are the lightest parts of your image.

TIP: Skipping the Show Clipping Checkbox

Pressing-and-holding the **Option (PC: Alt) key** and dragging those Input sliders does the same thing as temporarily turning on the Show Clipping checkbox.

Step 13:

Now that you know where your highlight area is, drag that highlight slider back all the way to the right, and turn off the Show Clipping checkbox. Click on the highlight Eyedropper, move out over your photo, and click once on that highlight area. I try to look for a white area that has some detail (rather than clicking on what's called a specular highlight, which is a blown out highlight area with no detail, like the sun, or a bright sun reflection on a chrome car bumper, etc.). In this case, I clicked on the white bass drum head in the background (as shown here), and that made the highlight areas neutral and removed any color cast in the highlights (we're only two clicks into this correction, and look how much better the photo already looks).

Continued

Step 14:

Now for your third click—finding something that's supposed to be a neutral gray. This one's a little trickier, because not every photo has a neutral gray area, and the Curves dialog doesn't have a "find the gray" trick like it does for shadows and highlights, but never fear—there's a project coming up in this chapter that shows you a way to find that neutral area every time. In the example we're working on, finding an area that's supposed to be a neutral gray isn't a problem—you can click on the back of the uniform of the guy holding the bass drum in the background (as I did here). It neutralizes the color cast in the midtones, and as you can see here, it removed that blue color cast that was still there after neutralizing the highlights and shadows. Now we have a much warmer and more natural looking tone.

Step 15:

Before you click OK, you're going to use Curves to increase the overall contrast in the photo (in fact, it's the best way to increase contrast in Photoshop). Plus, it's easy: (1) first, click once right in the very center of the grid to add a point; (2) click above and to the right of the center, right along the line, where the gray grid lines intersect with the diagonal line; and (3) add one more point on the line, where the lines intersect at the bottom quarter (they're shown circled here).

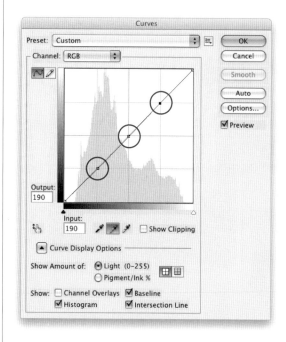

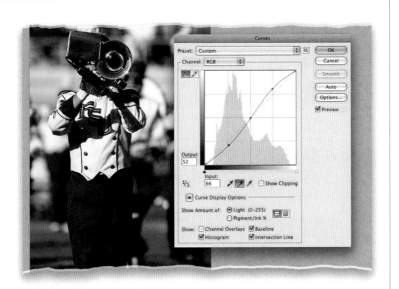

Step 16:

Now, while the bottom-left point is selected, press the **Down Arrow key** on your keyboard eight or nine times to move that point of the curve downward, which increases the contrast in the shadow areas. Then, click on the top-right point, but now press the **Up Arrow key** on your keyboard 10 or 12 times to increase the contrast in the highlights. Moving the top point up and the bottom point down like this steepens the curve and adds more contrast. Now you can click OK, and you're done.

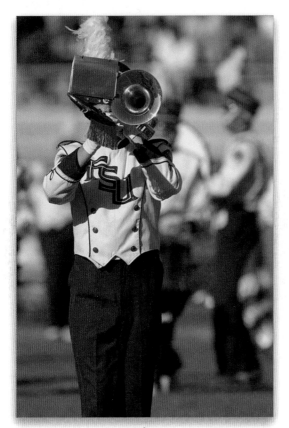

Before

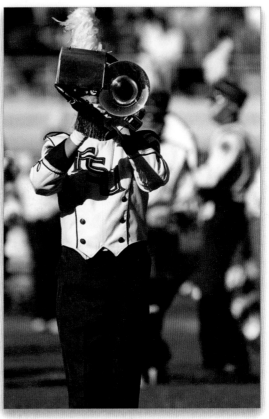

After

The Advantages of Adjustment Layers in Photoshop CS4

Before we really dive into color, we need to spend two minutes with the Adjustments panel. Of all the new enhancements in Photoshop CS4, the new Adjustments panel is my favorite, because it streamlines our workflow so dramatically that even if you've never used adjustment layers before, you've got to start working with them now. In fact, from this point in the book on, we're going to try and use adjustment layers every chance we get, because of all the advantages they bring. Here's a quick look at them and how to use them to your advantage:

Advantage One:
Undos That Live Forever

By default, Photoshop keeps track of the last 20 things you've done in the History panel (shown here), so if you need to undo a step, or two, or three, etc., you can press **Command-Option-Z (PC: Ctrl-Alt-Z)** up to 20 times. But, when you close your document, all those undos go away. However, when you make an edit using an adjustment layer (like a Levels or Curves adjustment), you can save your image as a layered file (just save it in Photoshop format), and your adjustment layers are saved right along with it. You can reopen that document days, weeks, or even years later, click on that adjustment layer, and either undo or change that Curves, Levels, or other tonal adjustment. It's like an undo that lives forever.

Advantage Two:
Built-In Masks

Each adjustment layer comes with a built-in layer mask, so you can easily decide which parts of your photo get the adjustment just by painting. If you want to keep an area of your photo from having the adjustment, just get the Brush tool (**B**) and paint over it in black. There's more on layer masks to come, but they offer tremendous flexibility, and since they don't actually affect the pixels in your image, they're always undoable.

Advantage Three:
One-Click Presets

In CS4, Adobe added a bunch of built-in presets, and you can apply them with one click right from within the Adjustments panel. Plus, if you come up with a setting you like, you can save your own custom presets. So, for example, if you come up with a favorite Levels setting (using a Levels adjustment layer), you can save it as a preset (by choosing Save Levels Preset from the panel's flyout menu), and then apply it anytime from the Adjustment panel's Preset list with just one click.

Advantage Four:
Blend Modes

When you apply an adjustment layer, you get to use the layer blend modes. So if you want a darker version of your adjustment, you can just change the layer blend mode of your adjustment layer to Multiply. Want a brighter version? Change it to Screen. Want to make a Curves adjustment that doesn't affect the skin tone as much? Change it to Luminosity. Sweet!

Advantage Five:
Everything Stays Live

Back in previous versions of Photoshop, when you created an adjustment layer (let's say a Curves adjustment layer, for example), it would bring up the floating Curves dialog (as seen here). While it was onscreen, the rest of Photoshop was frozen—you couldn't make changes or do anything else until you closed the Curves dialog by either applying your adjustment or hitting Cancel. But thanks to the Adjustments panel, everything stays live—you just go to the Adjustments panel and make your changes there. There is no OK or Apply button, so you can change anything anytime. This will make more sense in the next step.

Continued

Step One:

The best way to understand this whole "live" thing is to try it, so go open any photo (it really doesn't matter which one), then go to the Adjustments panel and click on the Curves icon (it's the third one in the top row). Rather than bringing up the Curves dialog in front of your image (and freezing everything else), the Adjustments panel now displays the curve, so you can make your adjustments, but everything stays live—you can adjust your curve, go right down and change the blend mode of a layer, or paint a few brush strokes, then grab another part of the curve and adjust it. There's no OK button, and everything stays live. This is bigger than it sounds (ask anyone who's used CS3).

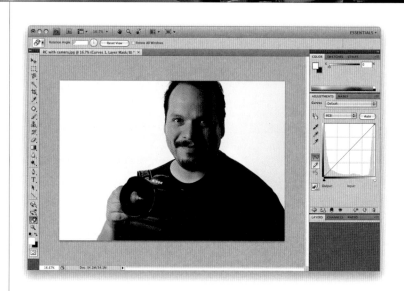

Step Two:

If you're thinking the curve itself looks a little small stuck in that narrow panel, Adobe must have been thinking the same thing, because there's a little icon in the bottom-left corner of the panel (shown circled here in red), and if you click on it, it expands the size of the entire panel so everything's easier to work with (as seen here).

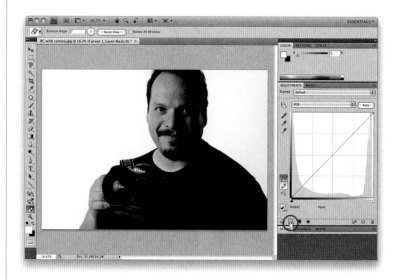

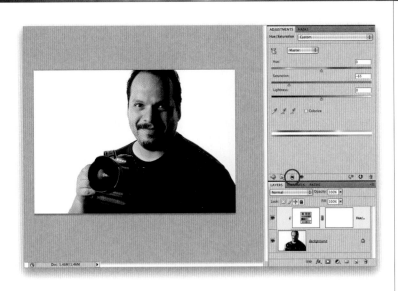

Step Three:

Now let's delete our Curves adjustment layer by clicking on the Trash icon at the bottom of the panel. Add a Hue/Saturation adjustment by clicking on its icon (it's the second one in the middle row). Drag the Saturation slider way over to the left to remove most of the color, for the look you see here. Now, the way adjustment layers work is this: they affect every layer below them. So if you have five layers below it, all five layers will have their color desaturated like this. However, if you want this adjustment layer to just affect the one single layer directly below it (and not the others), then click on the clipping icon (it's the third from the left at the bottom of the panel, shown circled here in red). This clips the adjustment layer to the layer directly beneath it.

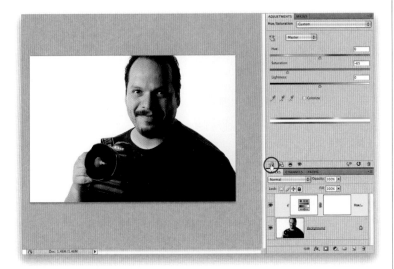

Step Four:

There are a couple other options: To edit any adjustment layer you've already created, just click on it once in the Layers panel and its controls will appear in the Adjustments panel. To return to the list of adjustment layers and their presets, click on the Return to Adjustment List icon at the bottom of the panel (shown circled here in red). To hide any adjustment layer you've created, click on the Eye icon (either at the bottom of the Adjustments panel, or to the left of the adjustment layer in the Layers panel). To reset any panel to its default settings, click the round arrow icon to the immediate left of the Trash icon. To see a before/after of just your last change, click the icon to the left of the Reset icon. The hardest thing about the Adjustments panel is figuring out which icon represents which adjustment, so just move your cursor over an icon, and its name appears in the upper-left corner of the panel.

Creating Contrast Using CS4's New TAT

Besides using Curves for color correction, this is my main tool for creating contrast, because it gives you a range of control you really can't get any other way. Of course, in the past, you really had to know Curves inside and out to tweak individual areas of your image, but in Photoshop CS4, Adobe introduced the Targeted Adjustment Tool (or TAT for short), which lets you click-and-drag right on the image, and the tool will tweak the right part of the curve for you automatically. It's way cooler than it sounds.

Step One:
Here's a pretty flat-looking photo that could use a Curves adjustment to bring more contrast to the photo and, as I mentioned above, we're going to use the TAT (shown circled in red here), so we really don't have to mess with the curve at all, we just have to tell Photoshop two simple things: (1) which area of the photo we want to adjust, and (2) if we want that area to be darker or brighter. That's it—and we do the whole thing using just our mouse. So, start by pressing **Command-M (PC: Ctrl-M)** to open the Curves dialog and clicking on the TAT.

TIP: Using a Curves Adjustment Layer
Don't worry—if you use a Curves adjustment layer (rather than just using the standard Curves dialog seen here), it has the TAT, too! (Get it, TAT too? Tattoo? Aw, come on, that one wasn't that bad.)

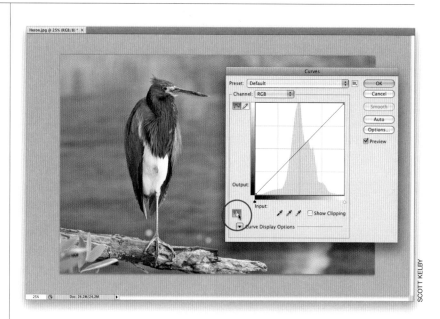

SCOTT KELBY

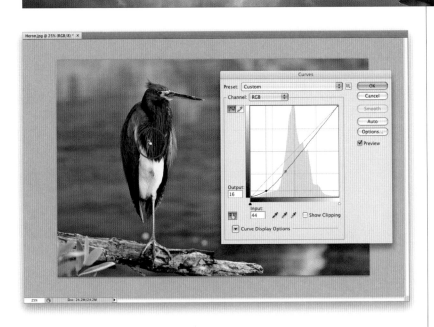

Step Two:
Now, move your cursor outside the Curves dialog, and out over the part of your image you want to adjust. In our case, we want to make the neck of our blue heron darker. Start by clicking-and-holding on the blue part of the neck, and you'll notice that your cursor turns into a hand with a two-headed arrow, pointing up/down. That tells you that dragging up/down will make the adjustment. In our case, we want this blue area darker, so drag downward. As you do, it knows exactly which part of the curve to adjust to darken that area. Now move just to the left, to the purple feathers (the tool's shown circled here), then click-and-drag downward again to darken that area.

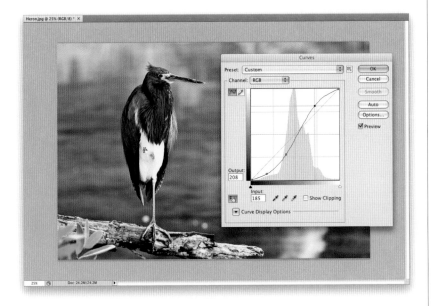

Step Three:
So, now that we've darkened the blue and purple feathers, let's go make the white feathers on his chest brighter. Move your cursor over these feathers, but this time you're increasing the brightness, so you'd click-and-drag upward (rather than downward). As you do this, it knows exactly which part of the curve to adjust to affect that area (if you look at the curve, you can see a new point has been added on the top right of the curve—that was added when you clicked-and-dragged on the white feathers).

Continued

Step Four:

Lastly, now that we've darkened the bird, let's brighten the water behind him by moving our cursor over to the lighter area up in the top-left corner, and clicking-and-dragging upward to brighten that area (also note where it added a new curve point, and how it adjusted that new point upward). This is so darn easy to do, but as you can see, it's also pretty darn powerful.

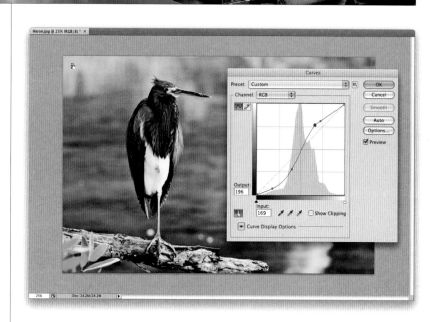

The Trick Pros Use to Make Color Correction Simple

If you're shooting in a studio or on location, whether you're shooting portraits or products, there's a technique many pros use that can make the color-correction process so easy that you'll be able to train laboratory test rats to correct photos for you. The secret is this: in the back of this book I included my version of a gray card, and it's perforated, so you can easily tear it out. By sticking this card into the first shot of your shoot (and shooting it again only if your lighting setup changes), it will make your color correction almost automatic.

Step One:
When you're ready to start shooting and the lighting is set the way you want it, tear out the swatch card from the back of this book and place it within your shot (if you're shooting a portrait, have the subject hold the card for you), then take the shot. After you've got one shot with the swatch card, you can remove it and continue with the rest of your shoot.

Step Two:
When you open the first photo taken in your studio session, you'll see the swatch card in the photo. By having a card that's pure white, neutral gray, and pure black in your photo, you no longer have to try to determine which area of your photo is supposed to be black (to set the shadows), which area is supposed to be gray (to set the midtones), or which area is supposed to be white (to set the highlights). They're right there in the card.

Continued

Step Three:

Go to the Adjustments panel and click on the Curves icon (it's the third one from the left in the top row). Click the black Eyedropper on the black panel of the card to set the shadows, then click the middle gray Eyedropper on the darker gray panel to set the midtones (as shown here). Finally, click the white Eyedropper on the white panel to set the highlights, and the photo will nearly correct itself. No guessing, no Threshold adjustment layers, no using the Info panel to determine the darkest areas of the image—now you know exactly which part of that image should be black and which should be white.

Step Four:

Once you have the Curves setting for the first image, you can correct the rest of the photos using the exact same curve: Just open the next photo and position it so you can see part of both photos. Now click back on the first photo (the one you corrected), click on the Curves adjustment layer in the Layers panel, and drag-and-drop that adjustment layer onto the second photo. Do this until all the photos are corrected. (*Note:* You won't be able to drag-and-drop the adjustment layer if you're working in the Application Frame, so be sure that you're viewing your photos in floating windows.)

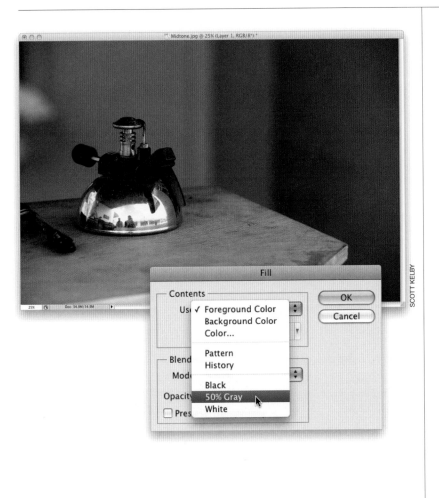

Finding a neutral midtone while color correcting has always been kind of tricky. Well, it was until Dave Cross, who works with me as Senior Developer, Education and Curriculum for the National Association of Photoshop Professionals (NAPP), came into my office one day to show me his amazing trick for finding right where the midtones live in just about any image. When he showed me, I immediately blacked out. After I came to, I begged Dave to let me share his very slick trick in my book, and being the friendly Canadian he is, he obliged.

Dave's Amazing Trick for Finding a Neutral Gray

Step One:
Open any color photo, and click on the Create a New Layer icon at the bottom of the Layers panel to create a new blank layer. Then, go under the Edit menu and choose Fill. When the Fill dialog appears, in the Contents section, under the Use pop-up menu, choose 50% Gray (as shown here).

Continued

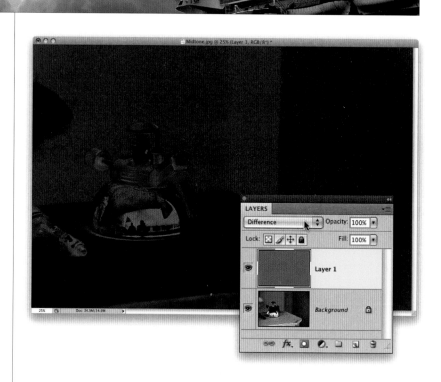

Step Two:

When you click OK, it fills your layer with (you guessed it) 50% gray (you can see the gray thumbnail for Layer 1 in the Layers panel shown here). Now, go to the Layers panel and change the blend mode of this layer to Difference. Changing the layer blend mode to Difference doesn't do much for the look of your photo (as you can see here), but don't worry—it's only temporary.

Step Three:

Choose Threshold from the Create New Adjustment Layer pop-up menu at the bottom of the Layers panel. Then, in the Adjustments panel, drag the slider under the histogram all the way to the left (your photo will turn completely white). Now, slowly drag the slider back to the right, and the first areas that appear in black are the neutral midtones. In the bottom right of this photo is a decent-sized area of black, so that will be our midtone correction point. To help you remember exactly where that area is, get the Color Sampler tool (nested under the Eyedropper tool), and click on that spot to add a Color Sampler point as a reminder. Then click the Trash icon at the bottom of the Adjustments panel to discard the adjustment layer.

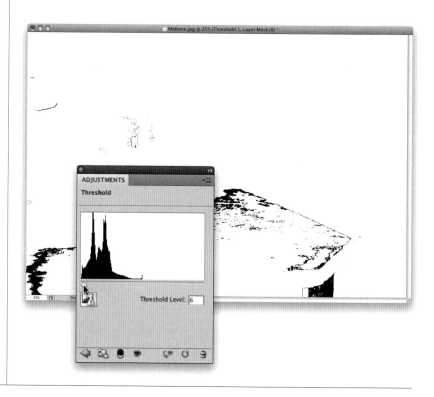

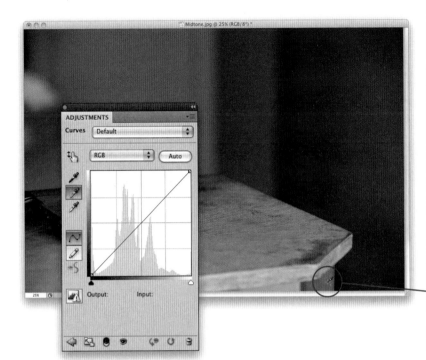

Step Four:
Now that your midtone point is marked, go back to the Layers panel and drag the 50% gray layer onto the Trash icon to delete it (it already did its job, so you can get rid of it). You'll see your full-color photo again. Now, click on the Curves icon in the Adjustments panel (the second icon from the right in the top row) to open the Curves Adjustments panel, get the midtones Eyedropper (it's the middle Eyedropper), and click directly on that Color Sampler point (shown circled in red here).

Step Five:
That's it; you've found the neutral midtones and corrected any color cast within them. So, will this trick work every time? It works most of the time, but you will run across photos that just don't have a neutral midtone, so you'll have to either not correct the midtones or go back to what we used to do—guess.

Adjusting RGB Flesh Tones Using the TAT

So what do you do if you've used Curves to properly set the highlights, midtones, and shadows, but the flesh tones in your photo still look too red? Try this quick trick that works great for getting your flesh tones in line by removing the excess red.

Step One:
Open a photo that you've corrected using the Curves technique shown earlier in this chapter. If the whole image appears too red, skip this step and go on to Step Three. However, if it's just the flesh-tone areas that appear too red, press **L** to get the Lasso tool and make a selection around all the flesh-tone areas in your photo. Press-and-hold the Shift key to add other flesh-tone areas to the selection, such as arms, hands, legs, etc., or press-and-hold the Option (PC: Alt) key to subtract from your selection. This can be a really loose selection like the one shown in Step Two (which doesn't include his neck).

Step Two:
Go under the Select menu, under Modify and choose Feather. Enter a Feather Radius of 3 pixels (as shown here), and then click OK. By adding this feather, you're softening the edges of your selection, which will keep you from having a hard, visible edge show up where you made your adjustment.

TIP: Hiding the Selection Border
Once you've made a selection of the flesh-tone areas, you might find it easier if you hide the selection border from view (that makes it easier to see what you're correcting) by pressing **Command-H (PC: Ctrl-H)**.

SCOTT KELBY

Step Three:
In the Adjustments panel, click on the Hue/Saturation icon, and when the Hue/Saturation options appear, click on the TAT (the Targeted Adjustment Tool—more on how it works on page 214). To reduce some of the reds in his face, move the cursor over an area of his face that looks overly red, click-and-hold the tool, and drag to the left. The tool knows which Hue/Saturation slider to move (it jumps to the Reds, and reduces the Saturation amount), so just keep dragging until his skin tone looks more natural (a before and after is shown below). When it looks good to you, press **Command-D (PC: Ctrl-D)** to Deselect, completing the technique.

Before

After

Creating Vibrance Outside of Camera Raw

Vibrance—one of my favorite features in Camera Raw—has made it outside of Camera Raw in Photoshop CS4. It pretty much does the same thing that Vibrance inside of Camera Raw does—it boosts the least vivid colors in your photo the most, it affects the already vivid colors the least, and it tries to avoid boosting skin tones. And here in CS4, it's an adjustment layer, so you get the built-in mask, as well. Sweet! Here's how it works:

Step One:
Just click the Vibrance icon in the Adjustments panel (the first icon in the center row), and the Vibrance controls appear (as seen here). Adobe also put a Saturation slider there, and I avoid it like the plague (except for using it occasionally to remove color), so if I come to this panel, it's for Vibrance—not Saturation. However, you can use this Saturation slider in conjunction with Vibrance (like lowering Saturation, which evenly takes color from the entire photo, then really boosting Vibrance, so the dullest colors start to stand out more).

Step Two:
Using Vibrance is a no-brainer—just drag the slider to the right (as shown here), and the farther you drag it, the more vibrant your less vibrant colors become.

TIP: The Sponge Has Vibrance
Unless you take your images to a printing press, you probably haven't used the Sponge tool **(O)**, which either saturates or desaturates the color in any areas you paint with it, and is often used to desaturate colors that are out-of-gamut (colors too vibrant for a CMYK printing press). In CS4, they added Vibrance as an option (in the Options Bar) that will focus more on less saturated colors while not affecting already saturated colors as much.

Email applications (and nearly all Web browsers) don't support color management. So, if you're working in Adobe RGB (1998) or ProPhoto RGB as your Photoshop color space, when you email your photos or post them on the Web, they probably look like %$*# (with the colors all desaturated and flat-looking). Ah, if only there was a trick that would let anyone you email (or anybody who sees your photos on the Web) see your photos pretty much the same way you do in Photoshop (of course, there is—I just wish I knew it. Kidding!) Here ya go:

Keeping Great Color When Emailing or Posting Photos to the Web

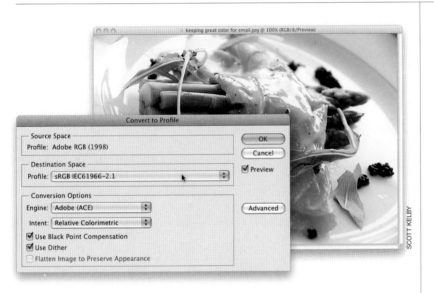

Step One:
To convert this photo to the proper color space for emailing or posting to the Web, go under the Edit menu and choose Convert to Profile. This brings up the Convert to Profile dialog (shown here). The Source Space at the top shows you the current color space your photo is in (if you're working in Adobe RGB [1998], like in this example, that's what you'll see here). For your Destination Space (what you're converting to), choose sRGB IEC61966-2.1 from the Profile pop-up menu (as shown here) and click OK. That's it—it's ready to go.

Step Two:
One quick way to ensure that your photo has been converted to sRGB is to look at the window's title bar. If you've got Photoshop's color space set to Adobe RGB (1998), which is pretty typical for photographers, and you just converted this photo to a different color space (sRGB), then you have a "profile mismatch." So, you should see an asterisk right after (RGB/8) in the title bar (as shown circled here in red), which is Photoshop's way of letting you know that your photo is one space, and Photoshop is in another. In this case, that's a good thing.

Black & White World
how to create stunning b&w images

If you search the iTunes Store for "Black & White," you will be stunned at how many songs are named exactly that—"Black & White." In fact, if I just wanted to stay with the chapter title "Black & White" (like I did back in the CS2 book), then I'd be pretty much covered until about Photoshop CS46. However, for some reason I was drawn to "Black and White World" by Elvis Costello. I almost went with "Black Widow" by Mötley Crüe, but I noticed that the song was tagged with the iTunes Store Clean icon, which means there must also be an explicit version, too. Now, you know, and I know, that when you search for "Black Widow" in the iTunes Store, you're going to listen to the explicit version, right? See, I knew it! And I'm sure that explicit version is laden with words so naughty that you'd normally have to listen to an Andrew Dice Clay show just to keep up, but some-how when Vince Neil sings them, they don't sound as naughty. They sound beautiful, and melodic, with meaning, texture, and a certain poetic charm to them. Aw, who am I trying to kid? It's super-dirty naughtiness, but you don't even care. You know why? Because you're a photographer, which means that at least one time in your career you did a client shoot where some setting in the camera was horribly wrong, but you didn't realize it until you opened the images later in Photoshop. It was at that moment you learned that the entire shoot was done with your camera set to JPEG Basic mode, with your image size set to Small. Right then you started scream-ing expletives that would make Snoop Dogg wash your mouth out with soap. So, the next time this happens, just pop in that Crüe song and let Vince do the cussing on your behalf. Apparently, he's quite comfortable with it.

Using the Black & White Converter

I'm starting this chapter with Photoshop's built-in Black & White converter, because it was introduced back in Photoshop CS3 just for converting your color images to black and white, and I think it's better than the old Channel Mixer technique we used to use. However, even though I'm going to show you how this Black & White converter works, I honestly think there are better methods that produce much better results, and I'm going to show you those, as well, later in this chapter, but go ahead and try this first and see what you think.

Step One:

Open the color photo you want to convert to black and white. Click on the Black & White icon (shown circled here) in the Adjustments panel. A Black & White converter is also found under the Image menu, under Adjustments, however, by applying it as an adjustment layer, it's non-destructive (you can edit your conversion later, paint [mask] over parts that you don't want black and white, lower the opacity for a faded-color look, or you can delete the adjustment layer and return to your full-color photo). It's like an undo that lives forever (well, at least until you discard the layer).

Step Two:

When you click the Black & White icon, its options appear in the Adjustments panel, and it applies the default B&W conversion (seen here). This default conversion isn't as flat as you'd get by going under the Image menu, under Mode, and choosing Grayscale, but it's usually not real great either. If you notice, the percentage of each group of two colors (Reds and Yellows, for example) adds up to 100%. That's fine if your goal is to maintain the same brightness in the photo, but most photographers want that rich, high-contrast B&W look, which means your numbers will probably add up to more than 100%. Don't let that freak you out.

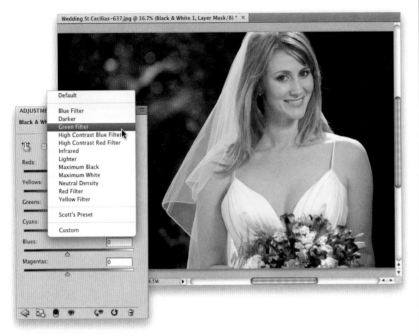

Step Three:

At the top of the Adjustments panel, there's a pop-up menu with a list of built-in Black & White presets (as shown here), so click on the menu to see the presets. Go ahead and give these a try and see what you think (most of them are pretty lame, but click on them now anyway just so you know). The main reason I wanted to show you these presets is because if you come up with a B&W conversion setting you like, you can save your own custom presets to this list. Just click on the little down-facing triangle in the top-right corner of the panel, and choose Save Black & White Preset from the flyout menu that appears. Then give your preset a name, and it will now appear in this presets pop-up menu.

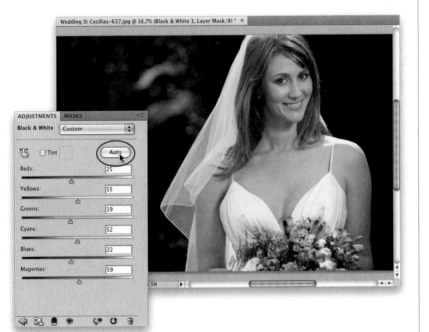

Step Four:

After you've tried the presets, choose Default from the top of the preset pop-up menu to return to the default B&W conversion. Luckily, there is an Auto button (shown circled in red here), which does an auto-B&W conversion. I think it tends to give better results than the default conversion or any of the presets, so go ahead and click on it, and use it as a starting point for your conversion (of course, you could just click Auto and be done with it, but you're really not one of those "Auto" people, are you? I didn't think so. You're a tweaker, right? I knew it—I knew it! Okay, then you'll really love the next step, because it's the most fun part of this process).

Continued

How to Create Stunning B&W Images | Chapter 8 | 229

Step Five:

Since you're now seeing the photo in black and white, it's a little challenging figuring out which color slider will affect which area, and that's one of the problems with the old Channel Mixer—it was somewhat of a guessing game. Just like with layer visibility, you could toggle the Preview checkbox on and off and peek at the color photo for a moment, so you could make an educated guess as to which color would adjust what. Thankfully, now there's a better way, because the Black & White adjustment has a TAT (Targeted Adjustment Tool), just like Curves does. Click on the TAT (shown circled here) and move your cursor out over the area in your photo you want to adjust (as shown here on her veil). Now click-and-drag to the left to darken the area where you're at, or click-and-drag to the right to lighten that area. Your cursor knows which colors are below it, and it moves just the color sliders that would affect that particular area. TATs are pretty slick.

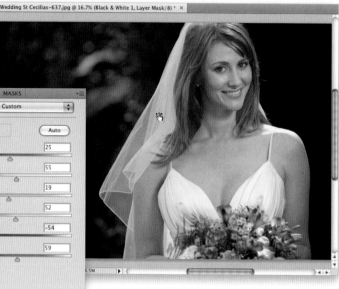

Step Six:

So, that's what you'll do from here on out. If I use this Black & White adjustment, this is the way I work with it—using the TAT. The only difference is, once I see which slider is adjusting the colors where I clicked, I sometimes go over and manually drag that slider a little just to tweak it, as shown here. Also, sometimes you'll drag left (or right), and the change will be very subtle. In those cases, I go straight to the slider itself and drag it all the way to the left, then back all the way to right. That way I can clearly see which areas in the photo are being adjusted, and whether it's worth even bothering with. I think the photo looks better here, after dragging in different parts of it, and as you can see, some of the numbers add up to more than 100%. Yet, I'm still able to sleep at night.

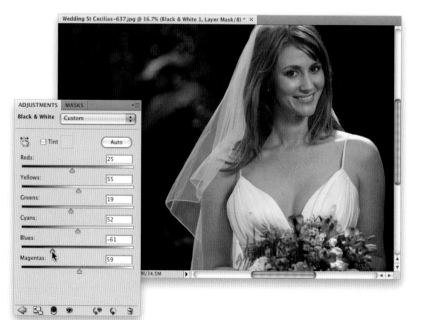

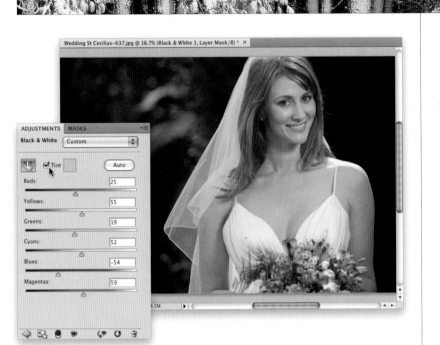

Step Seven:
Another nice feature of the Black & White adjustment is that you can apply a tint for an instant duotone effect. Just turn on the Tint checkbox (to the right of the TAT), and it applies a tint to your photo—you choose your tint color by clicking on the little square color swatch to the right of the checkbox. (If you choose the Black & White adjustment found under the Image menu, under Adjustments, the Saturation amount is set pretty high, so just drag the Saturation slider to the left to reduce the amount of saturation until it looks about right.) So, although it's not my favorite B&W conversion method, it does have its advantages over the old Channel Mixer technique. Lastly, there are a couple of one-click controls at the bottom of this panel: to delete this adjustment layer, click on the Trash icon; to reset it to its default settings, click on the circular arrow icon; to see a before/after, click on the eye icon; to see a before/after of just your last change, click-and-hold on the eye with the curved arrow icon.

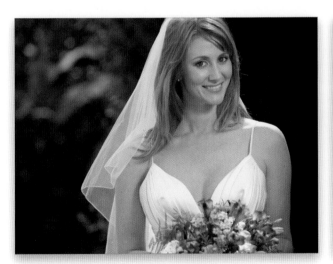

Standard grayscale conversion

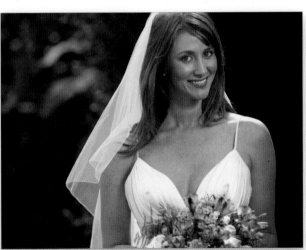

CS4's Black & White conversion

Converting to Black and White Using Camera Raw

Sometimes when you're taking a shot, you're thinking to yourself, "This would make a great black and white," or maybe before you went shooting, you knew what you'd be shooting would make a great black and white. In those cases, I prefer to do my conversions right in Camera Raw (in fact, it's one of my two favorite ways to go from color to black and white). Camera Raw has a version of the Black & White adjustment you just learned, but after I show you that, I'm going to show you a technique I like even better.

Step One:
We'll start with the color original image in Camera Raw (as seen here).

Step Two:
Converting from color to black and white is simple—just click on the HSL/Grayscale icon (it's the fourth icon from the left) and then turn on the Convert to Grayscale checkbox at the top of the panel (as seen here). This brings up the Grayscale Mix options, which look pretty much like the Black & White adjustment options you just learned about on the previous pages, but with these two exceptions: (1) here there are two more sliders—Oranges and Purples; and (2) there's no TAT (Targeted Adjustment Tool) in the panel, although you can use the TAT found in the toolbar up top while you're in Grayscale Mix. Other than that, it's pretty much the same idea. So, go ahead and turn on that Convert to Grayscale checkbox, and Camera Raw performs an Auto grayscale adjustment. It's not terrible, but it usually looks a little flat to me (as you can see here).

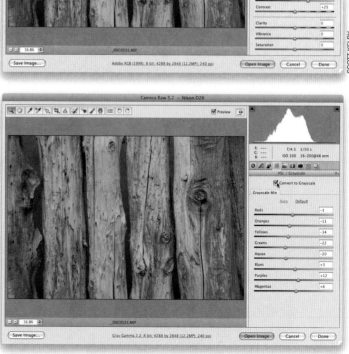

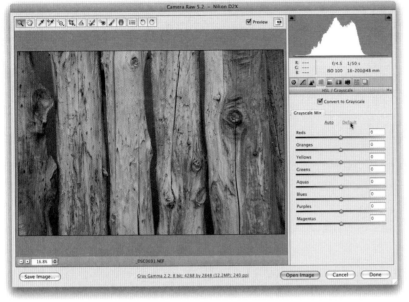

Step Three:
There's also a Default button (it looks like a link, but it's a button), just to the right of the Auto button (which looks like a link, too) and if you click on it, it sets all the Grayscale Mix sliders back to zero, which generally looks even worse (as seen here) than the Auto adjustment, so I don't recommend it.

Step Four:
If, for some reason, you like this "zero'd out" look more than the Auto-adjusted look (hey, it's possible), press **Command-K (PC: Ctrl-K)** to bring up Camera Raw's Preferences dialog and turn off the checkbox for Apply Auto Grayscale Mix When Converting to Grayscale (the checkbox is shown turned on here, so you'd turn that checkbox off).

Continued

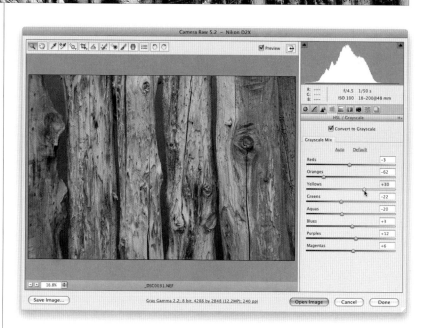

Step Five:

The color sliders in the Grayscale Mix panel are pretty much like the HSL sliders for adjusting color. The catch is you can't see which colors you're adjusting because the photo is already converted to black and white. So, what I do is press the letter **P** to toggle the Grayscale Mix Preview on/off. That way I can take a peek back at the original colors, and try to figure out which slider would adjust which parts of my image. If you're not sure which slider does what, just drag any slider back and forth, and you'll know pretty quickly what it affects (if anything). By now you've probably come to the same realization that I have, and that is the Grayscale Mix sliders alone aren't enough to make a great B&W photo. You need to add some serious contrast, including pushing the highlights exposure and shadows to create a B&W photo with any decent depth.

Step Six:

Because we need all that contrast and depth, I only use the Grayscale Mix panel for one thing—turning on the Convert to Grayscale checkbox—and I let the Auto setting be my starting place. So, go back to the Basic panel and adjust the photo like you would any other. Drag the Exposure slider to the right to increase the exposure in the highlights. If it starts to clip the highlights, drag the Recovery slider to the right to bring those clipped highlights back. Increase the Blacks to make the shadow areas nice and rich, and if part of it gets too dark, drag the Fill Light slider to the right to open up those areas. Here, I've increased the Exposure, Blacks, Contrast, and Clarity settings quite a bit to really create that high-contrast look.

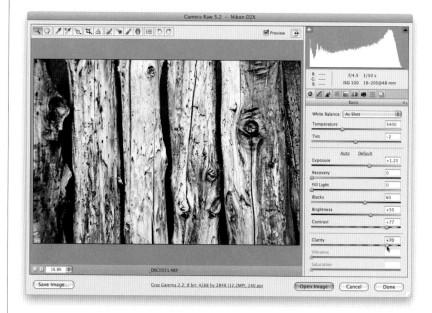

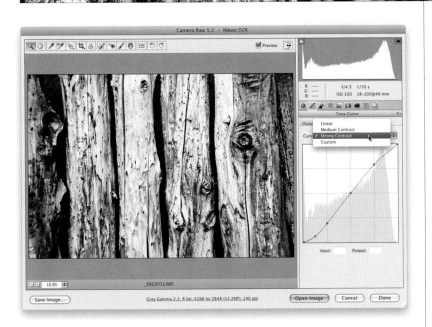

Step Seven:

Of course, when it comes to adding contrast, nothing beats the Tone Curve. So click on the Tone Curve icon (second from the left), then click on the Point Curve tab, and choose Strong Contrast from the Curve pop-up menu (as shown here). In our example, I went with just the default Strong Contrast curve, but if you wanted to "juice" that curve and make it a little steeper (for more kick in your contrast), then click on the top-right point and nudge it upward using the **Up Arrow key** on your keyboard. Then click on the second point from the bottom left and nudge it downward using the **Down Arrow key** (again, I didn't do that here, but…well…ya could).

Step Eight:

The before/after is shown below, with the Auto conversion on the left and our tweaked version on the right, which makes our case that we can't rely on the Grayscale Mix panel alone to give us that rich B&W photo we're hoping for.

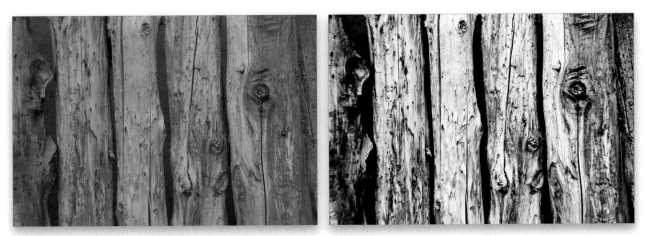

Before (the Auto grayscale conversion) *After (tweakin' it a bit)*

Calculations Method

If there's one dialog in Photoshop that scares the living daylights out of people, it's the Calculations dialog. It's got an awfully intimidating layout for a dialog that simply lets you combine two channels, but that's part of the beauty of it—once you learn this technique, you can "name drop" it to impress other Photoshop users. Anyway, I like the Calculations conversion for three reasons: (1) it gives you an instant B&W just by choosing it, (2) you can choose your favorite variations, and (3) it's where I go for tricky images that didn't convert well using another method.

Step One:

Open the color photo that you want to convert to black and white using Calculations. Go under the Image menu and choose Calculations (as shown here) to bring up the Calculations dialog. Basically, what you're going to do here is choose the best two grayscale channels from your color photo, and use a blend mode to blend them together to create a high-contrast B&W image. For example, if you have one channel that looks too dark and one that looks too light, you can usually combine the two to create a B&W image with added depth.

Step Two:

As soon as the Calculations dialog appears, it does a B&W conversion (as seen here). By default, it takes the Red channel (seen up top in the Source 1 section of the dialog), and combines it with a copy of the same Red channel (under Source 2). By default, it blends them using Multiply mode (in the Blending pop-up menu), but we need to use Soft Light as our blending mode (it's more balanced than Multiply for this task), so change the Blending pop-up menu to Soft Light (as shown here). Now, your job is to look at four different channels and find out which two look best together.

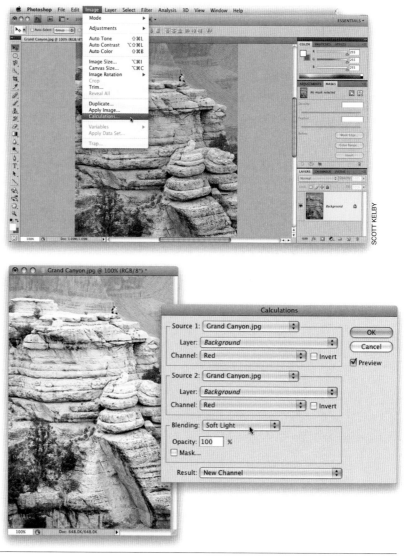

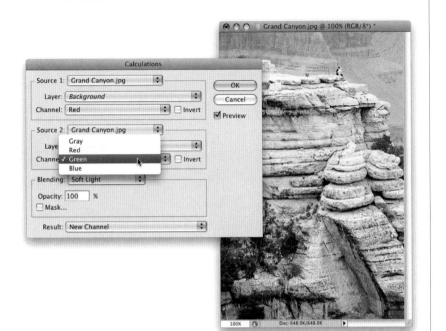

Step Three:
You've already seen what the Red channel and the Red channel look like blended together (that's what you see when the Calculations dialog first appears). Now, let's take a look at the second channel. Go to the Source 2 section, and choose Green from the Channel pop-up menu, as shown here, and see how that looks when paired with the Red channel from Source 1. If you think it's perfect, you're done—just click OK and then go under the Image menu, under Mode, and choose Grayscale. If not (personally, I think this combination still looks a little flat), then go on to Step Four and let's try another look and see what you think.

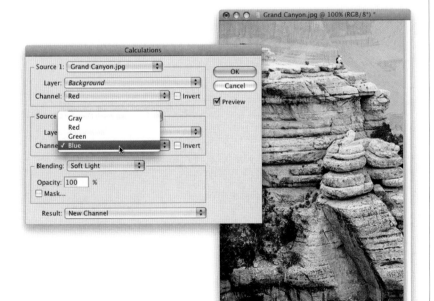

Step Four:
Now try the Blue channel (as shown here), and see how this pairing looks (the Red channel with the Blue channel). Again, what you're doing here is just choosing a channel, sitting back and looking at it, and seeing if it looks better than what you tried in Step Three (using the Green channel—and I think it does look better). But we're not out of choices yet.

Continued

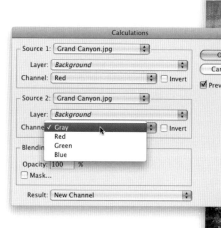

Step Five:

Your fourth choice is trying the Gray channel (as shown here), and seeing how that looks. Not too shabby, eh (this combination is the Red channel with the Gray channel combined)?

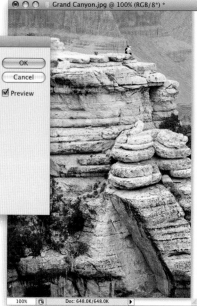

Step Six:

For most images, one of those four combinations is going to look best, and 99% of the time, I choose one of those four, hit the OK button, and then convert to Grayscale mode (as mentioned at the end of Step Three). But if you have one of those really stubborn images, you could try two last resorts: First, you could change the top channel (Source 1) and run through those channels. For example, you've tried the Red and the Gray in Step Five, right? How about blending the gray with itself (the Gray and the Gray, as shown here)? Or the Green with the Gray, or Blue with the Gray? You get the idea. But there's one more thing you could also try.

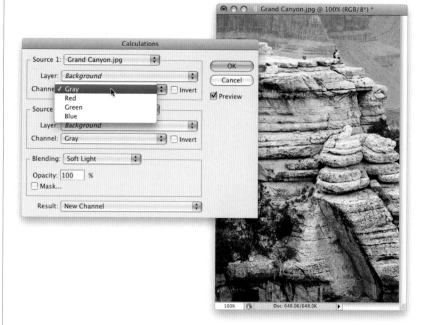

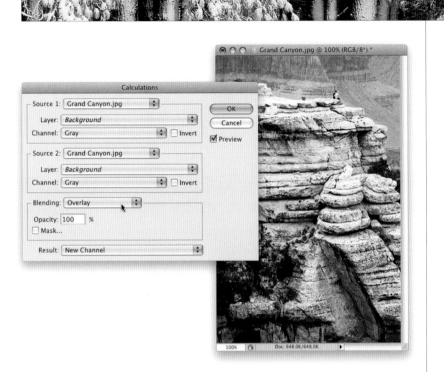

Step Seven:

If you want your photo even darker and richer, in the Blending section, change the Blending from Soft Light (which is more subtle) to Overlay (as shown here, which is more intense). This makes everything…well…more intense. I usually try this first, before going through the different channel pairings like I showed you earlier, because it's faster and easier (it's just one simple change—from Soft Light to Overlay—and it either looks better or it doesn't). Now, just to reiterate: 99% of the time, you won't need Step Six—you'll be done with Step Five (maybe sooner), so think of Step Six as your conversion of last resort. Below is the conversion using Gray and Gray, blended with Overlay mode.

Regular grayscale conversion

B&W conversion using Calculations

Scott's Favorite High-Contrast B&W Technique

Some of the best techniques unfold when you least expect it, and this technique is a perfect example. I was working on a completely different technique when I stumbled upon this and I fell in love. It's about the easiest, fastest, most predictable way to create stunning high-contrast B&W images. Plus, at the end I show you how you can get two different variations to choose from with just a few clicks each. Not bad, eh matey?

Step One:

Open the color photo you want to convert into a high-contrast B&W image You start by pressing the letter **D** to set your Foreground color to black, and then in the Adjustments panel, click on the Gradient Map icon (it looks like a horizontal gradient—it's shown circled in red here).

Step Two:

Once you click that button, you're done! The Gradient Map options appear, but you don't have to do anything. Not a bad B&W conversion, eh? Believe it or not, just the simple act of applying this black-to-white gradient map will almost always give you a much better conversion than choosing Grayscale from the Image menu's Mode submenu, and I feel it's generally even better than both the default and Auto settings of the Black & White adjustment layer technique you learned at the beginning of this chapter. Now, if I was going to nitpick this conversion, I'd like to see the edges a little darker. Easy enough.

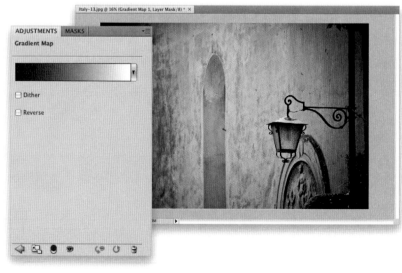

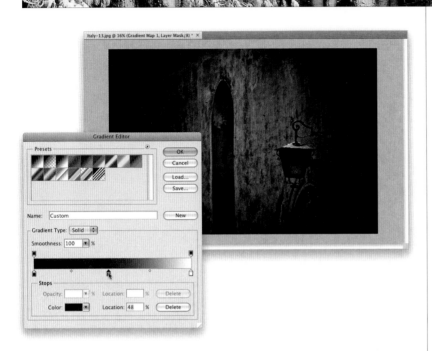

Step Three:

If you find a photo (like this one) where you want to tweak the conversion a little (like darkening the edges), then go to the Adjustments panel, and click directly on the gradient to bring up the Gradient Editor dialog. Once it appears, click once directly below the center of the gradient to add a color stop to your gradient (as shown here). The stop appears in the color black, so it's going to greatly darken your photo, but you'll fix that in the next step.

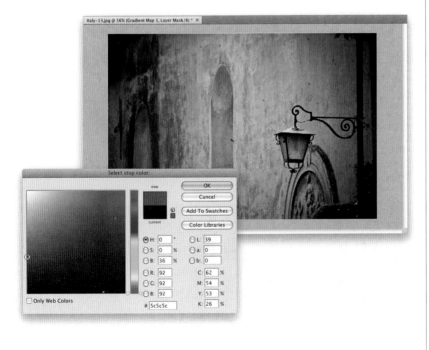

Step Four:

Double-click on that color stop you created and Photoshop's Color Picker appears (seen here). All you have to do is click-and-drag your cursor all the way over to the left side of the Color Picker, right up against the edge (as shown here), and pick a gray color. As you slide up and down that left side, let go of the mouse button and look at your photo, and you'll see the midtones changing as you drag. Once you find a spot that looks good (in our case, one where the center looks lighter), click OK to close the Color Picker (don't close the Gradient Editor, though—just the Color Picker at this point—because there's another tweak you can do. Of course, what we've done so far is probably all you'll have to do, but since there is something else you can do, I at least want to show you, but know that this next step usually isn't necessary).

Continued

Step Five:

Once you're back at the Gradient Editor, and your color stop is now gray, you can drag that middle gray stop around to adjust the tone of your image (as shown here). What's weird is you drag the opposite way that the gradient shows. For example, to darken the photo, you drag to the right, toward the white end of the gradient, and to lighten the photo, you drag left toward the dark end. Freaky, I know. One other thing: unlike almost every other slider in all of Photoshop, as you drag that color stop, you do not get a live preview of what's happening—you have to release the mouse button and then it shows you the results of your dragging. Click OK, and you're done.

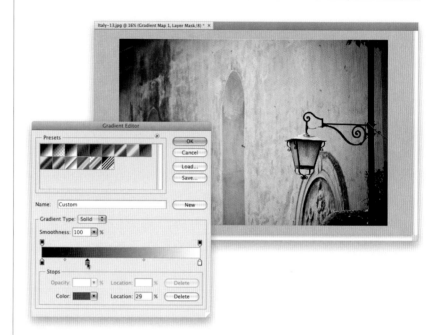

Step Six:

Here's one of the two variations I talked about in the introduction for this technique: just go to the Layers panel and lower the Opacity of your Gradient Map adjustment layer to 70% (as shown here). This bleeds back in a little of the color, and gives a really nice subtle "wash" effect (compare this slightly-colored photo with the full-color photo in Step One, and you'll see what I mean. It's kinda nice, isn't it?). Okay, now raise it back up to 100% for the second variation, which is also a second version of your B&W conversion.

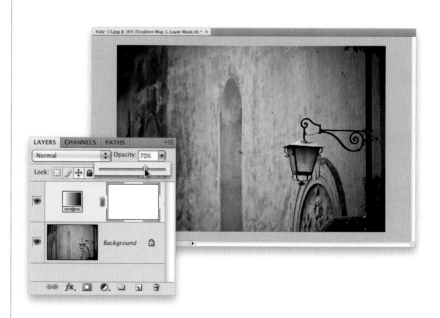

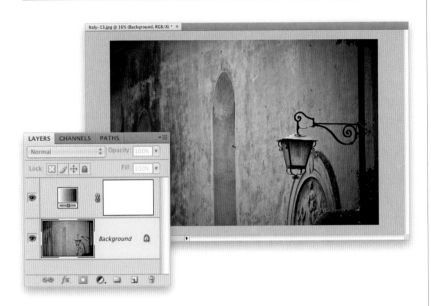

Step Seven:

For this version, go to the Layers panel and click on the Background layer, which is still in color. If you remove the color from that Background layer, you'd get a somewhat different conversion, right? Right! So, once you've clicked on the Background layer, press **Command-Shift-U (PC: Ctrl-Shift-U)**, which is the shortcut for the Desaturate command (it's found under the Image menu, under Adjustments). This removes the color and gives you a different look (although the change is fairly subtle with this photo, with some photos it's pretty dramatic—it just depends on the photo). But, either way, wouldn't you rather choose between two B&W conversions and then pick your favorite? If you don't like this other look, just press **Command-Z (PC: Ctrl-Z)** to Undo it.

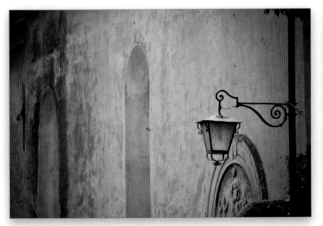

Regular grayscale conversion

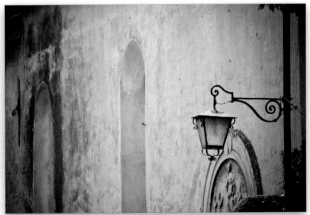

Scott's high-contrast B&W conversion

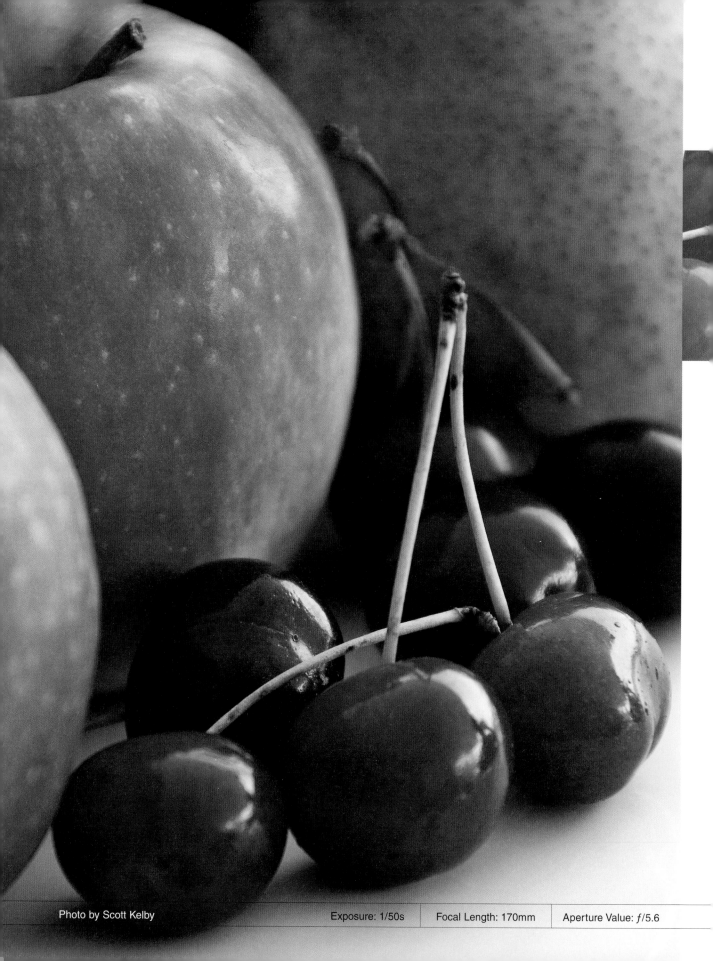

Photo by Scott Kelby

Exposure: 1/50s | Focal Length: 170mm | Aperture Value: ƒ/5.6

High Times
creating HDR (high dynamic range) images

I said in the Chapter One intro that I generally pull the names of my chapters from titles of movies, TV shows, and songs, and while there probably is a song named "High Times," I'm actually pulling this name from the magazine of the same name—*High Times*. Now, I can't swear that this magazine (who as best as I could tell was targeting illegal drug aficionados) is still being published. If I had an Internet connection, I would check it out, but I'm writing this on a flight to New York, and they seem to frown on accessing the Internet at 37,000 feet. That amazes me, because every year for the past five years, you read an article that they're going to start having Internet access on airplanes. Every article makes it sound like it's just a few more weeks away, and they're always saying stuff like, "On a number of test flights from Stockholm to Toronto last week, such-and-such an airline tested their in-flight Internet service, and it worked flawlessly," but yet, not only have I not been on a flight with Internet access, I've never met anyone who has, and I'm starting to believe that the entire thing has just been made up to divert us from the fact that since the 1980s there has been a magazine for people who use illegal drugs and nobody in our government even realizes it. If they did, by now they would have bought the *High Times* subscriber list, and assigned agents to follow these people around (like they don't already, right?), until they ultimately lead the agents to an undisclosed location where people wearing hemp t-shirts meet in closed door sessions to decide how to keep creating enough seemingly realistic delays to ensure that no one actually gets Internet access on a commercial flight, until the original publishers of *High Times* are too old to stand trial. This is the stuff that keeps me up at night. This and cannabis. Kidding!

Setting Up Your Camera to Shoot HDR

For the HDR (High Dynamic Range) technique to work, you have to "shoot for HDR" (in other words, you have to set up your camera to shoot exposure-bracketed shots that can be used by Photoshop to create an HDR image). Here, I'm going to show you how to set up both Nikon and Canon cameras (the two most popular dSLR brands) to shoot three- and five-stop brackets, so all you have to do is hold the shutter button and your camera will do the rest.

Step One:

When you're shooting for HDR, you're going to be shooting multiple shots of the exact same scene (at different exposures), and since these images need to be perfectly aligned with one another, you really need to be shooting on a tripod. Now, that being said, Photoshop does have an Auto-Align feature that does an amazingly good job, so if you don't have a tripod, or you're in a situation where you can't use one, you can try hand-holding—just make sure you're shooting in a well-lit area, so your shutter speed will be fast enough that your images won't be blurry.

SCOTT KELBY AND BRAD MOORE

Step Two:

We'll need to vary our exposure as we take each HDR shot, but we can't vary the f-stop or our depth of field will change from shot to shot, so instead we vary our shutter speed (actually, the camera will do this for us). So, switch your camera to Aperture Priority mode (the A mode on Nikon cameras like a D300, D200, D700, D2X, and D3, and the Av mode on Canon cameras like the 50D, 40D, 30D, 5D, 5D Mark II, 1D Mark III, etc.). In Aperture Priority mode, we choose an aperture (like f/8 or f/11 for outdoor shots), and then the camera will vary the shutter speed for us.

BRAD MOORE

Step Three:
Go ahead and compose your shot, and focus on the scene you want to shoot. Once it's in focus, go ahead and switch your lens to Manual focus. That way, while your camera is taking multiple shots, it doesn't accidentally change focus. Now, just so we're clear, you're not going to manually focus—you're going to go ahead and use Auto focus just like always, but once it's focused on your scene, just switch off Auto focus, and then don't touch the lens.

Step Four:
Now we set up the camera to shoot bracketed, which tells the camera to shoot the regular exposure, and then extra photos that are exposed both brighter and darker. The minimum number of exposures you can use for HDR is three, but I generally use five bracketed photos to make an HDR image (although some folks use as many as nine). So, with five, I wind up with one shot with my normal exposure, then two darker shots (one 1 stop underexposed and one 2 stops underexposed), followed by two brighter ones (one 1 stop overexposed and one 2 stops overexposed). Here's how to set up your camera to shoot bracketed (we'll start with a Nikon D300, for example): To turn on bracketing on a Nikon D300, press the Fn (function) button on the front of the camera, below the lens. Then use the main command dial to choose how many exposures to bracket (the control panel on the top of the camera shows the bracketing settings; choose 5F, so you get five bracketed shots). Use the sub-command dial (in front of the shutter button) to set the bracketing amount to 1 stop (as seen here).

Continued

Step Five:
Now, switch your Nikon camera to Continuous Low shooting mode, and just press-and-hold the shutter button until it takes all five bracketed shots for you. That's it. Okay, on to the setup for Canon cameras.

BRAD MOORE

Step Six:
To turn on bracketing for a Canon camera (like the Canon 50D or 40D), start by going to the Camera Tab menu in the LCD on the back of the camera, then scroll down to Expo Comp/AEB (Auto Exposure Bracketing), and press the Set button. Now, use the Main Dial to choose 2 stops brighter, then press the Set button again (this automatically sets the bracketing to also shoot 2 stops darker). Now set your camera to Low-Speed Continuous Shooting mode, and then press-and-hold the shutter button and your camera will automatically shoot all five bracketed photos (once all five are taken, you can release the shutter button). That's all there is to it.

Merging HDR Images in Photoshop

Now, before we go through all this, I've got to be straight with you—Photoshop's built-in HDR functionality is surprisingly lame (and that's being terribly kind). It actually does a decent job of compiling the three or five photos in an HDR file, but it's Photoshop's HDR tone mapping (which is where the HDR file gets it look) that's so weak. This is why most folks start in Photoshop (to compile the HDR file), but then do their tone mapping in a separate program (which I'll talk about after this project). So first, here's how the built-in HDR works (then you'll see what I mean):

SCOTT KELBY

Step One:

If you shot for HDR (like I talked about in the previous tutorial), you can take those images straight from Bridge CS4 to Photoshop's Merge to HDR function. In the example here, I've selected five shots I bracketed with my camera (again, you can use as few as three shots, or as many as nine, but for most images, nine just seems like overkill and it takes that much longer to process, so I've pretty much stayed away from nine for a while). Once you've selected them, go under Bridge's Tools menu, under Photoshop, and choose Merge to HDR (as shown here).

Continued

Step Two:

This launches Photoshop, and brings up the Merge to HDR dialog you see here. Your image will generally look pretty horrible, but don't let that throw you—it gets better later in the process. The thumbnails in the left column show your bracketed shots: the one in the middle shows 0.00 (that's the standard exposure), and the ones above it show 1 stop brighter, and 2 stops brighter (the ones below are –1 and –2). There's really only one control here, and that's the Set White Point Preview slider, which appears under the histogram. If your photo's highlights look really blown out, you could drag this slider to the right until you reach the end of the black graph, but I haven't been able to see any significant difference when I do this, so I don't do anything here—I just click OK.

Step Three:

This opens your compiled image in Photoshop, but it still looks pretty lame. One reason is because you're in 32-bit mode (which is outside the range of what today's monitors can display. Well, outside the range of any monitor I could buy, anyway), so to get this puppy fixed up, you'll need to convert it to 16-bit (or even 8-bit) mode by going under the Image menu, under Mode, and choosing 16 Bits/Channel (as shown here).

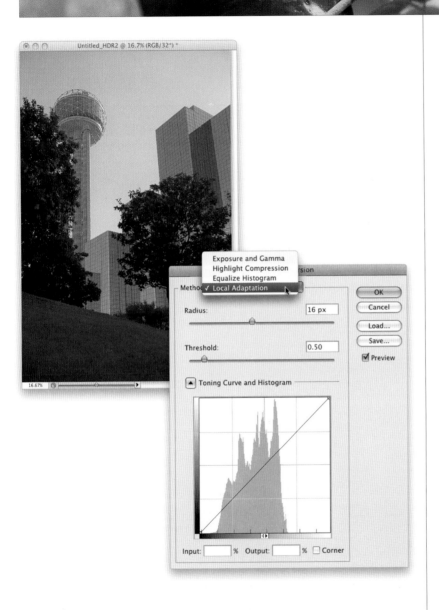

TIP: Using Only Three of the Five
Because of the way most cameras are designed, you'll need to shoot five bracketed shots, but you don't actually need to use all five to make your HDR file (in fact, many HDR pros just use three of the five bracketed photos—(1) the original "base" exposure, and then (2) the 2-stop darker photo, and (3) the 2-stop brighter photo). Those three contain enough depth to make the file, no problem, and by only using three photos, the processing is much faster. Give it a try yourself.

Step Four:
When you do this, your photo still doesn't look good, but luckily the HDR Conversion dialog appears so you can tweak its look. Start by clicking on the little down-facing triangle that appears to the left of Toning Curve and Histogram, so those options appear (seen here). The default Method will be set to Exposure and Gamma, but you'll need to click on that Method pop-up menu and choose Local Adaptation (as shown here). Just choosing Local Adaptation does wonders for the look of your image, so you finally start to make some progress toward getting an HDR look to your photo, but we still have some processing to do.

Continued

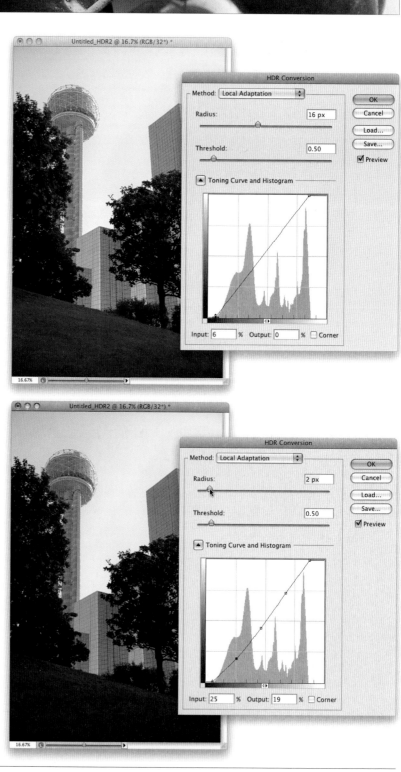

Step Five:

To balance out the tones in your image and maximize the tonal range, you're going to drag the two points (one in the top-right corner of the Toning Curve and one in the bottom left) in toward the histogram graph (which looks like some steep mountains). So, click on the top-right corner point and drag it to the left until it reaches the right edge of the graph (as seen here) to increase the highlights. Next, click on the bottom-left corner point and drag it to the right until it reaches the left edge of the graph (as shown here) to really pump up the shadows. Now things are starting to look a lot better.

Step Six:

If you want to add more points to the graph (like a center point to control the midtones, or quarter-tone points between the top point and the center point, so you can add more contrast like we learned earlier in Chapters 3 and 7), just click on the curve, then use the **Up/Down Arrow keys** on your keyboard to adjust the points. *Remember:* The steeper the curve, the more contrast is adds. Also, one thing to look out for are little halos that appear around the edges of things in your image, which make things look kind of blurry. Because of this, I usually wind up lowering the Radius amount quite a bit, just to retain detail and avoid those halos (as shown here). Now click OK to apply these changes.

Step Seven:
Let's save the file, so press **Command-S (PC: Ctrl-S)** to bring up the Save As dialog (seen here). For the next step to work, you have to save the file in TIFF format (because we're going to open this image next in Camera Raw for final processing, and Camera Raw only opens TIFFs, JPEGs, and of course, RAW photos. It won't open the default format for this photo, which is PSD, so you have to change it to save as a TIFF from the Format pop-up menu, as shown here). Now, name your new image, click the Save button, and then close your image.

Step Eight:
Go under Photoshop's File menu and choose Open (PC: Open As). When the Open dialog appears, click on the TIFF photo you just saved, and from the File Format (PC: Open As) pop-up menu at the bottom of the dialog, choose Camera Raw (as shown here) to have the TIFF image open for processing in Camera Raw, and then click Open.

Continued

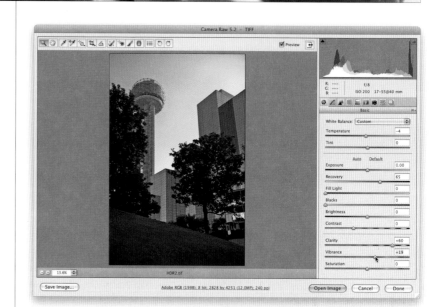

Step Nine:

Now for some final tweaks in Camera Raw: To make the clouds more dramatic, drag the Recovery slider over to around 65, then increase the Clarity to around +60. If you want the blue sky to be more blue, drag the Temperature slider to the left, towards blue, until it reads −4, then increase the Vibrance amount to +19 (as shown), and click the Open Image button. Of course, the final step is (as always) to add some sharpening, so go under the Filter menu, under Sharpen, and choose Unsharp Mask. Then, for Amount, enter 120%; for Radius, enter 1.0; and for Threshold, enter 3, and click OK.

Step 10:

The final HDR-processed image is shown here, along with the original regular exposure image. As you can see, it looks somewhat better, but only somewhat, and it's not the trademark "HDR Look" you've probably been hoping for, and that's because (as I said in the beginning), Photoshop's built-in HDR functionality is pretty lame. However, on the next page, you'll learn a much better workflow that will give you the tools to create the popular HDR look.

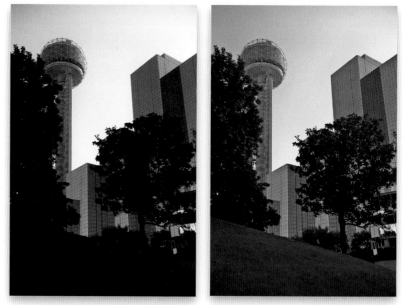

Original regularly exposed image *HDR-processed image*

I was teaching a Photoshop seminar, and I asked the crowd for a show of hands, "How many of you shoot HDR photos?" Hands went up all over the room. Then I asked, "How many of you use Photomatix Pro to process your photos?" Not a single hand went down. Everybody chuckled, but it speaks volumes. Everybody I know shooting HDR uses Photomatix Pro, because it's vastly better and easy to use. It costs $99, but you can download a free trial version from www.hdrsoft.com Do that now, so you can follow along and see the amazing difference it makes.

Creating HDR Images with Photomatix Pro

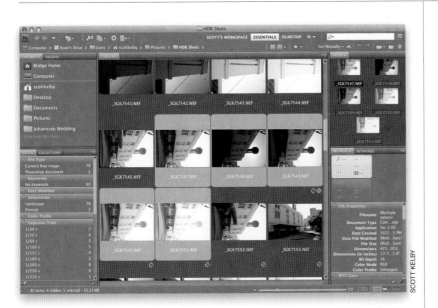

Step One:
You actually start this process in Bridge doing a little image clean up, then you jump over to Photoshop and let it compile the initial HDR image for you, and you'll save that .hdr file and open it in Photomatix Pro for the fun part—tone mapping (it sounds hard, but don't worry, it's easy). Start by selecting your HDR-bracketed photos in Bridge (as shown here).

TIP: Quickly Finding HDR Shots
If you want to be able to quickly identify which shots from your shoot are HDR-bracketed shots, right before you take your first bracketed shot, take a single shot with your index finger in the frame and then take another one once you're done (as seen here). Then when you see a shot with your finger in it, you'll instantly know that the next five shots are your HDR-bracketed shots.

Continued

Step Two:

Now press **Command-R (PC: Ctrl-R)** to open your bracketed images in Camera Raw (as seen here). There are three things you need to do here: (1) if your photos need rotating, do that now using Rotate Image in the Toolbar (the circular arrows, or just press the **R** or **L key**), (2) use the Spot Removal tool **(B)** to remove all the spots (as shown here) that were on your lens or sensor, because HDR will just amplify those big time, and (3) remove any lens vignetting, which also gets exaggerated once your file is processed as HDR.

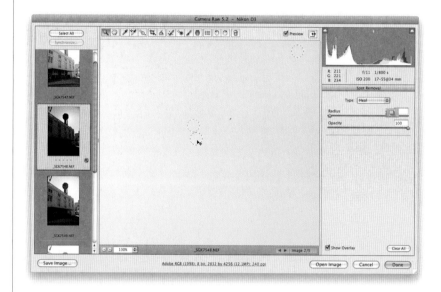

Step Three:

Click the Done button in Camera Raw to save your changes and close the images. When you look in Bridge, you'll see the updated thumbnails (you can see here the photos have been rotated). Now go under Bridge's Tools menu, under Photoshop, and choose Merge to HDR (as shown here).

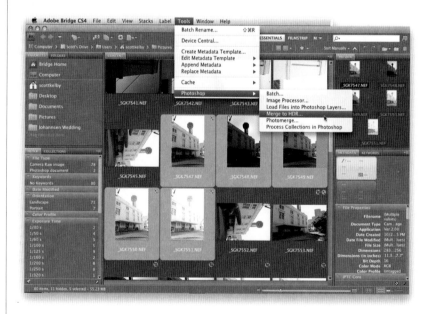

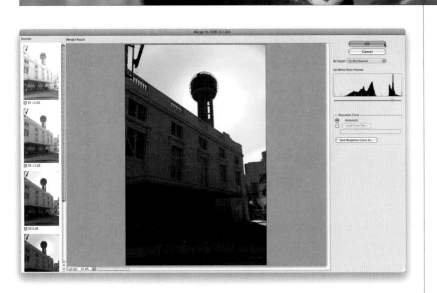

Step Four:

Just like in the previous project, this launches Photoshop CS4 and brings up the Merge to HDR dialog (and your image is going to look pretty awful in the big preview window). Don't do anything here; just click OK (for more on why, go back to Step Two in the previous project).

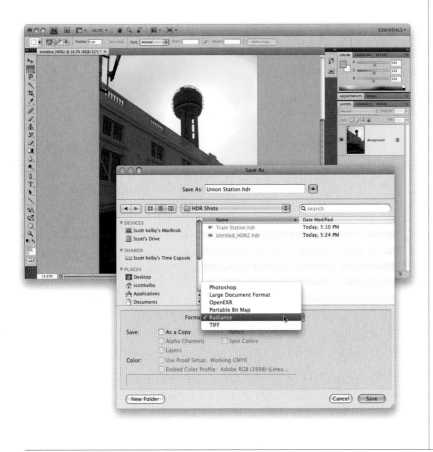

Step Five:

Clicking OK opens your compiled HDR image in Photoshop and, if at all possible, your image looks even worse, but don't sweat it (it will get better very soon). We don't need to do anything else to the photo here in Photoshop, but you do need to save it in a specific file format, so you can process it in Photomatix Pro. To do that, go under the File menu, and choose Save As. When the Save As dialog appears, from the Format pop-up menu choose Radiance (as shown here), which adds ".hdr" to the end of the filename. Name your HDR and then click the Save button. Now you're done with the Photoshop part (so you can close your image), and it's time to jump over to Photomatix Pro.

Continued

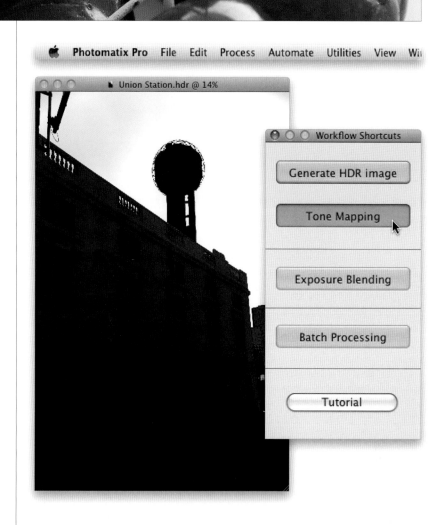

Step Six:

Now launch Photomatix Pro (don't forget—if you don't have it, you can download a free fully-working trial copy at www.hdrsoft.com. The trial never expires, but it does apply a watermark to your final images), go under the File menu, choose Open, find the HDR image you just saved out of Photoshop, and click the Open button. Once the photo opens in Photomatix (looking more awful than ever), click the Tone Mapping button (as shown here, in the Workflow Shortcuts panel), or just press the shortcut **Command-T (PC: Ctrl-T)** to enter the Tone Mapping function.

TIP: Rotating in Photomatix

If you didn't do any touch up in Camera Raw, and your HDR image is portrait (tall) orientation, it might appear in Photomatix horizontally (like it's lying on its side). Before you enter the Tone Mapping function (or do anything else), go under Photomatix's Utilities menu, under Rotate, and choose the rotation direction you need (90° Clockwise or 90° Counterclockwise). If you don't rotate it now, once you enter Tone Mapping, the rotation options are grayed out.

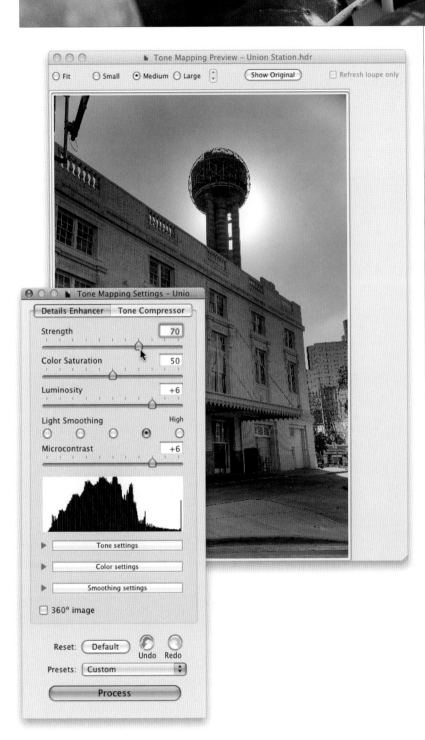

Step Seven:

Once your image appears in the Tone Mapping Preview dialog, finally, and at long last your image looks like an HDR image (as seen here) with some of the depth and dimension you've been holding out for. There are a few essential controls here I want to go over, so we'll start at the top, in the Details Enhancer tab. The Strength slider is critical because it helps determine the balance between a realistic look and more of a fantasy look, where your HDR image takes on more of an illustrative surreal look (which my buddy, Matt Kloskowski, calls the "Harry Potter look"). Both looks (the real and fantasy) are popular—you just have to choose which one you want. The farther you drag the Strength slider to the right, the farther your image is drawn into the fantasy realm (like the way I worded that?). I usually like something more in-between myself, so I usually set the Strength at around 50 to 60, but in our example shown here, I cranked it up to 70 so the effect would be more apparent.

Continued

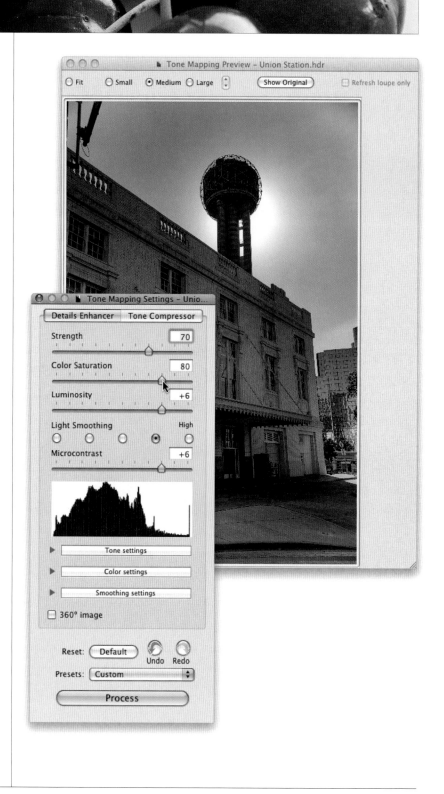

Step Eight:

The Color Saturation slider also plays into the fantasy look—the farther you drag it to the right, the more saturated your colors become. I dragged the slider over quite a bit here, and you can see how much more saturated the colors look now. Again, this is one of those "drag it 'till it looks good to you" kind of adjustments, so it's your call on how vivid you want your colors. In this particular image, the colors were pretty drab to start with, so even with dragging the Color Saturation slider pretty far to the right, the color still looks fairly tame.

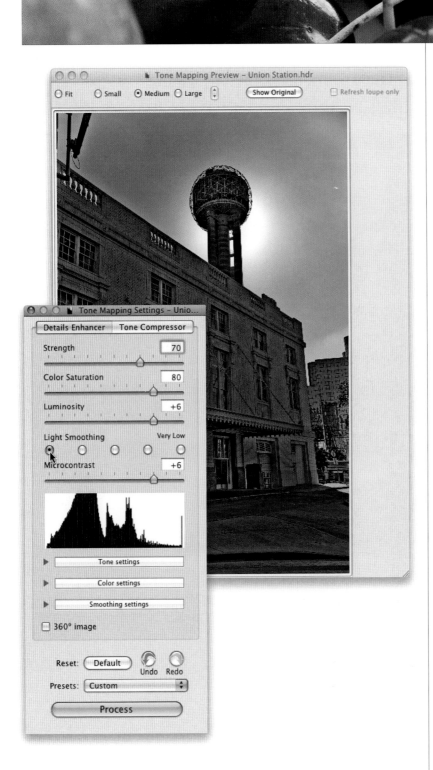

Step Nine:

The third part of the "Harry Potter look" triad is the Light Smoothing radio buttons. There are five buttons, and if you click the far-left button, you get "Maximum Potter." As you click each button moving to the right, the fantasy effect is lessened, with the far-right button having the least Harry Potter look to it. I usually use the second to the last button on the right, because I do like a little bit of what the Light Smoothing brings to the overall look. Again, how far you want to take things is totally up to you. If you're a child of the 60s, click the far-left button (sorry, I couldn't help myself). As a rule of thumb, for more realistic images, set your Strength below 50, and click the fourth or fifth Light Smoothing radio button. If you're into the Harry Potter look, raise the Strength to 90 or 100, and click the first or second Light Smoothing radio button.

Continued

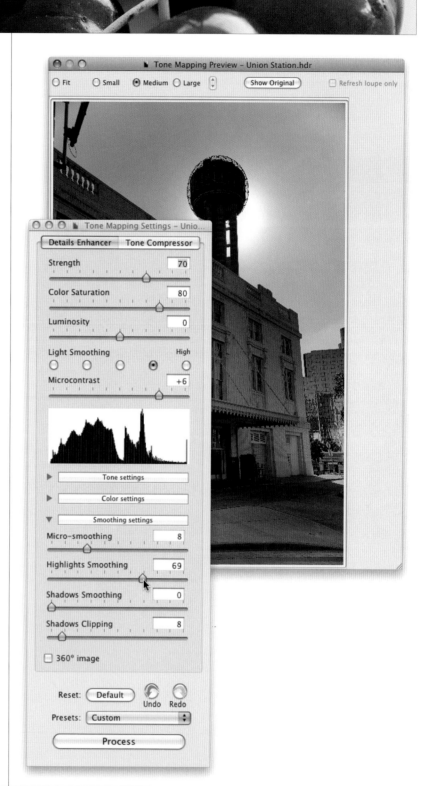

Step 10:

There are really just three other controls here you need to know about: (1) The Luminosity slider, which is kind of like the Fill Light slider in Camera Raw, but because HDR images tend to be somewhat noisy, be careful when dragging this slider to the right, or you'll increase any noise already in the photo. (2) The Microcontrast slider is well-named, as it controls how much contrast appears in the smallest detail areas of your photo—the farther to the right you drag, the more contrast you'll see there. (3) If you start to see halos appear around edges in your photos, especially in bright areas (more likely if you went the Harry Potter route), you can usually tame them by clicking on the Smoothing Settings button near the bottom of the panel, and then dragging the Highlights Smoothing slider to the right (as shown here) until they go away.

Step 11:
You could continue tweaking your image here in Photomatix Pro, and if you look beneath the histogram in the Tone Mapping Settings panel, and click on the Tone Settings button, a new section of controls appears. The three sliders seen here (White Point, Black Point, and Gamma) are pretty much like Photoshop's Levels sliders for highlights, shadows, and midtones. I normally do this type of tweaking in Photoshop itself, so at this point, I save the file and jump over to Photoshop to finish up, because I'm pretty much done with what I came here to do, which was to create the HDR look. So, click the Process button at the very bottom of the Tone Mapping panel, and Photomatix Pro processes your HDR photo in its final form.

Step 12:
When your processed image appears in Photomatix Pro, choose Save As from the File menu. Near the bottom of the Save dialog, from the File Format (PC: Save as Type) pop-up menu, choose TIFF 16-bit (which is what you'll want for editing in Photoshop), then turn on the Open Saved Image With checkbox, and choose Adobe Photoshop CS4 from the pop-up menu (as shown here). Now click the Save button and your image is saved and opened in Photoshop automatically for your final tweaks, and for you to save it in its final format (JPEG, TIFF, etc.).

Continued

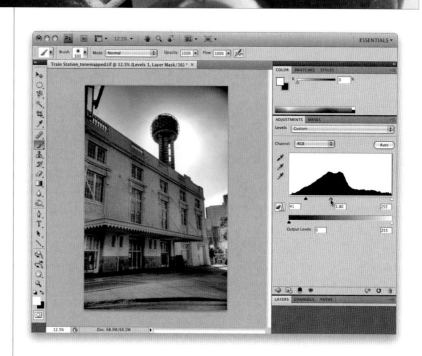

Step 13:

Here's the tone-mapped image opened in Photoshop CS4 for the final tweaks. In this case, I think it just needs a little more contrast first, so in the Adjustments panel, click on the Levels icon (the second icon from the left at the top), and drag the center midtones slider a bit to the left to brighten the midtones (so you can see the face of the building a bit better). Then, drag the shadows slider (on the left) to the right to darken the shadows (and keep the photo from looking washed out). You can also use the Clone Stamp tool (S) to get rid of that little bit of vignetting in the upper-right corner. Then lastly, apply an Unsharp Mask filter (from the Filter menu, choose Sharpen, then Unsharp Mask. I'd use a high amount of sharpening, like Amount: 120, Radius: 1, Threshold: 3, for a detailed image like this) and save the file (if you want to save it as a JPEG, you'll have to convert it to 8-bit first by going under the Image menu, under Mode, and choosing 8 Bits/Channel). On the next page are a before and afters.

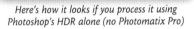

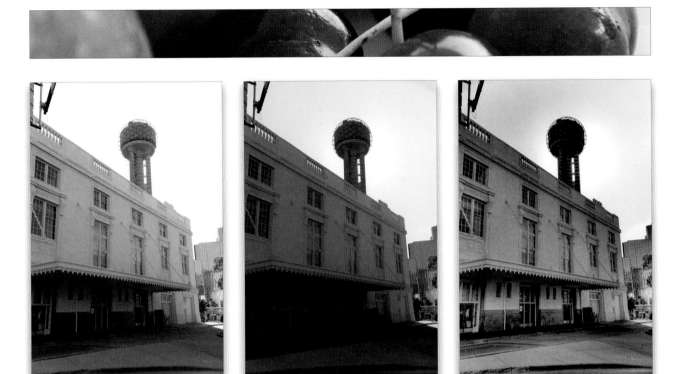

The original, standard exposure image, as taken by the camera (without bracketing)

Here's how it looks if you process it using Photoshop's HDR alone (no Photomatix Pro)

The final image tone mapped in Photomatix Pro, and with a Levels and sharpening tweak in Photoshop

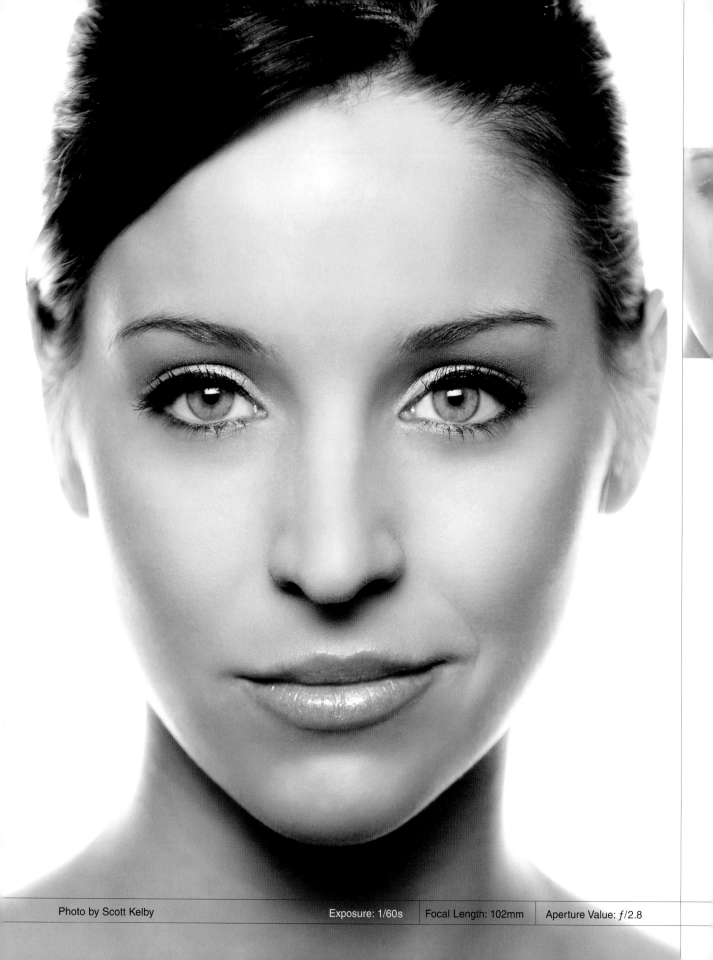

99 Problems
dealing with common digital image problems

Yo, we got some Jay-Z up in the house (that's my sad attempt at trying to sound "street." Seriously, is there nothing sadder than some 40-something guy trying to sound like he's 17 because he's trying to appeal to a demographic with huge amounts of disposable income? That's exactly why I would never stoop to those tactics. Yo dog, I just ain't all that)! Anyway, his song "99 Problems" is actually a pretty decent song, even though when I watched the video in Apple's iTunes, a lot of the words had been blanked out (there were gaps in the vocals—his mouth was moving, but you couldn't hear what he was saying). For example, at one point he says, "In my rear view mirror is…" and then the next few phrases are blanked out. So, I guess we're to form our own conclusions about what Jay-Z was seeing in his rear view mirror. You know what I think he was seeing? I think it was probably a billboard advertising a local dry cleaner, and they had one of those "Spring Cleaning" specials where you get like 20% off when they clean your comforters, blankets, or quilts, and you know they really have to give a pretty decent discount like that because it's already spring, and you won't be using that stuff again until next fall, but then it will be full price, so it's probably good if you take advantage of that discount now. Anyway, I'll bet Jay-Z saw something like that, and since they weren't paying Jay-Z a promotional fee, he wasn't going to give the name of the dry cleaner out—or their special offer—without "gettin' some bank" (dig my street lingo), right? So, in the studio, they probably blanked out that part. Yeah, that's probably what it was. Yo!

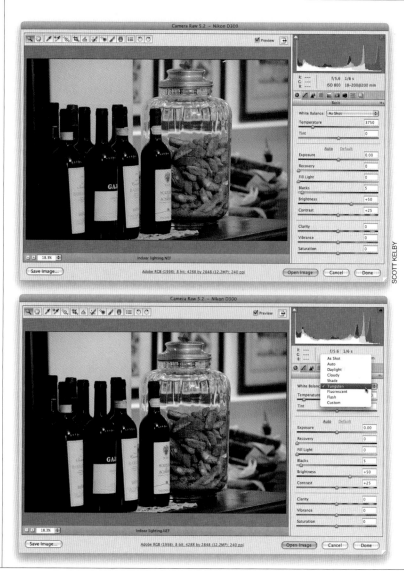

Fixing Color in Indoor Shots

You can shoot outside all day and be getting shots that look just great, but step indoors and everything changes. The culprit is Auto white balance (the default setting on digital cameras, and most people never change from this default). With Auto white balance, shooting indoors (like the interior shot shown below) you get what you see here—a photo that looks way too yellow (or if I had shot in an office, where the standard is fluorescent lighting, it would be too blue). You don't have to reach for Curves to fix this—it's simple in Camera Raw (even for JPEGs).

Step One:
Here's the interior photo, taken under standard household lighting (called "tungsten lighting" by photographers, people who sell home lighting for a living, and people who are seriously geeky). In our example, the photo was shot in RAW format, so when you open the photo from Adobe Bridge (or wherever), it opens in the Camera Raw dialog (shown here). Now, you can use Camera Raw to process your JPEG photos (as you'll see in Step Four), but adjusting white balance is one area where you get better results from RAW than from JPEG (as you'll soon see).

Step Two:
Since you took the shot indoors (under tungsten lighting) and you shot in RAW, you can take the easy way out and simply choose Tungsten from the White Balance pop-up menu (as shown here). Just look at the immediate difference (the labels are white again!). By the way, if you had changed your camera's White Balance setting to Tungsten before you took the shot, you wouldn't even be reading this page, so it's worth it to get it right in the camera, rather than having to waste time fixing it later in Photoshop. Hey, I'm sorry—this is "tough love."

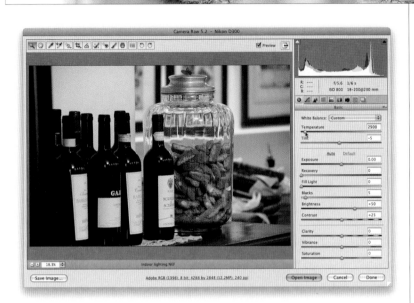

Step Three:
After you choose Tungsten, see if the wall on the left side of the photo doesn't look a little red to you (it did to me). Luckily, that's easy to fix—just go to the Tint slider and drag slowly to the left away from magenta until the reddish look disappears. If it still looks a little yellow, drag the Temperature slider to the left a little, too (as shown here). By the way, if for some reason choosing the Tungsten preset in Camera Raw doesn't look good, then instead set the White Balance pop-up menu back to As Shot, and just drag the Temperature slider to the left until the yellowing goes away.

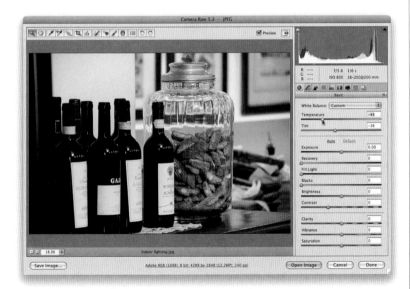

Step Four:
If you shot in JPEG, to use Camera Raw to adjust your white balance, in the Open (PC: Open As) dialog, choose Camera Raw from the Format (PC: Open As) pop-up menu. The problem is there is no Tungsten preset for JPEGs or TIFFs—just As Shot and Auto (neither of which looks good for this photo). So, all you can do is either try to find a neutral gray and click on it with the Eyedropper tool (I) (I had some luck clicking on the left edge of the wall), or you can drag the Temperature slider to the left until the yellowing goes away, and if the reddish look persists, you can drag the Tint slider to the left a little bit. This was as close as I was able to come with a JPEG (you can see on the next page the advantage of RAW in this instance).

Continued

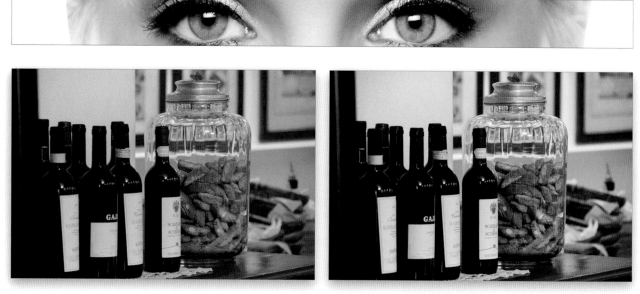

Before

RAW (after adjusting the white balance in Camera Raw)

JPEG (after adjusting the white balance in Camera Raw)

We all wind up shooting subjects that are backlit (where the sun is behind your subject). That's because our eyes automatically adjust to the situation and we see the subject just fine in our viewfinder. The problem is our cameras aren't nearly as sophisticated as our eyes are, so you're almost guaranteed to get some shots where the subject is way too dark when you open them in Photoshop. That's why Shadows/Highlights rocks, and here you'll learn how easy it is to use, and a cool trick at the end that makes it non-destructive and totally editable.

When Your Subject Is in the Shadows

SCOTT KELBY

Step One:
Open a photo containing shadow or highlight areas that need adjusting (in this case, it's a photo of the Italian coast). In this example, the light is coming from behind the buildings, and I'm standing in front of them shooting into the shadow areas, so ideally we'd like to open up the shadows on this side. The other problem is the sky is a bit washed out on the right, so I'd like to darken the sky by pulling back the highlights. That's when you reach for Shadows/Highlights—it's found under the Image menu, under Adjustments (as shown here).

Continued

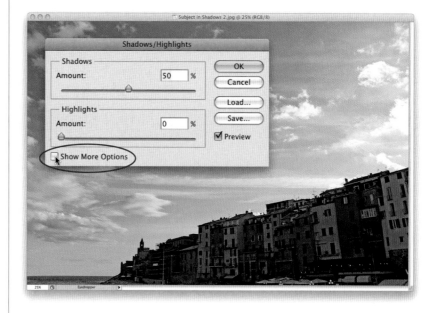

Step Two:

Adobe knows that if you're choosing Shadows/Highlights, you probably have a problem in the shadow areas. That's why, by default, it's set to open up (lighten) the shadow areas in your photo by 50% (as seen here). Here's the thing: to me, that 50% default setting seems like too much lightening (look at the photo shown here), so the first thing I do is lower the Shadows Amount until it looks better. There's another problem with opening the shadows 50% or more— it looks a bit fake, and your photos tend to look "milky" and overadjusted. To get around that, turn on the Show More Options checkbox, as shown here.

Step Three:

This brings up an expanded version of the dialog (as shown here). I have a little formula that I use that usually gives me the opened up shadow areas I need, without looking totally fake. First, I lower the Amount to some-where between 25% and 35% (the final amount depends on the individual photo—I start at 25% and drag up a little to see if I can get away with 35%). Then, I drag the Shadows Radius slider to the right to between 160 and 190 (as shown here), which smoothes out the effect even more.

TIP: Save a New Default

If you find a setting you like better than the default 50% Shadows Amount set-ting, dial in that setting, then click the Save As Defaults button in the bottom-left corner of the dialog.

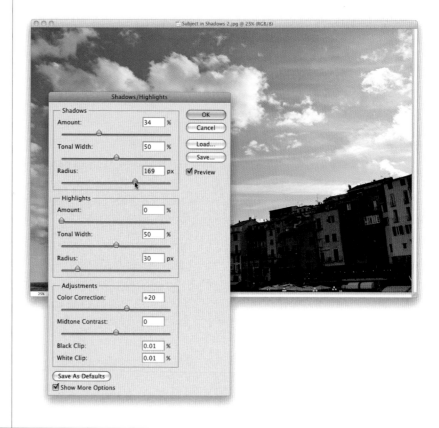

Step Four:

Now that the shadows are opened up (and look reasonably realistic), you can work on the highlights. In most cases, you'll only be working on one or the other—the shadows or the highlights, but not both. It takes someone special to actually take a photo that is so wrong on every level that it needs both areas adjusted. So, to pull back (darken) the highlights in the sky, you go to the Highlights section and drag the Amount slider to the right (as shown here). This darkens the highlights, which is good, but in our case it also introduced a new problem— a white glow around the tops of the buildings. Luckily, that's easy enough to fix.

Step Five:

To get rid of those white halos around the tops of the buildings, in the Highlights section drag the Radius slider all the way to the left (as shown here), and the halos are gone. By the way, before we move on, here's what the Tonal Width, Radius, and Adjustments sliders actually do: If you're tweaking shadows, lowering the Tonal Width lets you affect only the darkest shadow areas; increasing it affects a wider range of shadows. Increase it a bunch, and it'll start to affect the midtones, as well. It works similarly for the highlights. The Radius amount determines how many pixels each adjustment affects, so to affect a wider range of pixels, increase the amount. If you increase the shadow detail, the colors may become too saturated. If that's the case, reduce the Color Correction amount (which basically only affects the area you're adjusting). You can also adjust the contrast in the midtones using the Midtone Contrast slider.

Continued

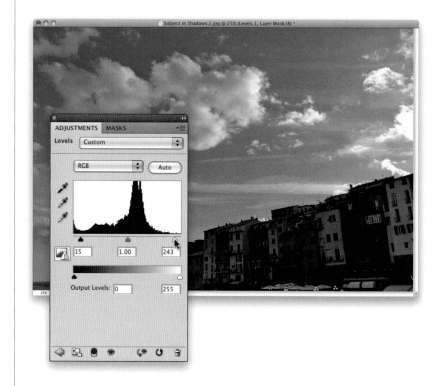

Step Six:

Go ahead and click OK to apply your Shadows/Highlights edits. Lastly, go to the Adjustments panel and click on the Levels icon to create a Levels adjustment layer, which we'll use to add some contrast back into the photo and saturate the colors a bit. So, grab the Highlights slider (on the far right under the histogram), and drag it to the left to brighten the highlights (as shown here). Then drag the Shadows slider (the black triangle on the far left) to the right to darken the shadows, and click OK to get the final image shown below.

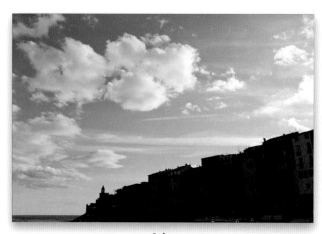

Before

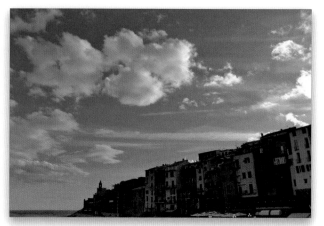

After (opening up the shadows, pulling back the highlights, and making a simple Levels adjustment)

Step Seven:

Okay, remember that cool trick I mentioned in the intro? Well, here it is: I'm going to show you a way that you can apply the Shadows/Highlights as a totally editable, non-destructive Smart Filter, even though it's not a filter (oh yeah, baby—this sounds sa-weet!!!). There are two prep steps, but you only have to do this first prep step if your photo is a standard 8-bit image (so if it's a 16-bit RAW photo, you can skip #1): (1) Go under the Image menu, under Mode, and choose 16-Bits/Channel. The look of your photo won't change, but we have to be in 16-bit for this trick to work. Then, (2) go under the Filter menu and choose Convert for Smart Filters (as shown here), which basically turns your photo into a Smart Object.

Step Eight:

Now, just like before, go under the Image menu, under Adjustments, and you'll see that every adjustment is grayed-out but one—Shadows/Highlights—so go ahead and choose it (as shown here). This brings up the regular Shadows/Highlights dialog just like always, and you can go ahead and adjust the photo using the techniques you learned on the previous pages, then click OK. This is where everything changes.

Continued

Step Nine:

When you go to the Layers panel, you'll see that your Shadows/Highlights adjustment has been added to your photo as a Smart Filter. What that means is this: a new layer (actually, a layer mask) has been added below your photo (you can choose a brush, set your Foreground color to black, click on that mask layer, and start painting over any areas where you want the Shadows/Highlights effect removed, and if you paint in white, it brings the effect back, so it works like an adjustment layer). But there's more: If you double-click directly on Shadows/Highlights, it brings back up the Shadows/Highlights dialog with the last settings you entered, so you can edit it after the fact. If you want to hide the effect altogether, click on the Eye icon to the left of the words "Shadows/Highlights" (just like you'd hide a layer).

Step 10:

Another feature of this Smart Filter that makes it more like an adjustment layer is that if you double-click directly on the little Edit Blending Options icon to the far right of your Shadows/Highlights filter in the Layers panel (you can see it in the previous step), it brings up a dialog where you can choose a layer blend mode for your Shadows/Highlights adjustment, and you can control the opacity of the effect. In the example shown here, I lightened the effect by choosing the Lighten blend mode from the pop-up menu, and then I lowered the Opacity to 70%.

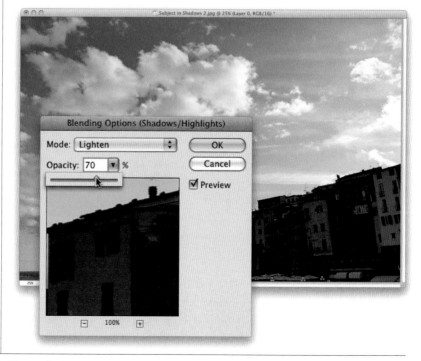

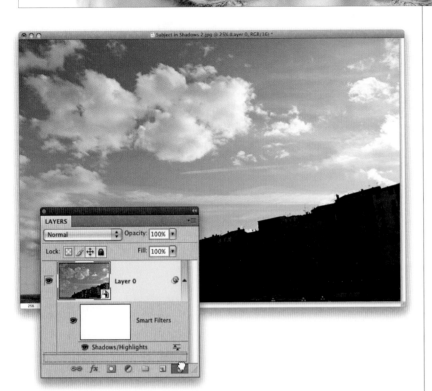

Step 11:
Again, like an adjustment layer, your Shadows/Highlights Smart Filter is non-destructive, so if you decide that later you want to remove the Shadows/Highlights adjustment altogether, just go directly to the Layers panel, click on the Shadows/Highlights layer, and drag it into the Trash at the bottom of the panel.

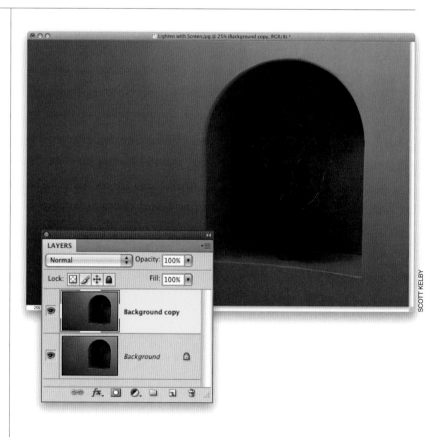

15-Second Fix for Under- or Overexposed Photos

This is a tonal correction for people who don't like making tonal corrections (more than 60 million Americans suffer from the paralyzing fear of MTC [Making Tonal Corrections]). Since this technique requires no knowledge of Levels or Curves, it's very popular, and even though it's incredibly simple to perform, it does a pretty incredible job of fixing both underexposed and overexposed photos, and the only difference between the two is one simple change.

Step One:

We'll start by fixing a dark, underexposed photo, and once you learn this technique, the overexposed fix is almost the same (with just one small change). This photo was taken of a white wall (which gives you an idea of how underexposed this shot really is). The first step is just to duplicate the Background layer (as seen here) by dragging it onto the Create a New Layer icon at the bottom of the Layers panel.

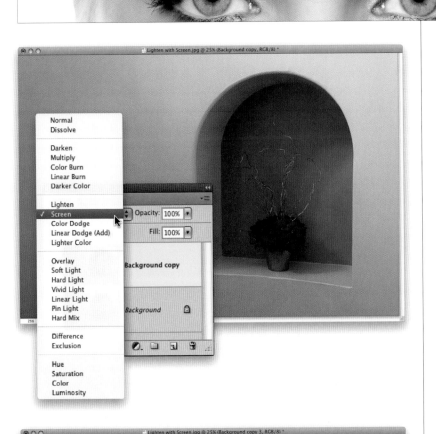

Step Two:
On this new layer, change the layer blend mode at the top of the Layers panel from Normal to Screen to lighten the entire photo (as shown here).

Step Three:
If the photo is still too dark, press **Command-J (PC: Ctrl-J)** to duplicate this Screen layer, which makes the photo that much lighter again. You can keep adding layers until it's light enough. In this case, adding a fourth layer helped, but it also made it look slightly over-exposed. So, lower the opacity of this layer (as shown here) to "dial in" the perfect amount of lightening. The opacity lets you choose anything between the full brightness of this fourth layer (at 100%) and no Screen layer at all (at 0%). Once the photo looks properly exposed, choose Flatten Image from the Layers panel's flyout menu. You can see the before/after on the next page.

Continued

Before

After (using three Screen blend mode layers)

Step Four:

Now, for an overexposed photo you pretty much do the same thing: you start by duplicating the Background layer (as shown here), so it's exactly the same thus far.

Step Five:
The only difference in the technique is that instead of choosing Screen mode (which makes things lighter), you choose Multiply, which makes the image darker (as shown here). Even just adding one Multiply layer looks dramatically better. In the After example shown below, I duplicated the Multiply layer twice (for a total of three layers) to get the face of the building dark enough, and lowered the Opacity slider a bit. So, the next time you run across a photo that's too light or too dark, give these two 15-second fixes a try. By the way, these techniques are particularly handy when you're working on restoring old scanned family photos.

Before

After (using three Multiply blend mode layers)

Dodging and Burning in CS4

Photoshop CS4 is the first version of Photoshop where it's safe to use the Dodge and Burn tools for lightening and darkening different parts of your image. In the past, we had to come up with an entirely different way to dodge and burn, because the tools were way too coarse, and they were totally off-limits for using on portraits, where even minor burning-in would make your subjects look sunburned. Luckily, that's all changed in CS4, but I'm going to include the old version, as well, which still works fine—it's just not as necessary as it once was.

Step One:
In this photo, the light simply didn't fall where we wish it had. So, here we're going to dodge (lighten) the wine labels (so they're easier to read), and the wine in the bottles themselves, along with the corks in the foreground. Then, we're going to burn (darken) the areas that we wish were darker (like the background behind the bottles and the wine in the glass). Basically, we're just going to rearrange how the light is falling on our photo. Now, I don't dodge and burn directly on the photo. Instead, press **Command-J (PC: Ctrl-J)** to duplicate the layer. That way, if we don't like what we've done, we can lessen the effect (by lowering the layer's opacity) or undo it altogether by throwing the layer away.

Step Two:
Get the Dodge tool **(O)** from the Toolbox (as shown here), and begin painting over the area you want to lighten (in our case, we'll start by painting over the label on the left—you can see the brush cursor on the label in the example shown here). Keep holding the mouse button down as you paint, because the Dodge and Burn tools have a build-up effect—each time you release the mouse button and start painting again, the amount of Dodge (or Burn) builds up.

TIP: Your Brush Cursor Works Better
In CS4, Adobe tweaked how the brush tip cursor works, so that if you move it over something darker than it is (which happens very often), it actually has a very tiny glow around it, so now you can see the size and location of your brush dramatically easier when you're over dark areas.

Step Three:
Release the mouse button, and paint over that same label again, and you'll see how it gets another level brighter. Now go ahead and paint (dodge) over the corks, and the bottle right above the label, as well. Remember—while the mouse button is held down, you're painting one level of brightness. Release the mouse button, then click-and-paint over that area, and you're painting over the original brightness with more brightness, and so on (it's kind of like polishing a silver platter—the more times you polish it, the brighter it gets). Now look at how much brighter the label, bottle, and corks are here, compared with the original image in Step One.

Continued

Step Four:

Here I've pushed it a little farther than I probably would, just to show you what can be done by simply building up that dodging a bit. I've gone two more times over the labels, the bottles, and the corks. Look at the detail and light we've been able to bring out in the bottles. Now, before we switch to burning in the background, take a look up in the Options Bar for this tool, and you can see that we've been dodging just the Midtones (and that's generally where I do my dodging and burning), but if you wanted the tool to just affect the Highlight or Shadow areas, you can choose it from the pop-up menu. Also, the 50% Exposure amount is fine for something like this, but if I were doing this on a portrait, I'd usually want something much more subtle, and I'd lower the amount to around 10%–15%.

Step Five:

Now let's switch to burning: first start by pressing **Command-J (PC: Ctrl-J)** to duplicate your top layer (so, at this point, you've got the original untouched image as your Background layer, the brightened Dodge layer in the middle (I renamed it "Dodge Layer" just to make it easier to see), and a copy of the brightened layer on top, which is the one we're going to burn on (I named it "Burn Layer"). By keeping everything on separate layers, if you don't like the burning effect, you can reduce it by lowering the opacity, or delete it altogether and you won't lose the dodging you did on the layer below it. Now get the Burn tool (as shown here), and paint over the background behind the wine glass, paint over the wine glass itself, and paint that bright area behind the bottles on the right side of the photo. This darkens those areas, and puts the focus on the bottles and labels even more (you're painting with light).

Step Six:

If you want it to be darker, just release the mouse button, and paint over the background area again. Also, don't forget the background areas between the two bottles. One more thing: up in the Options Bar you'll see a new checkbox for Protect Tones. That's the checkbox that helps to keep the color of what you're dodging and burning intact, so things just get brighter or darker, and not sunburned and color saturated. I leave this on all the time, even when I'm not dodging and burning portraits (which is when it's most useful). The next page shows a before/after, and again, I took things a little farther than I normally would, just to show a clear example of the power of dodging and burning.

Step Seven:

The old version works like this: Press **Command-Shift-N (PC: Ctrl-Shift-N)** to bring up the New Layer dialog (seen here). Change the Mode to Soft Light, then right below it, turn on the checkbox for Fill with Soft-Light-Neutral Color (50% Gray), as shown here. This creates a new layer filled with 50% gray above your Background layer. (When you change the blend mode to Soft Light, Photoshop ignores the gray color.) Now get the Brush tool, lower the Opacity to around 30% (up in the Options Bar) and paint in white on this layer to dodge or in black to burn. As you paint, in the Layers panel, you'll see strokes appear on the thumbnail of your gray layer, but on your photo you'll see those areas simply getting lighter or darker.

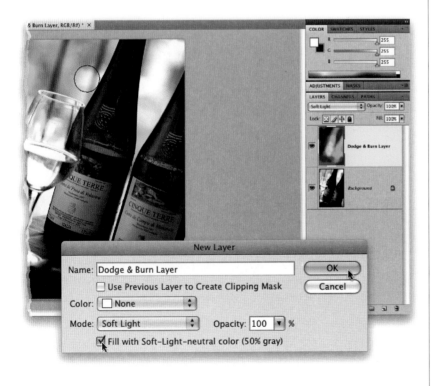

Continued

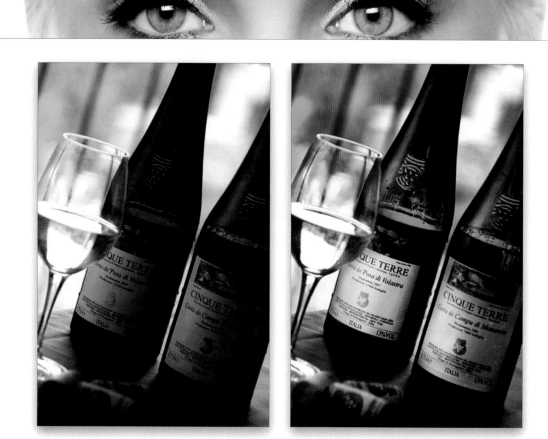

Before *After*

Instant Red-Eye Removal

When I see a digital camera with the flash mounted directly above the lens, I think, "Hey, there's a red-eye maker." If you're a pro, you probably don't have to deal with this as much, because your flash probably isn't mounted directly above your lens—you're using bounce flash, using off-camera wireless flash, using studio strobes, or one of a dozen other techniques that avoid red eye. But even when the pros pick up a point-and-shoot camera, red eye can find them (it senses fear). Here's the quick "I-just-want-it-gone" technique for getting rid of red eye fast.

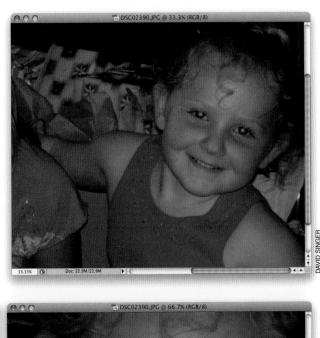

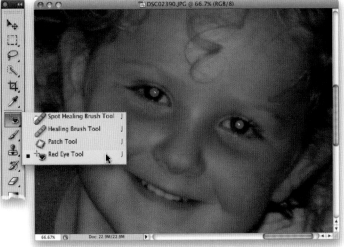

Step One:
Open a photo where the subject has red eye, like the one shown here.

Step Two:
Press **Z** to get the Zoom tool and zoom in on the eyes by clicking-and-dragging out a rectangle around them. Now get the Red Eye tool from the Toolbox (it's nested under the Spot Healing Brush, or you can press **Shift-J** until you get the tool).

TIP: Zooming In Really, Really Close
You won't see this neat little enhancement Adobe snuck into CS4 unless you zoom in to 600% magnification or more—it's a little pixel grid that appears that makes it visually easier to tell pixels apart when you're zoomed in crazy tight. It's on by default (give it a try—zoom in crazy tight and see), but if you want to turn it off, just go under the View menu, under Show, and choose Pixel Grid.

Continued

Step Three:

Tools don't get much easier to use than this—click it once on the red area of the eye, and in just a second or two the red is gone (as shown here, where I just clicked it in the red area of her left eye). Think of it as a "Red Eye Magic Wand" because it automatically selects all the red area with just one click. Now, what do you do if you click in the red area, and you don't like the results? Well, there are two controls that can help you tweak the performance of the Red Eye tool: Pupil Size and Darken Amount (you find both of these in the Options Bar).

Step Four:

Think of the Pupil Size control like you would the Threshold setting for the Magic Wand tool—the higher the amount, the more colors it will select. So if your first try doesn't select all the red, increase the Pupil Size. The Darken Amount basically determines how dark the color is that replaces the red eye. The default setting of 50% gives you a very dark gray pupil. If you want a pure black pupil, just increase the amount. To complete the retouch, just click the Red Eye tool once in the right eye (you did the left eye earlier). Press **Command-0 (zero; PC: Ctrl-0)** to fit your image onscreen, and you'll have the red-eye retouched photo you see here.

Fixing Reflections in Glasses

I get more requests for how to fix this problem than probably all the rest combined. The reason is it's so darn hard to fix. If you're lucky, you get to spend an hour or more desperately cloning. In many cases, you're just stuck with it. However, if you're smart, you'll invest an extra 30 seconds while shooting to take one shot with the glasses off (or ideally, one "glasses off" shot for each new pose). Do that, and Photoshop will make this fix absolutely simple. If this sounds like a pain, then you've never spent an hour desperately cloning away a reflection.

Step One:
Before we get into this, make sure you read the short intro up top here first, or you're going to wonder what's going on in Step Two. Okay, here's a photo of my buddy Larry Becker (the Director of the National Association of Photoshop Professionals).

Step Two:
I could see right away that we were going to have a reflection in his glasses, so I told him after the shot not to move his head, but just to reach up and remove his glasses, and then we took another shot. Now, with both images open, get the Move tool **(V)**, press-and-hold the Shift key, and click-and-drag the "no glasses" shot on top of the "glasses" photo.

Continued

Step Three:

Holding the Shift key will help get the alignment of the two layers somewhat close, but in this case, it's still off by a bit because the shot was hand-held. Anyway, for this to work, the two photos have to be lined up with each other right on the money, and in CS4, Photoshop will do it for you. You start by going to the Layers panel, clicking on the Background layer, then pressing-and-holding the Command (PC: Ctrl) key and clicking on Layer 1 to select them both (you can see they're both highlighted here). Then go under the Edit menu and choose Auto-Align Layers (if that function is grayed out, it's because you don't have both layers selected). When the dialog appears, leave it set to Auto and just click OK.

Step Four:

A little progress bar will appear telling you that it's aligning the selected layers based on their content, and within a few seconds the two layers will be precisely lined up (as shown here. Of course, it's hard for you to tell they're precisely lined up unless you've downloaded these two photos and checked it yourself. What? You didn't know you could download these same photos and follow along? That's only because you skipped "Five Quick Things You'll Wish You Had Known Before Reading This Book" at the front of the book). Once your images are aligned, use the Crop tool **(C)** to crop away any transparent areas. Okay, now you'll need to hide the top layer by clicking on the little Eye icon to the left of the layer, then click once on the Background layer (as shown here). Now you're seeing the original shot, with the reflection in the glasses.

Step Five:
You're going to need to select the inside area of both lenses, and you can use whichever selection tool you're most comfortable with (like the Magnetic Lasso tool perhaps), but for a job like this, I think the Pen tool is perfect. If you choose to go the Pen tool route, get the Pen tool **(P)**, then go up to the Options Bar and click on the second icon from the left (so it just draws a path). Then click the Pen tool once on a lower part of one of the glass lenses, move your cursor over to the left, and click, hold, and drag slightly to the left (as shown here). This draws a slightly curved path between the two points (the farther you drag after clicking, the more the curve bends).

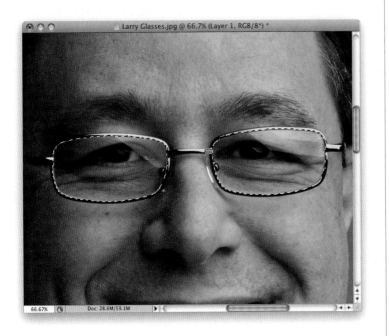

Step Six:
So basically, that's how it works—you move a little further along the lens, click, hold, and drag. Move again—click, hold, and drag, and continue this as you're basically going to trace around the lens with a path. When you get back to the point where you started, a little circle appears in the bottom-right corner of your Pen tool's icon letting you know you've come "full circle." Click on that point to close your path. Now do the same thing to the other lens. Once you've gotten paths drawn around both lenses, press **Command-Return (PC: Ctrl-Enter)** to turn your paths into a selection (as shown here). Remember, you don't have to do this using the Pen tool—use any selection tool(s) you're comfortable with.

Continued

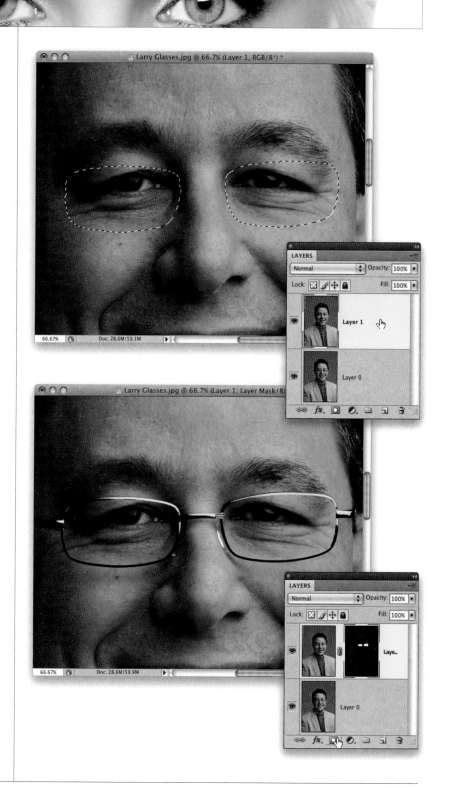

Step Seven:
After your selection is in place, make the top layer visible again (seen here) by clicking in the first column on the Layers panel where the Eye icon used to be. Then, click on the top layer to select it.

Step Eight:
To complete the effect, just click the Add Layer Mask icon at the bottom of the Layers panel (as shown here) and the eyes from the top layer replace the eyes from the original glasses layer, and your reflection problems are gone.

Before (notice the reflection—most visible in the right eye)

After (the reflection is gone)

The CS4 Secret to Fixing Group Shots

Group shots are always a challenge because, without a doubt, somebody in the group will be totally hammered (at least, that's been the experience with my family. You know I'm kidding, right?). Okay, the real problem is that in group photos there's always one or more people who blinked at just the wrong time, or forgot to smile, or weren't looking at the camera, etc. Of course, you could just take their expression from another frame and combine it with this one, but that takes a lot of work. Well, at least it did before the Auto Blend feature. This thing rocks!

Step One:
Here's a photo of my friends and NAPP Curriculum Developers, Corey Barker, RC Concepcion, and Matt Kloskowski, taken at NAPP's headquarters. The problem here is Corey (on the left) has his eyes closed and RC (in the middle) is not really smiling.

Step Two:
Of course, with group shots you take as many shots as the group will endure, and luckily in the very next frame there was a great shot of Corey with his eyes open, and RC has a little bit of a smile, but now Matt (on the right) has his eyes closed. So, the idea is to take Corey and RC from this shot, and combine them with the previous photo, where Matt has his eyes open.

Step Three:

Start by dragging the two photos into the same document: get the Move tool **(V)**, press-and-hold the Shift key, and click-and-drag one photo over onto the other (it will appear as its own layer in the other document, as you can see in the Layers panel shown here). Now, you'll need to convert the Background layer into a regular layer, so go to the Layers panel and double-click directly on the Background layer. This brings up the New Layer dialog (shown here), which by default renames your Background layer as Layer 0. Just click OK and it's now a regular ol' Photoshop layer.

TIP: Auto-Align Can Help

In this case, the photos lined up pretty well because the shots were taken on a tripod, but if you're hand-holding, you might want to select both layers and choose Auto-Align Layers from the Edit menu first, to have Photoshop CS4 align the two layers for you. Then just use the Crop tool **(C)** to crop away any transparent areas.

Step Four:

The next two steps couldn't be easier: First, in the Layers panel, hide Layer 0 from view by clicking on the little Eye icon to the left of the layer. Then click on Layer 1. Now, get the Rectangular Marquee tool **(M)** and draw a rectangular selection over the parts of this layer that don't look good (in other words, you're going to delete everything you don't want to keep—so put a selection around the two guys on the left) and hit the Delete (PC: Backspace) key. This leaves you with just the part of this layer you want to keep. Now, Deselect by pressing **Command-D (PC: Ctrl-D)**.

Continued

Step Five:

Now hide that top layer from view, and make Layer 0 visible again by clicking once in the first column where the little Eye icon used to be. Click on Layer 0, then do the same thing—erase what you don't want (in this case, you're putting a Rectangular Marquee selection around Matt with his eyes closed), then press the Delete (PC: Backspace) key, so you have the image you see here. Now you can Deselect. The key thing to remember here is this: make sure these two layers overlap, because CS4 needs some overlapping area to do its blending (in other words, don't erase so much that there's any gap between the two layers—it's got to overlap. I'd shoot for a 20% overlap if you can, although I didn't have that much here, because RC shifted position, moving the shoulder closest to Matt).

Step Six:

Go to the Layers panel and make both layers visible (as seen here). Now, you have the right poses together, but you also have a very harsh seam moving right through Matt's arm, and look at the extra shadows that appear on the floor. It looks "pieced together" big time. Of course, you could add layer masks and try blending the edges yourself with the Brush tool, but that's what makes this technique so sweet: CS4 will do a brilliant job of all that for you—in just seconds.

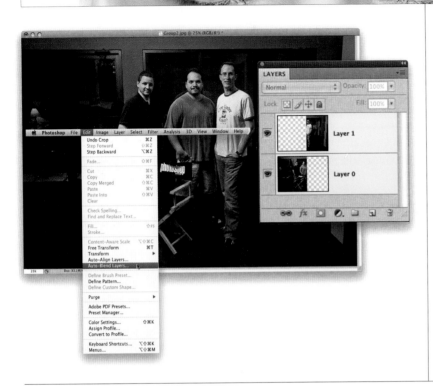

Step Seven:
Here's the last step: select both layers in the Layers panel (click on one layer, press-and-hold the Command [PC: Ctrl] key, then click on the other layer to select it as well), then once both layers are selected, go under the Edit menu, choose Auto-Blend Layers, and click OK in the resulting dialog. That's it—in just seconds you have a perfectly smooth, seamless blend of the two photos, and Photoshop did all the hard work. You can see the before/after below and look close—that seam is 100% gone! It does leave the layer masks that Auto-Blend Layers creates in place, just in case you want to tweak them, but I haven't come up with an instance where I needed to yet. Just choose Flatten Image from the Layers panel's flyout menu, and you're done.

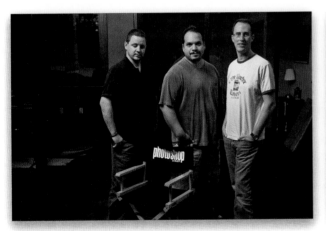

Before (the two guys on the left are in bad poses—one has his eyes closed, one's not smiling)

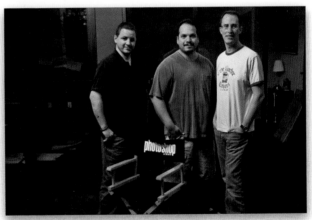

After (the first photo is seamlessly blended with the second photo, replacing the two guys on the left with their better poses from a different frame)

Having Photoshop Extend Your Depth of Field

If you're shooting with a macro lens, you know how incredibly shallow the depth of field is, even when shooting at f/22. If you shoot something really tight in, like a flower, your front petals may be in focus, but the petals an inch or so back can be totally out of focus. In the past, we'd shoot a number of different shots, each focusing just a little further into the flower, and then we'd go through the pains-taking process of masking the in-focus areas together to create a level of depth our lenses can't capture. Now, Photoshop can do all that for you (well, not the shooting—the other stuff).

Step One:
This technique definitely does start with the shoot, and you'll need to shoot close-up macro shots on a tripod, so nothing moves or changes between shots, and so your images are sharp and in focus. Once you get your camera on a tripod, and positioned, you'll need to take multiple shots of your subject (in my example here, it's a flower) and make each shot have a different focus point. For example, here I have the tips of the petals in focus, and then the next shot I focused a little farther in, and then the next farther in yet, and lastly, I focused on the stigma. Here are the four shots I took, displayed in a four-up view (you get the view you see here by opening four images, then choosing 4-up from the Arrange Documents pop-up menu in the Application Bar, as shown here).

Step Two:
Now you'll need to get all four images into the same single document as individual layers, but rather than dragging-and-dropping them, go under the File menu, under Scripts, and choose Load Files into Stack. When the dialog appears, click the Add Open Files button, and then turn on the Attempt to Automatically Align Source Images checkbox (as shown here), which is the advantage of using the script rather than dragging-and-dropping. Then, click OK.

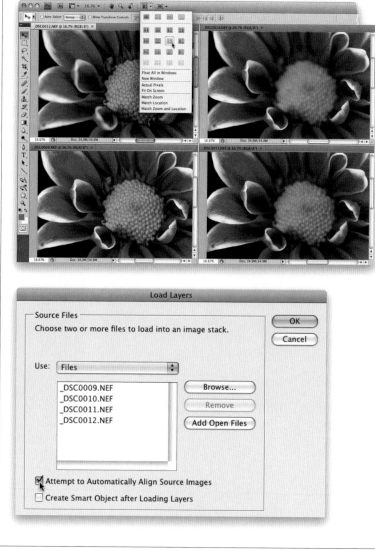

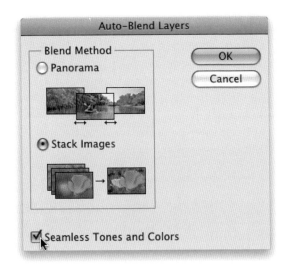

Step Three:
Once the stacking script is done, and all your images are perfectly aligned by Photoshop (it'll take a minute or two for all this to happen), you'll need to go to the Layers panel, press-and-hold the Command (PC: Ctrl) key, and click on all four layers to select them. Then go under the Edit menu and choose Auto-Blend Layers (this is the function that will analyze the focus points of each flower and combine and mask them for you). When the Auto-Blend Layers dialog appears (seen here), make sure you have Stack Images chosen (take a look at the little graphic, which actually shows a stack of flower photos, with the top one having a blurry background, and then it becomes the image with a deeper depth of field). Also turn on the Seamless Tones and Colors checkbox, which is critical to this process, as it measures the color and tone of each image and helps combine them into one seamless looking image.

Step Four:
Now click OK, then sit back and relax, because this is going to take a few minutes. Once it's done, you're presented with the final image (as seen here), where you've got depth all the way through the flower. In the Layers panel, you'll see the layer masks it had to create on each layer to combine these four images into one seamless final result. Now, I personally don't mess with those masks at all—I just flatten the image (from the Layers panel's flyout menu), then use the Clone Stamp tool **(S)** to fix any minor ghosting that may occur (you may occasionally see an area with a ghosted image along the petal of a flower, or another part of your photo, in which case, I just take the Clone Stamp tool and quickly clone it away).

The Fastest Way to Resize Brushes Ever (Plus, You Can Change Their Hardness, Too)

In CS4, Adobe added one of those seemingly little things that is actually a really big thing—the ability to resize your brush visually onscreen. I've been using the Left and Right Brackets keys to change brush sizes for years, and that works pretty well, but you never get exactly the size you want (because they jump between preset increments), and you never get there fast enough. But now, not only do you finally get the exact size you want really fast—the first time—you can use a slight variation of the technique to change the hardness of your brush, as well. Ahhh, it's always the little things, isn't it?

Step One (Mac):
When you have a Brush tool selected, just press-and-hold **Option-Control** and then **click-and-drag** onscreen. A red brush preview will appear inside your cursor (as seen here)—drag outward to increase the brush size preview or inward to shrink the size. When you're done, just release those keys and you're set. Not only is this the fastest way to resize, it shows you more than just the round brush-size cursor—it includes the feathered edges of the brush, so you see the real size of what you'll be painting with (see how the feathered edge extends beyond the usual round brush size cursor)?

Step Two (Mac):
To change the Hardness setting, you just add one key—now you press-and-hold **Command-Option-Control** and **click-and-drag** inward to harden the edges, and outward to make them softer (here I dragged in so far that it's perfectly hard-edged now). If you want to change the color of your brush preview, go to Photoshop's Preferences **(Command-K [PC: Ctrl-K])**, click on Cursors on the left, and in the Brush Preview section, click on the red Color swatch (seen here), which brings up a Color Picker where you can choose a new color.

Step Three (PC):

To get the red brush preview on a PC, you'll need to turn on a preference first. So, go to Photoshop's preferences **(Ctrl-K)**, and click on Performance on the left side. In the GPU Settings section near the bottom right, turn on the Enable OpenGL Drawing checkbox, then restart Photoshop. Now, when you have a Brush tool selected, press-and-hold the **Alt key** and **Right-click-and-drag** onscreen. The red brush preview described in Step One will appear inside your cursor (as seen here)—drag outward to increase the brush size preview or inward to shrink the size.

Step Four (PC):

To change the Hardness setting, you'll need to add two keys—just press-and-hold **Ctrl-Alt-Shift** and **Right-click-and drag**. To change the color of your brush preview, see Step Two on the previous page.

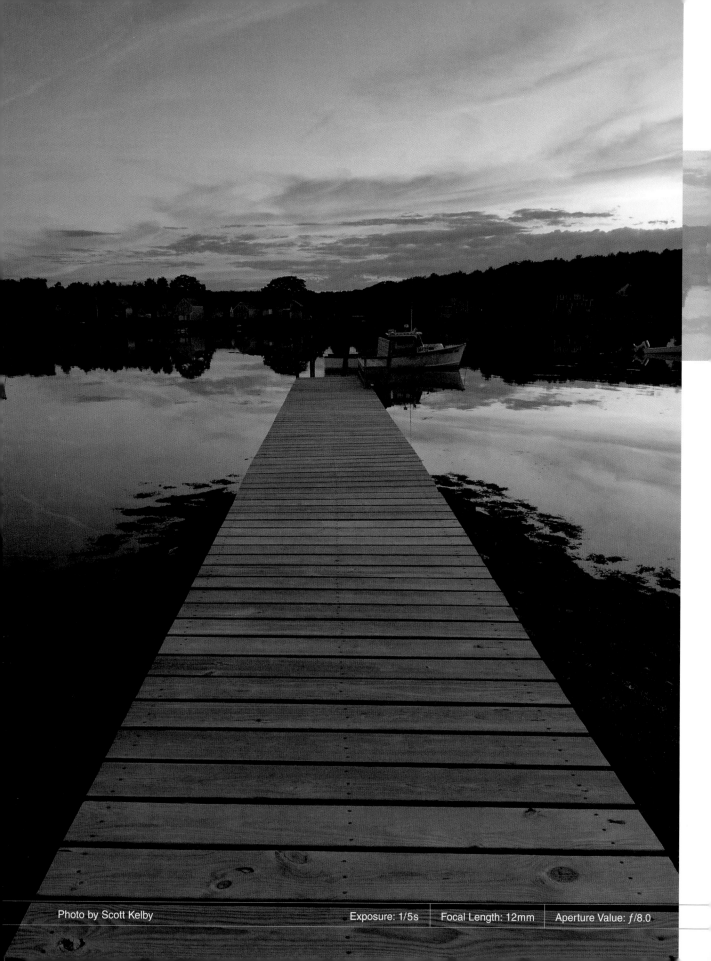

Special Delivery
special effects for photographers

The chapter title above is actually the name of a band. I ran across their song "Love Broke" as I was searching in Apple's iTunes Store under the word "Special." Of course, iTunes came up with songs from bands like .38 Special, as well as a band called The Specials, but somehow in the midst of all this, another title caught my eye. The song was named "Specinal" (which is either a typo, or a very clever misspelling of Special designed to throw off authors using iTunes as a research tool for naming chapters), but it wasn't the name of the song that drew me to it, it was the name of the band—Dufus. That's right, they named their band Dufus. Now, I'm not entirely sure, but the name Dufus might not be the best name for attracting members of the opposite sex (if you can, indeed, determine what that would be). I mean, imagine the following conversa-tion between the bass player for Dufus and a potential date chosen at random from the crowd before they take the stage. Bass player: "So, we haven't met. I'm Mike, the bass player for Dufus." Audience member: "Buh-bye, Dufus." See what I mean? It's hard to put a good spin on that name. I think I might call a band meeting and politely request a snappier name, citing the bass player's bad experience transcribed above. Some alternate names might be The Studs. Or The Heartbreak Kids, or even Eddie from Ohio. So, let's try that scenario again, but using one of these new and improved names. Bass player: "So, we haven't met. I'm Mike, the bass player for Eddie from Ohio." Audience member: "Can you introduce me to Eddie?" Bass player: "Uh, I dunno, he's pretty busy." Audience member: "Leave me alone, you Dufus."

Quadtoning for Richer B&Ws

If you've ever wondered how the pros get those deep, rich-looking B&W photos, you might be surprised to learn that what you were looking at weren't just regular B&W photos, instead they were quadtones or tritones—B&W photos made up of three or four different grays and/or brown colors to make what appears to be a B&W photo, but with much greater depth. For years, Photoshop had a bunch of very slick presets buried somewhere on your computer, but luckily in CS4, they're now just one click away.

Step One:

Open the photo you want to apply your quadtoning effect to (the term quadtoning just means the final photo will use four different inks mixed together to achieve the effect. Tritones use three inks, and do I really have to mention how many duotones use?). Quadtoning effects seem to look best with (but are not limited to) two kinds of photos: (1) landscapes, and (2) people.

Step Two:

To create a quadtone, you'll have to convert to Grayscale mode first, but by now you know what a flat-looking B&W photo that creates, so instead use whichever method from the B&W chapter (Chapter 8) of this book you like best (in the example shown here, I used the simple Gradient Map adjustment layer method, but here it looks a little light, so we'll need to add a color stop in the center of our gradient to darken up the midtones a bit—which we'll cover in the next step.

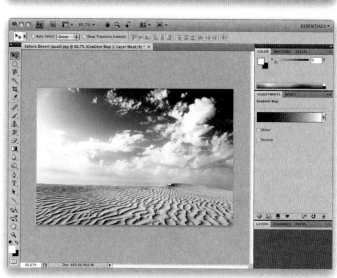

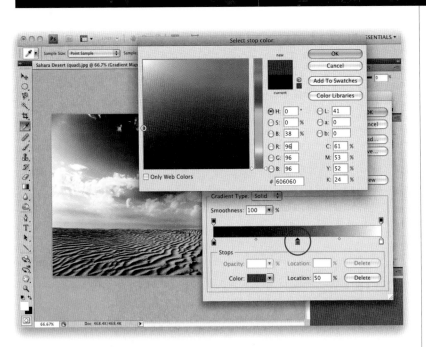

Step Three:

In the Gradient Map Adjustments panel, click on the gradient, and when the Gradient Editor appears, click right in the center below the gradient to add a stop. It adds a black stop, but you want a dark gray one (as shown circled here in red), so double-click on that stop to bring up the Color Picker. Choose a dark gray, click OK, and then close the Gradient Editor by clicking OK. You'll see this gives us a much richer B&W look. Now that your photo looks black and white, it's okay to convert to Grayscale mode. This won't change the look of the photo, it will just change the mode, and at this point (when the color's already gone), it's harmless.

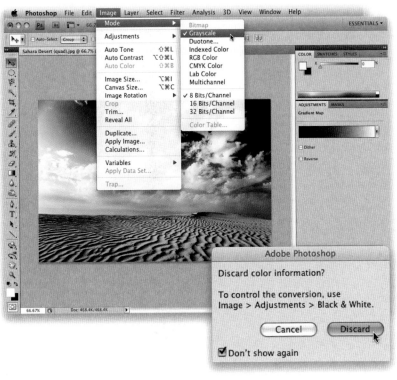

Step Four:

Go under the Image menu, under Mode, and choose Grayscale. When you do this, it will ask you if you want to flatten your layers (along with your Background layer, you also have a Gradient Map adjustment layer), so click the Flatten button (if you keep the Gradient Map adjustment layer as its own layer, it changes the look of your photo because the gradient map relies on the color channels to do its thing. Taking them away changes its effectiveness, so that's why you should click the Flatten button). This brings up another dialog, asking if you really want to discard the color information (shown here), and saying that you should be using the Black & White adjustment to make your conversion. Click the Discard button, but before you do, may I recommend turning on the Don't Show Again checkbox? If you don't turn this on, you'll become well acquainted with this well-meaning, yet incredibly annoying, warning dialog.

Continued

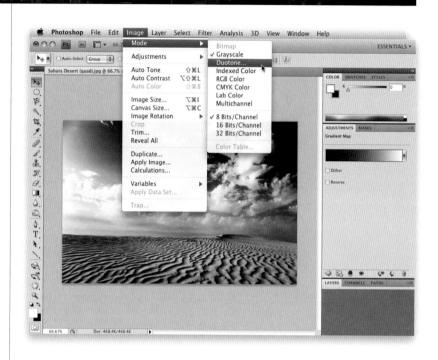

Step Five:

Once your photo is in Grayscale mode, the Duotone menu item (which has been grayed out and unchoosable until this very moment) is now open for business. So, go under the Image menu, under Mode, and choose Duotone (if Duotone is still grayed out, you forgot Step Four—converting to grayscale).

Step Six:

When you choose Duotone, the Duotone Options dialog appears (shown here), but don't let it throw you off that, even though you chose Duotone and you're in the Duotone Options dialog, the default Type setting is for a one-color Monotone. (I'll bet some nights the Adobe engineers who designed this sit at a restaurant with glasses of wine and just laugh and laugh when they think about the looks on our faces when we see Monotone as the default type.) Luckily, in CS4 you don't even have to mess with the Type setting, because we're going to use the built-in presets instead, and unlike in all previous versions of Photoshop, they're not buried somewhere inside a half-dozen nested folders. Now you can access them from the Preset menu at the top of the Duotone Options dialog.

Step Seven:

If you click-and-hold on the Preset pop-up menu at the top of the dialog, a list of literally 137 built-in presets (I actually counted them) appears for you to choose from. Now, you'd think they'd be organized by duotones first, tritones, then quadtones, right? No, that makes too much sense, and people would easily understand it. Instead, they're organized in a way that makes it just about an all-out guessing game. First, there's a bunch of duotones ordered by number, then tritones, then back to duotones, then quadtones, then back to duotones, and so on. So, what I thought I'd do is give you a few of my favorites to get you started.

TIP: Try Different Photos

One thing about these multi-ink looks: they look different depending on the photo you apply them to, so make sure you give at least a few of them a try on different photos and you'll see what I mean.

Step Eight:

One I use often is named "BL 541 513 5773" (to make it easy. Listen closely, and you can hear those Adobe engineers giggling uncontrollably. Seriously, why can't it be named "Quad: BL 541 513 5773"? Don't get me started). Anyway, the BL stands for black, and the three sets of numbers are the PMS numbers of the three other Pantone colors used to make the quadtone. So, we are actually able to figure out which are which by spending a moment looking at each one and counting the number of PMS colors listed in the name. (Of course, just adding Duo, Tri, or Quad to the name would make it much easier, but obviously easy isn't the goal. Arrrggg!)

Continued

Step Nine:

How about a nice duotone? This one uses black and it adds a reddish brown to the mix. It's called "478 brown (100%) bl 4," and really works well for certain photos (that goes back to my "give at least a few of them a try on different photos" tip on the previous page. You'll be surprised at how different these same exact quadtones, tritones, and duotones will look when applied to different photos).

Step 10:

There's a nice tritone that uses black and two grays named "BL WmGray 7 WmGray 2" (exactly what I would have named it. By the way, I did some research and learned that the "BL" doesn't stand for Black. It actually stands for "Big Laugh").

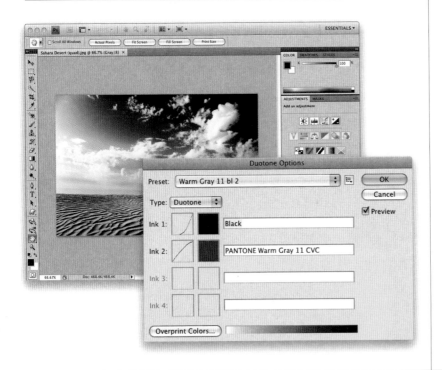

Step 11:

We'll wrap things up with another nice duotone—this one's named "Warm Gray 11 bl 2," which gives you the duotone effect shown here. Below is a before/after showing the regular B&W image, and the quadtone I showed back in Step Eight. See how much warmer the image looks, and how much more depth it appears to have next to the cold, flat B&W image? Well, there you have it—four of my favorites (and don't forget, when you're done, convert back to RGB mode).

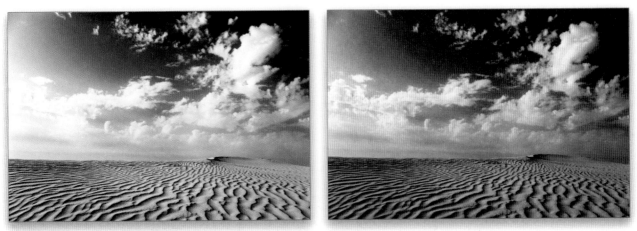

Before　　　　　　　　　　　　　　　　　*After*

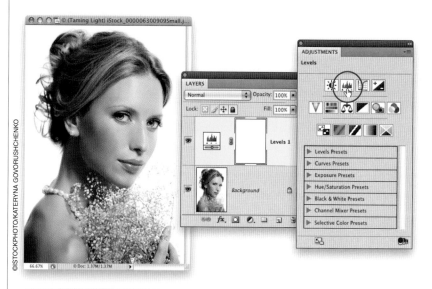

Taming Your Light

Sometimes the light falls where you don't want it, and sometimes you just mess up (like in the case here, where not enough attention was paid to the spread of the light, and both the bride's face and the flowers she's holding share pretty much the same intensity of light. The subject really is the bride's face, and the flowers are just playing a supporting role, but she was lit like they're sharing the starring role). Luckily, it's pretty easy to tame and refocus the light in Photoshop (though it's better to do it right when you shoot it).

Step One:
As I mentioned above, here's the shot where the bride's face and the flowers are both equally as bright, which is not a good thing (in fact, the flowers may even be a little brighter, and are drawing your attention away from the bride, which is absolutely not what you, or the bride, want). So, we're going to tame our light using a very simple Levels move. Click on the Levels icon near the top of the Adjustments panel (as shown here).

Step Two:
The changes I make in the Levels Adjustments panel will affect the entire photo, but since adjustment layers come with their own built-in mask, we'll be able to tweak things very easily after the fact. At this point, you want to darken the flowers, so drag the Input Levels middle slider to the right a bit to darken the midtones (and the flowers), and then drag the bottom-right Output Levels slider to the left a little bit to darken the overall photo (as shown here). One downside is that this oversaturates the colors quite a bit, which can also draw attention away from the face, but that's easy to fix.

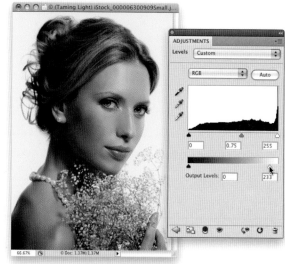

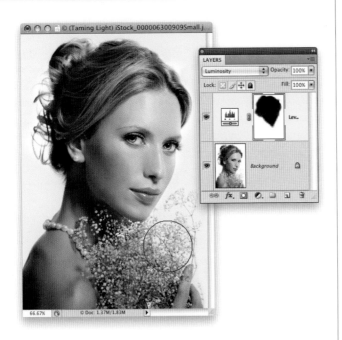

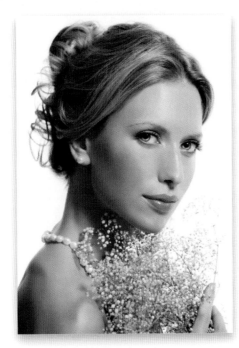

Step Three:

First, to reduce the oversaturation caused by our Levels move, go to the Layers panel and change the blend mode of the Levels adjustment layer from Normal to Luminosity. This keeps the darkening without oversaturating the color. Next, press **Command-I (PC: Ctrl-I)** to Invert the layer mask, which hides the darkening added by our Levels move behind a black mask. Now, get the Brush tool **(B)**, make sure your Foreground color is set to white, then paint over everything in the photo except for her face and hair. As you paint, it darkens those areas (as shown here where I'm darkening the flowers, so now the bride's face is once again the focus).

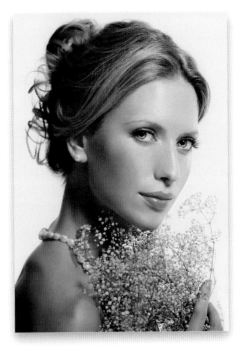

Before (the flowers have at least as much or more light than the bride's face)

After (everything else is darkened, leaving the bride's face nicely lit and making it the visual focus of the portrait)

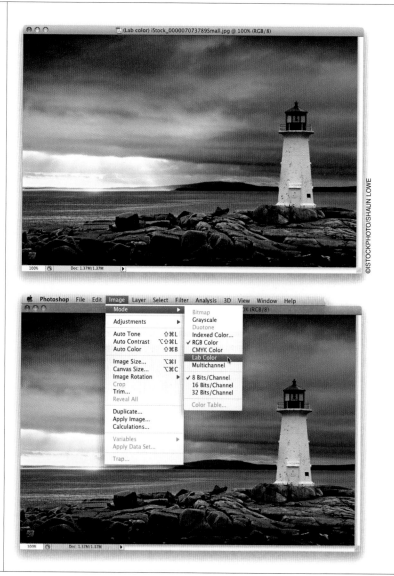

Punching Up Drab Colors Using Lab Color

Okay, so why isn't this in the color correction chapter? It's because this isn't color correction. We're not trying to make colors look as they did, we're punching up the colors big time so they look better, more vibrant, and more contrasty than the scene really looked when the shot was taken. It's totally a color effect and what you're about to learn is a much simplified version of a Lab color technique I learned from Dan Margulis, master of all things color. The full-blown technique is found in Dan's amazing book *Photoshop LAB Color*.

Step One:

This technique works best on photos that are kind of flat and drab. If you apply this to an already colorful photo, it will pretty much take the color right over the top, so choose an appropriate photo whose color needs some serious pumping up (I'm going to totally resist the urge to use a *Saturday Night Live* reference, like "We're here to pump—you—up!" Oh rats, I just did it, didn't I? My bad).

Step Two:

This is a Lab color move, so go under the Image menu, under Mode, and choose Lab Color (as shown here). This is a totally non-destructive move (moving from RGB to Lab color and back), so don't hesitate to jump over there whenever you feel the need.

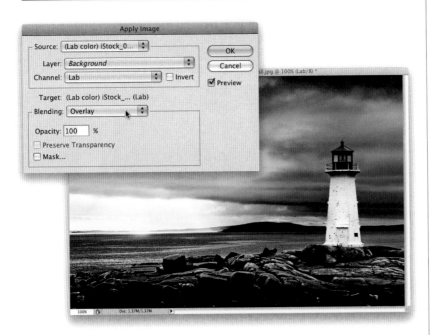

Step Three:

There's no need to head over to the Channels panel, because you're going to be doing your work in the Apply Image dialog. So, go under the Image menu and choose Apply Image. Now, before we start working in Apply Image, here's a little background: You know how we have layer blend modes (like Multiply, Screen, Overlay, etc.)? Well, in the Channels panel, there is no channel blend mode pop-up menu like there is for layers in the Layers panel, so to get channels to blend using blend modes, you use Apply Image to apply a channel to itself. When the Apply Image dialog appears, by default the blend mode is set to Multiply (which always seems too dark), so to get to the starting place for our effect, change the Blending pop-up menu to Overlay, as shown here. As you can see, it looks pretty sweet! If anything, Overlay mode may make your photo look too vivid and contrasty, but we'll deal with that soon.

Step Four:

The nice thing about using Apply Image is that you get at least three different "looks," and you simply have to choose which one looks best to you (they look different depending on the photo, so you have to try all three). By default, you're seeing the full Lab color channel (that's seen back in Step Three), so once you've seen that channel, then click on the Channel pop-up menu and choose "a" (as shown here) to see how the "a" channel looks blended with an invisible copy of itself in Overlay mode. It certainly looks better than the original, but I don't think it looks as good as the Lab channel did in Step Three.

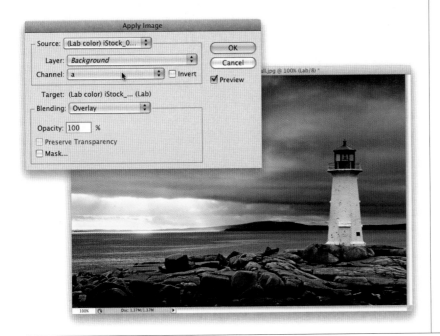

Continued

Step Five:

Now try the "b" channel by choosing "b" from the Channel pop-up menu (as shown here). This channel usually adds more yellow and warm tones to the photo (as seen in the example here). In fact, if you want to make an outdoor scene instantly look like a fall color scene somewhere in the Northeast, convert to Lab Color mode, choose Apply Image, switch to Overlay mode, and simply choose the "b" channel—voilá—instant fall colors. Now, back to our project: in the example shown here, it's very yellowish, and if you like that look— you're done—just click OK. If not, continue on with me.

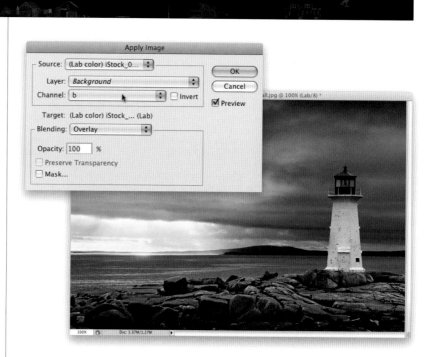

Step Six:

So far, you've seen the photo blending in Overlay mode (which is a pretty punchy mode), using the Lab channel, the "a" channel, and the "b" channel. Personally, I like the Lab channel by far, and if you feel it's the best of the three, but think it might actually be a little too "punchy," then change the Blending pop-up menu to Soft Light (as shown here). This is a more mellow mode than Overlay (how's that for a New Age explanation), and if Overlay is too intense for you, you'll probably love Soft Light. I don't mind admitting that I probably use Soft Light more than Overlay. It's probably from burning incense and sitting in the Lotus position (by the way, I have no idea what the Lotus position is, but it sounds painful).

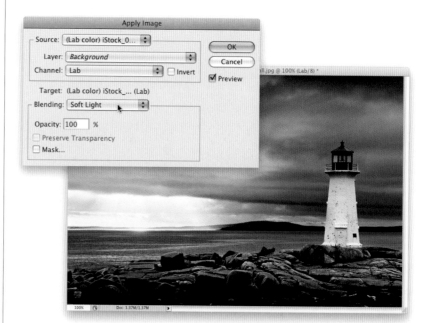

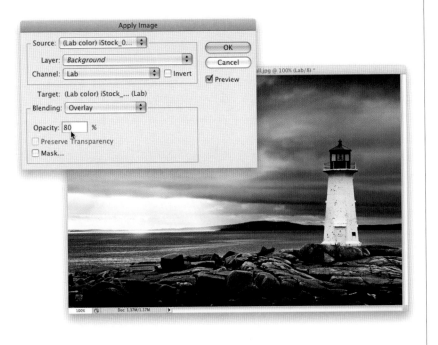

Step Seven:

There is another way to go if you think Overlay is too intense, and that's to use the volume knob. Well, I call it the volume knob, but it's actually the Opacity amount (which appears just below the Blending pop-up menu). The lower the opacity, the lower the amount of the effect. In the example shown here, I switched back to the Lab channel, chose Overlay in the Blending pop-up menu, but then lowered the Opacity to 80%. The After photo below was done using those same exact settings.

TIP: Creating an Action

This Apply Image trick is a great thing to record as an action. But once you create it, go to the Actions panel and click in the second column, beside the words "Apply Image" (a dialog icon will appear), and then when you run the action, the Apply Image dialog will appear onscreen for you to try your three choices. Once you make your choice, click OK, and the action will continue, and will convert you back to RGB.

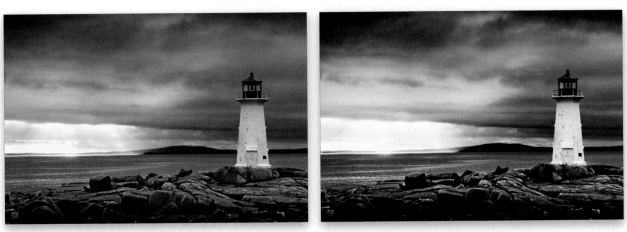

Before

After (using the Lab channel in Overlay mode at 80%—no Curves, no Levels, no nuthin')

Trendy High-Contrast Portrait Effect

This is just about the hottest Photoshop portrait technique out there right now, and you see it popping up everywhere, from covers of magazines to CD covers, from print ads to Hollywood movie posters, and from editorial images to billboards. It seems right now everybody wants this effect (and you're about to be able to deliver it in roughly 60 seconds flat using the simplified method shown here!).

Step One:
Open the photo you want to apply this trendy high-contrast portrait effect to. Duplicate the Background layer by pressing **Command-J (PC: Ctrl-J)**. Then duplicate this layer using the same shortcut (so you have three layers in all, which all look the same, as shown here).

Step Two:
In the Layers panel, click on the middle layer (Layer 1) to make it the active layer, then press **Command-Shift-U (PC: Ctrl-Shift-U)** to Desaturate and remove all the color from that layer. Of course, there's still a color photo on the top of the layer stack, so you won't see anything change onscreen (you'll still see your color photo), but if you look in the Layers panel, you'll see the thumbnail for the center layer is in black and white (as seen here).

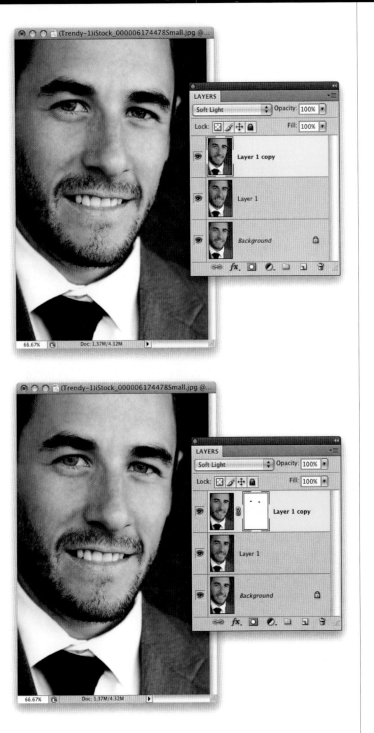

Step Three:

In the Layers panel, click on the top layer in the stack (Layer 1 copy), then switch its layer blend mode from Normal to Soft Light (as shown here), which brings the effect into play. Now, Soft Light brings a very nice, subtle version of the effect, but if you want something a bit edgier with even more contrast, try using Overlay mode instead. If the Overlay version is a bit too intense, try lowering the Opacity of the layer a bit until it looks good to you.

Step Four:

Fairly often, you'll find that the person's eyes really stand out when you see this effect, and that's usually because it brings the original eye color and intensity back (this is an optional step, but if your subject has blue or green eyes, it's usually worth the extra 15 seconds of effort). It's just two quick steps: Start by clicking on the Add Layer Mask icon at the bottom of the Layers panel. Then get the Brush tool **(B)**, choose a small, soft-edged brush from the Brush Picker up in the Options Bar, press **X** to set your Foreground color to black, and paint right over both eyes (not the whites of the eyes—just the irises and the pupils). This will seem kind of weird, because since you knocked a hole out of the eyes on this layer, you're now only seeing the eyes on the B&W layer below it, but you're going to fix that in the next step.

Continued

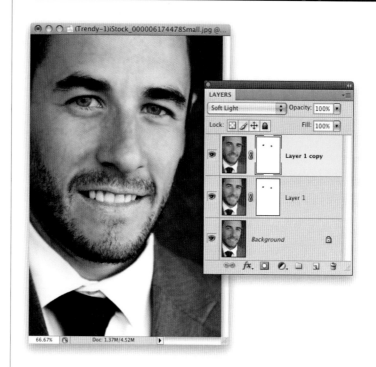

Step Five:

To knock the exact same hole out of the B&W layer (which means there will be "eye holes" knocked out of the top two layers, so you'll see the original eyes from the Background layer), just press-and-hold the **Option (PC: Alt) key**, click directly on the layer mask thumbnail itself on the top layer, and drag it to the middle layer. This puts an exact copy of the top layer's layer mask on your middle layer (as shown here). Now you're seeing the original full-color unretouched eyes from the Background layer. Pretty neat little trick, eh?

Step Six:

Now flatten the image by choosing Flatten Image from the Layers panel's flyout menu. The final step is to add some noise, so go under the Filter menu, under Noise, and choose Add Noise. When the Add Noise filter dialog appears (seen here), set the Distribution to Gaussian, and turn on the Monochromatic checkbox (otherwise, your noise will appear as little red, green, and blue specks, which looks really lame). Lastly, dial in an amount of noise that while visible, isn't overly noisy. I'm working on a very low-resolution version, so I only used 4%, but on a high-res digital camera photo, you'll probably have to use between 10% and 12% to see much of anything. You can see the before/after at the top of the next page. Beyond that, I gave you some other examples of how this effect looks on other portraits.

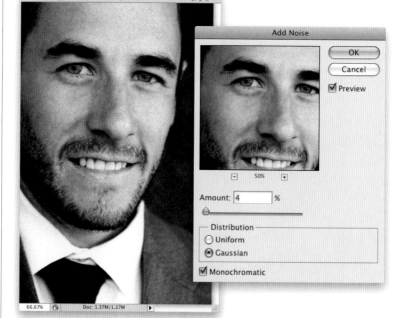

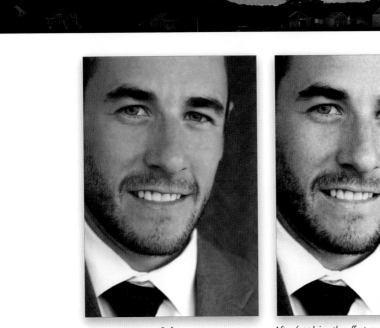

Before | *After (applying the effect and revealing the eyes)*

Before | *After*

©ISTOCKPHOTO/ROXANA GONZALEZ

Step Seven:

Here's another example using the exact same technique, and you can see how different the effect looks on a completely different image. I particularly love the almost bronze skin tone it creates in this image. Very cool stuff. Turn the page for more examples.

TIP: Don't Add Too Much Noise

Be careful not to add too much noise, because when you add an Unsharp Mask to the image (which you would do at the very end, right before you save the file), it enhances and brings out any noise (intentional or otherwise) in the photo.

ANOTHER TIP: Background Only

I once saw this effect used in a motorcycle print ad. They applied the effect to the background, and then masked (knocked out) the bike so it was in full color. It really looked very slick (almost eerie in a cool eerie way).

Continued

Step Eight:

Here's the same technique applied to a photo of a woman, however I didn't knock out the eyes because her eye color was pretty subtle. Instead I lowered the Brush tool's opacity to 50% and painted over her lips on the top layer, then copied that layer mask down to the B&W layer (just like before with the eyes—same technique with the mask). Without doing that, her lips looked pretty cold, and this way the subtle 50% pink looks right with the rest of the photo.

Before *After*

Step Nine:

Here's the final example, and there's a version of that bronze skin again. I love what it did to his skin (kind of blowing out the highlights in a cool way).

TIP: Vary the Opacity

Here are a couple of variations you can try with this effect: If the effect seems too subtle when you first apply it, of course you could try Overlay mode as I mentioned earlier, but before you try that, try duplicating the Soft Light layer once and watch how that pumps up the effect. Of course, you can lower the opacity of that layer if it's too much. Another trick to try is to lower the opacity of the original Soft Light layer to 70%, which brings back some color with almost a tinting effect. Give it a shot and see what you think. One last thing: wouldn't this be a great effect to apply as an action? Oh yeah—that's what I'm talkin' 'bout!

Before *After*

The duotone tinting look is all the rage right now, but creating a real two-color duotone, complete with curves that will separate in just two colors on press, is a bit of a chore. However, if you're outputting to an inkjet printer, or to a printing press as a full-color job, then you don't need all that complicated stuff— you can create a fake duotone that looks at least as good (if not better).

Fake Duotone

Step One:
Open the color RGB photo that you want to convert into a duotone (again, I'm calling it a duotone, but we're going to stay in RGB mode the whole time, so you can just treat this like any other color photo). Now, the hard part of this is choosing which color to make your duotone. I always see other people's duotones and think, "Yeah, that's the color I want!" but when I go to the Foreground color swatch and try to create a similar color in the Color Picker, it's always hit or miss (usually miss). That's why you'll want to know this next trick.

Step Two:
If you can find another duotone photo that has a color you like, you're set. So I usually go to a stock photo website (like iStockphoto.com) and search for "duotones." When I find one I like, I return to Photoshop, press **I** to get the Eyedropper tool, click-and-hold anywhere within my image area, and then (while keeping the mouse button held down) I drag my cursor outside Photoshop and onto the photo in my Web browser to sample the color I want. Now, mind you, I did not and would not take a single pixel from someone else's photo—I'm just sampling a color (take a look at your Foreground color swatch to see the sampled color).

Continued

Step Three:
Release the mouse button, then return to your image in Photoshop. Go to the Layers panel and click on the Create a New Layer icon at the bottom of the panel. Then, press Option-Delete (PC: Alt-Backspace) to fill this new blank layer with your sampled color. The color will fill your image area, hiding your photo, but we'll fix that.

Step Four:
While still in the Layers panel, change the blend mode of this sampled color layer to Color (as shown here).

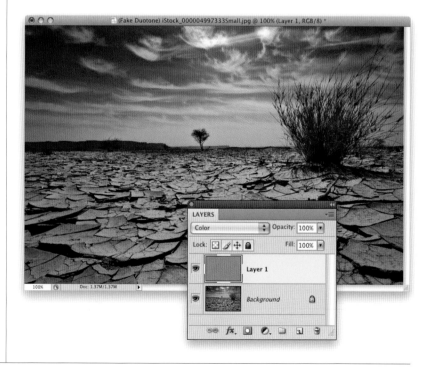

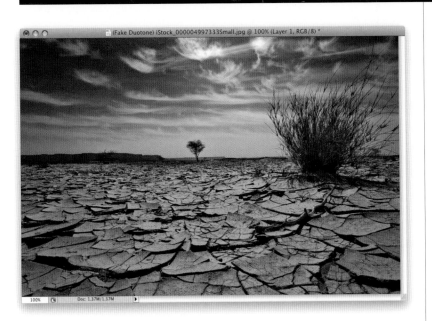

Step Five:

If your duotone seems too dark, you can lessen the effect by clicking on the Background layer, and then going under the Image menu, under Adjustments, and choosing Desaturate. This removes the color from your RGB photo without changing its color mode, while lightening the overall image. Pretty sneaky, eh? If you don't like the original color you chose—no sweat—just take the Eyedropper tool back to that stock photo and choose a different color (as I did here), and refill that color layer with your new color.

Creating Photo Collages

Photoshop collage techniques could easily fill a whole chapter—maybe a whole book—but the technique shown here (using layer masks) is probably the most popular, and one of the most powerful collage techniques used by professionals. *Note:* The term "collage" has kind of emerged as the word most often used to describe combining photos like this in Photoshop, but I've been told (in quite a harshly worded note, mind you) that they are actually photo "montages," so don't make the same horrible mistake I made. ;-)

Step One:

Here are the three photos we're going to collage together in Photoshop. I usually choose one of the photos as the "base" photo, which will act as the background for the other photos to blend into. In this case, I'm going to choose the ambulance photo, but I could just as easily have chosen any one of the three.

Step Two:

Go to the first photo that you want to collage with your background ambulance photo (in this case, it's the doctors). Press the letter **V** to switch to the Move tool, and then click-and-drag the photo right onto your background photo (as shown here). It will appear on its own separate layer above your Background layer.

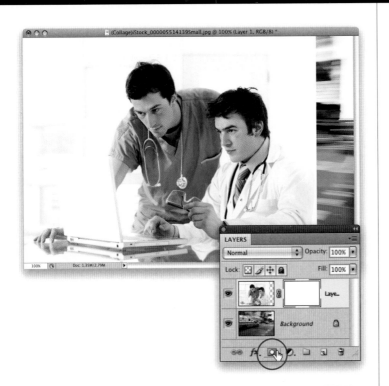

Step Three:
Click on the Add Layer Mask icon at the bottom of the Layers panel (it's circled here in red) to add a layer mask to your doctors layer.

Step Four:
Then, press the letter **G** to get the Gradient tool from the Toolbox (shown circled here). You need to use a black-to-white gradient, so you can either use: (a) the default gradient, which uses your current Foreground and Background colors, and if that's the case, just press the letter **D**, then **X**, on your keyboard to get them to black and white (respectively); or (b) you can go up to the Gradient Picker (in the Options Bar) and choose the third gradient in the top row (which is the Black, White gradient). Once you've got a black-to-white gradient chosen, click the Gradient tool on the photo at the spot you'd like to be 100% transparent, and drag to the right to the spot where you'd like the photo to be 100% solid (as shown here, where the direction is indicated with a red arrow). You'll need to start dragging well inside the edge of the photo because you want that hard edge to be totally transparent.

Continued

Step Five:

When you release the mouse button, the photo on the top layer will smoothly blend from a solid image (on the right) to transparent (as it overlaps the ambulance on the layer below it). Once the blend is in place, if you don't like how it blended (or worse yet—you see the hard edge on the left of the doctors photo), then just press **Command-Z (PC: Ctrl-Z)** to undo your drag of the gradient and then try again. Remember, if you see that left edge, you're dragging too close to it. Start an inch or so to the right of the edge, then drag (this shouldn't be a problem with this example, though, because the doctors photo was placed all the way on the left of the ambulance photo).

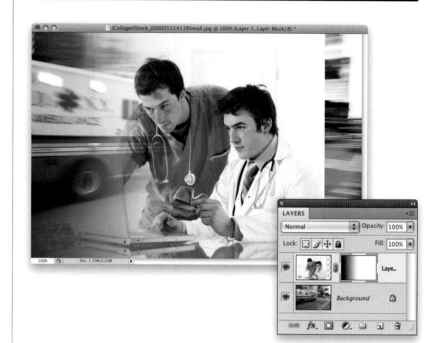

Step Six:

Open another photo you'd like to blend in with your existing two photos (in this case, it's a photo of someone writing with a pen). Switch to the Move tool **(V)**, and click-and-drag this photo onto the top of your collage-in-progress (as shown here). You can reposition your photo where you'd like it while you've still got the Move tool. In the example shown here, I dragged it over to the right so the pen photo was offset to the far right of the document.

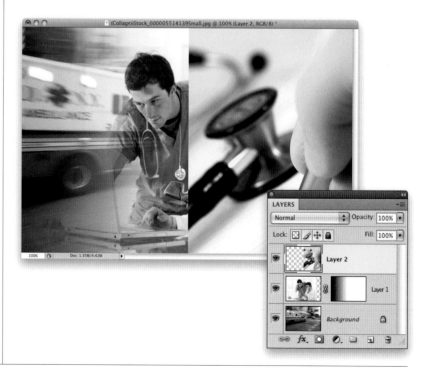

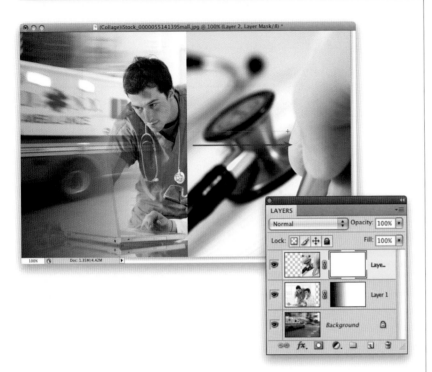

Step Seven:
Click on the Add Layer Mask icon again at the bottom of the Layers panel to add a layer mask to this new layer. Switch back to the Gradient tool (press the letter **G**), then click the Gradient tool about a half an inch inside the left edge of the pen photo, and drag to the right, to where you're almost touching the hand.

Step Eight:
When you release the mouse button, the pen photo now blends in with the rest of the photo (as seen here). You can also manually tweak the blend. For example, if you wanted to make the stethoscope less transparent, you could switch to the Brush tool **(B)**, choose a soft-edged brush, set your Foreground color to black, and with the top layer's mask active, paint over the stethoscope, bringing just the area where you paint back to full 100% opacity. The final step here is simply to add some text. The font shown here is Helvetica Neue, which comes with the Adobe Creative Suite, so click the Type tool **(T)** on your photo and add your text to the final collage (shown here).

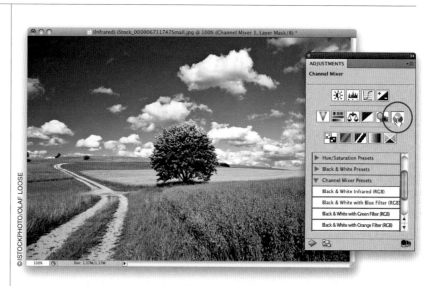

Instant Infrared Effects

Here's my digital twist on getting an infrared look from regular photos taken with your digital camera. The first three steps give you the standard infrared look, which I totally love (and which makes it kinda look like you popped a Hoya R72 infrared filter on your lens), and the last steps let you bleed some color in for some really interesting looks.

Step One:

Open the RGB photo you want to apply an infrared effect to in Photoshop. Go to the Adjustments panel and click on the Channel Mixer icon, as shown here (it's the icon with three overlapping circles on the far right of the second row).

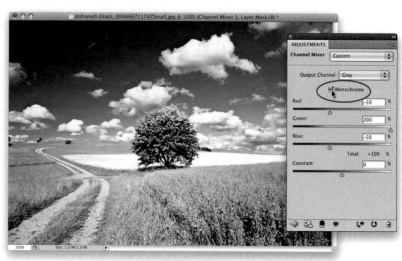

Step Two:

When the Channel Mixer options appear, turn on the Monochrome checkbox at the top of the panel first (it's shown circled here in red). Then, drag the Red channel slider to the left to –50% (it's actually quicker to just type –50 in the field at the top right of the Red slider); set the Green channel to 200%; and set the Blue channel to –50% for the subtle infrared effect you see here. *Note:* There is a built-in Black & White Infrared (RGB) preset conversion you can choose from the Channel Mixer Presets on the main Adjustments panel, but I think in most cases it creates too light an effect, especially in the sky where it should be almost black.

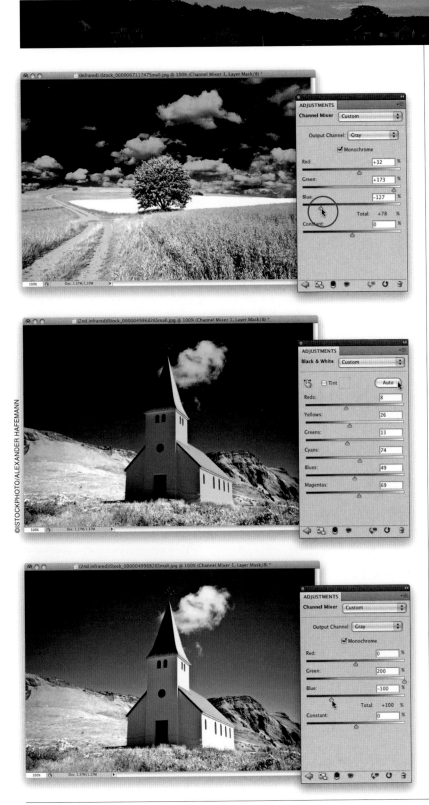

Step Three:

So, think of the settings you just entered as a starting place. In this photo, to make the light green grass even whiter and the blue sky darker, raise the Red back up to 32%, lower the Green to 173%, and lower the Blue to –127 (as shown here), which for photos like this is a pretty darn good recipe for a B&W infrared. Now, if you're wondering how I knew which way to drag the sliders to make the grass behind the tree whiter—I didn't. That is, until I dragged them back and forth to see what they would do to the photo. When the green and yellow highlights got brighter, I was happy. Lowering the amount of Blue to make the blue sky darker was pretty easy to figure out.

Step Four:

Here's a different photo, and I thought I'd demonstrate the difference between a standard B&W photo and a B&W infrared. Click on the Black & White icon in the Adjustments panel (the fourth icon from the left, in the second row), then click the Auto button (as shown here) to give you an auto B&W conversion. It ain't great, but it gives you the idea.

Step Five:

Now click the Trash icon at the bottom of the panel, and click on the Channel Mixer icon instead. Input similar settings to what we used in Steps Two and Three, and look at the difference. If you'd like a color infrared effect, then try this: duplicate the Background layer, drag it to the top of your layer stack (in the Layers panel), change the layer blend mode at the top of the Layers panel to Overlay, then lower the Opacity to 50%. Not bad, eh?

Scott's Three-Step Portrait Finishing Technique

One of the questions I get asked most about my portraits is how do they look so sharp, but at the same time have a soft quality to them? It's because for all portraits of women, children, or families, I apply a three-step Photoshop finishing technique that does the trick. It actually combines two techniques you've already learned, and introduces a third. They're all exceedingly easy (in fact, you can write an action to apply all three steps with the click of one button)—it's just the order you do them in, and the settings you use. Here's exactly what I do:

Step One:

Once you've color corrected the photo, done any retouching, etc., that's when you add these three finishing steps. The first step is to add a lot of sharpening to the photo (because in the second step, you're going to blur the entire photo). I always use Lab sharpening for this, so go under the Image menu, under Mode, and choose Lab Color.

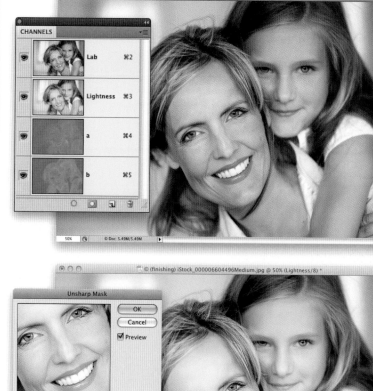

Step Two:

Go to the Channels panel and click on the Lightness channel, so your sharpening is applied to just the detail areas of the photo, not the color areas. When you do this, it displays the grayscale Lightness channel (as seen here). Now go under the Filter menu, under Sharpen, and choose Unsharp Mask. The settings I use are pretty strong—Amount: 120%, Radius: 1, and Threshold: 3—but you generally need it (however, if you have a small, low-resolution file, you'll need to lower the Amount to 80%). Click OK, click back on the Lab channel, then switch back to RGB mode.

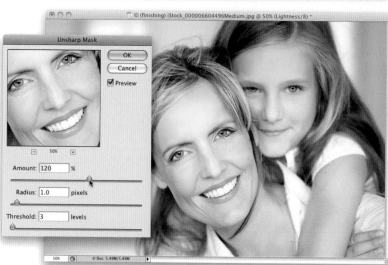

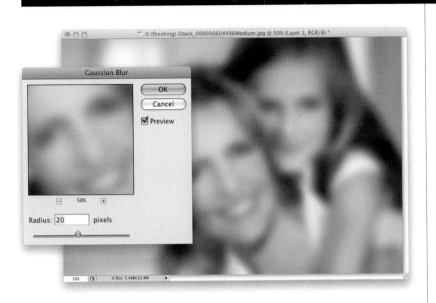

Step Three:
Duplicate the Background layer by pressing **Command-J (PC: Ctrl-J)**, then you're going to apply a pretty significant Gaussian Blur (20 pixels) to this layer. So, go under the Filter menu, under Blur, and choose Gaussian Blur. When the dialog appears, enter 20 pixels for a regular high-res digital camera photo (for a low-res file, only use 6 pixels), then click OK to apply the blur to this layer.

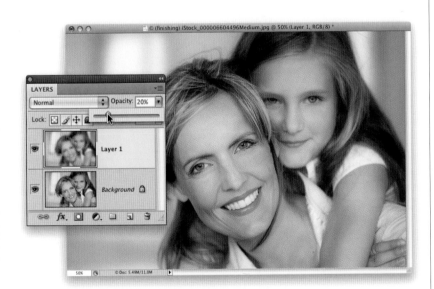

Step Four:
Now, in the Layers panel, lower the layer Opacity of this blurry layer to just 20% (as shown here), which gives the photo almost a glow quality to it, but the glow is subtle enough that you don't lose sharpness (look at the detail in the hair and eyes).

Continued

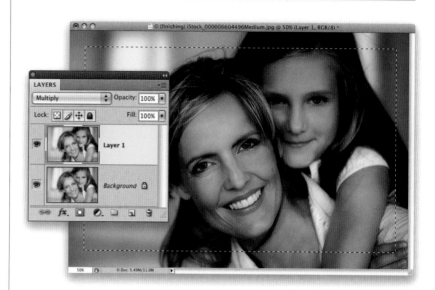

Step Five:

Press **Command-E (PC: Ctrl-E)** to merge those two layers together and flatten the photo. Now, you're going to add an edge vignette effect (which looks great for portraits), so start by duplicating the Background layer again (you know the keyboard shortcut, right? Oh come on, you just did it in Step Three. I thought I was the only one with the memory retention of a hamster). Anyway, once you duplicate the layer, change the blend mode of the layer to Multiply (which makes the layer much darker). Then get the Rectangular Marquee tool **(M)** and draw a rectangular selection that is about ½" to 1" inside the edges of your photo (as shown here).

Step Six:

Now you're going to majorly soften the edges of your rectangular selection, so go up to the Options Bar and click on the Refine Edge button to bring up the Refine Edge dialog (shown here). Below the five sliders, click on the first icon on the left (shown circled here in red), so you view your photo as a full-color composite image. Now, to soften the edges, drag the Feather slider all the way to 200 pixels (if you're using a low-res file, only feather 100 pixels). One advantage of this Refine Edge dialog is you can see the amount of feathering as you move the slider. Now press the Delete (PC: Backspace) key on your keyboard to knock a soft-edged hole out of your darker Multiply layer (as seen here).

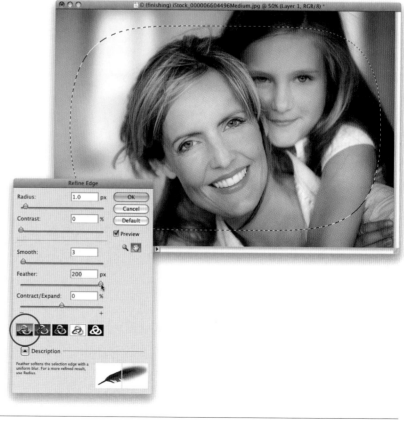

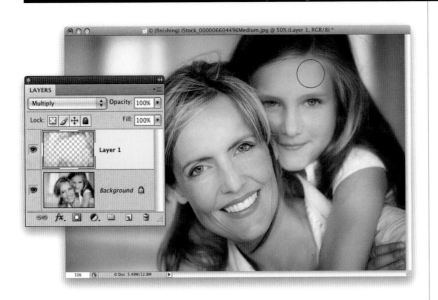

Step Seven:

Press **Command-D (PC: Ctrl-D)** to Deselect, and you'll see the effect is like a really soft spotlight aimed at your subjects. If the edge darkening actually is close enough to their faces to matter, get the Eraser tool **(E)**, choose a soft-edged brush, and simply paint over the top of the head and hair (as shown here) to remove the edge vignetting in just that area. The final photo is seen below right. Notice the sharp eyes and hair, and general overall sharpness, but there's also a general overall softness, enhanced even more by that soft spotlight vignette you added at the end. Again, this is a perfect routine to turn into an action so it's always just one click away.

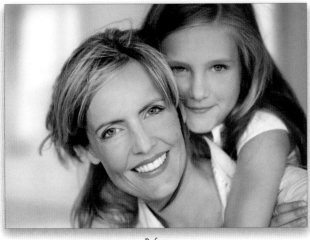

Before

After (applying all three steps)

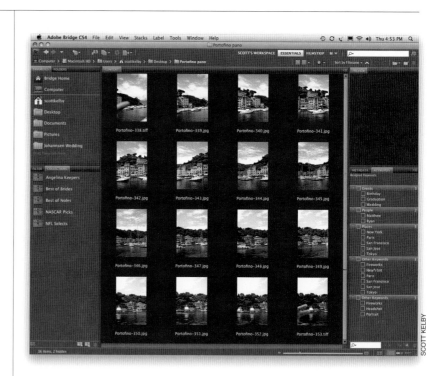

Panoramas Made Crazy Easy

I used to have an entire segment in my live Photoshop seminars where I'd show you the seven things you needed to do with your camera to shoot a pano that Photoshop would merge seamlessly together. Then Adobe improved the Photomerge feature so vastly that you only needed to do one simple thing (more on that in a moment), and in CS4, they added a few extra features that make it produce the best results yet. In fact, it's so easy now, there's no reason not to be shooting panos every chance you get. Here's how:

Step One:

This first thing isn't technically a Photoshop thing, but if you do it, it sure will make working with panos easier. When you're out shooting, and you're about to shoot a pano, before you shoot your first pano frame, hold your index finger up in front of your lens and take a photo. Then go ahead and take your pano, and right after you shoot your last frame, hold up two fingers in front of your lens and take another photo. Here's where this pays off: When you open all your photos from that day's shoot in Bridge, you could easily have hundreds of photos (especially if these are vacation photos). As you scroll through, as soon as you see an index finger, you know these are your pano photos (by the way, if you have that whole self-loathing thing going on, or if you're a teen, you don't have to use your index finger). Plus, it not only tells you that you shot a pano, it tells you exactly where it starts and where it ends (as seen here). It sounds silly, but if you don't do this, you'll actually miss panos you took, and you'll just kind of wonder, "What was I thinking when I took those?" and you'll scroll right by them. It's happened to me, and so many of my friends, that we now all use this technique, and we never miss a pano.

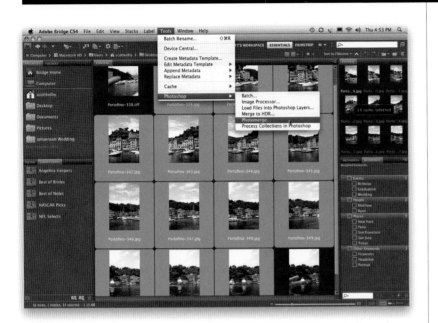

Step Two:

You can start by selecting the individual pieces of your pano in Bridge (as I have here, where I took 14 individual photos, hand-held, standing on a small moving boat, something I never would have tried even two years ago. That's how good this new Photomerge feature is). You just select everything between the two finger shots, go under the Tools menu, under Photoshop, and choose Photomerge (as shown here). *Note:* If you already have your photos open in Photoshop, then you can go under the File menu, under Automate, and choose Photomerge. Either way—they both will get you to the same place.

Step Three:

When you choose Photomerge, it brings up the dialog you see here, with the images you selected listed in the center column. (*Note:* If you opened your pano photos from within Photoshop, the center column will be empty, so you'll click the Add Open Files button.) We'll look at the Layout part in the next step, and jump down below that center column. Leave the Blend Images Together checkbox turned on. Now, there are two other options (both new in CS4) you may need, depending on how you shot your pano: (1) If you have lens vignetting (the edges of your images appear darkened), then turn on Vignette Removal, and although it will take a little longer to render your pano, it will try to remove the vignetting during the process (it does a pretty decent job). If you're using a Nikon, Sigma, or Canon fisheye lens to shoot your panos, then turn on the Geometric Distortion Correction checkbox at the bottom to correct the fisheye distortion.

Continued

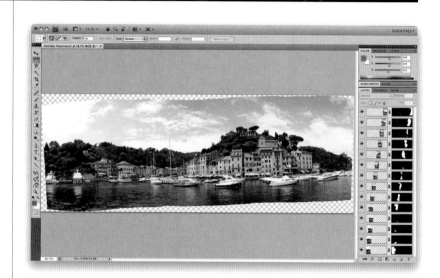

Step Four:

In the Layout section on the left, the default setting is Auto (as seen in Step Three), and I recommend leaving that set to Auto to get the standard wide pano we're looking for. The five Layout choices below Auto (Perspective, Cylindrical, Spherical, Collage, and Reposition) all give you...well...funky looking panos (that's the best description I can give you), but suffice it to say—they don't give you that nice wide pano most of us are looking for. So, let's just stick with Auto. Click OK, and within a few minutes (depending on how many photos you shot for your pano), your pano is seamlessly stitched together (as seen here), and you'll see status bars that let you know that Auto-Align Layers and Auto-Blend Layers are both being applied to make this mini-miracle happen.

Step Five:

To make your pano fit perfectly together, Photomerge has to move and rearrange things in a way that will cause you to have to crop the photo down to get the final result you want (we get the easy job—cropping only takes about 10 seconds). So, get the Crop tool (C) and drag out your cropping border (like you see here, encompassing as much of the pano as possible without leaving any gaps).

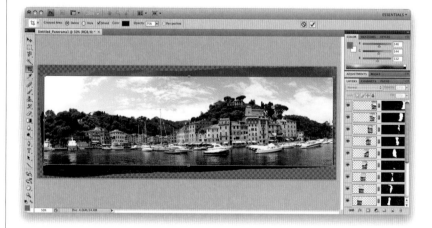

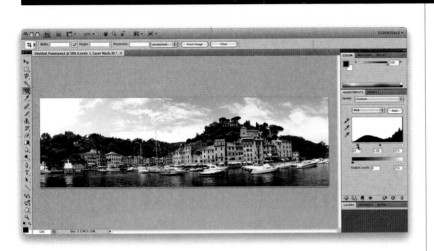

Step Six:

Press **Return (PC: Enter)**, and your pano is cropped down to size (as shown here) and you can make any other adjustments you want. Now, for Photoshop to pull this mini-miracle off, there's just one rule to remember when you're shooting: overlap each photo segment by around 20%. That's the one rule I still teach. Do that, and the rest will take care of itself.

TIP: Why Make Panos with Photomerge Instead of Auto-Align Layers?

If you use Auto-Align Layers in CS4, you'll notice that many of the layout features seem the same as in Photomerge. So, why use Photomerge for stitching? It's because Photomerge does more than just align layers—it stacks all your images into one document, then it aligns them (like Auto-Align Layers), but then it blends them together into one seamless pano. It does all three things at once. So don't let the Photomerge dialog fool you—it's doing more than it seems.

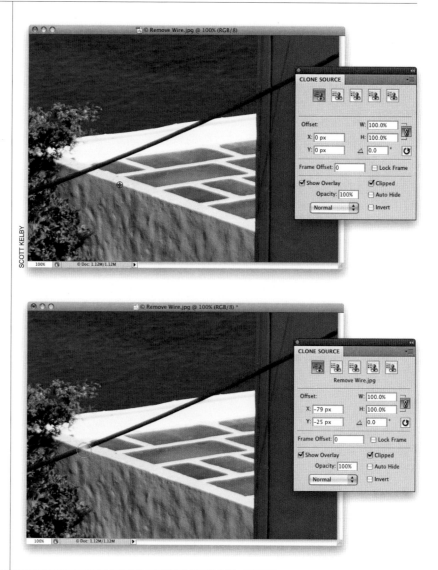

Removing (and Adding) Stuff with Help from CS4's Clone Source Panel

Okay, the Clone Source panel itself might not be new (it was added in CS3), but they added some nice tweaks in CS4—not just to the panel, but to how the Clone Stamp tool works—that make cloning away unwanted objects easier than ever. In the project below, we want to remove the distracting power line running through (and ruining) our seaside shot.

Step One:
Getting rid of the power line in the bushes and over the wall on the top-right corner is going to be no problem—the sticky part will be removing it along that half-wall in the center, and keeping that nice crisp edge on both sides of the wall. That's where having a live preview of the area you're cloning over (courtesy of the Clone Source panel) comes in really handy, because with it, this once tricky repair becomes just plain simple. First, open the Clone Source panel. Now get the Clone Stamp tool **(S)** from the Toolbox, then press-and-hold the Option (PC: Alt) key and click once directly on the front edge of the half wall (as shown here) to sample that part of the wall.

Step Two:
Now move your cursor to the left, down the half-wall, right over the power line (don't click—just hover it there for now). Look inside your brush tip—you see a pre-view of the area you just sampled appear right within your round brush cursor. Just move the brush a little until the preview of what you're about to clone (the edge of the wall), is perfectly in line with the area you're cloning over (as seen here). This live preview makes it so easy to line stuff up like this because now you can finally see what you're doing before you do it.

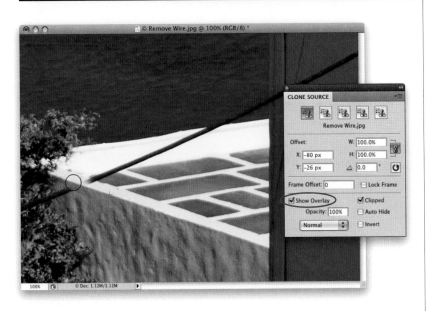

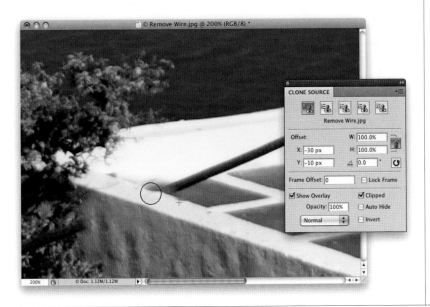

Step Three:

Once you can see it's lined up right, just start painting and the preview will go away, and you can paint that nice clean edge right in (as seen here). This preview is controlled from right within the Clone Source panel itself, at the bottom of the panel. By default, this preview is clipped so it only appears inside your cursor (you'll see why you do and don't want that on the next page, but it's on by default). If you find this distracting, you can turn it off by turning off the Show Overlay checkbox (shown circled here in red). We've got a little more to do, but while we're here, I want to point out those five Clone Stamp tool icons across the top of the panel. You can sample from (and have Photoshop remember) up to five separate photos (it keeps track of which open photo you sampled from as you click on the different Clone Stamp tool icons). For example, if you thought you might like to add a potted plant to the deck from another photo, you could jump over to that image, sample the edge of the potted plant, then come back to this one. When you're ready for it, you'd click the second icon from the left, and just start painting. Pretty handy.

Step Four:

Let's finish this one off by doing the other side of the short wall (after all, we still have some power line left). Option-click (PC: Alt-click) on the right side edge of the half-wall to sample it, then use that live preview to line up the edge again, and start painting (cloning) right down that wall to the left (as seen here). Now we have both sides nice and crisp. Next, you might try cloning the brown floor over to the left to cover over the line in that area (that preview thing will be helpful here, too).

Continued

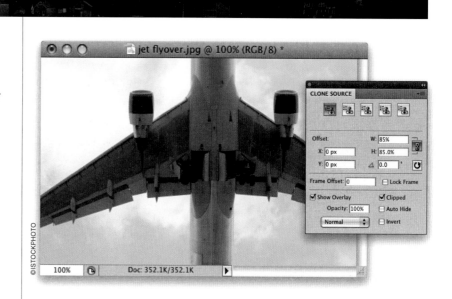

Step Five:

Now let's switch to a different cloning situation: cloning something, but the thing we need to clone has to be smaller after we clone it. We're going to use the preview differently here. We want to add two more engines to the plane (on the outside of the existing engines), but we need them to be around 15% smaller (this would be a lot trickier to do without the Clone Source panel). Now we can enter the percentage size (larger or smaller) that we want our clone to be. In our case, I need the clones to be only 85% of the size of the existing area we're going to sample (the engines), so in the W and H (width and height) fields, enter 85% (as seen here). By the way, the W and H fields are linked by default, so when you enter the width at 85%, the height goes to 85% automatically. If you don't want these linked, click on the little link button to the right.

Step Six:

In the Clone Source panel, turn off the checkbox for Clipped (near the bottom right), so you'll see a full-size preview of what you're about to clone, and not just a small area that fits inside your brush cursor. At the bottom of the panel, lower the Opacity amount to 50%, so you'll be able to see through the 15% smaller version of the photo you'll be working with in just a moment. Option-click (PC: Alt-click) on the left side of the left engine, then move over to the left, and as you do, a ghosted preview of an 85% smaller plane appears attached to your cursor, as shown here. Just move your cursor to position your ghost engine where you'd like it to appear on your wing (as seen here, where I used the left wing to help line things up).

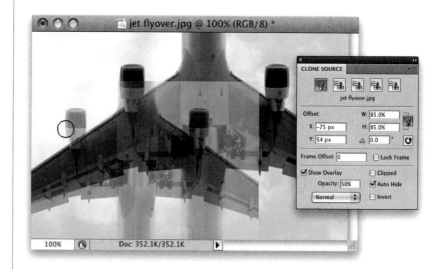

THE ADOBE PHOTOSHOP CS4 BOOK

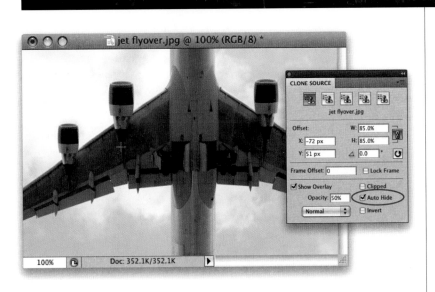

Step Seven:
Now click and start painting (cloning) in the new extra engine (as shown here—the crosshair cursor shows where I sampled from, and the round brush cursor is where my brush is now cloning). Did you notice that the moment you actually started painting (and not just hovering your cursor over the area), the preview went away? That's because of a feature in the Clone Source panel called Auto Hide (shown circled here in red). When it's turned on (and luckily it's on by default), as soon as you actually start cloning, it turns the preview off (after all, you don't need the preview anymore—now you're actually painting…er…cloning. You know what I mean!). Hey, while we're here, under the W and H fields is a Rotation field for when you want your cloning to be rotated as you clone—just type in the angle amount.

Step Eight:
When you're done adding the extra left engine, try adding the right side one. Option-click (PC: Alt-click) the right side center of the right engine (to sample it), then move your cursor over the right wing where you think you want this smaller engine clone. As you do, the large full-size preview comes back so you can line things up again (that 50% opacity thing really makes sense now, eh? Without it, your preview would just cover everything behind it, so you wouldn't be able to see the wing or precisely line up the edges). Once you can see it's lined up right, just start painting and the engine will be added, as shown here.

Exposure: 1/20s Focal Length: 24mm Aperture Value: f/2.8

Look Sharp
sharpening techniques

For those of you who bought the CS3 version of this book, you might be looking up at that title "Look Sharp" and thinking, "Hey, that's the same title he used in the old book," and while that may be technically true, it's not the same song. The song I referenced in the CS3 book was from the band Roxette, but the song I'm referring to this time around is from Joe Jackson (the guy who had the '80s hit "Is She Really Going Out With Him?"). Now, you're probably wondering, with copyright laws being what they are today, how can two different songs have exactly the same name without creating an avalanche of lawsuits? Well, it's because of a special exemption within international trademark and copyright laws, which stipulates that the names of books or songs can't be copyrighted. It's because of this exemption that I nearly named this book

The DaVinci Code, but beyond that, it's the only reason why Joe Jackson was allowed to not only name his song "Look Sharp" (like Roxette), but he was also allowed to have the same name as the father of the Jackson Five, which not coincidentally is (you guessed it) Joe Jackson. The more I thought about this, the more intrigued I became, and after months of intense research (most of which was conducted with the gracious help of a team at a small university about 30 kilometers outside of Gstaad), we learned that Joe Jackson isn't even his real name. It's David Ian Jackson. Worse yet, his original name for the song was actually "Unsharp Mask," but at the last minute, in the recording studio, he changed the name to "Look Sharp" to avoid creating confusion in the marketplace with the Beatles' #1 hit from 1968 "Lab Sharpen Man," from their classic album *Levels & Curves*.

Sharpening Essentials

After you've color corrected your photos and right before you save your file, you'll definitely want to sharpen your photos. I sharpen every digital camera photo, either to help bring back some of the original crispness that gets lost during the correction process, or to help fix a photo that's slightly out of focus. Either way, I haven't met a digital camera (or scanned) photo that I didn't think needed a little sharpening. Here's a basic technique for sharpening the entire photo:

Step One:
Open the photo you want to sharpen. Because Photoshop displays your photo differently at different magnifications, choosing the right magnification (also called the zoom amount) for sharpening is critical. Because today's digital cameras produce such large-sized files, it's now pretty much generally accepted that the proper magnification to view your photos during sharpening is 50%. If you look up in your image window's title bar, it displays the current percentage of zoom (shown circled here in red). The quickest way to get to a 50% magnification is to press **Command-+ (plus sign; PC: Ctrl-+)** or **Command--(minus sign; PC: Ctrl--)** to zoom the magnification in or out.

Step Two:
Once you're viewing your photo at 50% size, go under the Filter menu, under Sharpen, and choose Unsharp Mask. (If you're familiar with traditional darkroom techniques, you probably recognize the term "unsharp mask" from when you would make a blurred copy of the original photo and an "unsharp" version to use as a mask to create a new photo whose edges appeared sharper.)

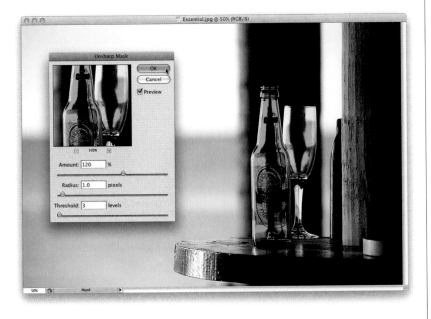

Step Three:
When the Unsharp Mask dialog appears, you'll see three sliders. The Amount slider determines the amount of sharpening applied to the photo; the Radius slider determines how many pixels out from the edge the sharpening will affect; and Threshold determines how different a pixel must be from the surrounding area before it's considered an edge pixel and sharpened by the filter (by the way, the Threshold slider works the opposite of what you might think—the lower the number, the more intense the sharpening effect). So what numbers do you enter? I'll give you some great starting points on the following pages, but for now, we'll just use these settings—Amount: 120%, Radius: 1, and Threshold: 3. Click OK and the sharpening is applied to the entire photo (see the After photo below).

Before

After

Continued

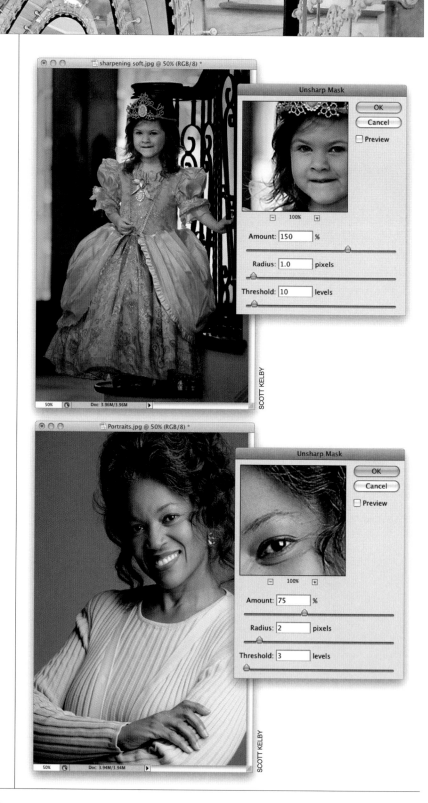

Sharpening soft subjects:

Here are Unsharp Mask settings—
Amount: 150%, Radius: 1, Threshold:
10—that work well for images where
the subject is of a softer nature (e.g.,
flowers, puppies, people, rainbows,
etc.). It's a subtle application of sharp-
ening that is very well suited to these
types of subjects.

Sharpening portraits:

If you're sharpening close-up portraits,
try these settings—Amount: 75%,
Radius: 2, Threshold: 3—which apply
another form of subtle sharpening, but
with enough punch to make eyes spar-
kle a little bit, and bring out highlights
in your subject's hair.

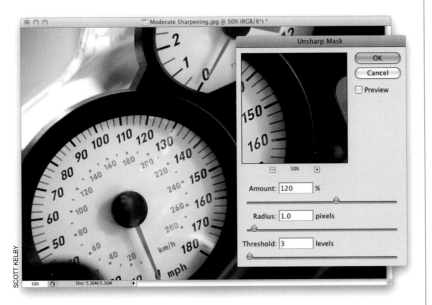

Moderate sharpening:

This is a moderate amount of sharpening that works nicely on everything from product shots, to photos of home interiors and exteriors, to landscapes (and in this case, a speedometer). These are my favorite settings when you need some nice snappy sharpening. Try applying these settings—Amount: 120%, Radius: 1, Threshold: 3—and see how you like it (my guess is you will). Take a look at how it added snap and detail to the numbers and the dashboard.

Maximum sharpening:

I use these settings—Amount: 65%, Radius: 4, Threshold: 3—in only two situations: (1) The photo is visibly out of focus and it needs a heavy application of sharpening to try to bring it back into focus. (2) The photo contains lots of well-defined edges (e.g., rocks, buildings, coins, cars, machinery, etc.). In this photo, the heavy amount of sharpening really brings out the detail in the labels and reflections on the bottles.

Continued

All-purpose sharpening:

These are probably my all-around favorite sharpening settings—Amount: 85%, Radius: 1, Threshold: 4—and I use these most of the time. It's not a "knock-you-over-the-head" type of sharpening—maybe that's why I like it. It's subtle enough that you can apply it twice if your photo doesn't seem sharp enough the first time you run it, but once will usually do the trick.

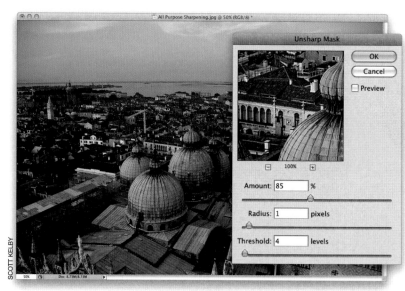

Web sharpening:

I use these settings—Amount: 200%, Radius: 0.3, Threshold: 0—for Web graphics that look blurry. (When you drop the resolution from a high-res, 300-ppi photo down to 72 ppi for the Web, the photo often gets a bit blurry and soft.) If the sharpening doesn't seem sharp enough, try increasing the Amount to 400%. I also use this same setting (Amount: 400%) on out-of-focus photos. It adds some noise, but I've seen it rescue photos that I would otherwise have thrown away.

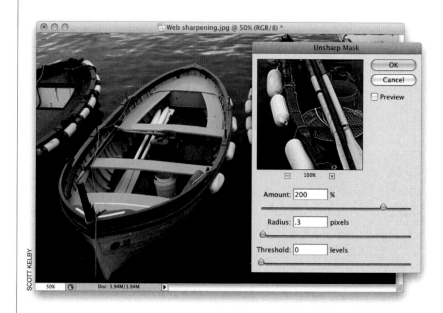

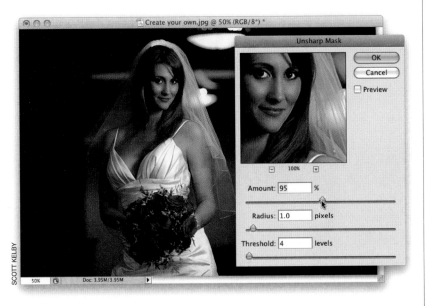

SCOTT KELBY

Coming up with your own settings:

If you want to experiment and come up with your own custom blend of sharpening, I'll give you some typical ranges for each adjustment so you can find your own sharpening "sweet spot."

Amount

Typical ranges run anywhere from 50% to 150%. This isn't a hard-and-fast rule—just a typical range for adjusting the Amount, where going below 50% won't have enough effect, and going above 150% might get you into sharpening trouble (depending on how you set the Radius and Threshold). You're fairly safe staying under 150%. (In the example here, I reset my Radius and Threshold to 1 and 4, respectively.)

Radius

Most of the time, you'll use just 1 pixel, but you can go as high as (get ready) 2 pixels. You saw one setting I gave you earlier for extreme situations, where you can take the Radius as high as 4 pixels. I once heard a tale of a man in Cincinnati who used 5, but I'm not sure I believe it. (Incidentally, Adobe allows you to raise the Radius amount to [get this] 250! If you ask me, anyone caught using 250 as their Radius setting should be incarcerated for a period not to exceed one year and a penalty not to exceed $2,500.)

Continued

Threshold

A pretty safe range for the Threshold setting is anywhere from 3 to around 20 (3 being the most intense, 20 being much more subtle. I know, shouldn't 3 be more subtle and 20 be more intense? Don't get me started). If you really need to increase the intensity of your sharpening, you can lower the Threshold to 0, but keep a good eye on what you're doing (watch for noise appearing in your photo).

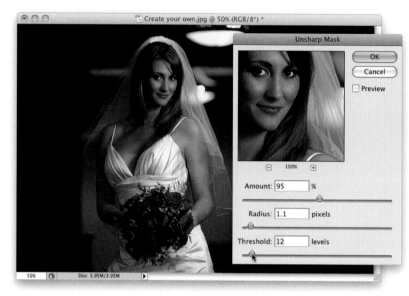

The Final Image

For the final sharpened image you see here, I used the Portraits Sharpening setting I gave earlier, and then I just dragged the Amount slider to the right (increasing the amount of sharpening), until it looked right to me (I wound up at around 85%, so I didn't have to drag too far). If you're uncomfortable with creating your own custom Unsharp Mask settings, then start with this: pick a starting point (one of the set of settings I gave on the previous pages), and then just move the Amount slider and nothing else (so, don't touch the Radius and Threshold sliders). Try that for a while, and it won't be long before you'll find a situation where you ask yourself, "I wonder if lowering the Threshold would help?" and by then, you'll be perfectly comfortable with it.

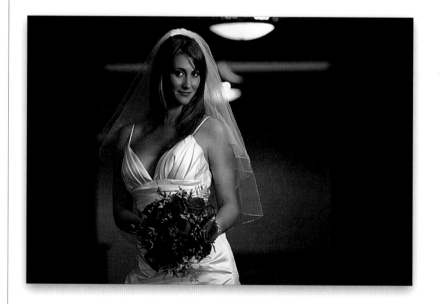

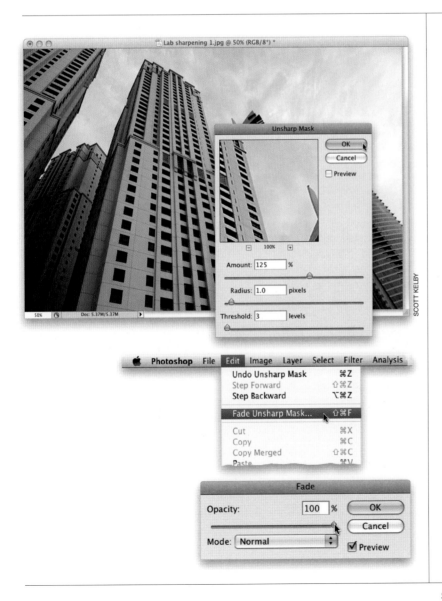

This sharpening technique is my most often-used technique, and it has replaced the Lab Sharpening technique I've used in the past, because it's quicker and easier, and pretty much accomplishes the same thing, which is helping to avoid the color halos and color artifacts (spots and noise) that appear when you add a lot of sharpening to a photo. Because it helps avoid those halos and other color problems, it allows you to apply more sharpening than you normally could get away with.

Luminosity Sharpening

Step One:
Open the RGB photo you want to sharpen, and apply an Unsharp Mask just like you normally would (for this particular photo, let's apply these settings—Amount: 125, Radius: 1, Threshold: 3, which is my recipe for nice, punchy sharpening).

Step Two:
Immediately after you've applied the sharpening, go under the Edit menu and choose Fade Unsharp Mask (as shown below).

TIP: Undo on a Slider
I think of Fade's Opacity slider (seen here) as "Undo on a slider," because if you drag it down to 0, it undoes your sharpening. If you leave it at 100%, it's the full sharpening. If you lower the Opacity to 50%, you get half the sharpening applied, and so on. So, if I apply sharpening and I think it's too much, rather than changing all the settings and trying again, I'll just use the Fade Opacity slider to lower the amount a bit. I'll also use Fade when I've applied some sharpening and it's not enough. I just apply the Unsharp Mask filter again, then lower the Opacity to 50%. That way, I get 1½ sharpenings.

Continued

Step Three:

So, at this point, you can ignore the Opacity slider altogether, because the only thing you're going to do here is change the Fade dialog's Mode pop-up menu from Normal to Luminosity (as shown here). Now your sharpening is applied to just the luminosity (detail) areas of your photo, and not the color areas, and by doing this it helps avoid color halos and other pitfalls of sharpening a color image.

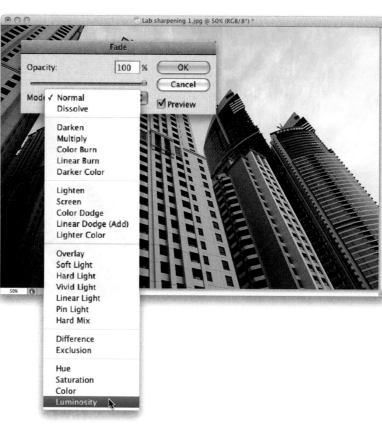

Step Four:

Click the OK button, and now your sharpening is applied to just the luminosity of the image (which is very much like the old Lab mode sharpening we used to do, where you convert your image to Lab color mode, then just sharpen the Lightness channel, and then convert back to RGB color). So, should you apply this brand of sharpening to every digital camera photo you take? I would. In fact, I do, and since I perform this function quite often, I automated the process (as you'll see in the next step).

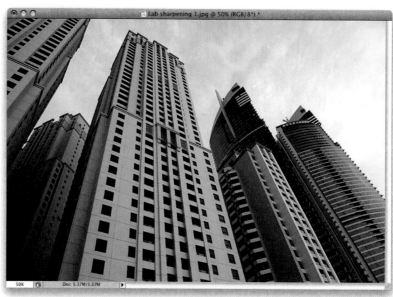

Step Five:

Open a different RGB photo, and let's do the whole Luminosity sharpening thing again, but this time, before you start the process, go under the Window menu and choose Actions to bring up the Actions panel (seen here). The Actions panel is a "steps recorder" that records any set of repetitive steps and lets you instantly play them back (apply them to another photo) by simply pressing one button (you'll totally dig this). In the Actions panel, click on the Create New Action icon at the bottom of the panel (it looks just like the Create a New Layer icon from the Layers panel, and it's shown circled in red here).

Step Six:

Clicking that icon brings up the New Action dialog (shown here). The Name field is automatically highlighted, so go ahead and give this new action a name. (I named mine "Luminosity Sharpen." I know—how original!) Then, from the Function Key pop-up menu, choose the number of the Function key (F-key) on your keyboard that you want to assign to the action (this is the key you'll hit to make the action do its thing). I've assigned mine F11, but you can choose any open F-key that suits you (but everybody knows F11 is, in fact, the coolest of all F-keys—just ask anyone. On a Mac, you may need to turn off the OS keyboard shortcut for F11 first). You'll notice that the New Actions dialog has no OK button. Instead, there's a Record button, because once you exit this dialog, Photoshop CS4 starts recording your steps. So go ahead and click Record.

Continued

Step Seven:

With Photoshop recording every move you make, do the Luminosity sharpening technique you learned on the previous pages (apply your favorite Unsharp Mask setting, then go under the Edit menu, choose Fade Unsharp Mask, and when the dialog appears, change the blend mode to Luminosity and click OK. Also, if you generally like a second helping of sharpening, you can run the filter again, but don't forget to Fade to Luminosity right after you're done). Now, in the Actions panel, click on the Stop icon at the bottom of the panel (it's the square icon, first from the left, shown circled here in red).

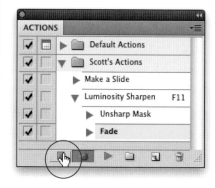

Step Eight:

This stops the recording process. If you look in the Actions panel, you'll see all your steps recorded in the order you did them. Also, if you expand the right-facing triangle beside each step (as shown here), you'll see more detail, including individual settings, for the steps it recorded. You can see here that I used the Amount: 120%, Radius: 1, and Threshold: 3 Unsharp Mask settings.

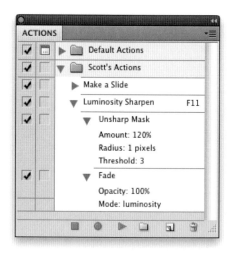

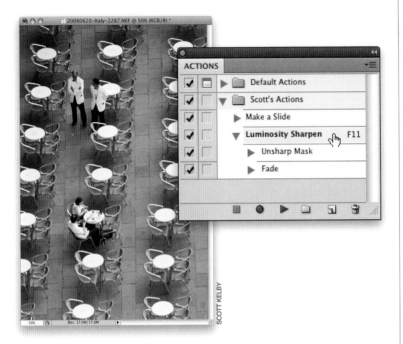

SCOTT KELBY

Step Nine:
Now, open a different RGB photo and let's test your action to see that it works (it's important to test it now before moving on to the next step). Press the F-key you assigned to your action (you chose F11, right? I knew it!). Photoshop immediately applies the sharpening to the Luminosity for you, and does it all faster than you could ever do it manually, because it takes place behind the scenes with no dialogs popping up.

Step 10:
Now that you've tested your action, we're going to put that baby to work. Of course, you could open more photos and then press F11 to have your action Luminosity sharpen them one at a time, but there's a better way. Once you've written an action, you can apply that action to an entire folder full of photos—and Photoshop will totally automate the whole process for you (it will literally open every photo in the folder and apply your Luminosity sharpening, and then save and close every photo— all automatically. How cool is that?). This is called batch processing, and here's how it works: Go under the File menu, under Automate, and choose Batch to bring up the Batch dialog (or you can choose Batch from the Tools menu's Photoshop submenu within Adobe Bridge CS4). At the top of the dialog, within the Play section, choose your Luminosity Sharpen action from the Action pop-up menu (if it's not already selected, as shown here).

Continued

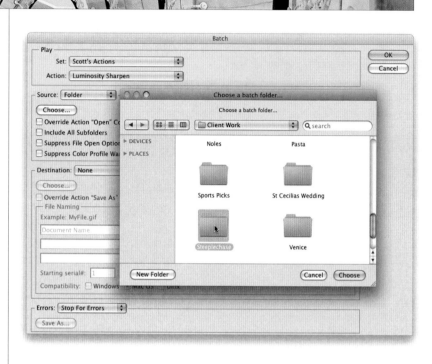

Step 11:

In the Source section of the Batch dialog, you tell Photoshop which folder of photos you want to Luminosity sharpen. So, choose Folder from the Source pop-up menu (you can also choose to run this batch action on selected photos from Bridge, or you can import photos from another source, or choose to run it on images that are already open in Photoshop). Then, click on the Choose button. A standard Open dialog will appear (shown here) so you can navigate to your folder of photos you want to sharpen. Once you find that folder, click on it (as shown), then click the Choose (PC: OK) button.

Step 12:

In the Destination section of the Batch dialog, you tell Photoshop where you want to put these photos once the action has done its thing. If you choose Save and Close from the Destination pop-up menu (as shown here), Photoshop will save the images in the same folder they're in. If you select Folder from the Destination pop-up menu, Photoshop will place your Luminosity-sharpened photos into a totally different folder. To do this, click on the Choose button in the Destination section, navigate to your target folder (or create a new one), and click Choose (PC: OK).

Step 13:

If you do choose to move them to a new folder, you can automatically rename your photos in the process. In short, here's how the file naming works: In the first field within the File Naming section, you type the basic name you want all the files to have. In the other fields, you can choose (from a pop-up menu) the automatic numbering scheme to use (adding a 1-digit number, 2-digit number, etc., and if you choose this, there's a field near the bottom where you can choose which number to start with). You can also choose to add the appropriate file extension (JPG, TIFF, etc.) in upper- or lowercase to the end of the new name. At the bottom of the dialog, there's a row of checkboxes for choosing compatibility with other operating systems. I generally turn all of these on, because ya never know. When you're finally done in the Batch dialog, click OK and Photoshop will automatically Luminosity sharpen, rename, and save all your photos in a new folder for you. Nice!

Two-Pass Super Sharpening

This is a technique I learned from Photoshop color genius Dan Margulis (author of the brilliant *Photoshop LAB Color* book). Dan was gracious enough to let me include his technique in my book, *The Photoshop Channels Book*, and this pretty much breaks every rule you've ever heard about sharpening, but man does it work wonders on the right photo (and, by the way, the right photo is any photo with lots of texture, or very well-defined edges that can handle an awful lot of sharpening. I wouldn't try this on a photo of a puppy, or a baby chick, etc.).

Step One:
The first step is to switch to Lab color mode, so go under the Image menu, under Mode, and choose Lab Color (as shown here).

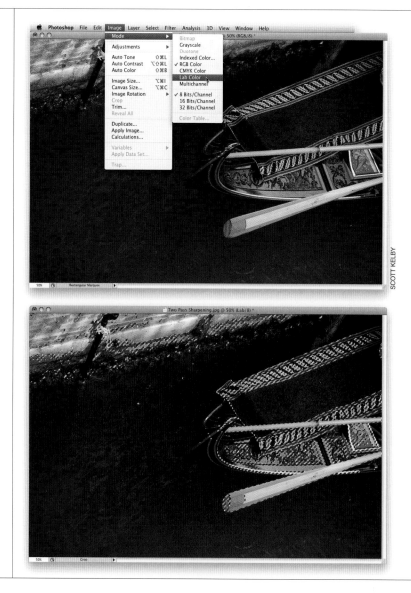

Step Two:
Now you're going to load the Lightness channel as a selection (remember, we're in Lab color mode, so there's a Lightness channel, where all the detail is, and an "a" color channel and a "b" color channel, which hold the color). To load the Lightness channel as a selection, press **Command-Option-3 (PC: Ctrl-Alt-3)**.

Step Three:
Once your selection is in place, you'll need to inverse it, so go under the Select menu and choose Inverse (or use the keyboard shortcut **Command-Shift-I [PC: Ctrl-Shift-I]**). Once your selection is inversed, we want to keep that selection in place, but hide it from view (so we can see how our sharpening looks without the distracting selection border), so press **Command-H (PC: Ctrl-H)**.

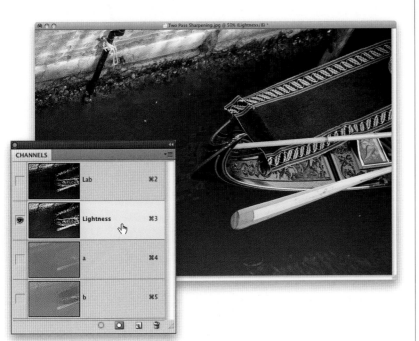

Step Four:
Now that our selection is hidden from view, go to the Channels panel and click on the Lightness channel. We're going to apply our sharpening to the selected area on just this channel. This lets us avoid applying our sharpening to the color channels, which (as you now know) can cause a host of annoying problems. The big advantage of doing our sharpening this way is that since we're avoiding many of the problem areas of sharpening, we can actually get away with applying more sharpening without damaging our images.

Continued

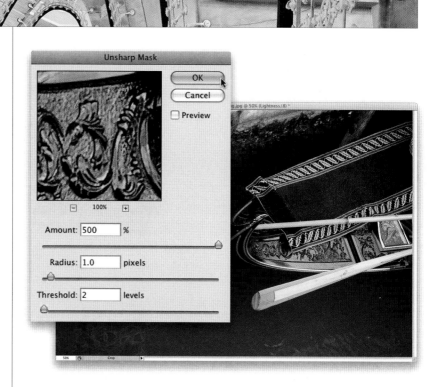

Step Five:

Now you're going to apply your first round of sharpening using the Unsharp Mask filter (by now you know it's found under the Filter menu, under Sharpen). When the Unsharp Mask dialog appears, for Amount choose 500%, set the Radius at 1 pixel, set the Threshold to 2 levels, and click OK. This will apply a good, solid sharpening to the selected area of the Lightness channel.

Step Six:

Now you're going to add a second pass of sharpening, so bring up the Unsharp Mask filter once again. Start by leaving the Amount set to 500%, but then drag the Radius slider all the way to the left. Then slowly raise the radius by dragging the slider to the right, until the shape starts to come back. This two-pass sharpening is designed to be used on high-resolution images, and on a high-resolution image, your Radius setting will probably be somewhere between 25 and 35 pixels. I turned on the Preview checkbox in the example shown here, so you can see what this amount of sharpening does to your photo. Okay, I know it's not pretty, but you're going to fix that in the next step.

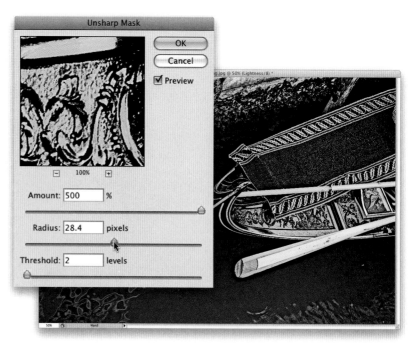

Step Seven:
Once you've dialed in that Radius amount (again, it will probably be between 25 and 35), lower the Amount to somewhere between 50% and 60% (just choose which looks best to you), and click OK to apply the final sharpening. Then go back under the Image menu, under Mode, and choose RGB Color to return to RGB. That's it—two different passes of the Unsharp Mask filter that make for some incredibly sharp photos (as seen below in the After photo).

Before

After

Making Photos Look Sharper Than They Really Are

One of the tricks the pros use to get incredibly sharp photos is to apply their sharpening once, and then go back and spot sharpen only those areas in the photo that can hold a lot of sharpening (for example, areas that contain chrome, metal, steel, buttons on clothing, jewelry, or even your subject's eyes in some cases). This is a really great way to make your photos appear to be much sharper and crisper than they really are.

Step One:
Open a photo you want to appear extra sharp. Go under the Filter menu, under Sharpen, and choose Unsharp Mask. For Amount, enter 120%; for Radius, enter 1; and for Threshold, enter 3 (as shown here). Then click OK to apply a moderate amount of sharpening to your entire photo.

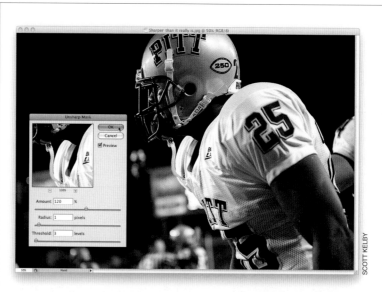

Step Two:
Press **Command-J (PC: Ctrl-J)** to duplicate the Background layer. Now, on this duplicate layer, press **Command-F (PC: Ctrl-F)** to run the Unsharp Mask filter again, using the exact same settings. In fact, see if you can get away with applying it another time (or two). Unless you're working on a super-high-resolution photo, applying the filter three times in a row will oversharpen your photo enough to where it's pretty much trashed (as shown here, where the photo is totally oversharpened).

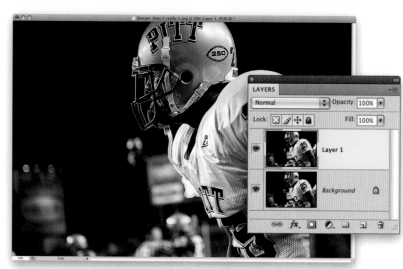

Step Three:
In the Layers panel, press-and-hold the **Option (PC: Alt) key** and click on the Add Layer Mask icon at the bottom of the Layers panel (as shown here). This adds a black mask to your super-sharp layer, and this mask totally hides that layer (so you're seeing the original Background layer with just one pass of the Unsharp Mask filter). Now your photo looks regular again.

Step Four:
Now press **B** to get the Brush tool, choose a medium-sized, soft-edged brush, and with your Foreground color set to white, paint over areas with lots of detail to bring out just those areas. In the example shown here, I painted over part of the chin strap on his helmet (as shown here), along with the letters on his helmet. I also painted over the face mask on his helmet, as well as the numbers and letters on his jersey. Revealing just these few sharper areas, which immediately draw the eye, makes the whole photo look much sharper (as seen below).

Before

After

When to Use the Smart Sharpen Filter Instead

Count me as a fan of the Smart Sharpen filter (introduced back in Photoshop CS2), and although at the time I felt I would switch over to it for all my filter-based sharpening, I now pretty much find that I use it primarily when I run into a photo that is out of focus, or just needs some really serious sharpening. There are other advantages to Smart Sharpen, like being able to save your favorite settings in a pop-up menu, and there's a new sharpening algorithm that lets you avoid color halos, among others things, but here's how I'm using it today:

Step One:

Go under the Filter menu, under Sharpen, and choose Smart Sharpen. This filter is in Basic mode by default, so there are only two sliders: Amount (which controls the amount of sharpening—sorry, I had to explain that) and Radius (which determines how many pixels the sharpening will affect). The default settings are 100% for Amount (which I think is too high to use for just regular everyday sharpening), and the Radius is set at 1, which usually does the trick. You can see the first thing I like about the Smart Sharpen dialog, and that's the nice big preview window (shouldn't every Photoshop filter have a nice big preview like that? Don't get me started).

Step Two:

Below the Radius slider is the Remove pop-up menu (shown here), which lists the three types of blurs you can reduce using Smart Sharpen. Gaussian Blur (the default) applies a brand of sharpening that's pretty much like what you get using the regular Unsharp Mask filter (it uses a similar algorithm). Another choice is Motion Blur, but unless you can determine the angle of blur that appears in your image, it's tough to get really good results with this one.

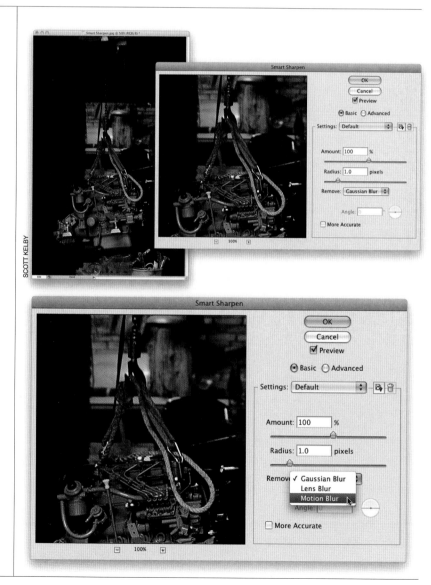

SCOTT KELBY

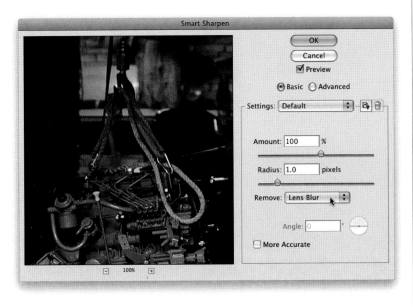

Step Three:

So, which one do I recommend? The third choice—Lens Blur. This is a sharpening algorithm created by Adobe's engineers that's better at detecting edges, so it creates fewer color halos than you'd get with the other choices, and overall I think it just gives you better sharpening for most images. The downside? Choosing Lens Blur makes the filter take a little longer to "do its thing." (That's why it's not the default choice, even though it provides better-quality sharpening.)

Step Four:

So, after you choose Lens Blur, go to the bottom of the dialog and you'll see a checkbox for More Accurate. It gives you (according to Adobe) more accurate sharpening by applying multiple iterations of the sharpening. I leave More Accurate turned on nearly all the time. (After all, who wants "less accurate" sharpening?) *Note:* If you're working on a large file, the More Accurate option can cause the filter to process slower, so it's up to you if it's worth the wait (I think it is). By the way, the use of the More Accurate checkbox is one of those topics that Photoshop users debate back and forth in online forums. For regular everyday sharpening it might be overkill, but again, the reason I use Smart Sharpen is because the photo is visibly blurry, slightly out of focus, or needs major sharpening to save. So I leave this on all the time. Please don't let anyone in the forums know I do that. They might slap me with some sort of fine. ;-)

Continued

Step Five:

I've found with the Smart Sharpen filter that I use a lower Amount setting than with the Unsharp Mask filter to get a similar amount of sharpening, so I usually find myself lowering the Amount to between 60% and 70%. However, if the photo I'm working on is really soft, I would actually go above 100% to... well...whatever it takes. So that's the extent of what I do with Smart Sharpen— I generally set the Amount to 60%–70%, I leave the Radius set at 1, I choose Lens Blur from the Remove pop-up menu, and I turn on the More Accurate checkbox. Take a look at the before/after on the bottom of the next page to see the results of using the Smart Sharpen filter.

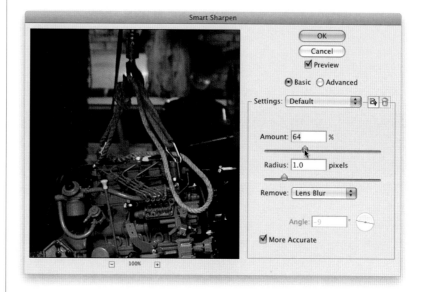

Step Six:

If you find yourself applying a setting such as this over and over again, you can save these settings and add them to the Settings pop-up menu at the top of the dialog by clicking on the floppy disk icon to the right of the pop-up menu. (Why a floppy disk icon? I have no idea.) This brings up a dialog for you to name your saved settings, so name your settings and click OK. Now, the next time you're in the Smart Sharpen filter dialog and you want to instantly call up your saved settings, just choose it from the Settings pop-up menu (as shown here).

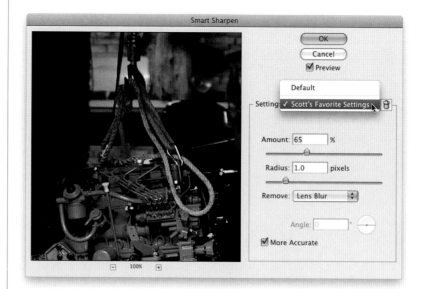

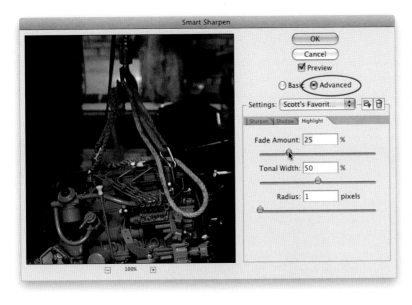

Step Seven:

If you click the Advanced radio button, it reveals two additional tabs with controls for reducing the sharpening in just the shadow or just the highlight areas that are applied to the settings you chose back in the Basic section. That's why in the Shadow and Highlight tabs, the top slider says "Fade Amount" rather than just "Amount." As you drag the Fade Amount slider to the right, you're reducing the amount of sharpening already applied, which can help reduce any halos in the highlights. (*Note:* Without increasing the amount of fade, you can't tweak the Tonal Width and Radius amounts. They only kick in when you increase the Fade Amount.) Thankfully, I rarely have had to use these Advanced controls, so 99% of my work in Smart Sharpen is done using the Basic controls.

Before *After*

Edge-Sharpening Technique

This is a sharpening technique that doesn't use the Unsharp Mask filter, but still leaves you with a lot of control over the sharpening, even after the sharpening is applied. It's ideal to use when you have an image (with a lot of edges) that can hold a lot of sharpening or one that needs heavy sharpening to really make it snap.

Step One:
Open a photo that needs edge sharpening. Duplicate the Background layer by pressing **Command-J (PC: Ctrl-J)**, as shown here.

Step Two:
Go under the Filter menu, under Stylize, and choose Emboss. You're going to use this filter to accentuate the edges in the photo. You can leave the Angle, Height, and Amount settings at their defaults (135°, 3, and 100%), but for low-res images, you'll want to lower the Height setting to 2 pixels (and for high-res 300-ppi images, try raising it to 4 pixels). Click OK to apply the filter, and your photo will turn gray with neon-colored highlights along the edges. To remove those neon-colored edges, press **Command-Shift-U (PC: Ctrl-Shift-U)** to Desaturate the color from this layer.

Step Three:
In the Layers panel, change the layer blend mode of this layer from Normal to Hard Light. This removes the gray color from the layer, but leaves the edges accentuated, making the entire photo appear much sharper.

Step Four:
If the sharpening seems too intense, you can control the amount of the effect by simply lowering the Opacity of this layer in the Layers panel (in the After photo shown below, I lowered the layer's opacity to 80%, as shown here).

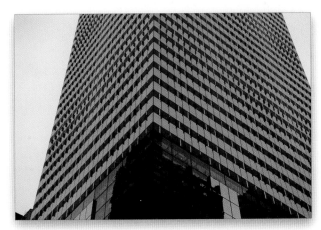

Before

After

Exposure: 1/20s Focal Length: 24mm Aperture Value: ƒ/2.8

Fit to Print
step-by-step printing and color management

In previous versions of this book, this chapter was simply called color management, when in reality it was pretty much a chapter on printing, because if you're not printing, who really cares if you're color managed, right? What you see onscreen is what you get—you don't have to match it to anything. But once you start printing, all heck breaks loose. (*Note:* I didn't want to use the word "heck" there, but my editors are sensitive and I didn't want to startle them.) The two are very closely tied together, and maybe that's why much of Photoshop's color management takes place in the Print dialog itself. So why did I change the name of this chapter? It's because I would get letters from people asking, "Why didn't you include a chapter about printing?" I would write them back and say, "I did—it's the color management chapter," and they'd write back and say, "I didn't read that chapter because I didn't want to learn about color management, I wanted to learn about printing." Then I would write back, "But don't you want the prints that come out of your printer to match what you see onscreen?" And they would write back, "I don't use a screen because I'm Amish" and then I would write back, "Then how did you send this email?" And I would never hear from them again. Anyway, because Adobe made a number of enhancements and advances to printing in CS3, I gave this chapter a more descriptive subtitle last time (as seen above). The chapter name, "Fit to Print," is from John Mann's album *Hands in the Pavement.* It's actually a pretty good song—ya know, for a song about printing and color management.

Configuring Your Camera to Match Photoshop's Color Space

Although there are entire books written on the subject of color management in Photoshop, in this chapter we're going to focus on just one thing—getting what comes out of your color inkjet printer to match what you see onscreen. That's what it's all about, and if you follow the steps in this chapter, you'll get prints that match your screen. Now, I'm not going into the theory of color management, or CMYK soft proofing, or printing to multiple network printers, etc. It's just you, your computer, and your color inkjet printer. That, my friends, we can do.

Step One:
If you want to get consistent color from your camera to Photoshop to your printer, you'll want everybody speaking the same language, right? That's why if you shoot in either JPEG, TIFF, or JPEG+RAW, I'm recommending that you change your camera's color space from its default sRGB (which is a color space designed for images only shown on the Web) to Adobe RGB (1998), which is probably the most popular color space used by photographers whose final image will come from a color inkjet printer. Now, if you only shoot in RAW, you can skip this because you'll assign the color space later in Photoshop's Camera Raw dialog, but otherwise, do it now. As an example, here's how to set up a Nikon D300 to tag your photos with the Adobe RGB (1998) color profile. First, click the Menu button on the back of your camera.

Nikon D300

Step Two:
When the menu appears, use the round multi selector on the back of your camera to go to the Shooting menu, and then in that menu, choose Color Space (as shown here) by pressing the Right Arrow on the multi selector.

Step Three:
This brings up the Color Space menu (shown here). Use the Down Arrow on the multi selector to choose Adobe RGB (as shown here), and then press the Right Arrow on the multi selector to lock in your change.

Step Four:
Now when you look in the Shooting menu, you should see the word "Adobe" to the right of Color Space, which lets you know that Adobe RGB (1998) is your camera's color space. So now you've taken your first step towards color consistency.

Setting Up a Canon:
I just showed the simple color space set-up for a Nikon D300, however if you've got a Canon digital camera (like the popular Canon 50D), it's pretty simple to configure, too: Just like with the Nikon, you go under the Shooting menu, and use the Quick Control dial to scroll down to Color Space. Press the center Set button to edit the color space, then choose Adobe RGB (as shown here) and press Set again to lock in your choice.

Note: Most dSLRs from Nikon and Canon work fairly similarly (although the menus may be slightly different), but if you're not shooting Nikon or Canon, it's time to dig up your owner's manual (or download it from the manufacturer's website) to find out how to make the switch to Adobe RGB (1998).

Configuring Photoshop for Adobe RGB (1998)

Once your camera's set to the right color space, it's time to set up Photoshop that way. In Photoshop 5.5, when Adobe (and the world) was totally absorbed with Web design, they switched Photoshop's default color space to sRGB (which some pros refer to as "stupid RGB"), which is fine for photos on the Web, but your printer can print a wider range of color (particularly in the blues and greens). So, if you work in sRGB, you're essentially leaving those rich vivid colors on the table. That's why we change our color space to Adobe RGB (1998), which is better for prints.

Step One:

Before we do this, I just want to reiterate that you only want to make this change if your final print will be output to your own color inkjet. If you're sending your images out to an outside lab for prints, you should probably stay in sRGB—both in the camera and in Photoshop—as most labs are set up to handle sRGB files. Your best bet: ask your lab which color space they prefer. Okay, now on to Photoshop: go under the Edit menu and choose Color Settings (as shown here).

Step Two:

This brings up the Color Settings dialog. By default, it uses a group of settings called "North America General Purpose 2." Now, does anything about the phrase "General Purpose" sound like it would be a good space for pro photographers? Didn't think so. The tip-off is that under Working Spaces, the RGB space is set to sRGB IEC61966–2.1 (which is the long-hand technical name for what we simply call sRGB, also sometimes referred to as "stupid RGB"). In short, you don't want to use this group of settings. They're for goobers—not for you (unless of course, you are a goober, which I doubt because you bought this book, and they don't sell this book to goobers. It's in each bookstore's contract).

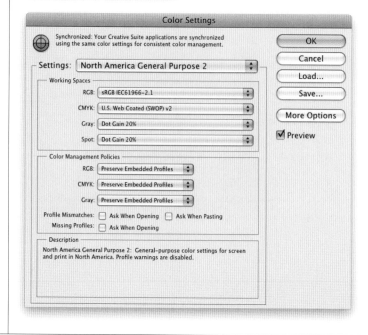

Step Three:

To get a preset group of settings that's better for photographers, from the Settings pop-up menu, choose North America Prepress 2. Don't let it throw you that we're using prepress settings here—they work great for color inkjet printing because it uses the Adobe RGB (1998) color space. It also sets up the appropriate warning dialogs to help you keep your color management plan in action when opening photos from outside sources or other cameras (more on this on the next page).

TIP: Settings for Photoshop Lightroom

If you're using Adobe Photoshop Lightroom for your printing, instead of printing from here in Photoshop CS4, you might want to change your RGB working space to ProPhoto RGB, which is the native color space for Lightroom. That way, when you export a file from Lightroom over to Photoshop, make edits in Photoshop, and then save back to Lightroom, everything stays in the same consistent color space.

Step Four:

Before you click OK, just for fun, temporarily change the Settings pop-up menu to North America Web/Internet. You'll see that the RGB working space changes back to sRGB. That's because sRGB is best suited for Web design. Makes you stop and think, doesn't it? Now, switch back to North America Prepress 2, click OK, and Photoshop is configured with Adobe RGB (1998) as your RGB working space. However, you probably still want to know about the warnings you turned on, right?

Continued

Step Five:

About those warnings that help you keep your color management on track: Let's say you open a JPEG photo, and your camera was set to shoot in Adobe RGB (1998), and your Photoshop is set the same way. The two color spaces match, so no warnings appear. But, if you open a JPEG photo you took six months ago, it will probably still be in sRGB, which doesn't match your Photoshop working space. That's a mismatch, so you'd get the warning dialog shown here, telling you this. Luckily it gives you the choice of how to handle it. I recommend converting that document's colors to your current working space (as shown here).

Embedded Profile Mismatch

The document "DSCF1410.JPG" has an embedded color profile that does not match the current RGB working space.

Embedded: sRGB IEC61966-2.1

Working: Adobe RGB (1998)

What would you like to do?

○ Use the embedded profile (instead of the working space)
◉ Convert document's colors to the working space
○ Discard the embedded profile (don't color manage)

(Cancel) (OK)

Step Six:

You can have Photoshop do this conversion automatically anytime it finds a mismatch. Just reopen the Color Settings dialog, and under Color Management Policies, in the RGB pop-up menu, change your default setting to Convert to Working RGB (as shown here). For Profile Mismatches, turn off the Ask When Opening checkbox. Now when you open sRGB photos, they will automatically update to match your current working space. Nice!

Color Management Policies

RGB: Convert to Working RGB ▲▼
CMYK: Preserve Embedded Profiles ▲▼
Gray: Preserve Embedded Profiles ▲▼

Profile Mismatches: ☐ Ask When Opening ☑ Ask When Pasting
Missing Profiles: ☑ Ask When Opening

Step Seven:

Okay, so what if a friend emails you a photo, you open it in Photoshop, and the photo doesn't have any color profile at all? Well, once that photo is open in Photoshop, you can convert that "untagged" image to Adobe RGB (1998) by going under the Edit menu and choosing Assign Profile. When the Assign Profile dialog appears, click on the Profile radio button, ensure Adobe RGB (1998) is selected in the pop-up menu, then click OK.

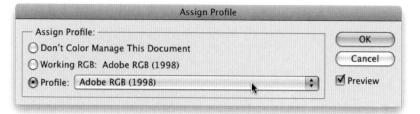

Assign Profile

Assign Profile:
○ Don't Color Manage This Document
○ Working RGB: Adobe RGB (1998)
◉ Profile: Adobe RGB (1998) ▲▼

OK
Cancel
☑ Preview

To have any hope of getting what comes out of your color inkjet printer to match what you see onscreen, you absolutely, positively have to calibrate your monitor. It's the cornerstone of color management, and there are two ways to do it: (1) buy a hardware calibration sensor that calibrates your monitor precisely; or (2) use the free built-in system software calibration, which is better than nothing, but not by much since you're just "eyeing" it. We'll start with the freebie calibration, but if you're serious about this stuff, turn to the next technique.

Calibrating Your Monitor (The Lame Built-In Freebie Method)

Step One:
First, we'll look at the worst-case scenario: you're broke (you spent all available funds on the CS4 upgrade), so you'll have to go with the free built-in system software calibration. Macintosh computers have calibration built into the system, but Windows PCs don't. Adobe used to include a separate utility for Windows called Adobe Gamma, so if you upgraded from CS2 or an older version (or have the installation CD for CS3), you should have Adobe Gamma in your Control Panel (or in the Goodies folder on the installation CD). Now for the freebie calibration on the Macintosh: To find Apple's built-in monitor calibration software, go under the Apple menu and choose System Preferences. In the System Preferences dialog, click on the Displays preferences, and when the options appear, click on the Color tab. When the Color options appear, click on the Calibrate button to bring up the Display Calibrator Assistant window (shown in the next step).

Continued

Step Two:

Now, at first this seems like a standard Welcome screen, so you'll probably be expecting to just click the Continue button, but don't do that until you turn on the Expert Mode checkbox. I know what you're thinking: "But I'm not an expert!" Don't worry, within a few minutes you'll be within the top 5% of all photographers who have knowledge of monitor calibration, because sadly most never calibrate their monitor. So turn on the checkbox and click the Continue button with the full confidence that you're about to enter an elite cadre of highly calibrated individuals (whatever that means).

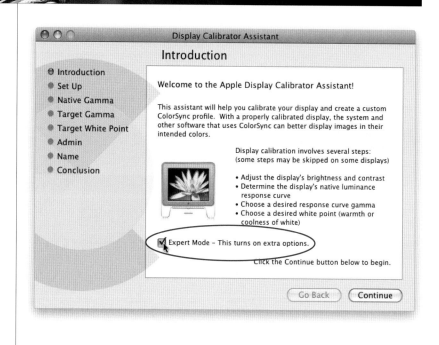

Step Three:

The first section has you go through a series of five different windows, and each window will ask you to perform a simple matching test using a slider. It's a no-brainer, as Apple tells you exactly what to do in each of these five windows (it's actually the same for all five windows, so once you've read the first window's instructions, you're pretty much set). So, just follow Apple's easy instructions to get through these five windows, then I'll join you right after.

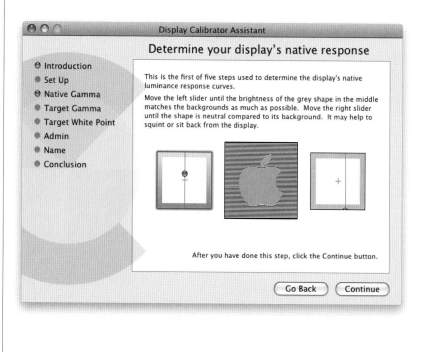

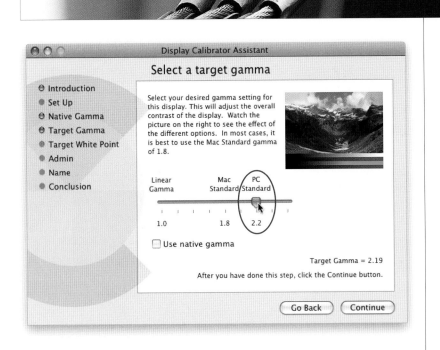

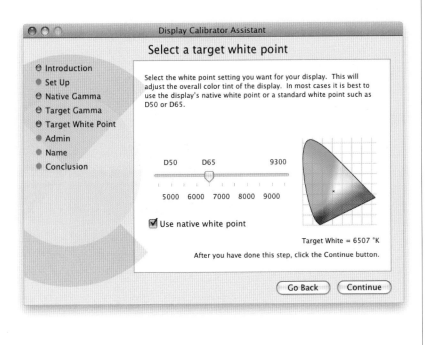

Step Four:

Okay, so you survived the "five native response windows of death." Amazingly easy, wasn't it? (It even borders on fun.) Well, believe it or not, that's the hard part—the rest could be done by your 5-year-old, provided you have a 5-year-old (if not, you can rent one from Apple's website). So here we are at a screen asking you to select a target gamma (basically, you're choosing a contrast setting here). Apple pretty much tells you "it is best to use the Mac Standard gamma of 1.8," but it has no idea that you're a photographer and need something better. Most digital imaging pros I know recommend setting your gamma to 2.2 (the PC Standard), which creates a richer contrast onscreen (which tends to make you open the shadows up when editing, which is generally a good thing detail-wise). Drag the slider to PC Standard and see if you agree, then click Continue.

Step Five:

Now it asks you to select a white point. I use D65 (around 6500 Kelvin, in case you care). Why? That's what most of the pros use, because it delivers a nice, clean white point without the yellowish tint that occurs when using lower temperature settings. With the slider set at D65, you can click the Continue button. The next window just asks if you're sharing your computer with other users, so I'm skipping that window, because if you are, you'll turn on the checkbox; if you're not, you won't. Snore.

Continued

Step Six:

When you click Continue again, you'll be greeted with a window that lets you name your profile. Type in the name you want for your profile, and click the Continue button. The last window (which there's no real reason to show here) just sums up the choices you've made, so if you made some egregious mistake, you could click the Go Back button, but seriously, what kind of huge mistake could you have made that would show up at this point? Exactly. So click the Done button and you've created a semi-accurate profile for your monitor (hey, don't complain—it's free calibration). Now, you don't have to do anything in Photoshop for it to recognize this new profile—it happens automatically (in other words, "Photoshop just knows." Eerie, ain't it?).

Display Calibrator Assistant

Give the profile a name

- Introduction
- Set Up
- Native Gamma
- Target Gamma
- Target White Point
- Admin
- Name
- Conclusion

Give your profile a name.

Scott's Profile

After you have done this step, click the Continue button.

Go Back Continue

Hardware calibration is definitely the preferred method of monitor calibration (in fact, I don't know of a single pro using the freebie software-only method). With hardware calibration, it's measuring your actual monitor and building an accurate profile for the exact monitor you're using, and yes—it makes that big a difference. I now use X-Rite's Eye-One Display 2 (after hearing so many friends rave about it), and I have to say—I'm very impressed. It's become popular with pros thanks to the sheer quality of its profiles, its ease-of-use, and affordability (around $200 street).

The Right Way to Calibrate Your Monitor (Hardware Calibration)

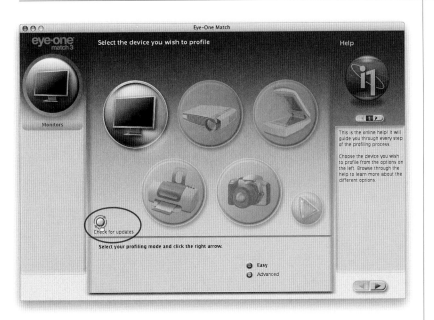

Step One:
You start by installing the Eye-One Match 3 software from the CD that comes with it (the current version was 3.6.2 as of the writing of this book. However, once you launch Match 3 for the first time, I recommend clicking the Check for Updates button [as shown here] to have it check for a newer version, just in case). Once the latest version is installed, plug the Eye-One Display into your computer's USB port, then relaunch the software to bring up the main window (seen here). You do two things here: (1) you choose which device to profile (in this case, a monitor), and (2) you choose your profiling mode (where you choose between Easy or Advanced. If this is your first time using a hardware calibrator, I recommend clicking the Easy radio button).

Continued

Step Two:

After choosing Easy, press the Right Arrow button in the bottom right, and the window you see here will appear. Here you just tell the software which type of monitor you have: an LCD (a flat-panel monitor), a CRT (a glass monitor with a tube), or a laptop (which is what I'm using, so I clicked on Laptop, as shown here), then press the Right Arrow button again.

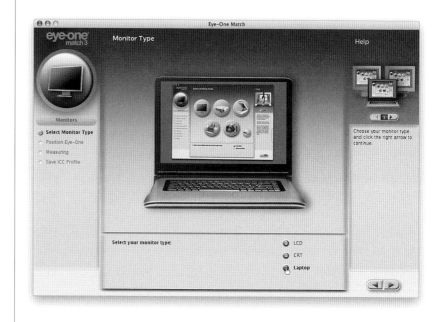

Step Three:

The next screen asks you to Place Your Eye-One Display on the Monitor, which means you drape the sensor over your monitor so the Eye-One Display sits flat against your monitor and the cord hangs over the back. The sensor comes with a counterweight you can attach to the cord, so you can position the sensor approximately in the center of your screen without it slipping down. There is a built-in suction cup for use on CRT monitors.

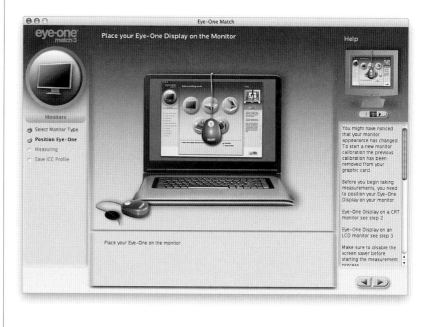

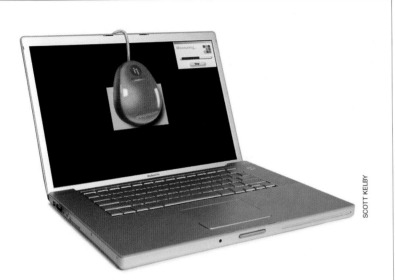

SCOTT KELBY

Step Four:

Once the sensor is in position (this takes all of about 20 seconds) click the Right Arrow button, sit back, and relax. You'll see the software conduct a series of onscreen tests, using gray and white rectangles and various color swatches, as shown here. (*Note:* Be careful not to watch these onscreen tests while listening to Jimi Hendrix's "Are You Experienced," because before you know it, you'll be on your way to Canada in a psychedelic VW Microbus with only an acoustic guitar and a hand-drawn map to a campus protest. Hey, I've seen it happen.)

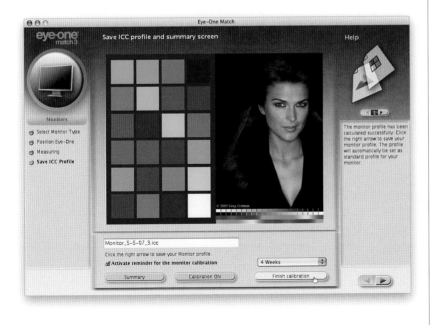

Step Five:

This testing only goes on for around six or seven minutes (at least, that's all it took for my laptop), then it's done. It does let you see a before and after (using the buttons on the bottom), and you'll probably be shocked when you see the before/after results (most people are amazed at how blue or red their screen was every day, yet they never noticed). Once you've compared your before and after, click the Finish Calibration button and that's it—your monitor is accurately profiled, and it even installs the profile for you and then quits. It should be called "Too Easy" mode.

The Other Secret to Getting Pro-Quality Prints That Match Your Screen

When you buy a color inkjet printer and install the printer driver that comes with it, it basically lets Photoshop know what kind of printer is being used, and that's about it. But to get pro-quality results, you need a profile for your printer based on the exact type of paper you'll be printing on. Most inkjet paper manufacturers now create custom profiles for their papers, and you can usually download them free from their websites. Does this really make that big a difference? Ask any pro. Here's how to find and install your custom profiles:

Step One:

Your first step is to go to the website of the company that makes the paper you're going to be printing on and search for their downloadable color profiles for your printer. I use the term "search" because they're usually not in a really obvious place. I use two Epson printers—a Stylus Photo R2880 and a Stylus Pro 3800—and I generally print on Epson paper. When I installed the 3800's printer driver, I was tickled to find that it also installed custom color profiles for all Epson papers (this is rare), but my R2880 (like most printers) doesn't. So, the first stop would be Epson's website, where you'd click on the Drivers & Support link (as shown here). *Note:* Even if you're not an Epson user, still follow along (you'll see why).

Step Two:

Once you get to Drivers & Support, find your particular printer in the list. Click on that link, and on the next page, click on Drivers & Downloads (choose Windows or Macintosh). On that page is a note linking you to the printer's Premium ICC Profiles page. Here's what Epson says right there about these free profiles: "In most cases, these custom ICC profiles will provide more accurate color and black and white reproduction than with the standard profiles already shipping with every printer." So, click on that Premium ICC Profiles link.

Step Three:

When you click that link, a page appears with a list of Mac and Windows ICC profiles for Epson's papers and printers. I primarily print on two papers: (1) Epson's Ultra Premium Photo Paper Luster, and (2) Epson's Velvet Fine Art paper. So, I'd download the ICC profiles for the Glossy Papers (as shown here) and the Fine Art Papers (at the bottom of the window). They download onto your computer, and you just double-click the installer for each one, and they're added to your list of profiles in Photoshop (I'll show how to choose them in the Print dialog a little later). That's it—you download them, double-click to install, and they'll be waiting for you in Photoshop's print dialog. Easy enough. But what if you're not using Epson paper? Or if you have a different printer, like a Canon or an HP?

Continued

Step Four:

We'll tackle the different paper issue first (because they're tied together). I mentioned earlier that I usually print on Epson papers. I say usually because sometimes I want a final print that fits in a 16x20" standard pre-made frame, without having to cut or trim the photo. In those cases, I use Red River Paper's 16x20" Ultra Satin Pro instead (which is very much like Epson's Ultra Premium Luster, but it's already pre-cut to 16x20"). So, even though you're printing on an Epson printer, now you'd go to Red River Paper's site (www.redriverpaper .com) to find their color profiles for my other printer—the Epson 3800. (Remember, profiles come from the company that makes the paper.) On the Red River Paper homepage is a link for Premium Photographic Inkjet Papers, so click on that.

Step Five:

Once you click that link, things get easier, because on the left side of the next page (under Helpful Info) is a clear, direct link right to their free downloadable color profiles (as seen here). Making profiles easy to find like this is extremely rare (it's almost too easy—it must be a trap, right?). So, click on that Color Profiles link and it takes you right to the profiles for Epson printers, as seen in Step Six (how sweet is that?).

Step Six:

Under the section named Epson Wide Format, there's a direct link to the Epson Pro 3800 (as shown here), but did you also notice that there are ICC Color profiles for the Canon printers, as well? See, the process is the same for other printers, but be aware: although HP and Canon both make pro-quality photo printers, Epson had the pro market to itself for quite a while, so while Epson profiles are created by most major paper manufacturers, you may not always find paper profiles for HP and Canon printers. As you can see at Red River, they widely support Epson, and some Canon profiles are there, too—but there's only one for HP. That doesn't mean this won't change, but as of the writing of this book, that's the reality. Speaking of change—the look and navigation of websites change pretty regularly, so if these sites look different when you visit them, don't freak out. Okay, you can freak out, but just a little.

Step Seven:

Although profiles from Epson's website come with an installer, in Red River's case (and in the case of many other paper manufacturers), you just get the profile (shown here) and instructions, so you install it yourself (don't worry—it's easy). On a PC, just Right-click on the profile and choose Install Profile. Easy enough. (*Note:* If you're using Windows XP and this doesn't work, you'll have to drag the profile into the Profiles folder itself. It's at C:\Windows\system32\spool\drivers\color.) On a Mac, go to your hard disk, open your Library folder, and open your Color-Sync folder, where you'll see a Profiles folder. Just drag the file in there and you're set (in Photoshop CS4 you don't even have to restart Photoshop—it automatically updates).

Continued

Step Eight:

Now, you'll access your profile by choosing Print from Photoshop's File menu. In the Print dialog, change the Color Handling pop-up menu to Photoshop Manages Color. Then, click on the Printer Profile pop-up menu, and your new color profile(s) will appear (as shown here). In our example, I'm printing to an Epson 3800 using Red River's Ultra Pro Satin paper, so that's what I'm choosing here as my printer profile (it's named RR UPSatin 2.0 Ep3800.icc). More on using these color profiles later in this chapter.

TIP: Creating Your Own Profiles

You can also pay an outside service to create a custom profile for your printer. You print a test sheet (which they provide), overnight it to them, and they'll use an expensive colorimeter to measure your test print and create a custom profile. The catch: it's only good for that printer, on that paper, with that ink. If anything changes, your custom profile is just about worthless. Of course, you could do your own personal printer profiling (using something like one of X-Rite's i1 Family solutions) so you can re-profile each time you change paper or inks. It's really determined by your fussiness/time/money factor (if you know what I mean).

Okay, you've set your camera to Adobe RGB (1998); you've hardware calibrated your monitor (or at the very least—you "eyed it"); you've set up Photoshop to use Adobe RGB (1998); and you've set it up so any photos you bring in that are not in Adobe RGB (1998) will automatically be converted to Adobe RGB (1998). You've even downloaded a printer profile for the exact printer model and style of paper you're printing on. In short—you're there. Luckily, you only have to do all that stuff once—now we can just sit back and print. Well, pretty much.

Making the Print (Finally, It All Comes Together)

Step One:
Go under Photoshop's File menu and choose Print (as shown here). In previous versions of Photoshop, to access the color management features for printing you had to choose Print with Preview, but in CS4, we're happily down to just one simple command—Print!

Step Two:
When the Print dialog appears, let's choose your printer and paper size first. Near the top of the center column, you'll see a Page Setup button. Click on it to bring up the Page Setup dialog (shown here). Choose the printer you want to print to from the Format For pop-up menu (on a PC, you'll have to choose it from the Printer pop-up menu before clicking Page Setup), and then from the Paper Size pop-up menu (found in the Paper Settings on a PC) choose your paper size (in this case, a 16x20"sheet). You can choose your page orientation here if you want, but you can also choose this later in Photoshop's Print dialog. Leave the Scale at 100% (you can change that later), and click OK to return to the Print dialog.

Continued

Step Three:

In the Print dialog, at the top of the far-right column, make sure Color Management is selected from the pop-up menu (as shown here). Then, at the top of the center column, choose your Printer from the pop-up menu (even though you chose it in the Page Setup dialog, you may have to choose it again from here).

TIP: New 16-Bit Printing on a Mac

If you're working on a Mac, with 16-bit images, and have a 16-bit compatible printer, you can take advantage of CS4's support for 16-bit printing by choosing Output from the pop-up menu at the top right of the Print dialog, and then turning on the Send 16-bit Data checkbox (under Functions). Sixteen-bit printing gives you an expanded dynamic range on printers that support it, but at this time, this feature is only available for Mac OS X Leopard users (this is a limitation of the Windows operating system, not Photoshop).

Step Four:

From the Color Handling pop-up menu, choose Photoshop Manages Colors (as shown here) so we can use the color profile we downloaded for our printer and paper combination, which will give us the best possible match. Here's the thing: by default, the Color Handling is set up to have your printer manage colors. You really only want to choose this if you weren't able to download the printer/paper profile for your printer. So, basically having your printer manage colors is your backup plan. It's not your first choice, but today's printers have gotten to the point that if you have to go with this, it still does a decent job (that wasn't the case just a few years ago—if you didn't have a color profile, you didn't have a chance at getting a pro-quality print).

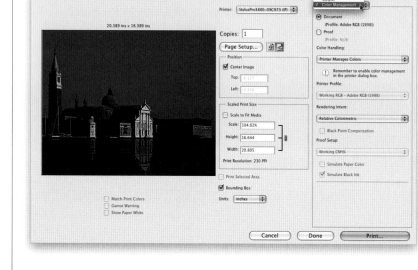

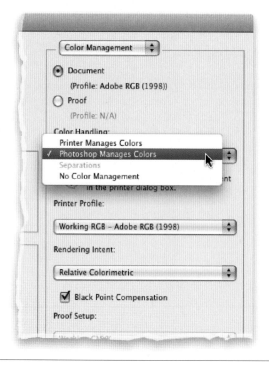

Fujifilm ETERNA 250D Printing Density (by Adobe)
Fujifilm ETERNA 400 Printing Density (by Adobe)
Fujifilm ETERNA 500 Printing Density (by Adobe)
Fujifilm F-125 Printing Density (by Adobe)
Fujifilm F-64D Printing Density (by Adobe)
Fujifilm REALA 500D Printing Density (by Adobe)
Generic RGB Profile
HDTV (Rec. 709)
hp color LaserJet RGB v402
iMac
Kodak 5205/7205 Printing Density (by Adobe)
Kodak 5218/7218 Printing Density (by Adobe)
Kodak 5229/7229 Printing Density (by Adobe)
NTSC (1953)
PAL/SECAM
Panavision Genesis Tungsten Log (by Adobe)
Pro38 ARMP
Pro38 EMP
Pro38 PGPP
✓ Pro38 PLPP
Pro38 PPSmC
Pro38 PQUP_MK
Pro38 PSPP
Pro38 SWMP
Pro38 SWMP_LD
Pro38 USFAP
Pro38 VFAP
Pro38 WCRW
Pro3800 3800C 3850 Standard
ROMM-RGB
RR UPSatin 2.0 Ep3800.icc
Scott's Profile
SDTV NTSC
SDTV PAL

Color Management

◉ Document
 (Profile: Adobe RGB (1998))
○ Proof
 (Profile: N/A)

Color Handling:

Photoshop Manages Colors

(!) Remember to disable color management
 in the printer dialog box.

Printer Profile:

Pro38 PLPP

Perceptual
Saturation
✓ Relative Colorimetric
Absolute Colorimetric

☑ Black Point Compensation

Proof Setup:

Step Five:

After you've selected Photoshop Manages Colors, you'll need to choose your profile from the Printer Profile pop-up menu. I'm going to be printing to an Epson Stylus Pro 3800 printer using Epson's Ultra Premium Luster paper, so I'll choose the printer/paper profile that matches my printer and my paper (as I mentioned in the previous technique, the Epson 3800 came with color profiles for Epson papers already installed, but Epson does their best to give these color profiles names designed to appeal to people who decipher encrypted code for the NSA. So, for the 3800 on Premium Luster, I'd choose Pro38 PLPP). Doing this optimizes the color to give the best possible color print on that printer using that paper.

Step Six:

Lastly, you'll need to choose the Rendering Intent. There are four choices here, but only two I recommend: either Relative Colorimetric (which is the default setting) or Perceptual. Here's the thing: I've had printers where I got the best looking prints with my Rendering Intent set to Perceptual, but currently, on my Epson Stylus Pro 3800, I get better results when it's set to Relative Colorimetric. So, which one gives the best results for your printer? I recommend printing a photo once using Perceptual, then print the same print using Relative Colorimetric, and when you compare the two, you'll know.

TIP: The Gamut Warning Isn't for Us

The new Gamut Warning checkbox (beneath the preview area) is not designed for use when printing to a color inkjet (like we are here, or any other RGB printer). It warns you if colors are outside the printable range for a CMYK printing press, so unless you are outputting to a printing press, you can ignore it altogether.

Continued

Step Seven:

Lastly, before you click the Print button, just make sure the Black Point Compensation checkbox is turned on (it should be by default). When you're printing photographic images (like we are here), this option helps maintain more detail and color in the shadow areas of your photos. Now click the Print button, and when you do, another Print dialog will appear—your print driver's dialog. Choose your printer from the Printer pop-up menu, as shown here (yes, this is the third time you've chosen your printer). The example shown here is from a Mac running Mac OS X. On a Windows PC, choose your printer in the Select Printer section, and then click on the Preferences button to choose from your printer's options.

Step Eight:

Click on the Layout pop-up menu to reveal a list of all the printer options you can choose from. There are two critical changes we need to make here. First, choose Print Settings (as shown here) so we can configure the printer to give us the best-quality prints.

WARNING: From this point on, what appears in the Layout pop-up menu is contingent on your printer's options. You may or may not be able to access these same settings, so you may need to view each option to find the settings you need to adjust. If you're using a Windows PC, after you click on the Preferences button, you may have to click on the Advanced tab or an Advanced button in your Printing Preferences dialog to be able to choose from similar settings.

Step Nine:

Once you choose Print Settings, and those options appear, choose the type of paper you'll be printing on from the Media Type pop-up menu (as shown here). In our example, I'm printing on Premium Luster Photo Paper. *Note:* The Premium Luster Photo Paper is my favorite overall Epson paper for color and black-and-white prints. My second favorite is their Velvet Fine Art Paper, which I use when I want more of a painterly watercolor look and feel. It works really nicely for the right kind of photos because the paper has a lot of texture, so your photos look softer. Try it for shots of flowers, nature, soft landscapes, and any shot where tack-sharp focus is not the goal. Velvet Fine Art Paper is also a very forgiving paper when your photo is slightly out of focus.

Step 10:

Under the Mode section, click on Advanced Settings. Choose your Print Quality from the pop-up menu (on a PC, choose Max Quality). I used to choose SuperPhoto - 2880 dpi because I wanted to get the highest possible quality, but I feel the trade-off between time and ink usage vs. the difference in quality (which is fairly negligible in most cases, if visible at all) isn't worth it, so now I choose SuperFine - 1440 dpi, which creates a wonderful quality print without waiting around all day. The only reason I might bump up to 2880 is if the photo I just printed has some visible banding, or I see a problem that I hope a higher printing dpi might fix, but thankfully that is rare. Again, this is one of those things to test with your own printer: print the same image on similar paper, once at 1440, once at 2880, and see if you spot a distinct difference.

Continued

Step 11:

This next change, turning off the printer's color management, is critical. You do this by choosing Printer Color Management from that third pop-up menu to make the Color Management options visible (on a PC, click on the Custom radio button and you'll be able to choose Off [No Color Adjustment] from the Mode pop-up menu). Then, ignore these very tempting-looking settings (the Mode pop-up menu, Gamma pop-up menu, and under Advanced Settings, lots of fun-looking sliders that are just begging you to mess with them—but don't do it). Those controls are evil. So why did we come here in the first place? To turn this junk off—just click on the Off (No Color Adjustment) radio button (as shown in the next step).

Step 12:

When you select Off (No Color Adjustment), thankfully all that tempting stuff is immediately hidden from view, because now the printer's color management features are turned off. You want no color adjustment from your printer—you're letting Photoshop manage your color instead. Now you're ready to hit the Print button to get prints that match your screen, as you've color managed your photo from beginning to end.

WARNING: If you're printing to a color inkjet printer, don't ever convert your photo to CMYK format (even though you may be tempted to because your printer uses cyan, magenta, yellow, and black inks). The conversion from RGB to CMYK inks happens within the printer itself, and if you do it first in Photoshop, your printer will attempt to convert it again in the printer, and your printed colors will be way off.

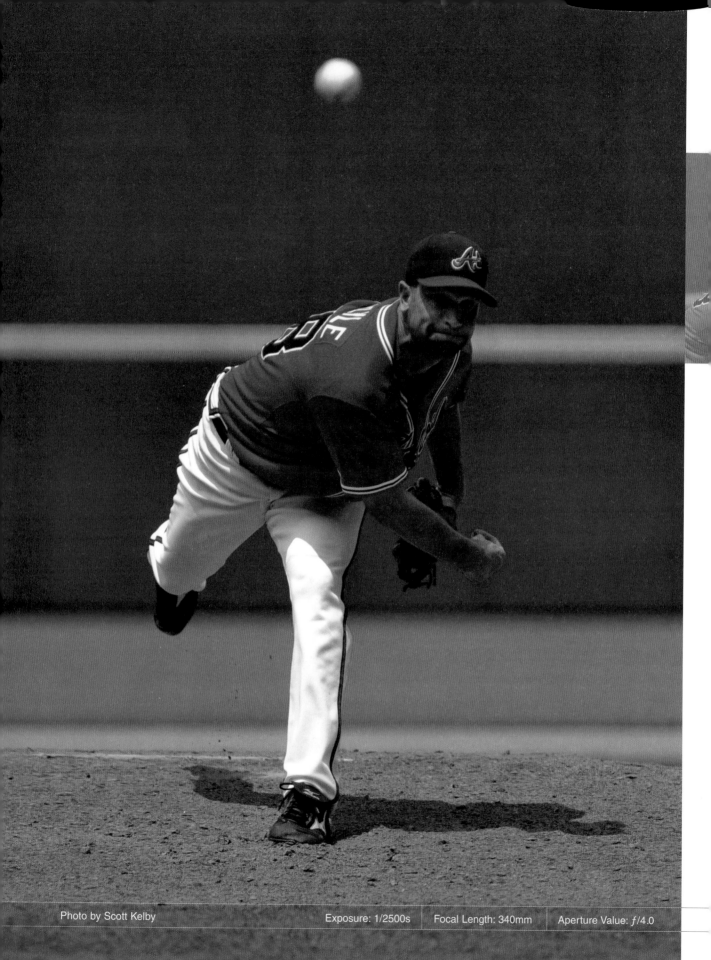

Exposure: 1/2500s | Focal Length: 340mm | Aperture Value: ƒ/4.0

Best in Show
how to show your work

At some point in all of this, you're eventually going to want to show your client, or more likely a potential client, samples (or even finished products) of your work. Make sure you work on this part of the process long before your client is within 100 miles of your studio because (and this is a little-known fact), hardwired into your color inkjet printer is a small integrated chip that actually senses fear. That's right—if you're on a tight deadline, and you have to get your samples out of the printer right before your client arrives, the tiny electrodes in the chip sense your fear, and as a defense mechanism it releases millions of tiny silicon wafers into your printer's USB port, which causes your printer to basically go into sort of a prolonged hibernation mode which makes it just sit there and quietly hum. This auto-sleep or shut down mode is called

"mocking mode" and is the digital equivalent of a small child giving you a raspberry. The more freaked out or rushed you get, the more of those tiny silicon wafers it releases, and the sleepier your printer becomes, until it gets to the point that it has the operating functionality of a block of cheese. Now, you can fool your printer into printing again, but it's not easy. First, you have to continue to act freaked out, but when the printer's not paying attention you sneak out of the room and use your cell phone to call the studio phone nearest the printer. Once it starts ringing, you rush into the studio, and looking exasperated, you grab the phone and pretend it's the client on the line, and they're calling to cancel today's appointment. When your printer hears this (and trust me, this is true), it will instantly start outputting your prints. Try this—it works every time.

Multi-Photo Poster Layouts

This technique uses both Bridge and Photoshop CS4. We use Bridge's built-in Contact Sheet feature, but we're going to tweak the size and layout, so it makes a poster design, instead. First, we're going to do a little Photoshop work, then we'll go to Bridge, and then we'll finish up the final poster back in Photoshop. It sounds like a lot of work, but believe me, Photoshop does all the hard stuff itself—the rest is easy.

Step One:
We'll start in Photoshop by making a name slug (a small graphic with the name of our poster, which goes in the bottom-right corner of it), so open a horizontal photo (it doesn't matter which photo—just a wide one that's the same size as the rest of the wide photos from your camera). Click on the Foreground color swatch in the Toolbox and, from the Color Picker, choose a color that goes well with the photos you're going to use in your poster, then press **Option-Delete (PC: Alt-Backspace)** to fill your Background layer with this color.

Step Two:
Get the Type tool **(T)** from the Toolbox, choose a font from the Font pop-up menu in the Options Bar (I chose Helvetica), then click on the color swatch (also in the Options Bar) and choose a text color from the Color Picker. Type in the name of your poster. Here, I'm using sports photos, so I typed in "Sports Photography," and then I made a separate type layer (by clicking on the Create a New Layer icon at the bottom of the Layers panel) and added "2008/2009 Season" in a smaller font. Then I switched to the Move tool **(V)** and tucked that smaller type right up under the larger type. Now press **Command-Shift-E (PC: Ctrl-Shift-E)** to merge all your visible layers down to just the Background layer.

SCOTT KELBY

Step Three:

Now save this file as a JPEG into the same folder where the photos you want to make into a poster are located. (*Note:* This effect works best if you use either all horizontal or all vertical photos. In our case, I put 35 horizontal photos, and that one name slug we just created, into the same folder.) Now, open Bridge CS4 and locate that folder of images on your computer (as shown here). In Bridge's thumbnail window, click-and-drag the name slug, so it's the last image in the window (as seen here). Then up at the top of the window, choose Output to Web or PDF from the Output pop-up menu (as shown here).

Step Four:

When you choose Output to Web or PDF, the Output panel you see here appears on the right side of the win-dow. Click on the PDF icon to show the PDF controls (we normally use this to create contact sheets, but like I said in the intro, we're gonna tweak that a bit). In the Document section, enter the largest size your printer will allow (I use an Epson Stylus Photo R2880, which makes up to 13x19" prints, so for Width I entered 13, for Height 19, and I chose Inches from the pop-up menu to the right). You can leave the rest at the default settings of High Quality, a White Background, and we'll ignore the password stuff altogether, because we're making this PDF for ourselves, not to send to a client.

Continued

Step Five:

Scroll down further in the Output panel to the Layout section (seen here). You'll need to enter these figures to set up our 36-image poster (which is four columns wide by nine columns deep): For Columns, enter 4; for Rows, enter 9 (you can move from field to field by pressing the **Tab key** on your keyboard); for Horizontal spacing, enter 0.2 inches; and enter the same for the Vertical spacing. For the Top margin, enter 1.5 inches; for the Bottom margin, enter 2.5 inches; and for the Left and Right margins, enter 2 inches (as shown here). Also, scroll down to the Overlays section and turn off the checkbox for Filename, or each image's name will appear below the photo (filenames are fine for regular contact sheets, but not for poster layouts like this).

Step Six:

Now press **Command-A (PC: Ctrl-A)** to select all the images in your folder, then click the Refresh Preview button at the top of the Output panel (shown circled here in red), and it creates a preview of your poster layout (as seen here). This particular 4x9 grid seems to work really well, but if you want to experiment with other grid layouts, just remember that each time you change the settings in the Layout section, you have to go up and click the Refresh Preview button (I know, it's a pain, but things like the Refresh Preview button are there to remind us daily that we're not living in a perfect world, or not even one that has live previews. Ah, but one can dream, can't one? I digress).

Step Seven:

If you don't like the order your photos appear in your poster layout, I recommend going up to the Workspace pop-up menu (click on the little down-facing triangle to the left of the Search field) and choosing the Light Table workspace, which hides just about everything but your thumbnails (as seen here). Now, press **Command-Shift-A (PC: Ctrl-Shift-A)** to Deselect all your photos. You can use the Thumbnail Size slider at the bottom-right corner to make your thumbnails large enough so there's just four across, which will give you nine rows of thumbnails—just like the poster. Now, just drag-and-drop them into the order you'd like them to appear in your poster (the first photo in the upper left will be the first photo, the next photo will be second, and so on), and when they're in the order you want, choose Output to PDF or Web from the Output pop-up menu up top (again). Also, don't forget to select all your images and click the Refresh Preview button once again (Arrgggg!) to see how your final changes look.

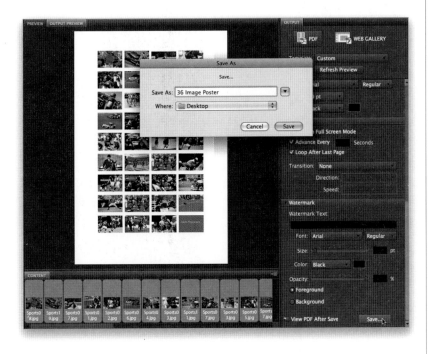

Step Eight:

When it all looks the way you want it to, first press **Command-A (PC: Ctrl-A)** to select all the photos, then scroll all the way down to the bottom of the Output panel, to the Watermark section. You're not going to add watermark text, but at the bottom of this section is the Save button, which creates the PDF and saves it, so you can open it in Photoshop. Click the Save button (as shown here) to bring up the Save As dialog, give your poster a name, and then click the Save button in that dialog. Now, we'll finish things off in Photoshop CS4.

Continued

Step Nine:

You bring your PDF into Photoshop like you would any other image: just go under the File menu, choose Open, and find the PDF on your computer. Once you do that, the Import PDF dialog (seen here) will appear. There's only one thing you need to do here, and that's make sure that your PDF comes in at the right size by choosing Media Box from the Crop To pop-up menu (as shown here). The default Crop To setting is Bounding Box, which crops in tight right around your photos, and because of that, it won't be 13x19" any longer, but choosing Media Box keeps the original size in place. Now just click OK to import the PDF into Photoshop (from here on out, it will act just like a regular image).

Step 10:

When your PDF appears, it appears on its own layer, with no Background layer, so everything surrounding the photos is transparent. To add a white background behind your photos, just press-and-hold the Command (PC: Ctrl) key, and click on the Create a New Layer icon at the bottom of the Layers panel (holding the Command key puts the new layer directly beneath your current layer, as seen here). To fill that layer with white, press the letter **D**, then press **X** (which makes white your Foreground color), and then press **Option-Delete (PC: Alt-Backspace)** to fill this layer with white. Now that we have our images on one layer, and a totally separate background layer, we have a lot of flexibility for how to customize this look. For example, one thing you can do is add a stroke around your photos (something you couldn't do in Bridge).

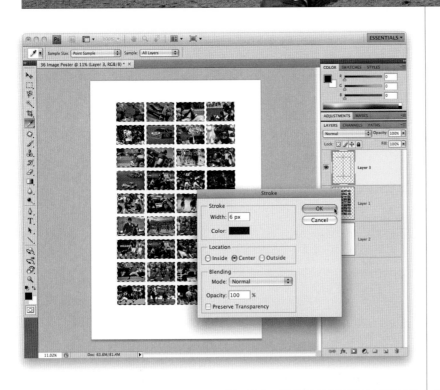

Step 11:

Click on the Create a New Layer icon again to add a new blank layer and then click-and-drag it to the top of the layer stack. Press-and-hold the Command (PC: Ctrl) key and click on the images layer's thumbnail to put a selection around each photo. Go under the Edit menu, choose Stroke, then choose the width and color of your stroke (I chose 6 pixels and black), and click OK. Press **Command-D (PC: Ctrl-D)** to Deselect. Lastly, get the Type tool **(T)** and add some text in the white space below the images (as seen below on the left, where the stroke layer is hidden). The center image below has the bottom layer filled with black and the stroke layer in white (select the stroke layer and press **Command-I [PC: Ctrl-I]** to Invert it). The bottom-right image has the bottom layer filled with light gray, and a black stroke around the images.

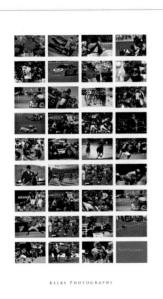

The original layout, with the black stroke layer turned off, and some text added

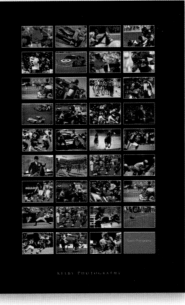

The background layer filled with black, and the stroke and text layers in white

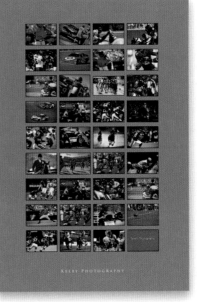

The background layer filled with light gray, the stroke layer in black, and text layer in white

Watermarking & Adding Your Copyright Info

This two-part technique is particularly important if you're putting your proofs on the Web for client approval. In the first part of this technique, you'll add a see-through watermark so you can post larger proofs without fear of the client downloading and printing them; and second, you'll embed your personal copyright info, so if your photos are used anywhere on the Web, your copyright info will go right along with the file.

Step One:

Open the photo you want to add your copyright watermark to, then get the Custom Shape tool from the Toolbox (as shown here), or just press **Shift-U** until you have the tool (it looks like a star with rounded corners).

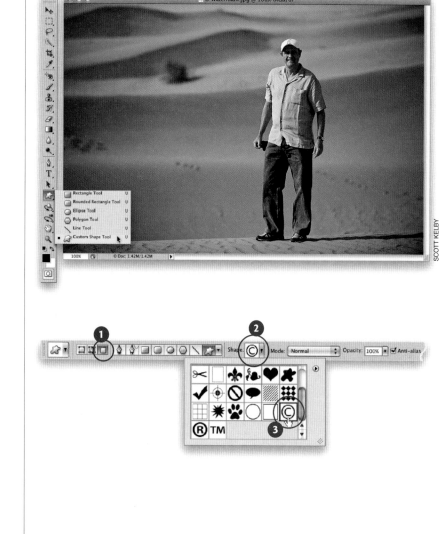

Step Two:

Once you have the Custom Shape tool, go up to the Options Bar and (1) click on the Fill Pixels icon (the third from the left), which makes your shape up of pixels (like normal), rather than as a Shape layer or path. Then, (2) click on the thumbnail to the right of the word "Shape" to bring up the Custom Shape Picker. When it pops down, (3) choose the copyright symbol, which is included in the default set of custom shapes (as shown here).

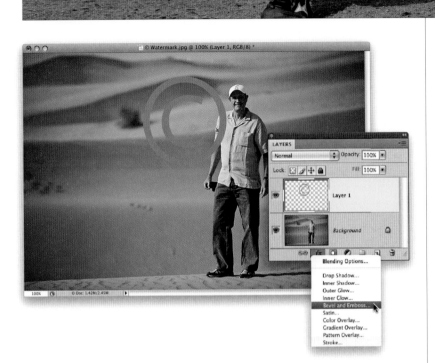

Step Three:
Create a new blank layer by clicking on the Create a New Layer icon at the bottom of the Layers panel. Click on the Foreground color swatch at the bottom of the Toolbox, and choose a light gray in the Color Picker for your Foreground color. Then, press-and-hold the Shift key (to keep things proportional), take your Custom Shape tool, and click-and-drag just above the center of your photo to add a large copyright symbol shape (seen here). Once it's drawn, click on the Add a Layer Style icon at the bottom of the Layers panel, and choose Bevel and Emboss from the pop-up menu (as shown here).

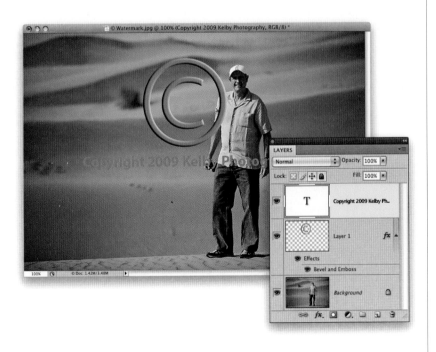

Step Four:
When the Layer Style dialog appears, you don't have to change any settings—just click OK to apply a beveled effect to your copyright symbol (seen here). Now, get the Type tool **(T)**, make sure your Text color swatch in the Options Bar matches your Foreground color, type in "Copyright," followed by the current year, and lastly the name of your studio, then position it under the copyright symbol (as shown here).

Continued

Step Five:

Now you're going to duplicate your Bevel and Emboss layer style and apply it to your new Type layer. To do that, just press-and-hold the **Option (PC: Alt) key**, and in the Layers panel click directly on the word "Effects" on your copyright symbol layer, and drag-and-drop it onto your Type layer (as shown here). Holding that Option key down tells Photoshop CS4 to duplicate the effect. If you didn't hold the Option key, it wouldn't duplicate the effect on that layer—instead it would actually move it to that layer.

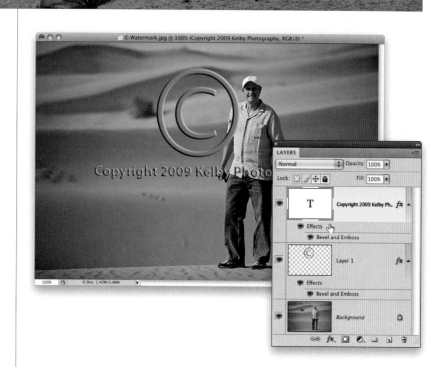

Step Six:

Go to the Layers panel, press-and-hold the Command (PC: Ctrl) key, and click on the top two layers to select them. Once they're both selected, press **Command-E (PC: Ctrl-E)** to merge these two layers into one single layer (don't worry—they will maintain the embossed effect look). Now, change the layer blend mode of this merged symbol layer from Normal to Hard Light (as shown here), which makes the watermark transparent. You can lower the Opacity of this layer enough to where your clients can easily evaluate the photo, but there's enough watermark visible to keep them from using it as their final print (in the example shown here, I lowered the Opacity to 30%).

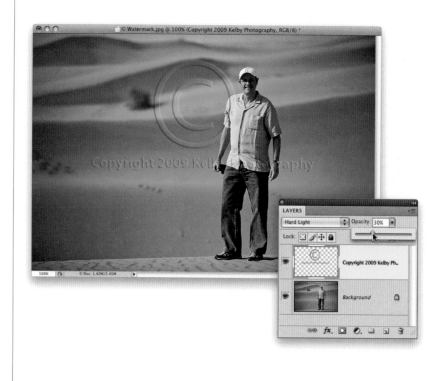

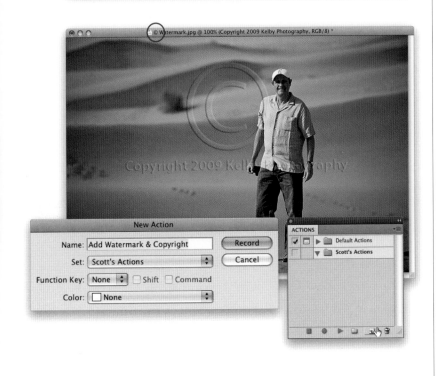

Step Seven:

Now that the watermarking is complete, let's embed your copyright info into the file itself. Go under the File menu and choose File Info to bring up the File Info dialog (seen here). At the top, click on the Description tab (if it doesn't come up by default). In the center section, choose Copyrighted from the Copyright Status pop-up menu. In the Copyright Notice field, enter your personal copyright info, and then under Copyright Info URL, enter your full Web address (so if someone downloads your photo and opens it in Photoshop, they can click on the Go To URL button to go directly to your website). Lastly, click OK and this info is embedded into the file.

Step Eight:

When you click OK, Photoshop automatically adds a copyright symbol before your file's name in the title bar (shown circled in red here). Flatten your image by choosing Flatten Image from the Layers panel's flyout menu. Now you're going to create an action to automate this entire process. Start by opening a different photo, then go to the Actions panel (found under the Window menu) and click on the Create New Action icon at the bottom of the panel. When the dialog appears, name your action (as shown here) and click the Record button.

Continued

Step Nine:

Now repeat the whole process of adding the copyright symbol and copyright info (Photoshop will record all your steps as you're doing them, as seen here in the Actions panel). Start at Step One and stop after Step Seven (you stop after Step Seven, before flattening your file, because you may want to keep your layers intact so you can reposition your watermark, depending on the image).

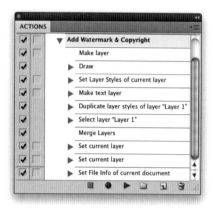

Step 10:

When you're done, click on the Stop icon (it looks like a tiny square) at the bottom left of the Actions panel. Here's where it gets fun: you can apply this action to an entire folder full of photos. Go under the File menu, under Automate, and choose Batch. In the Play section, choose your action set and new watermark action from the pop-up menus. Under Source, choose Folder, then click the Choose button, navigate to your folder full of photos, and under Destination choose Save and Close. (If you want to save your watermarked photos to a different folder, choose Folder under the Destination section, click the Choose button, and navigate to the folder you want to save them to. You'll also need to add either a Flatten Image step or a Save and a Close step to your action.) Now, click OK and your watermark and copyright will be added to each photo in that folder automatically.

Turning Your Signature Into a Brush

Artists always sign their work, and if you'd like to have your own signature so handy that you can add it to any finished piece with just one click, then you'll want to turn your signature into a brush. That way, you just grab the Brush tool, choose your signature brush, click once, and it's there.

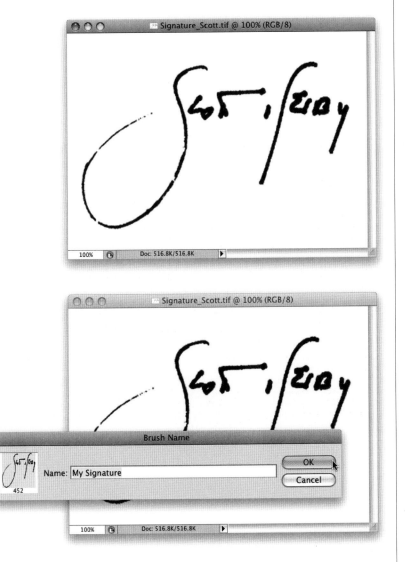

Step One:
The first step to all this is getting your signature into Photoshop CS4. There are basically two ways: (1) take a nice black writing pen, sign your name fairly large on a piece of paper, and then scan your signature (which is what I did here); or (2) if you have a Wacom tablet with its wireless pen, just open a new document (at a resolution of 300 ppi), press **D** to set your Foreground color to black, get the Brush tool **(B)**, then choose a small, hard-edged brush from the Brush Picker, and sign your name at a fairly large size.

Step Two:
Now go under the Edit menu and choose Define Brush Preset. This brings up the Brush Name dialog (shown here), where you give your new signature brush a name (I named mine "My Signature," which is another carefully thought-out, highly original name) and click OK (as shown here). That's all there is to creating your signature brush, and the nice thing is—you only have to do this once—it's saved into Photoshop's Brush Presets for use in the future. Now let's put this new signature brush to use.

Continued

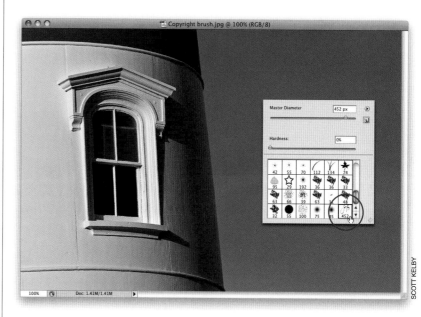

Step Three:

When you want to apply your signature to a photo, open that photo, get the Brush tool **(B)**, Control-click (PC: Right-click) anywhere inside your image area, and the Brush Picker will appear right at the location of your cursor (as seen here). The new signature brush you just created in Step Two will appear as the last brush in the list of brushes, so scroll all the way down to the bottom, and click on that very last brush (you'll see a tiny version of your signature as the brush's thumbnail).

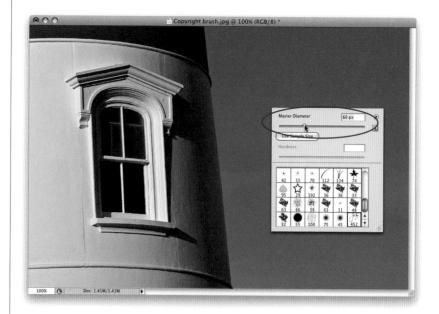

Step Four:

By default, the brush will be the size it was when you created your Brush Preset, so if you need to change the size of your brush, just drag the Master Diameter slider at the top of the Brush Picker (shown circled here in red). In my case, I needed to drag that slider to the left to make the brush much smaller, because if you look directly under the thumbnail, it shows your brush's size in pixels, and mine was 452 pixels. Kinda big, don'tcha think?

SCOTT KELBY

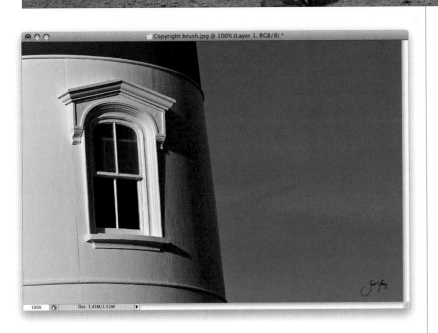

Step Five:
Now that you've got your signature brush, and have adjusted the size, go to the Layers panel and click on the Create a New Layer icon at the bottom. Then, take the brush and simply click once where you want the signature to appear (as shown here, where I clicked in the bottom-right corner). If your photo has a dark background, just change your Foreground color to something that can easily be seen on a dark background (like white).

How to Get Picture Package, Extract, Pattern Maker, and Other Old Friends Back

In Photoshop CS4, Adobe kind of "trimmed the fat" and got rid of some plug-in filters, automations, and presets it felt really didn't need to be there. However, apparently some users didn't agree (I, for one, was shocked to learn that they removed the Extract filter from CS4), so Adobe went and made these "legacy" plug-ins and presets available for free download from Adobe.com. All you have to do is download them and install them. Sounds like fun, eh? Luckily, it's easier than it sounds, and here's how it's done:

Step One:

Go to www.adobe.com, and in the search field at the top right, type in "CS4 Optional plug-ins," and it will take you to a page where you can download these plug-ins for Macintosh and Windows. Click the Proceed to Download button, and then click on the Download Now button to download the plug-ins, presets, and the installer.

Step Two:

Once it downloads, double-click on the downloaded file, and you'll find a Goodies folder inside with all the various stuff Adobe took out of CS4, separated by category (Optional Plug-ins and Presets).

Step Three:

There are ReadMe files included in most of the folders, which show the exact path of where each individual item gets installed in Photoshop (it's a drag-and-drop process), and it's really pretty easy. Since each one is different, I won't list them all here, but I'll give you an example: To get Picture Package back on the Mac, just go to your Mac's Applications folder, where you'll find your Adobe Photoshop CS4 folder. Look inside that and you'll find a Plug-ins folder, and inside that an Automate folder. Now just drag-and-drop the ContactSheetII.plugin file (found in the Optional Plug-ins folder, then inside the Automate folder) into that Automate folder. Next, go to your Users folder, then your Home folder, then your Library folder. Inside there, go to the Application Support folder, then the Adobe folder, and then the Adobe Photoshop CS4 folder. Now drag-and-drop the Layouts folder (found inside the Presets folder, inside the Goodies folder) into your Adobe Photoshop CS4 folder's Presets folder (whew!). Restart Photoshop, and Picture Package (along with Contact Sheet II) will appear back under the File menu, under Automate. On a PC, you'll drag-and-drop that same ContactSheetII .plugin file (in the Goodies folder, open the Optional Plug-ins Folder, choose the 32-bit or 64-bit Plug-ins folder, then look in the Automate folder) into the Adobe Photoshop CS4/Plug-ins/Automate folder on your computer (found under C://Program Files/Adobe). Then, you'll need to drag-and-drop the Goodies/ Presets/Layouts folder into your Adobe Photoshop CS4/Presets folders (in the same place as the Plug-ins folder) on your computer, and restart Photoshop.

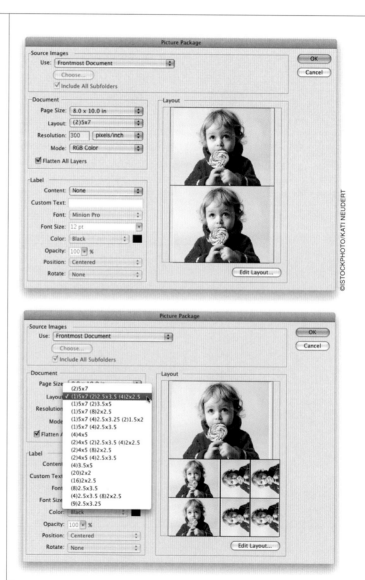

Getting Multiple Copies of Your Photo on One Page

When it's time to deliver final prints to your client, you can save a lot of time and money by creating a Picture Package, which lets you gang-print common final sizes together on one sheet. Luckily, Photoshop does all the work for you. All you have to do is open the photo you want gang-printed and then Photoshop will take it from there, except the manual cutting of the final print, which is actually beyond Photoshop's capabilities. So far. *Note*: You'll need to read the previous tutorial on how to get Picture Package back in CS4 first.

Step One:

Open the photo you want to appear in a variety of sizes on one page, and then go under the File menu, under Automate, and choose Picture Package. (You can also choose Picture Package from Bridge CS4, under the Tools menu, under Photoshop, if you've downloaded Picture Package into Bridge CS4, as well.) At the top of the dialog, the Source Images section is where you choose your source photo. By default, if you have a photo open, Photoshop assumes that's the one you want to use (your Frontmost Document), but you can choose from the Use pop-up menu to pick photos in a folder or an individual file on your drive. By default, Picture Package chooses an 8x10" page size for you, but you can also choose either a 10x16" or 11x17" page size.

Step Two:

You choose the sizes and layout for your Picture Package from the Layout pop-up menu. In this example, I chose (1) 5x7 (2) 2.5x3.5 (4) 2x2.5, but you can choose any combination you like. When you choose a layout, a large preview of that layout appears in the right section of the dialog.

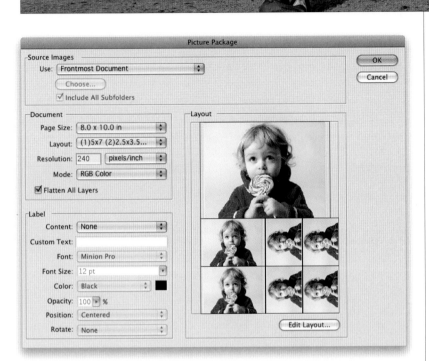

Step Three:
You can also choose the final resolution output in the Resolution field (which I lowered to 240 ppi here, because you don't really need a high resolution when you're not printing to a commercial press). Then, you can pick the color mode you'd like for your final output (in this case, I chose RGB Color in the Mode pop-up menu, because I'll be printing to a color inkjet printer). The bottom-left section of the dialog is for labeling your photos, but be forewarned—these labels appear printed right across your photos, so use them only if you're creating client proof sheets, not the final prints. *Note: With the exception of adding your own custom text, this information is pulled from embedded info you enter in the File Info dialog, found under the File menu.*

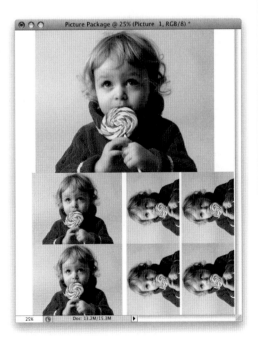

Step Four:
Click OK and Photoshop automatically resizes, rotates, and compiles your photos into one document (as shown here). Now, it's not letter-sized—it's 8x10", so if you print this on letter-sized photo paper (which is very common), you'll have a little more white border all the way around.

Continued

TIP: Adding a Photo Border

If you want to add a white border around each photo (including the wallet-size photos), then before you open Picture Package, go under the Image menu and choose Canvas Size. Make sure the Relative checkbox is turned on and enter the amount of white border you'd like in the Width and Height fields (i.e., 0.25 inches for a quarter-inch border). Now, make sure your Canvas Extension Color is set to white (at the bottom of the dialog). When you click OK in the Canvas Size dialog, a white border will appear around your photo. Now you can choose Picture Package.

Step Five:

Another nice feature of Picture Package is that you can have two or more different photos on the same Picture Package page (say that three times fast). For example, to change just one of the 2.5x3.5" prints to a different photo, click on the preview of the image that you want to change in the Layout section (as shown here, where I'm clicking on the top one of the 2.5x3.5" photos).

Step Six:

This brings up the standard Open dialog so you can select a photo to replace the one you clicked on. Navigate your way to the photo you want to appear at this size and location on your printed sheet, and click Open. That photo will appear at the right size and position (as seen here).

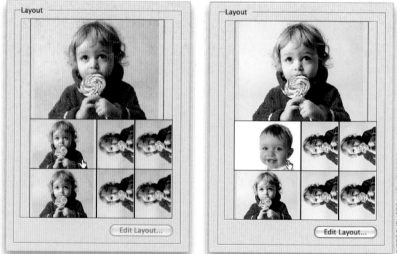

©ISTOCKPHOTO/KATI NEUDERT

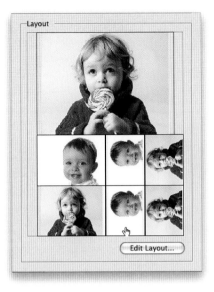

Step Seven:

You can replace any other photo (or all the photos) using the same method (here I replaced two of the smaller photos with that same photo I just imported earlier by clicking on each one individually and choosing that same photo to replace it). When the Picture Package layout preview looks the way you want it to, click OK and Photoshop CS4 will create your final document.

Step Eight:

This is really an optional step, but if you decide that the layout you want doesn't appear in the built-in list of layouts, then you can create your own custom layout. You do that by clicking on the Edit Layout button, found just below the Layout preview area (and seen in the close-up of the Layout preview area shown in the previous step—Step Seven). This brings up the Picture Package Edit Layout dialog (shown here). Adobe calls each photo cell a "zone." To delete a zone just click on it, then click on the Delete Zone button. To add a new zone, click on the Add Zone button, and the same photo you currently have selected appears in the blank space. You can grab the corners to resize it to your liking. (*Note:* Drag the corners outward to rotate the photo.)

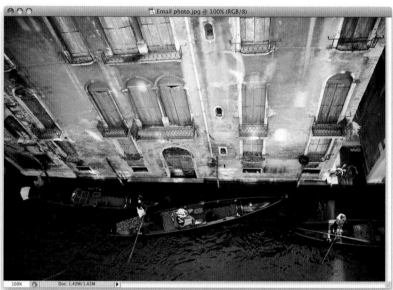

How to Email Photos (and Keep the Color Looking Right)

Believe it or not, how to prepare photos for emailing is one of those most-asked questions, and I guess it's because there are no official guidelines for emailing photos. The two emailing photos problems I hear the most are: (1) "My photos keep getting bounced back because they're too big," and (2) "When I email people my photos, they look really washed out, and don't look nearly as good as they did on my computer." Here's how to fix both of these:

Step One:
Open the photo that you want to email. Before you go any further, you have some decisions to make based on whom you're sending the photo to. If you're sending it to friends and family, you want to make sure the file downloads fast, and (this is important) can be viewed within their email window. I run into people daily (clients) who have no idea how to download an attachment from an email. If it doesn't show up in their email window, they're stuck, and even if they could download it, they don't have a program that will open the file. So the goal: make it fit in their email browser.

Step Two:
Go under the Image menu and choose Image Size (or press **Command-Option-I [PC: Ctrl-Alt-I]**). Because they'll just be viewing this onscreen, you can lower the resolution to what's called "screen resolution," which is 72 ppi (no matter what kind of monitor or which kind of computer they have). Next, set the Width (in inches) to no wider than 8" (the height isn't the big concern, it's the width, so make sure you stay within the 8" width). If you're sending this to a client or a photo lab, you'll need a higher resolution. I use 240 ppi if they're printing it to an inkjet printer, or 300 ppi if it will be printed on an actual printing press. Click OK.

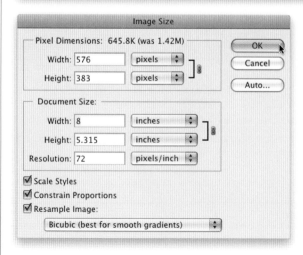

Step Three:

Now that you have the size and resolution figured out, here's a trick to keeping the colors looking right for email: Before you save the file in Photoshop, go under the Edit menu and choose Convert to Profile. When the Convert to Profile dialog appears, from the Destination Space Profile pop-up menu, choose Working RGB – sRGB IEC61966-2.1 (as shown here), and then click OK. This converts your image to a color space that works for email or Web images. (*Note*: You probably won't see a change in color onscreen on your end, but it will make a big difference when they see it on their end.)

Step Four:

Saving your file as a JPEG is the safest (and most popular) way to ensure that the person you're emailing this photo to will actually be able to see it. To save your photo as a JPEG, go under the File menu and choose Save As. In the Save As dialog, choose JPEG in the Format pop-up menu, and then click Save. This brings up the JPEG Options dialog (shown here), where you get to choose the amount of compression applied to your image (this compression shrinks the file size for email while maintaining as much of the quality as you choose using the Quality slider. Your goal is to email a photo that is small in file size (so it downloads quickly), yet still looks really good. I generally save all my JPEGs at a quality setting of 10, which I think is the ideal balance between getting a small file size and still keeping great image quality.

Fine Art Poster Layout

This technique gives your work the layout of a professional poster, yet it's incredibly easy to do. In fact, once you learn how to do it, this is the perfect technique to turn into a Photoshop action. That way, anytime you want to give your image the poster look, you can do it at the press of a button.

Step One:

Press **Command-N (PC: Ctrl-N)** to create a new document in the size you want for your fine art poster layout (in our example here, I'm creating a standard-sized 11x14" print). Set your Resolution to 240 ppi (for color inkjet printing), then click OK to create your new blank document.

Step Two:

Open the photo you want to feature in your fine art poster layout. Get the Move tool **(V)** and click-and-drag that photo over into your fine art poster layout (as shown here). Press **Command-T (PC: Ctrl-T)** to bring up Free Transform. Press-and-hold the Shift key, grab a corner, and drag inward to size the photo down so it fits within your layout like the photo shown here. Press **Return (PC: Enter)** to lock in your transformation. To perfectly center your photo within the document, click on the Background layer, press-and-hold the Command (PC: Ctrl) key, and click on the photo layer to select both layers. Then go up to the Options Bar, and click on the Align Horizontal Centers icon (circled here in red) to center the photo side-to-side (as shown here).

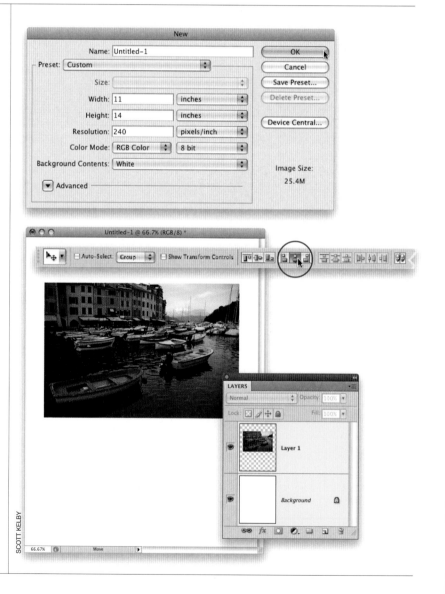

SCOTT KELBY

Step Three:
Go to the Layers panel, and click on the Background layer to select it. Now, click on the Create a New Layer icon at the bottom of the Layers panel to create a new blank layer, then get the Rectangular Marquee tool **(M)** and click-and-drag out a selection that is about ½" larger than your photo (as shown here). You're going to turn this selection into a fake mat. Press **D**, then **X** to make your Foreground color white, then fill this selected area with white by pressing **Option-Delete (PC: Alt-Backspace)**.

Step Four:
To create the mat effect, choose Inner Glow from the Add a Layer Style pop-up menu at the bottom of the Layers panel. This brings up the Inner Glow section of the Layer Style dialog. Click on the light yellow color swatch below the Noise slider and change the color of the glow to black. You won't be able to see the glow at this point, because the default blend mode for the Inner Glow is Screen, so to see your glow, change the Blend Mode pop-up menu (near the top of the dialog) to Normal. Increase the Size of the glow to 5 (try 10 for very high-res photos), then lower the Opacity of this glow to 20% (as shown here) to create the subtle shadow of a beveled mat (as seen in the next step), and click OK.

Continued

Step Five:

Press **Command-D (PC: Ctrl-D)** and you'll see the mat-like effect is in place around your photo. Although you want the photo centered side-to-side, you don't want the photo centered top-to-bottom. Fine art posters generally have the photo well above the center of the photo, at what is called the "optical center," which is the area just above the center. To move the photo up, go to the Layers panel, select both the photo layer and the mat layer beneath it, then get the Move tool **(V)**, and use the **Up Arrow key** on your keyboard to nudge the photo and mat upward until it's well above the center top-to-bottom (as seen here).

Step Six:

Now it's time to add your poster text. Press the letter **T** to get the Type tool to add your text (i.e., the name of your studio, the name of the poster, whatever you'd like). I chose the font Trajan Pro at 24 points, and I typed in upper- and low-ercase (this font comes with the Creative Suite, so chances are you already have it installed. It actually doesn't have lower-case letters—instead, it uses large caps and smaller caps, as seen here). The extra space between the letters adds an elegant look to the type. To do that, highlight your type with the Type tool, then go to the Character panel (found under the Window menu), and in the Tracking field, enter 120.

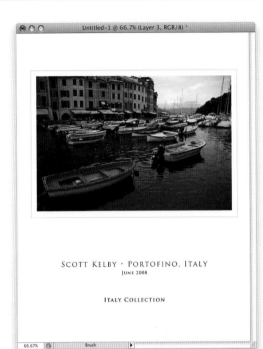

Step Seven:
The easiest way to add more type is to press **Command-J (PC: Ctrl-J)** to duplicate the Type layer. Then you can change the size of the type, and add additional lines of text (as I did here, where I added a line underneath the top line with the date the photo was taken. Then I duplicated the Type layer again and added the bottom line of text). To center all three lines of type side-to-side perfectly within your image area, click on the Background layer in the Layers panel, and then Command-click (PC: Ctrl-click) on each Type layer so all three layers are selected. Press **V** to get the Move tool, and in the Options Bar, click on the Align Horizontal Centers icon to center your text beneath your image (like you did earlier to center your image).

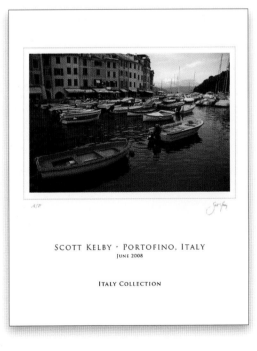

Step Eight:
Lastly, you can add your signature (either after it's printed, or right within Photoshop CS4 itself if you have a scan of your signature or a Wacom tablet, where you can just use the tablet's wireless pen to create a digital signature). Here's the final photo with my signature added under the right corner, and the letters "A/P" under the left corner, which stands for "Artist Print" indicating the print was output by the photographer him/herself.

Simple Three-Photo Balanced Layout Using Smart Objects

This is just a simple layout that is very effective. We're going to bring in our photos as Smart Objects, so we can save the layout as a template and update the look very quickly whenever we want. Here's how it's done:

Step One:

Press **Command-N (PC: Ctrl-N)** and create a new document that is very wide (the one shown here is 11" wide by 3" deep). Go to the Layers panel, click on the Create a New Layer icon at the bottom of the panel, and then get the Rectangular Marquee tool **(M)**. Press-and-hold the Shift key, and on the left side of the document, drag out a square selection (since you're holding the Shift key—don't worry—it will be perfectly square) that is almost as tall as the document itself (leave approximately ½" of white space all the way around). Press **D** to set your Foreground color to black, then press **Option-Delete (PC: Alt-Backspace)** to fill your selection with black. Don't deselect.

Step Two:

Press **V** to get the Move tool from the Toolbox. Press-and-hold **Option-Shift (PC: Alt-Shift)**, then click-and-drag yourself a copy of your selected black square. Drag it all the way over to approximately the same position on the right side of your document, as shown here. (Holding the Option key makes a duplicate of your square, and holding the Shift key keeps it perfectly aligned with the other square as you're dragging to the right.)

SCOTT KELBY

Step Three:

Deselect by pressing **Command-D (PC: Ctrl-D)**. Switch back to the Rectangular Marquee tool, but this time don't hold the Shift key (that way, you can draw a rectangle). Now, draw a rectangular selection between the two squares, leaving approximately the same amount of space between your shapes (as shown here). Then fill that long rectangle with black. So, what you have is (from L to R): a black square, a long black rectangle, and another black square. Press Command-D again to Deselect.

Step Four:

We're going to bring in our photos as Smart Objects, so go under the File menu and choose Place. When the Place dialog appears, choose the photo you want to appear over the square on the left. When it appears onscreen, position it over the first square on the left. Press-and-hold the Shift key and click-and-drag a corner handle to resize it, so it's slightly larger than the square (as shown here), then press the **Return (PC: Enter) key** to lock in your resizing. *Note:* If you can't see the transform handles, press **Command-0 (zero; PC: Ctrl-0)** and the window will expand out so you can reach them.

Step Five:

Now press **Command-Option-G (PC: Ctrl-Alt-G)** to mask your rectangular photo into that black square (as shown here). You can get the Move tool and reposition your photo inside that black square by just clicking-and-dragging on it. Don't freak out if you see part of your photo appearing in the center rectangle (like you see here), because we'll cover that with a different photo layer.

Continued

Step Six:

Now repeat the last two steps, opening two other photos, and resizing them so that they're slightly larger than the boxes they're going to be masked into. Once one of them is sized, press **Command-Option-G (PC: Ctrl-Alt-G)** to mask it into the shape. Then do the same for the other photo. If, when you're done, any one of those photos extends into a different box, just go to the Layers panel and move that layer down one (or two) layers until that extra area is hidden behind one of the other masked photos.

Step Seven:

At this point, your layout is basically done (but stick around for just a minute, so we can do the whole Smart Object thing, which you will totally dig, by the way), but if you'd like a different look, just click on the Background layer, press the letter **D** on your keyboard to set black as your Foreground color, then press **Option-Delete (PC: Alt-Backspace)** to fill your Background layer with black, which gives you the look you see here. Now, here's where it gets fun: because we placed those images into our document as Smart Objects, we can save a version of this file, with all our layers intact, so that becomes a quick-updating template (you'll see how in a moment). For now, just save the file and add the name "Template" at the end of the filename, so that you can use it again in the future.

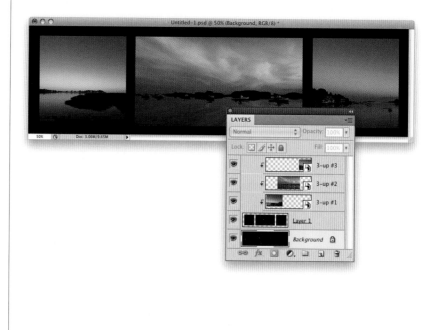

Step Eight:
Now, click on the first image's thumbnail in the Layers panel, then Control-click (PC: Right-click) on its name, and from the contextual menu, choose Replace Contents (as shown here). A dialog appears where you can choose which photo you want to replace this first one with. Choose the photo, click OK, and it replaces the first photo, and resizes it to fit in that exact spot (provided, the photo you're importing is the same dimensions and resolution, of course). Now, just repeat that process for the other two photos, and in just seconds you've got all three photos updated.

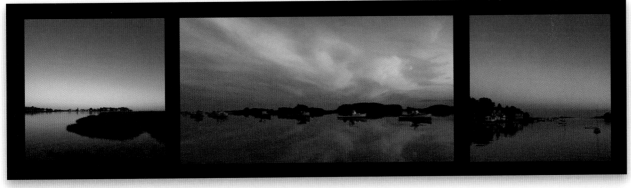

Here's our original three-up layout

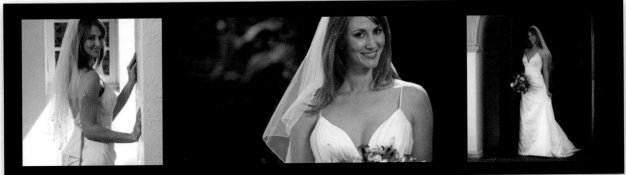

Here's a variation I was able to create in just seconds, because we made our photos Smart Objects, and I just swapped them out

Multi-Photo Look from Just One Photo

I first saw this layout on a website that sells fine art prints, and I thought it was a very slick way to show your work because it's not the standard old "photo in the middle of a page" look you see again and again, and the separation between the boxes really seemed to add some visual interest. Plus, even though you're just using one photo, it has the look of a multi-photo layout.

Step One:
Press **Command-N (PC: Ctrl-N)** to create a new document in the size and resolution you want for your final print. Go to the Layers panel and click on the Create a New Layer icon at the bottom. Get the Rectangular Marquee tool **(M)**, and click-and-drag out a small square over to the far-left side (you're going to fit five of these boxes across, so keep that in mind when choosing how big to make your first box; press-and-hold the Shift key while you drag to make it square). Once your box selection is in place, press **D** to set your Foreground color to black, then press **Option-Delete (PC: Alt-Backspace)** to fill your square selection with black (as shown here). Don't deselect yet.

Step Two:
Press **Command-Option-T (PC: Ctrl-Alt-T)** to bring up Free Transform. Press-and-hold the Shift key (to keep your alignment straight), then click-and-drag a copy of this square straight over to the right, leaving a small gap between the two squares (as shown here). Press **Return (PC: Enter)** to lock in your move.

Step Three:

Now press **Command-Option-Shift-T (PC: Ctrl-Alt-Shift-T)**, which creates another copy of your square to the right of your first two squares, with the exact same amount of spacing between the squares. Now, press this keyboard shortcut two more times until you have five squares in a row (as shown here). Press **Command-D (PC: Ctrl-D)** to Deselect the last square you copied.

Step Four:

Now, to perfectly center this row of five squares within your document, first click on the Background layer in the Layers panel. Then, press-and-hold the Command (PC: Ctrl) key and click on the five-squares layer to select it as well. Once both layers are highlighted (as shown here), get the Move tool **(V)**, go up to the Options Bar, and click on the icon for Align Horizontal Centers (you can see my cursor over that icon in the Options Bar here—it's the fifth icon from the left, and it's circled in red).

Continued

Step Five:

Now we're going to bring in our photo as a Smart Object. To do that, click on the Background layer, then just go under the File menu and choose Place (rather than Open). Once the photo appears, press-and-hold the Shift key, grab any corner point, and drag in to shrink the size or drag outward to increase the size (basically, you want to resize your imported Smart Object photo so it's just slightly larger than the five black boxes, as shown here). Once it's sized, press **Return (PC: Enter)** to lock in your size change.

Step Six:

To get your photo inside those five boxes, start by going to the Layers panel and dragging your photo layer to the top of the layer stack, so it's the top layer (as shown here). Now either go under the Layer menu and choose Create Clipping Mask (as shown here) or use the keyboard shortcut **Command-Option-G (PC: Ctrl-Alt-G)**.

Step Seven:

When you choose Create Clipping Mask (or use that keyboard shortcut), it masks your Smart Object photo inside the five boxes on the layer below it (as shown here, where the photo is clipped into those five boxes).

Step Eight:

The final step is to add your studio name over a scan of your signature (just sign your name with a thick black pen on a white piece of paper, and scan it on a flatbed scanner. Of course, if you have a Wacom tablet and wireless pen, you can just get a small hard-edged brush and sign your name right in your document). Position your signature so it's centered at the bottom of the five boxes, about halfway between the bottom of the document and the bottom of the boxes. Lower the opacity of your signature to around 40% or 50% so it looks like a medium gray color. Now, take the Type tool (**T**) and add your studio's name (or your name), and position this type centered, right over your signature (I used the font Trajan Pro, which is installed automatically when you install the Adobe Creative Suite). To add a little elegance to this type, increase the amount of tracking (the spacing between letters) to 200 (this is done in the Character panel).

Continued

Step Nine:

Since you brought in your photo as a Smart Object, you can easily change your photo, and it will automatically be masked into those five boxes. To do that, go to the Layers panel, Control-click (PC: Right-click) on your Smart Object layer, and choose Replace Contents. Now choose a different photo, and when you do, it automatically appears within your five boxes (as shown here). Yet another advantage of using Smart Objects.

SCOTT KELBY PHOTOGRAPHY

Instant Pano Layout

I originally came up with the idea for this when playing around with Print template designs in Adobe Photoshop Lightroom (Adobe's workflow tool for professional photographers), and what it does is takes any photograph and presents it as a panorama. When I showed this "instant pano" template in a Lightroom seminar I was teaching, the crowd loved it so much, I knew then I had to find a way to do the same thing in Photoshop CS4 (which I did, and here's how it's done).

Step One:
Press **Command-N (PC: Ctrl-N)** to create a new document in whatever size and resolution you'd like (in my example, I created a wide letter-sized document (11x8½") at a resolution of 240 ppi (for inkjet printing). Once you've opened the document, choose Solid Color from the Create New Adjustment Layer pop-up menu at the bottom of the Layers panel (as shown here).

Step Two:
This brings up a Color Picker, prompting you to Pick a Solid Color. Since our background is white (which is the default setting in the New document dialog), choose white as your solid color (as shown here), and click OK. This fills your new adjustment layer with solid white (okay, it's kind of hard to see a white-filled layer on top of a white background, so you'll just have to trust that it worked. Well, for now anyway).

Continued

Step Three:

Get the Rectangular Marquee tool from the Toolbox, or just press **M**, and click-and-drag a wide rectangle about 2" from the top of the document (as shown here). Don't make the selection too deep (in fact, while you're dragging out your selection, try dragging it out in the shape of a panorama—wide, but not very deep). Once your selection is in place, press the letter **X** on your keyboard to switch your Foreground color to black, then press **Option-Delete (PC: Alt-Backspace)** to fill your selected area with black. Now, you're only filling the white Solid Color adjustment layer's mask with black, so you won't see anything change onscreen. To confirm that your black fill worked, take a look in the Layers panel, and you should see a black rectangle in the adjustment layer's mask thumbnail (as shown circled here). Press **Command-D (PC: Ctrl-D)** to Deselect.

Step Four:

Click on the Background layer, then go under Photoshop's File menu and choose Place (importing a file using Place, rather than Open, automatically makes the photo a Smart Object. You'll see why it's so smart in just a moment). Now, locate the photo you'd like to have become an instant pano, and click OK to import that photo. When your photo appears, you'll see a large bounding box around the entire photo (with a big X over the image area). Press-and-hold the Shift key, click on one of the corner handles, and drag inward to scale the photo down to size, so it's just slightly larger than your pano opening.

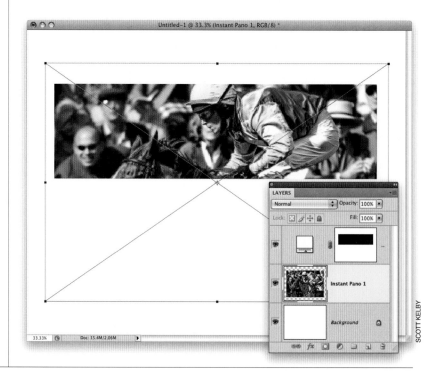

SCOTT KELBY

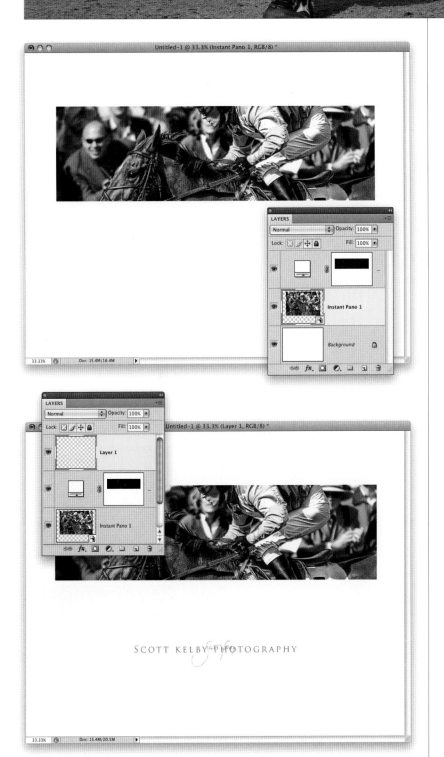

Step Five:
Once you have it sized the way you'd like it, you can click in the center and drag it up or down to reveal a different part of the image, then press the **Return (PC: Enter) key** to complete your resizing. But remember: since you imported this as a Smart Object, if you ever need to resize the photo, it draws upon the original file (which is automatically embedded into your document), so your resized photo looks pristine (but that's not the main reason we made it a Smart Object—that's coming in a moment). Now that your photo is placed as a Smart Object, the cool thing is it already looks like a pano, because all you can see of it is that wide, not very tall opening (which was the selected area you filled with black in the previous step).

Step Six:
Now that your photo is in place, you can add any poster-style text you'd like using the Type tool **(T)**. Here, I added a text-and-signature look that I showed you how to create in the previous tutorial.

Continued

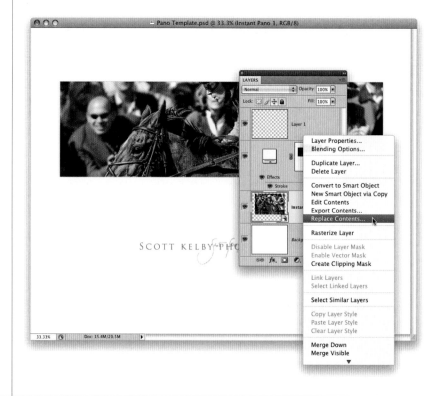

Step Seven:

Now, we're going to add a thin border around our photo that you'll be able to turn on/off, depending on how it looks with the particular photo you've imported, in just one click. Go to the Layers panel, click on your Solid Color adjustment layer, and choose Stroke from the Add a Layer Style pop-up menu at the bottom of the panel. When the Layer Style dialog appears, click on the Color swatch to bring up the Color Picker, then choose black as your stroke color and click OK. Set the Size to 1 pixel, set the Position to Inside (this makes the corners of your stroke nice and square), then lower the Opacity to 40% (this makes your stroke appear thinner), and click OK.

Step Eight:

At this point, you've created an Instant Pano template that can be used again and again, and it's the Smart Object (yes, we finally get to take advantage of it) that makes the template process so easy. So, first save this file (in Photoshop format) as a template (name it "Pano Template"). Now, let's say it's a week or so later and you want to turn a different photo into an instant pano. Open your template, then go to the Layers panel, Control-click (PC: Right-click) on your photo layer's name, and a contextual menu will appear. Choose Replace Contents (as shown here).

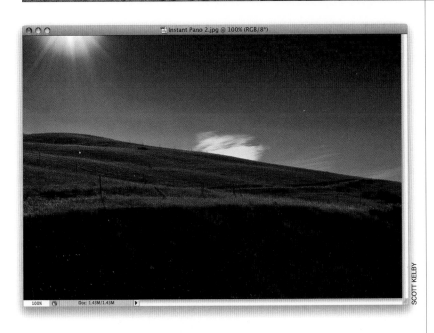

Step Nine:

Now navigate to a different photo you'd like to see as an instant pano (here's the photo that we're going to use—I'm just showing it to you here so you can see the full photo before it's brought into your template).

Step 10:

When you click the Place button, it replaces your current photo with the photo you just selected, and if the photos were the same size (and if they came from your digital camera, they're probably the exact same size), it automatically resizes to perfectly fit inside your pano opening (as shown here). If it's not the same size, you'll be able to change the size using the big bounding box (press-and-hold the Shift key, grab a corner point, and draw inward). Then hit the **Return (PC: Enter) key** to lock in your resize. To reposition your photo inside the pano opening, just take the Move tool **(V)**, click on the photo layer and drag up or down, and you can easily reposition it to get it right where you want it.

Continued

Step 11:

Remember that thin black border we added (well, at 40% opacity it actually looks gray)? Once you've imported your photo, you can decide whether it looks better with or without a border, and you can turn that border on/off with just one click. In the Layers panel, under your Solid Color adjustment layer, you'll see the word Effects with an Eye icon to the left of it. Click on that Eye icon to hide the stroke. To make it visible again, click where the Eye icon used to be.

Step 12:

Here's the final image. Now, since you've created a template, at this point you'd want to flatten the image and do a Save As, and give your file a different name. That way, your template stays intact, and the next time you want to try a different photo as an instant pano, you just open the original template, Control-click (PC: Right-click) on the Smart Object layer, choose Replace Contents, and choose a new photo. Once you've set this up like this, instant panos are about 30 seconds away.

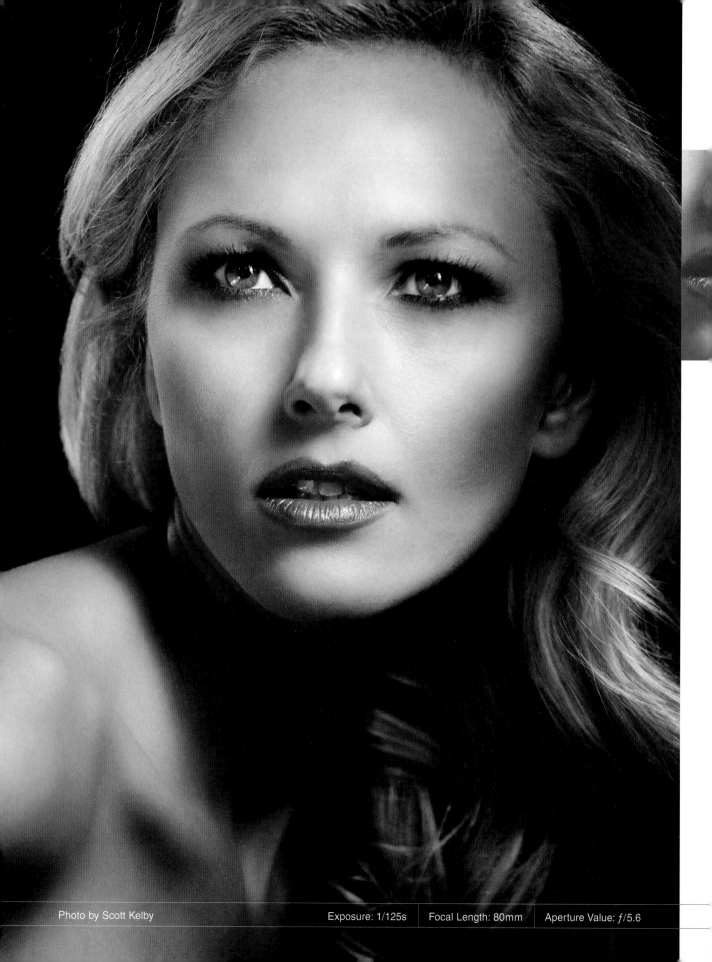

Working for a Livin'
my step-by-step workflow

This is the second time this chapter has appeared in any version of this book, and the only reason it's here is because I promised my assistant Kathy that I would find a way to include a Huey Lewis song as one of my chapter titles, but by the time the last book was done, I didn't have one, and there was no way she was going to let that book go to press without one. (She has an unnatural obsession with '80s singer Huey Lewis. She's seen the movie *Duets* [where he plays a karaoke singer] 316 times as of the writing of this book. By the time it comes off press, she will have seen it 321 times, based on past experience. It's sad to see her destroying her life like this, so I've been trying to focus her attention on something more positive, like drinking or shoplifting, and she's making some progress there. Sadly though, one day she got pretty hammered, went into Walmart, shoved a copy of *Back to the Future* into her purse, ran out to the parking lot, jumped into her DeLorean, and nearly sideswiped a kid on a skateboard wearing a red sleeveless hunting vest.) Anyway, this chapter, an homage to the song "Working for a Livin'" by Huey Lewis & the News, is where I bring the whole process together, from importing the photos into Bridge, to correcting the images, sharpening, and printing—the whole thing, in the same workflow order I use everyday in my own work. So, this is the mini-chapter where it all comes together. It's where the rubber meets the road. Where the brick meets the pavement. Where the goose gets the gander. Where Bartles meets Jaymes. Where the roaster grinds the coffee (where the roaster grinds the coffee?), etc.

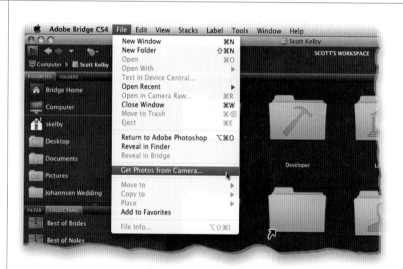

My Photoshop CS4 Digital Photography Workflow

I've been asked many times, "What is your Photoshop digital photography work-flow?" (What should I do first? What comes next? Etc.) So, I thought I would add this chapter here in the back to bring it all together. This chapter isn't about learning new techniques (you've already learned all the things you'll need for your workflow), it's about seeing the whole process, from start to finish, in order. (Every photographer has a different workflow that works for them, and I hope that shar-ing mine helps you build a workflow that works for you and your style of work.)

Step One:

Our first step is to get the photos from our memory card onto our computer, so we can start to work with them. Start by connecting your memory card reader to your computer, then go under Bridge CS4's File menu and choose Get Photos from Camera (as shown here). In our example, we're going to import some shots I took of a professional model named Angelina, from a live lighting demo I did at a tradeshow booth for the F.J. Westcott company (www.fjwestcott .com), showing off their daylight balanced continuous lights, the Spiderlite TD5s (those lights totally rock, by the way).

Step Two:

When the Photo Downloader appears, in the Save Options section, choose the location where you want your photos saved to on your computer, and I rec-ommend choosing the option to rename your files as you import them (choose a descriptive name). You can find out more about this importing process back on page 2.

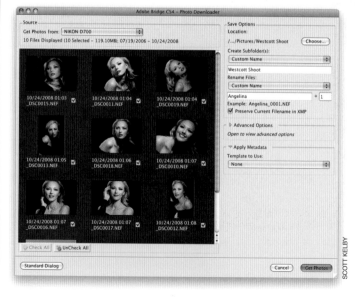

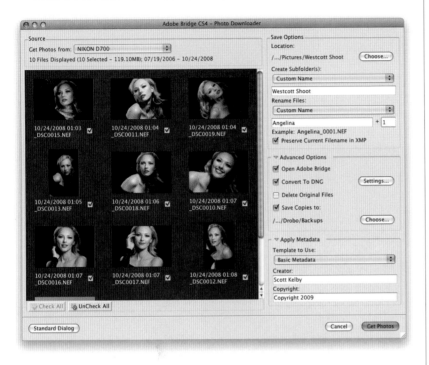

Step Three:
In the Advanced Options section of the dialog, turn on the checkbox to Open Adobe Bridge, and most importantly, turn on the Save Copies To checkbox and choose an external hard drive where a copy of your imported photos will be automatically backed up. That way, one copy of the photos on your memory card gets saved to your computer (these you can edit all you want, delete, and basically do whatever you want with as these are your working copies), and the second set of copies (the ones backed up to your external hard drive) act as your originals—your untouched negatives. In the Apply Metadata section, choose your copyright template to have your copyright and contact info embedded directly into your imported photos (see page 58 for how to create a Metadata template), then click Get Photos.

Step Four:
As the photos are imported, they appear in Bridge in the default workspace. The problem with the default workspace is that the Preview panel where you see your photos is way too small, which is why I always switch to a custom work-space that gives the largest possible pre-view, regardless of whether your photo is in landscape or portrait orientation (to learn how to set up this same work-space, jump back to page 9). Since I cre-ated this workspace earlier in the book, I just click on Scott's Workspace up at the top center of the window, which gives me the layout you see here. You can see, even at this early stage, the photo needs some serious editing (it's too green), and needs some retouching, sharpening, and some finishing effects.

Continued

Step Five:

In my workflow, I'm only concerned about finding two types of photos: (1) the very best ones from the shoot—the ones I might show the client—and (2) the photos that are so bad (way out of focus, taken by mistake, left the lens cap on, flash didn't fire, etc.) I just want them off my computer, because they're wasting space. To compare one or more photos at the same time, just click on the first photo, then press-and-hold the Command (PC: Ctrl) key, and click on any photos you want to compare (here I've clicked on four photos in the Content panel, and now all four photos appear in the Preview panel, as seen here). If a photo is so bad you want it off your computer, just click on it (in the Content panel) and press the Delete (PC: Backspace) key on your keyboard. This brings up a dialog asking if you want to mark it as a Reject (for deleting later) or move it to your computer's Trash (PC: Recycle Bin) right now (the choice is yours).

Step Six:

Now that the bad ones have been deleted, I want to quickly find "the keepers." I start by pressing **Command-A (PC: Ctrl-A)** to select all the photos, then I press **Command-B (PC: Ctrl-B)** to enter the full-screen Review mode. Here your images just rotate around, and each time you click the Left/Right Arrow buttons (in the bottom-left corner), it brings another image to the front (as seen here). If I come across an image that's not going to make it into the final batch I show the client, I just click on the Down Arrow button (shown circled here in red), and it removes it from this rotating carousel of photos. The idea is simple: keep dropping photos like this until all that's left in the carousel are the keepers.

Step Seven:

When there's nothing left in rotation but your keepers, click on the New Collection button in the bottom-right corner of the Review mode screen (it's shown circled here in red) to place all the remaining photos in their own separate collection (that way, all your best photos from this shoot are always just one click away). When you click this button, a little naming dialog will appear for you to name your new collection, then click the Save button. If ever you need to get back to this collection, just go to the Collections panel and you'll see it listed there. Click on it, and those keepers appear.

Step Eight:

Okay, now I can return to the Essentials workspace (click on Essentials up top), and once that workspace appears, I go and add keywords to these photos in the Keywords panel (see page 48 for how to keyword). Next, I'm ready to start editing my photos (what's nice is that, in this case, I'm down to just five photos, which keeps my editing and retouching manageable, because I'm only editing and retouching the photos the client will actually see). So, once I've added my keywords, it's time to start editing these images.

Continued

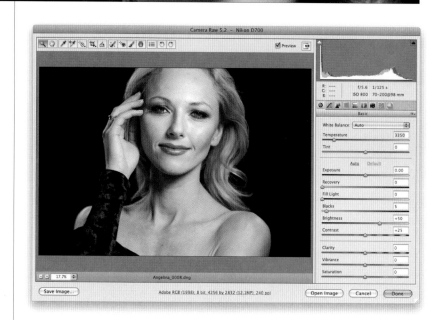

Step Nine:

To edit one of the images, just click on it in Bridge, and then press **Command-R (PC: Ctrl-R)**, which opens your photo in Bridge's Camera Raw, as seen here (just to clarify, it's not opening in Photoshop—Bridge has its own Camera Raw). Also, although I'm opening the image at this point from the regular thumbnail view, if you're in that full-screen Review mode and you want to open an image to tweak it in Camera Raw, you can use the same keyboard shortcut as above, and when you're done, just click the Done button and it returns you to the full-screen Review mode. Now, back in Camera Raw, if you look up in the histogram, you can see that the exposure really isn't too bad (it's not clipping the highlights), but the white balance is way off (which is why her hair looks green), so since I always start off by fixing the white balance first, let's do it.

Step 10:

I took these shots with two of those Spiderlite TD-5s, which as I mentioned are continuous lights (rather than a flash), but they use very bright fluorescent bulbs, so as a starting point, I chose Fluorescent from the White Balance pop-up menu. When I did this, most of the green went away, but it still looked a little bit cold, so I just dragged the Temperature slider to the right a little bit (toward yellow) to warm it up, and that made a huge difference in the overall color of the photo (as seen here). (For more on making adjustments in Camera Raw, see Chapters 2 and 3.)

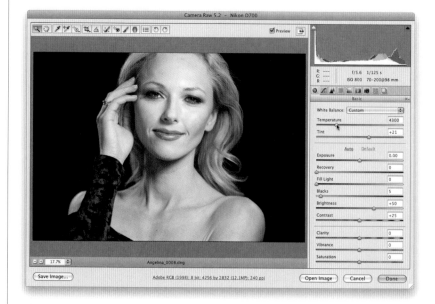

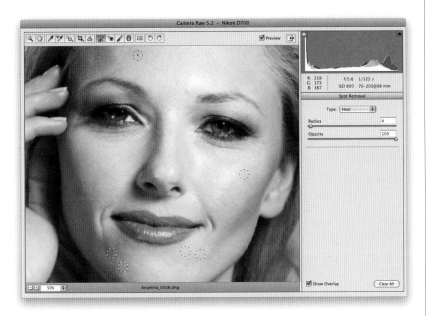

Step 11:

Now for a little retouching: Let's start by removing some of the blemishes on her face. Zoom in to at least 50%, then get the Spot Removal tool from up in the toolbar. Make your brush size (Radius) a little larger than the blemish you want to remove and just click. Don't paint—just click. Here, I found a few little blemishes, and I just moved my cursor over them and clicked once. This tool is ideal for little blemishes like this, but if it's much more than this simple type of one-click stuff, you're better off jumping over to Photoshop.

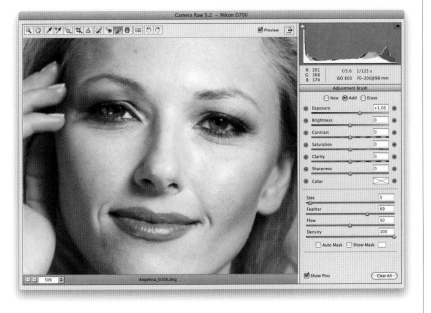

Step 12:

Now let's brighten her eyes a bit using the Adjustment Brush. First, click on it up in the toolbar, then click on the + (plus sign) button at the right end of the Exposure slider twice, which resets the tool, and increases the exposure a bit (of course, we can control the exposure amount after the fact, so just think of this as our starting place. For a how-to on this brush, jump back to page 155). Take the brush, shrink the brush size so it's nice and small, and then start painting over the whites of her eyes. A green pin will appear over the point where you started, which lets you know that you've adjusted that area. Once you've laid down a pin, you can control how bright the whites of her eyes are by dragging the Exposure slider.

Continued

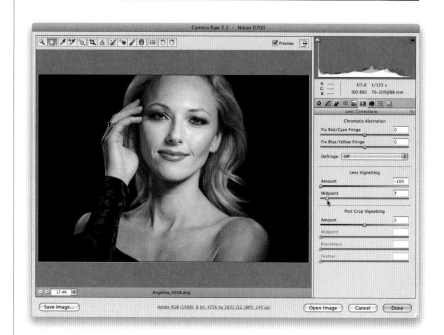

Step 13:

Let's do one more thing here in Camera Raw before we head to Photoshop (I try to do as much as I can in Camera Raw, because it's much easier and faster to do the adjustments here than it would be to do them in Photoshop itself). Let's finish up here by adding an intentional vignette effect, which gives the feeling of a soft spotlight by darkening the edges all the way around the image. Click on the Lens Correction icon, and in the Lens Vignetting section, drag the Amount slider all the way to the left to really darken the corners, then drag the Midpoint slider almost all the way to the left, as well, so that darkening extends farther into the photo than just the corners, which gives you this nice soft spotlight effect.

Step 14:

Now, click the Open Image button to open the photo in Photoshop, so we can do a little skin softening and sharpening (for more on these finishing techniques, see page 330). Press **Command-J (PC: Ctrl-J)** to duplicate the Background layer. Then, go under the Filter menu, under Blur, and choose Gaussian Blur. When the Gaussian Blur dialog appears, enter 25 pixels, then click OK to totally blur the photo (as shown here).

Step 15:

Now lower the Opacity setting of this layer to 50%, so you can clearly see the softening (this is more softening than you'll usually wind up using, but by starting at 50%, it's easier to see the softening as you apply it). We're actually going to hide this 50% blurry layer behind a mask, and then paint in the softening in just the spots where we really want it. Start by pressing-and-holding the **Option (PC: Alt) key** and clicking on the Add Layer Mask icon at the bottom of the Layers panel (shown circled here in red).

Step 16:

This will hide that blurry layer behind a black layer mask (as seen here). Now switch to the Brush tool **(B)**, choose a medium-sized, soft-edged brush (from the Brush Picker up in the Options Bar), and paint in white over just the areas you want to soften, being careful to avoid any areas that should remain nice and sharp, like the eyes, eyebrows, nostrils, lips, hair, etc., as shown here. If you take a look in the Layers panel, you can see the black layer mask, and the skin areas we've painted over appear in white on the mask's thumbnail.

Continued

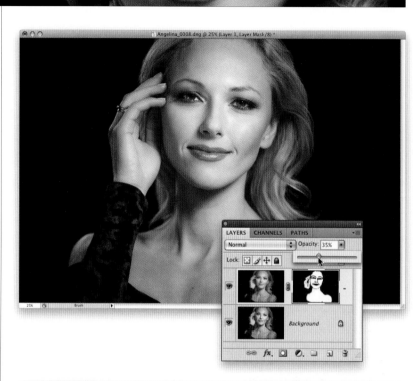

Step 17:

At this point, I generally lower the Opacity of this layer to 35% (as shown here), and I do this so you see some of the original skin texture, which keeps the softening from looking artificial. It's one of those "less is more" things.

Step 18:

Now let's finish up by applying some sharpening. We're going to use a similar technique to the one we just used for skin sharpening, but instead we'll be painting sharpening, rather than softening. Press **Command-Option-Shift-E (PC: Ctrl-Alt-Shift-E)** to create a new layer that is a flattened version of your image (this leaves your two original layers intact under this layer—should you ever need to get to them). Now press **Command-J (PC: Ctrl-J)** to duplicate the layer, then go under the Filter menu, under Sharpen, and choose Unsharp Mask. When the Unsharp Mask dialog appears, for Amount, enter 120%, for Radius, enter 1.0, and for Threshold, enter 3, then click OK to apply this sharpening to the duplicate layer.

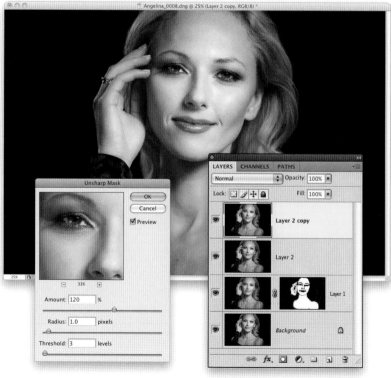

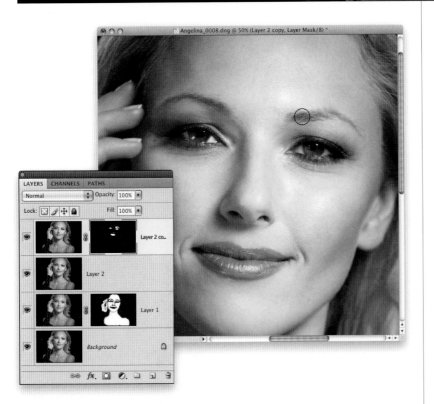

Step 19:

Press-and-hold the **Option (PC: Alt) key** and click on the Add Layer Mask icon at the bottom of the Layers panel to hide the sharpened layer behind a black layer mask. Get the Brush tool (use the same soft-edged brush), and paint over just the detail areas, like the eyes, eyebrows (as shown here), lips, nostrils, hair, and basically anything you want sharpened in the photo.

Step 20:

At this point, the editing is basically done, so I would start to set up the photo for printing. I want to print this on 13x19" paper, so I'm going to add a little bit of white canvas space around my photo (the original photo size is 17.73" wide by 11.8" high). Go under the Image menu and choose Canvas Size. When the Canvas Size dialog appears, turn off the Relative checkbox, then type in the final size you want for your print in the Width and Height fields (as shown here), and click OK. Now we're ready to start printing.

Continued

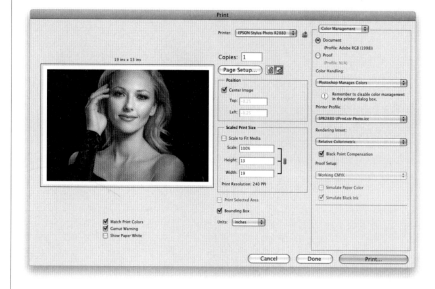

Step 21:

Now it's time to print the photo, so go under the File menu and chose Print. When the Print dialog appears, choose your printer from the pop-up menu at the top of the center column. If you need to change your page size, click on the Page Setup button below that. On the right side of the Print dialog, set the Color Handling pop-up menu to Photoshop Manages Colors, then from the Printer Profile pop-up menu, choose the paper profile for the exact paper and printer you're printing to (more on this, starting on page 389). In our case, we're printing on Epson Ultra Premium Photo Paper Luster (which used to be called just Epson Premium Luster) to an Epson Stylus Photo R2880 printer. For Rendering Intent, choose Relative Colorimetric, and leave the Black Point Compensation checkbox turned on, then click the Print button.

Step 22:

Clicking Print brings up your printer's Print dialog (seen here). In the previous dialog (Photoshop's Print dialog), you chose Photoshop Manages Colors (which is the right choice, by the way), but since Photoshop is going to manage the color, you don't also want your printer trying to manage the color, too (the results aren't pretty). So, go to the Print Settings section and turn your printer's color management feature off (as shown here). On a PC, click the Preferences button, change the Mode to Custom, then choose Off (No Color Adjustment) from the pop-up menu. Don't click the Print button yet—you've got one more step.

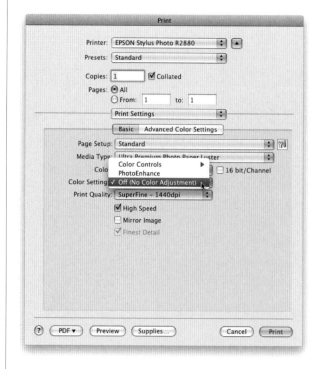

Step 23:

Now, also in the Print Settings section (the Printer Preferences dialog on a PC), choose the exact type of paper you'll be printing to in the Media Type pop-up menu, choose your Print Quality, and if the High Speed checkbox is on, turn that off. Okay, that's it. Now you can click Print. The final results are shown below. So that's it—from import, to finding the photos you want to keep, to applying some edits in Camera Raw, another round of edits in Photoshop, and then printing the final image (which is what it's all about, right?).

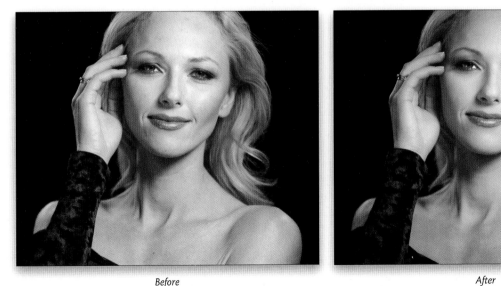

Before

After

Index

NAPP is a truly amazing resource, both creatively and professionally.

"As an artist, photographer and printing professional who spends a lot of time in the studio, having NAPP services and information at my fingertips is a truly amazing resource, both creatively and professionally. I own my own business and have a lot of demands on my time, so I greatly appreciate the massive amount of information, the discounts, the online classes, and the talented instructors that NAPP makes available to me on-demand on the Internet, in their magazines, and through live training events."

Deanne DeForest *Business Owner and Art Director*

Ask any member...
NAPP is the best investment in your Photoshop education!
One-year membership $99* | Two-year membership $179*